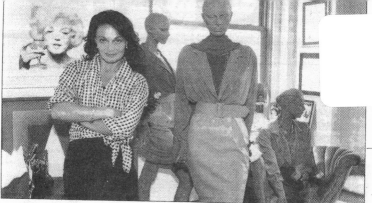

Diane Von Furstenberg with her new dress collection for Spring '92

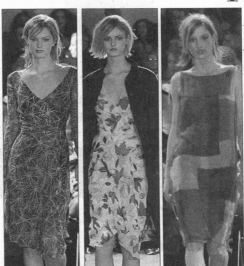

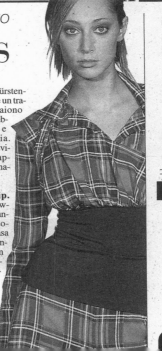

DIANE VON FURSTENBERG RETURNS TO THE FASHION SCENE BY SLIPPING INTO COMFORT WITH DRESS DESIGN

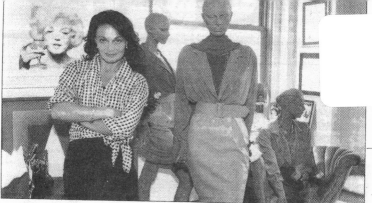

By TERE GREENDORFER

NEW YORK—Diane Von Furstenberg made fashion history in the '70s when she created the flattering, easy-to-wear wrap dress. Now, after pursuing other endeavors, she's back making dresses again. This time, she's not only inspired by her original style, she's created another winner—the "sock" dress.

She premiered her new line, which is licensed by Russ Togs, at her Fifth Avenue studio. She dedicated it to the modern working woman and rather than using live models, the showroom was divided into vignettes. Each featured ... her styles. ... like a fax m...

Expla... Von Furste... in your own... comfortabl... separates b... coordinated look.

She does variations of her wrap shapes—one with a ballerina

look, two others she calls the "Marilyn Wrap"—in pink gingham silk and in green along with a pink stripe trompe l'oeil version. She also does a shirt dress with a faux sarong and a sheath reminiscent of the style former first lady Jackie Kennedy favored.

Von Furstenberg's newest hits are her "sock" dresses. During a brief tour of her "office settings" the designer explains, "They look like a two- or three-piece outfit but pull one on without ... easy-to-wear, the designer says "It's the one you always reach for in your closet." Undoubtedly, as her customer, you will too.

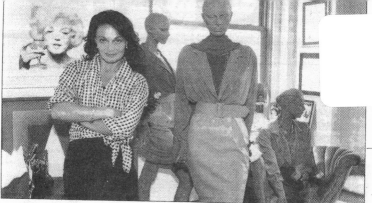

WOMEN'S WEAR DAILY, TUESDAY, JANUARY 29, 1986

...-to-wear dress on a mannequin ...e of Diane Von Furstenberg's 'office vignettes'

The New York Times
SundayBusiness

Sunday, September 5, 2004

Section 3

The Dress That Saved Diane von Furstenberg

By TRACIE ROZHON

IN Diane von Furstenberg's little shop on West 12th Street, in the meatpacking district of Manhattan, a young blonde who looked vaguely like Reese Witherspoon was looking for only one thing. "I want the wrap dress," she demanded.

The sales clerk tried to steer her to something else. "What about these wonderful tweed miniskirts?" she asked. "How about these cropped pants with the zippers?" Getting nowhere, the clerk gave up. "We're almost out of the wrap dresses now," she confessed, "but we'll be getting a whole new selection next week."

The young shopper brightened. "Well, I'll be back then," she said, and left.

Ms. von Furstenberg's wrap dress — made of printed jersey and designed, simply, to cling to the female body without looking raunchy — made its debut before that shopper was born. It is back in a big way, and so, too, is Ms. von Furstenberg.

In the world of fast-forward fashion, where careers are measured in minutes and where hot names melt into nothingness in the space of a summer's day, Diane von Furstenberg is that rare creature: a diva who fell off the map, only to be rediscovered by the daughters of her original customers.

"We call her Lazarus," said Paula Sutter, the president of her company.

Ms. von Furstenberg, now 57, has no problem with

that label. "I totally had gone," she said. "If you talk about a brand being 'clean,' my brand was the dustiest you can have. I only had one little license left. In my early 20's, I had grown so fast, into a hundred million a year in retail sales. I lost it — and my children in boarding school! I sold my company and fell in love with some guy and lived in Paris."

By the start of the 90's, the love affair had evaporated, and so had most of her business. She decided to leave Paris and start over in New York, making clothes again. Even with friends like Barry Diller, the mogul she later married, it wasn't easy. Once one of the most sought-after and glamorous women in this glamorous city, Ms. von Furstenberg said she could not get the big names in fashion to return her phone calls — or, when they did, "they treated me like I'm a has-been, thinking I was lucky because I invented a little dress."

"It was very hard; I ate a lot of humble pie," she said, her bare, tanned legs curled up under her as she perched on a sofa in her office.

But now, her revived clothing lines — including the same wrap dress, which now has its own label, "Diane von Furstenberg Vintage" — are in the trendiest stores. Julie Gilhart, the fashion director of Barneys New York, last week ranked her clothes next to those of Juicy Couture and Marc by Marc Jacobs among the coolest for young customers.

Next Sunday evening, as part of Fashion Week in New York, her headquarters on West 12th Street will be the

Jennifer Altman for The New York Times

Diane von Furstenberg, in her studio, wears her wrap dress, which is jumping off the shelves, again.

Continued on Page 4

...ic Dress Missing ...w Fall Collection

...Post News Service

...Diane von Furstenberg's ... put to bed. The historic ...illions for the princess-... is noticeably not includ-

... whose price tags still an-...wear a dress," is for the first time planning to include pants, sportswear and businessuits in her spring collection.

Why the changes?

Von Furstenberg shrugs. Making a personal appearance at a store in Westwood near Los Angeles, she stretches out languidly on a broad velvet sofa as if she were in her living room and fluffs her mane of frizzy black hair.

"A dress, after all, is only a dress. It has three holes —one for the head and two for the arms. After a while, you just have to move ... been happening to ...

Upon leaving the room, she casually picks shopping bag bearing her name on both sides, har free bottles of her new fragrance, "Tatiana," to persons and blows kisses to customers who rec the face on the dress tags and who rush to her f autograph.

If Von Furstenberg's image hasn't change view of her customers and of her collection ha has gone from using bold, brightly colored patter clingy, body-fitting dresses with bust darts, to a of solid-colored, silk shirtwaists and simply s slightly oversized dresses that are moresophist and conservative than her designs of former yea

"You see, I know the secret," she says. " women what they want, not what they can't wea what they can't afford. I have an added advant tha I am a woman and I know that what looks on the drawing board doesn't always look good on woman. Also, I have kept my dresses at about the prices — $80 to $135."

Since separating from her husband — now a swear shopper — she has branched out into other and now lends her name and design talent to a and coat line for Puritan; jewelry for DMA; fu Mohl; T-shirts for Camicetta; and sleepwear for The Diane von Furstenberg cosmetics compan cosmetics shop on Madison Avenue in New York only enterprise she owns-totally.

"When I think back, I really started in a very teurish fashion," she reflects, announcing that s about to move her offices to the entire top floor ...fashionable Fifth Avenue office building.

Os vestidos mágicos ...iane Von Furstenberg

Iga que é ...mundo da ...m Lisboa ...nferência ...onhecer ...joalharia ...para ...rn

...ASCENÇÃO

Faculdade ...le Lisboa e ...imas peças ...nos finalis-...oda. O que ...a atenção ...n diversos ...carteira ...umentos e ...garrafa de ...eal para as ..., por isso, ...euros.

...iane Von ...lista ame-...u famosa ...s (vestido ...ono) nos ...-se a Por-...ras con-...daLisboa ...ição com ...itectura, ...onhecer ...aria que ...ão com a ...a chegou

...percurso ...ta com al-...isas boas ...os quais ...Bélgica, ...stados

bailarinas, e vendia-os com saias", recorda. Tornou-se popular. Foi aí que lhe surgiu a ideia de adaptar a peça a vestido: nascia assim o *wrap dress*, que ia ser desejado por todas as mulheres americanas. A seguir, lançou-se também no mundo dos cosméticos.

Princesa, estilista, empresária de moda e personalidade do *jet-set* americano, Diane viu o seu negócio passar por altos e baixos. Chegou a ser a sétima mulher de negócios do país, e a ter honras de capa no *Wall Street Journal*, em 1976. Mas a má gestão levou-a a ter de mudar-se para Paris. "Pensei que o mundo da moda tinha acabado para mim", recorda. Diane Von Furstenberg é também uma apaixonada e colecciona-dora de jóias. Foi assim que procurou a colaboração com a H. Stern. "Pri-meiro tentei o pai, como não consegui, convenci o filho", conta, adiantando ter criado uma jóia em forma de coração ins-pirada numa peça de joalha-ria portuguesa ...

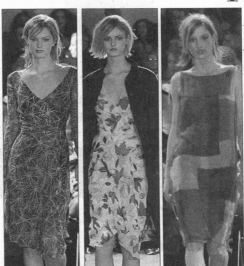

rado sucesso. Comprou todas as licenças que tinham o seu nome, e voltou a comercia-lizar os seus vestidos nos armazéns Sacks Avenue. O *slogan* que escolheu para atrair clientes deixou dúvi-das a muitos: "Alguma coisa em ti lembra-me a tua mãe". Não sabe explicar porque es-colheu esta frase, mas a men-sagem passou, e a sua roupa começou a ser comprada por jovens modelos ou actrizes, como Sarah Jessica Parker ou as "endiabradas" ir-mãs Hilton.

Hoje em dia, a sua marca é distribuída em 42 países, com lojas em Paris, Londres e Nova Iorque.

Mercoledì 14 Febbraio 2001

SFILATE A NEW YORK

off XI

LA STILISTA HA PRESENTATO I CAPI CON UNA FESTA NELLA SUA CASA-STUDIO

Torna il wrap dress

PAGINA A CURA DI FRANCESCA GUERRINI (NEW YORK)

Si è sposata da una settimana, ha una casa di moda che è stata un'icona negli anni 70, ha vissuto fallimenti e resurrezioni. Alla sua seconda stagione di sfilate a New York Diane von Fürstenberg, 50 anni, si diverte, gioca e lo fa seria-mente come solo chi non ha più niente da dimostrare riesce a fare. Una serata allegra e spensierata, una collezione sintonizzata sull'at-tualità.

Collezione. Abiti leggeri e ade-renti al corpo, pieghe frizzanti, un tocco di colore: anche in inverno c'è voglia di flirt e di risate, di leg-gerezza. Maglie di lana dal collo alto su gonne leggere di chiffon, pantaloni dalla vita bassa con jer-sey sovrapposto e gilet in persiano nero dagli orli slabbrati. Lo stam-pato scozzese si abbina alla maglia negli abitini e nelle gonne, i top se-guono il corpo e gli scolli si com-plicano in intrecci sexy. I cappotti a vestaglia ampi cadono dritti nelle ...

di fabbrica di Diane von Fürsten-berg. Abbandonarli sarebbe un tra-dimento, dunque ricompaiono negli abiti aderenti, negli abbi-namenti insoliti di jersey e flanella, chiffon e maglia. Scolli asimmetrici e tagli al vi-vo, sovrapposizioni e drap-peggi in un insieme coordina-to e ben strutturato.

Allestimento e Gossip. Nella sua casa-studio-show-room la solita folla delle gran-di occasioni, eclettica e co-smopolita. La padrona di casa si destreggia tra Marie Chan-tal di Grecia, André Leon Talley e Alessandra e Fabri-zio Ferri. Un pizzico di gla-mour e poi grande party.

Giudizio. Proposte be-ne articolate:Diane decide il ritmo e lo segue fino in fondo. Una donna-ragaz-za che conquistata la si-curezza non teme giudizi

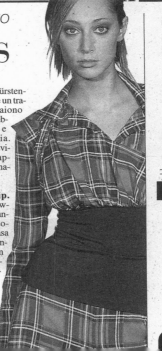

DIANE VON FURSTENBERG

Wra...

By EL...

NEW ...orld of f... ake mili... e seaso... xt, Dian... nained a... ylike sty... Von Fur... e wrap ... experie... mple fas... If you w... feel rea... ident, yo... will auto...

...terviewe... o, Von F... -fitting.

collection is ...'0s wrap dre...

in Nineties

Diane Redux
The little dress returns

With Style
GINI ZEMO

Just about everybody makes New Year's resolutions. Fashion maven Diane Von Furstenberg's resolution "to bring back the little dresses" has come to fruition.

You remember her — in the early '70s, Ms. Von Furstenberg designed a V-neck cotton jersey wrap dress that put her name on the fashion map. By 1976, 3 million had sold

fabrications, she said she still believes that Italian knits are the best.

"I love the way they feel against the skin," she said.

Every customer wanted it. And were there ever rip-offs? As I remember, it sold for under $100...

ment stores this spring. The dresses come in sizes 4 to 16 and will sell for between $110 and $160.

NEW YORK POST
MONDAY, JUNE 23, 1997

NEWYORKWOMAN
A POST PLUS SECTION

MONDAY: Fashion & Style

...he wrap make a comeback?

...navens are ...Furstenberg ...s is a hit

At once vulnerable (one tie and you're all undone) and provocative (one tie and you're all undone), the wrap dress and the phenomenal success landed Von Furstenberg — in a body-clinging green-and-white striped version — on the cover of Newsweek in 1976.

"The concept is still a valid one," says Von Furstenberg, who's teamed up with her 24-year-old daughter-in-law Alexandra Von Furstenberg to create her new clothing line, Diane. It will be available exclusively at Saks Fifth Avenue later this summer.

In her heyday, she sold five million of these frocks. Today, the idea of the dress, brings a feeling of nostalgia to the women who wore the originals and inspiration to young designers who're creating their own.

Question is, will '90s women embrace Von Furstenberg and get wrapped up in this style again?

Carolina Herrera, who showed two wrap dresses in her Spring 1997 collection — a silk yellow ruffled dress and a red jersey — says the style's appeal is that it's "easy to wear, airy and looks sexy. It's good for summer more than anything else."

Personally though, Herrera eschews wearing wrap dresses. "I don't feel comfortable," she says. "It feels like I'm wearing a dressing gown."

Nicole Miller reports that the two wrap dresses she designed for her Spring 1997 collection — a reversible crepe with bamboo ring and a nylon long sleeved pale

green — were rather modest sellers. "I put them in for a mix of silhouettes and shape and to test the market," Miller says. "But they don't hang well on hangers."

Besides, Miller says, most women today shop for work clothing, for evening wear and head to The Gap for weekend clothes. "Where does the wrap fit into today's lifestyle?" she asks.

That's a question Von Furstenberg asked herself before deciding to introduce a late '90s version of the wrap dress in silk knit (original was cotton and rayon). She's bringing back the bold prints, and the collar and cuff on one version, but the skirt will be leaner.

"Yes," Von Furstenberg acknowledges, "the challenge is that women have been wearing jackets for so long."

After much deliberation and encouragement, Furstenberg became convinced to unwrap her famous dress because of the younger generation, who were snapping up the originals in vintage clothing stores.

"I can't stop being surprised," she says.

Downtown designer Pixie Yates, 30, is among the admirers.

"I remember my mother wearing a wrap dress with sandals and a little straw bag," Yates recalls.

Now she designs her own in solids and prints in rayon and polyester micro fiber. "What do I like about the wrap dress?" asks Yates. Just like a woman of the '90s, she says, "They're ladylike, but at the same time they're not."

...rap dress launched fashion career

...n Fashion

...r clothes; they ...the world and ...they want to be ...beautiful, but ...le," she said. ...sign costumes, ...clothes for the ...woman who ...ook terrific." ...ears ago, when ...her husband, ...gon Von Fur- ...moved to ...s from Belgium, ...Furstenberg ...sees that would ...and wear well ...first patterns ...out on the dining ...

...room tables in her apartment.

She shipped the dresses to a friend in Italy who had them manufactured at a factory outside of Florence and when the first designs arrived in New York, she packed them up in a suitcase and started showing them to the various department stores in the area. These featherweight, classic shirt-dresses were the beginning of Diane Von Furstenberg, Ltd. "The fabric I use, which consists of a cashmere-blended jersey, is still knit, dyed and printed in Italy," she said.

Although the Von Furstenberg enterprise has grown from a single-handed operation to a group of 20 cutters and designers, Diane personaly selects and designs all the prints that are used in her collection. "I fight to keep the process as inexpensive as possible so the average woman can afford to buy an outfit," she added.

Like Coco Chanel, a woman designer of the '40s, Von Furstenberg of the '70s, is more interested in volume than designing creations for individual women. Her fall collection retails

Diane Von Furstenberg, above, made designer headlines in the fashion world last year with a simple wrap dress, below at left.

...want in their fashions. "Fashion show clothes are on the way out. I design the things I like. I put them on and see what they look like and how they feel," she said.

Diane fell in love with lavender and purple shades this fall and much of her collection sports that color. "The basic dress I design may be worn loose and flowing or tied with a self belt," she said. "When you start wearing jersey dresses like these, it's hard to wear anything else; if you add a little weight the dress stretches with you. You can wash it and pack

it and not have to worry. My fashions are designed for today's busy lifestyle."

The Von Furstenberg wrap-dress has remained a "favorite" and women everywhere have adopted it as their own unique look. Her latest style features a piped neckline, narrow cuffed sleeves and a waistline defined by thin wrap ties.

Besides creating clothes that make sense, Von Furstenberg has expanded her line into cosmetics, jewelry and fashion accessories and she uses the same principles she relied on for her

dresses — simplicity, comfort and versatility.

"Every woman should do her best to look as good as possible," she said. Believing that it should not take hours to do so, Von Furstenberg invented a line of cosmetics that consists of 13 makeup products, all clearly labeled and ten treatment products that are beneficial to all skin types when used regularly.

"People have asked me if I'll ever go into children's or men's fashions, but I cater only to women," she said. She admitted she is interested in interior design and is flirting with the idea of trying a hand at it.

"I love my career, but it's difficult because I have to travel a lot," said Diane, mother of two children, ages six and seven. She lives with her husband in an apartment in New York and vacations on an estate in Connecticut.

Ms. Von Furstenberg admits that being the wife of a prince has helped her career, but she said it didn't make it the success it has become. "When you bake a cake you have to have all the ingredients or it won't turn out," she said. "I've worked hard on my own and created a good, lasting product."

Born Diane Halfin, Ms. Von Furstenberg was

TUCSON, SUNDAY, FEBRUARY 20, 1977

The tried-and-true wrap

Diane Von Furstenberg

...s a wrap — Diane Von ...Furstenberg is back

...seasoned ...cially her ...ess, is back

...NEDY

...ashion, where design- ...ed garments one sea- ...next, Diane Von Fur- ...arbiter of a

...signature "wrap ...experienced a come- ...philosophy: "If you ...ou feel really com- ...u will act as such and ...attractive."

...k-walled studio, ...fitting, silk-jersey ...flage pattern. "I don't ...feeling that there

...rently shows shades of purple, blue, orange and green in bold, geometric patterns. Fabrics include jersey, chiffon and georgette.

She was born Diane Halfin in Brussels, Bel-

...daughter and a brand. And my son and my daughter turned out great and the brand just fell apart."

"But I had time to retire young and come

Wearing one of her signature wrap dresses from her fall collection, designer Diane Von Furstenberg poses in her New York shop.

...designed the wrap ...her love of T-shirts

Wrapping up success

Taking the Wrap

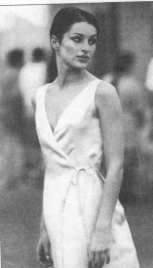

$30 million gross—
'Princess' business i...

By RICHARD BONNER
(Chicago Sun-Times)

CHICAGO — Diane Von Furstenberg, merchant princess.

In the past seven... Brussels has parlaye... a dress, cosmetics a... will gross $30 to $32... take into account th... such products as su... and rainwear, social...

Hardly an accomp... nected as a princess,...

"A TITLE certain... concedes with an e... from frequent encou... when you're startin... that I'm a very sensi... ing mind. I follow m... sense. And taste, too...

"I think you could... independent and I... dustry and give my c...

Clad in one of he... stenberg sits in an o... arms of the chair, re... gins of her Diane Vo...

After a brief stint... Cornfield in Switzer... (without graduating)... she met Prince Egon... whose title was Prus... Fiat automobile fort...

IN 1969 the two... caught on quickly w... stenberg knew she w... as possible: "I knew... boutique or somethi...

"We rushed into a... berg. Though having... ienced her, it didn't... some inventory work... cesarean section for...

Among designs from Diane Von Furstenberg's current collection are, left, an off-the-shoulder peasant dress in jersey with long sleeves and dropped waistline, and right, a "tulip fantasy" wrap-style of black jersey in yellow, red or blue print, made with deep...

DVF '75

John Sher's turquoise silk charmeuse dress; shoes by Warren Edwards and Susan Bennis.

Hayward, CA
Review
(Cir. D. 38,173)
(Cir. Sun. 38,558)

DEC 19 1976

Diane von Furstenberg
Owes success to 'little dress'

By BARBARA HERRERA
Copley News Service

Diane von Furstenberg, 29, the socialite-turned-designer, in six years has built her fashion operation from nothing to what she estimates will amount to $100 million in retail sales this year.

At 5 feet, 6 1/2 inches tall, Miss von Furstenberg presents a leggy, loose-jointed appearance in a size 4 dress. Shining auburn hair waves over her shoulders. Tawny blusher colors her aristocratic cheekbones. Shadow highlights her prominent eyelids.

And a line of blue drawn under her huge brown eyes is the only touch of color in her otherwise all black-and-white outfit. Her own black-and-white, three-piece knit dress. Black stockings. Black patent leather high-heeled shoes.

Miss von Furstenberg, surrounded by success, has no trouble explaining her own success.

"Nobody was doing what we call in French 'la petit robe (the little dress),'" she said. "So I filled the gap."

Miss von Furstenberg came along with her flattering, feminine dresses when Halston, Calvin Klein and the other superstars were concentrating on all those classic pants, jump suits and evening pajamas.

Or as Miss von Furstenberg put it herself...

Wrap dress co...

By ELIZABETH A. KENNEDY
ASSOCIATED PRESS

...YORK — In the fickle ...ashion, where designers ...tary-inspired garments ...n and gothic frocks the ...e Von Furstenberg has ...an arbiter of a feminine, ...yle.

...rstenberg, whose signa... ...dress from the 1970s ...enced a comeback, has ...ashion philosophy:

...wear clothes that make ...really comfortable and ...you will act as such and ...tomatically be attrac-

...wed in her pink-walled ...n Furstenberg wore a ...ing, silk-jersey wrap ...a camouflage pattern.

Diane Von Furstenberg

LEBENSART Mode
Comeback einer Kämpfe...

Se imp...
"wra...

...uer Kollektion und ...n meldet sich ...von Fürstenberg, ...h schwerer ...eit zurück. Ein ...e, das Mut macht

DAGMAR VON TAUBE

...mer werden ...cht älter, sondern bes- ...r. Prinzessin Diane von ...urstenberg, Mode-Desi- ...erin in New York ier ...(Tatjana, 26 und ...31, verheiratet mit ...e-Miller-Erbin Alexan- ...folgas-Frau Heute sagt ...bin weder müde, noch ...ern am Start zum zwei- ...n."

...ck: die wilden 70er. ...afgeweckter End-Twen. ...ussisch-griechischer El- ...Brüssel im verrückten ...Erst 29, aber bereits ...n von dem Deutschen ...n von Fürstenberg, als ...rem ,Wrap-Dress" über ...ntlich die Cover der ...agazine eroberte. Und ...Julie Nixon Eisenho- ...e. O. Über fünf Millio ...iele Jahre wie ein vo... ...n. Ein Schmetterlings-

Diane von Fürstenberg (r.) mit ihrer Tochter Tatjana: "Sie hat mich mit ihrer Liebe sehr unterstützt."

Leben, das sie leicht wie Luft von einer Blüte zur nächsten trug. Irgendwann war es vorbei. Andere Zeiten, andere Trends, andere Designer. Ein plötzlich nicht immer nur leichtes Leben für die alleinerziehende Mutter. Lange sag sich die Mode-Prinzessin zurück.

Jetzt ist sie wieder da – wieder als Titel-Star. Nur: Dieses Mal schrieb sie die Story selbst dazu. Ihre Biographie: „Diane. A Signature Life" (Simon & Schuster). Ein Spaziergang der Gedanken durch ein turbulentes Leben. Erstmals

spricht sie auch über ihre Krebs-Erkrankung. „Mein Freund Ralph Lauren erzählte mir von seinem bösartigen Hirn-Tumor. Es begann mit einem Geräusch im Ohr. Damals realisierte ich plötzlich, daß...

Sie hat den Krebs besiegt: „Schöne Menschen...

...im Ohr hatte, ging sofort zum ...müssen sic ...Arzt. Der fand erst nichts außer ...bemühen, I ...einer geschwollenen Nacken- ...auf Schönh ...Drüse." Im renommierten Sloan ...hen. Mußte ...Kettering Cancer Center ließ sie ...ke. Köpfch ...die Zyste entfernen. „Beim Auf- ...fen. Das hat ...schneiden entdeckte man bösar- ...und gefestig ...tige Zellen, die im Rachenraum ...selbst aus ...Metastasen gebildet hatten." ...hat, fällt m ...Acht Wochen Chemotherapie ...einmal und ...folgten. ...hinein. Ich ...

Parallel dazu konsultierte sie ...immer mit I ...den berühmten US-Heiler Dee- ...erzogen. W ...pak Chopra: „Ich glaube an seine ...Phantasiew ...Methode, bei der man Kraft aus ...später einfa ...sich selbst entwickelt: Ich mach- ...lernt mit Sc ...te lange Strandspaziergänge, ge- ...zugehen, un ...tete und meditierte täglich 40 ...man für spä ...Minuten. Ich zwang mich, im- ...Kraft finde ...mer gut auszusehen, wenn ich ...tur und der ...ins Hospital ging. Achtete auf ...Haus habe ...Haare und Make up mehr als ...Lavendel. De ...sonst. Trug helle, positive Far- ...lat ,Lavare' u ...ben. Ich ließ die 18 Block ins In- ...schen. Wenn ...stitut zu Fuß, statt mich fahren ...reibe ich ihn ...zu lassen wie sonst. Immer al- ...inhaliere der ...lein, weil ich allein klar kom- ...me. Die Wirk ...men wollte. Beim Gehen sang ...Dichters Joh ...ich immer ein selbsgetextetes ...Leistake: Ein ...Siegeslied. Darin ging es um bo- ...eine ewige F ...se Zellen, die erfolgreich gekillt ...ist wer Schö ...wurden. Ich suchte überall nach ...kommt imme ...positiven Zeichen. ,V wie ,Vic- ...gibt. Ich akze ...tory' – Sieg! Oder eine Astgabel, ...warte nichts ...die wie ein Herz gebogen war. ...man nichts e ...Ich gurgelte mit Senföl, trank ...nur Plus beko ...Weizenkeimsaft. Ließ mich täg- ...Sie lächel ...lich massieren für das Immunsy- ...dunklen Lock ...stem, aß getrockneten Ingwer." ...so schön. Ma ...wie es künstli ...lich selbst e ...sein. Dann ...mals allein...

...aking our ...thed our ...signature ...as part

...rap dress queen, Diane Von Furstenberg, right, teams up with her daughter-in-law socialite Alexandra Miller-Von Furstenberg.

...Por Jul...
Redactor E...

Aunque aquí en la Isla, en h... ...dad, parece que han pasado ina... ...otros países que nos ha tocado... ...mamente el cuadro es otro.

Nos referimos a los "trajes... ...de "wrap around", la invención de... ...ra Diane Von Furstenberg. El... ...ese modelito sensual, tan modern... ...tiene más de 20 años desde su... ...erangen. W... en el mercado y está próximo a rep...

En tiempos recientes, graci... ...del "retro look", diseñadores come... ...feld lo volvieron a colocar en la pa... ...dial. De hecho, ahora vemos e... ...reinterpretado no sólo en vestid... ...bién en blusas y faldas.

Y lo mismo ha hecho Dian... ...tenberg, quien lanzó al mercado u... ...bajo el nombre "Diane" con una v... ...lizada de los modelos "envolvent... ...e a lucir uno? □

DVF 40

JOURNEY

of a

DRESS

DIANE von FURSTENBERG

RIZZOLI

NEW YORK

New York · Paris · London · Milan

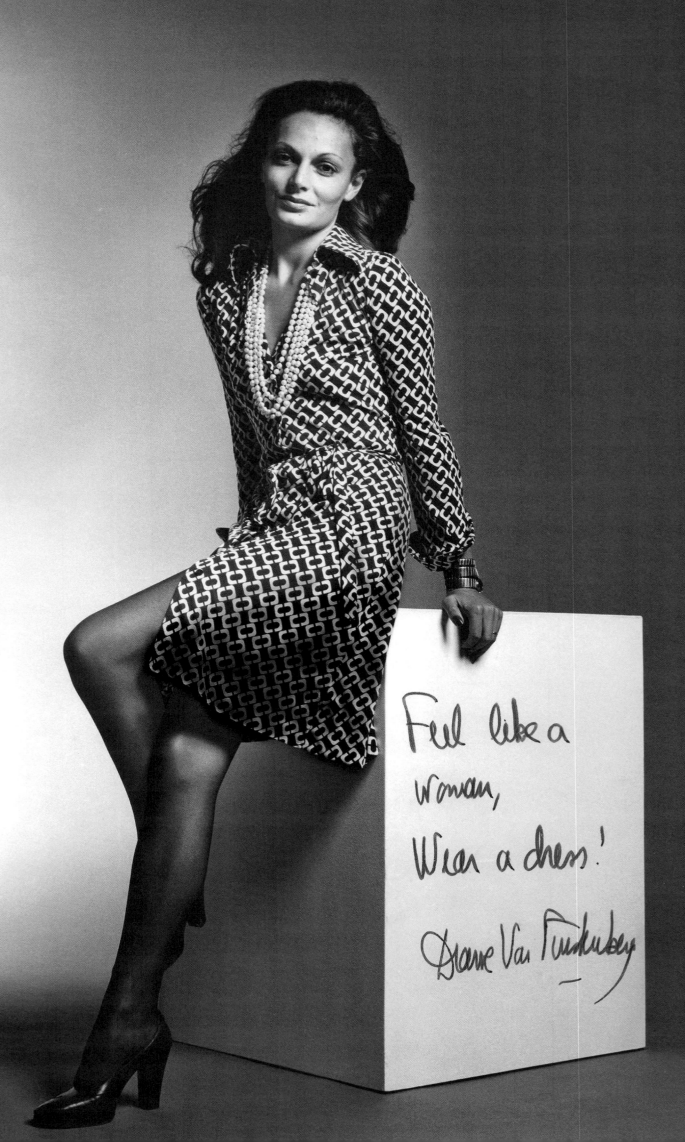

Feel like a
woman,
Wear a dress!

Diane Von Furstenberg

VOGUE

689-5900

THE CONDÉ NAST PUBLICATIONS INC.
420 LEXINGTON AVENUE, NEW YORK, N. Y. 10017

April 9, 1970

Diane:

I think your clothes are absolutely smashing.

I think the fabrics, the prints, the cut are all great. This is what we need. We hope to do something very nice for you.

Also, do you need any help with stores?

If there is anything you want us to do, please don't hesitate to call.

Very sincerely yours,

much love!
Congratulations —

Diana Vreeland

Diana

Princess Egon Furstenberg
1155 Park Avenue
New York, New York

Journey of a Dress

Once upon a time, there was a princess with an idea. The idea was a dress. Not a taffeta ball gown, like the ones fairy tale heroines wear—this was a drip-dry, cotton jersey dress that wrapped in front and tied at the waist. The princess devised cunning prints in vivid colors and arranged for the dress to be manufactured and sold. In no time, women all across the land were buying the dresses—five million of them—and wearing them. And even though the princess was a member of the jet set, famous far and wide as a glamorous party girl, her dress was seen as evidence of an uncanny knack for identifying with her customers: they felt that she must have understood them to have invented something so comfortable and practical, so suitable to their own everyday adventures and their newfound sense of independence.

For the women of the land had gone to work. Heigh-ho! It was the 1970s, and en masse they left their sculleries and their hearths for careers in finance, law, and other fields that had been the province of men. Wearing a wrap dress by the princess—an entrepreneur herself—the women went on job interviews; they went straight from the office out to dinner; they went around the world, washing the dress at night in their hotel rooms' bathroom sinks. Requiring no help with a zipper in back or hard-to-reach hooks and eyes, the wrap dress epitomized not only the spirit of women's liberation but of sexual liberation, too: in two minutes flat, a woman could be dressed and out the door; in even less time, she could be undressed.

Years passed, and the princess left the wrap dress behind, moving on to books, cosmetics, and other business ventures. The women of the land embraced her as one of them. Before long, a new generation was searching thrift shops for vintage wrap dresses; the populace was under the spell of the 1970s. And so it came to pass that the wrap dress, after a long slumber, was reawakened. The (now former) princess put it back into production—this time in silk jersey and a new range of fabrics, colors, prints, and silhouettes. And the calendars turned to 2014, and the day came when the wrap dress turned forty, an age at which women were once dismissed as over the hill. But women, like the princess, had by now proved that old notion wrong, and the wrap dress was still going strong. So the princess threw it a party, gathering beloved past examples from far-flung closets. Welcome to the party.

Holly Brubach

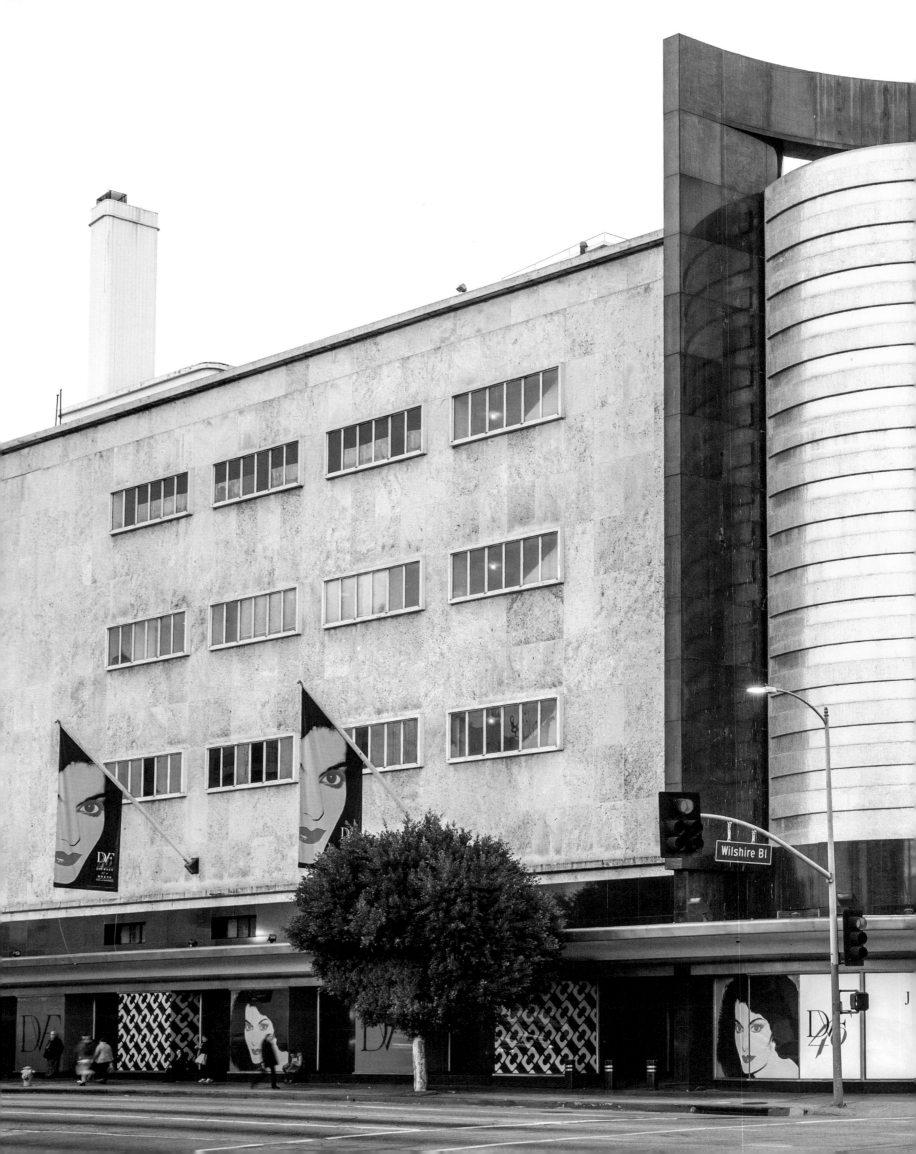

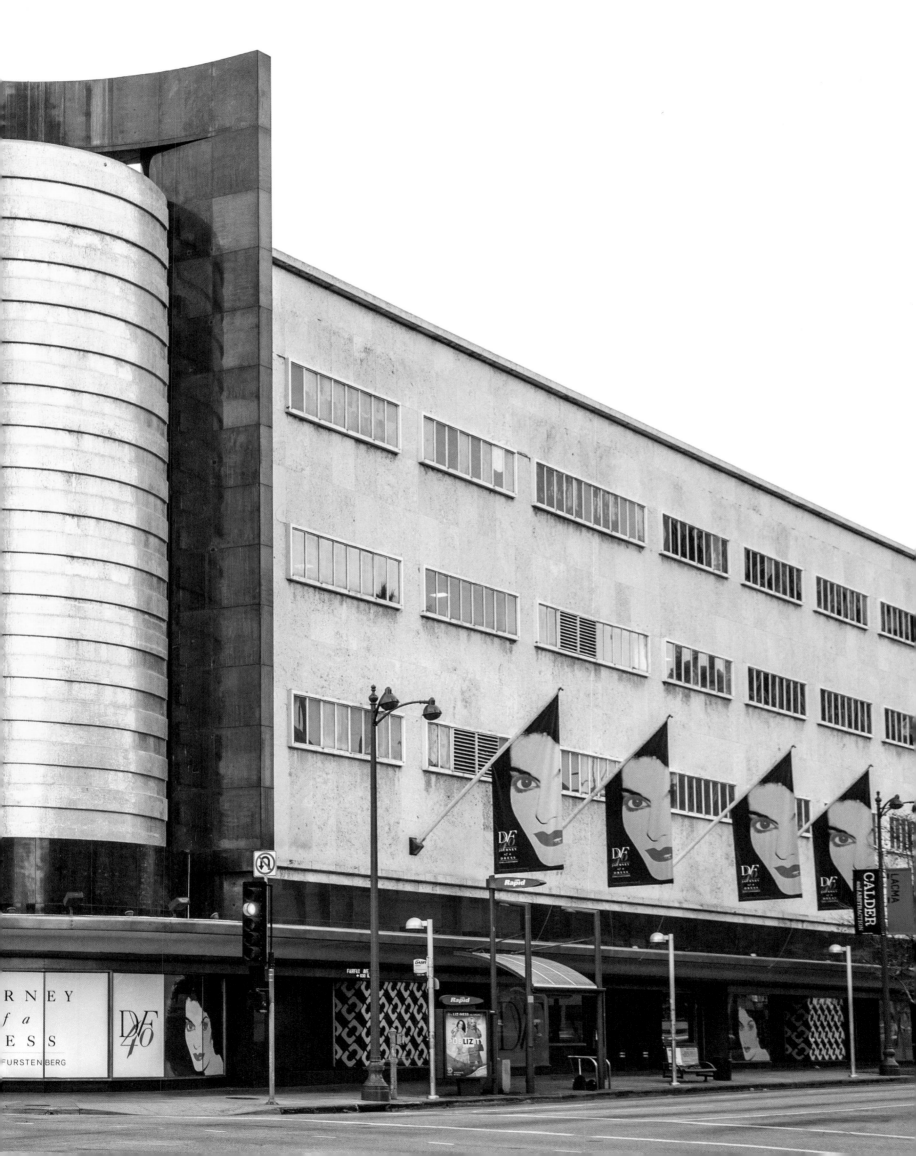

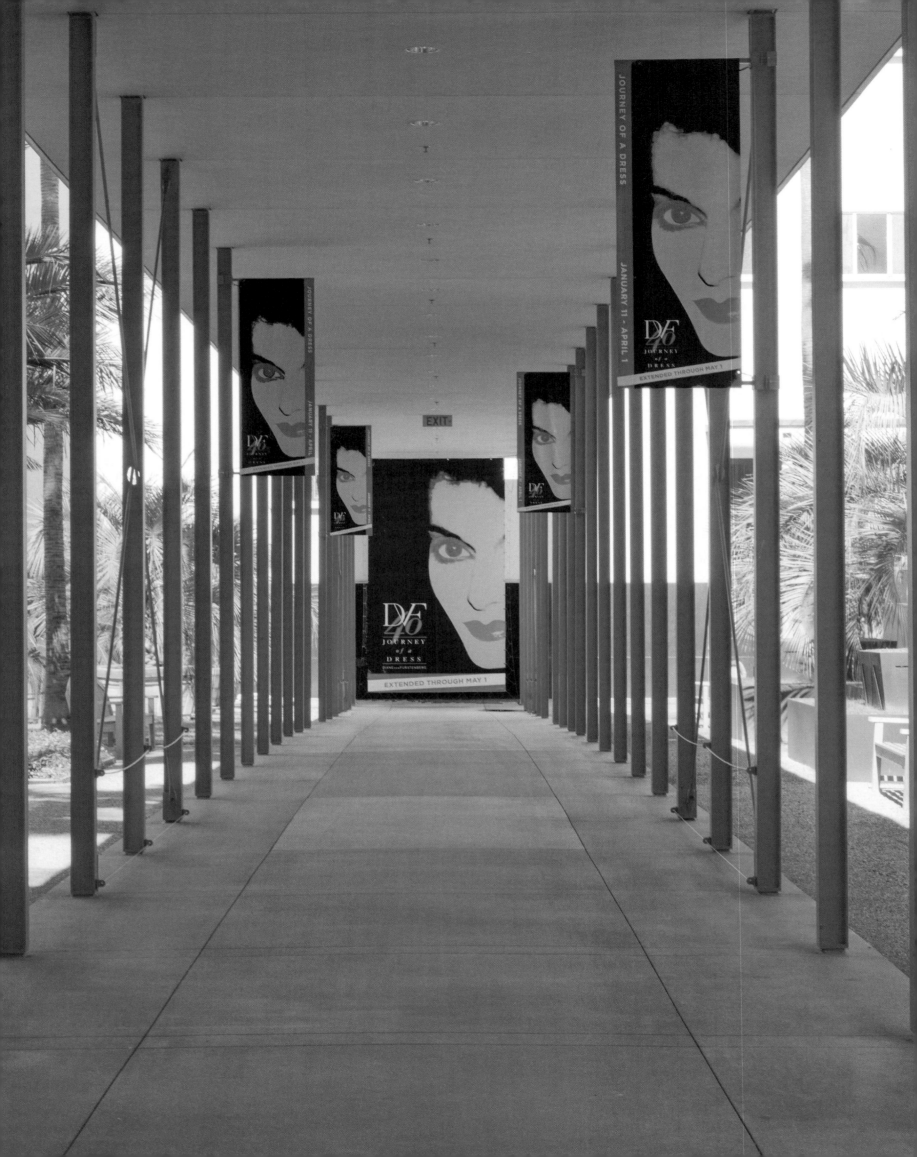

"Fashion is a mysterious energy, a visual moment—impossible to predict where it goes."

DIANE VON FURSTENBERG

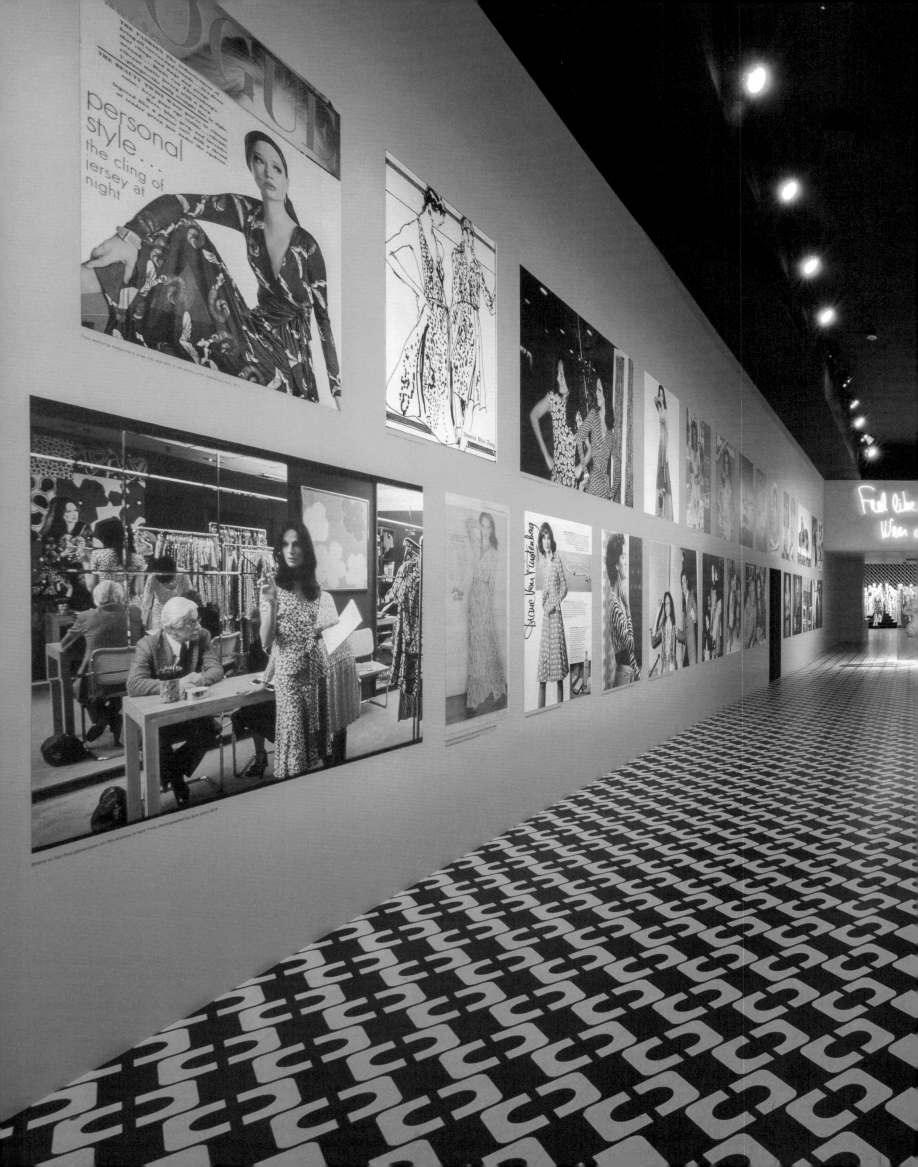

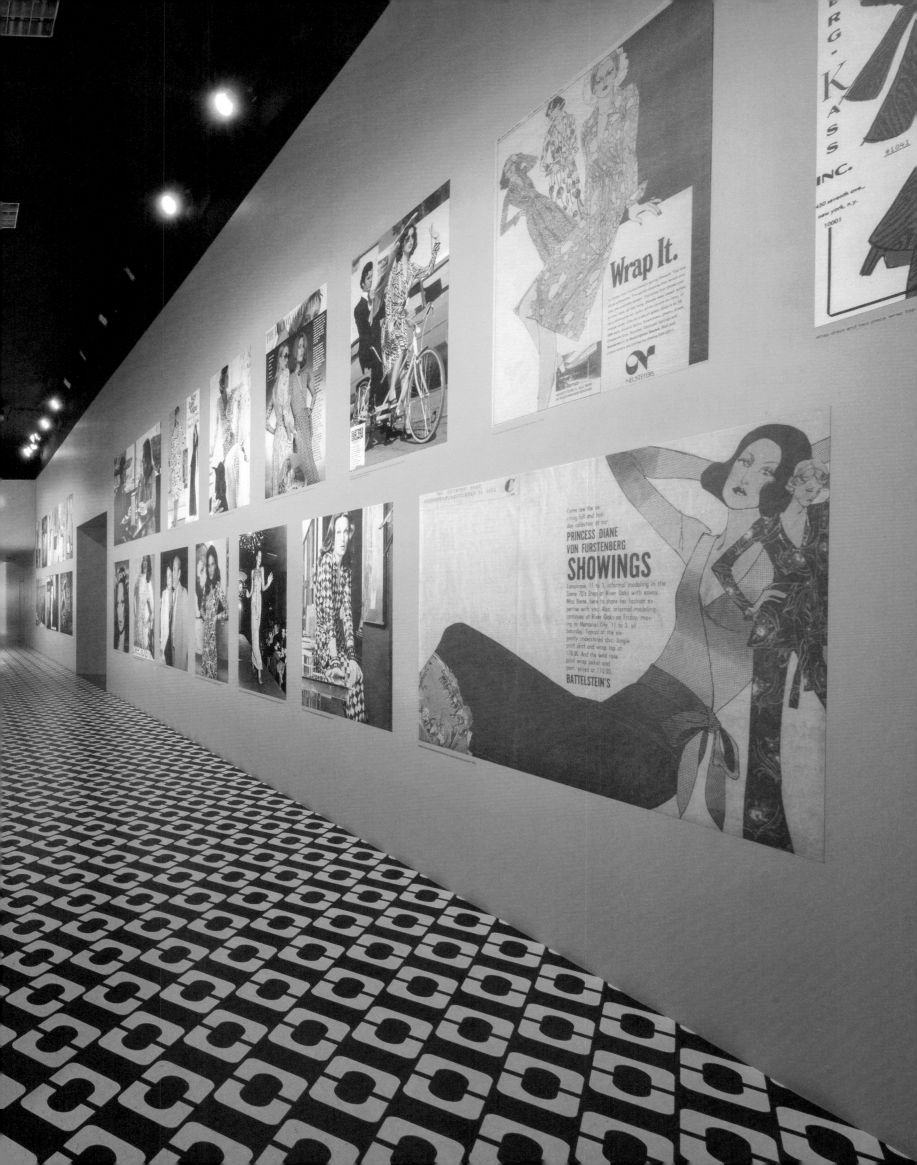

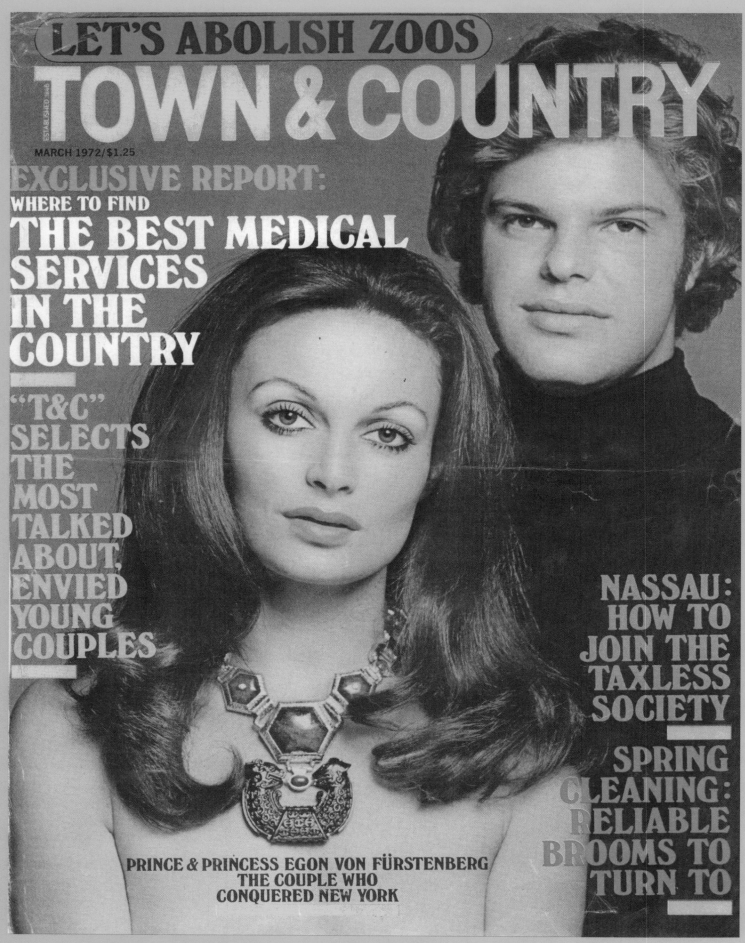

LET'S ABOLISH ZOOS

ESTABLISHED 1846

TOWN & COUNTRY

MARCH 1972/$1.25

EXCLUSIVE REPORT:

WHERE TO FIND

THE BEST MEDICAL SERVICES IN THE COUNTRY

"T&C" SELECTS THE MOST TALKED ABOUT, ENVIED YOUNG COUPLES

NASSAU: HOW TO JOIN THE TAXLESS SOCIETY

SPRING CLEANING: RELIABLE BROOMS TO TURN TO

PRINCE & PRINCESS EGON VON FÜRSTENBERG
THE COUPLE WHO
CONQUERED NEW YORK

1972 *Diane and her first husband, Prince Egon von Furstenberg, on the cover of* Town & Country

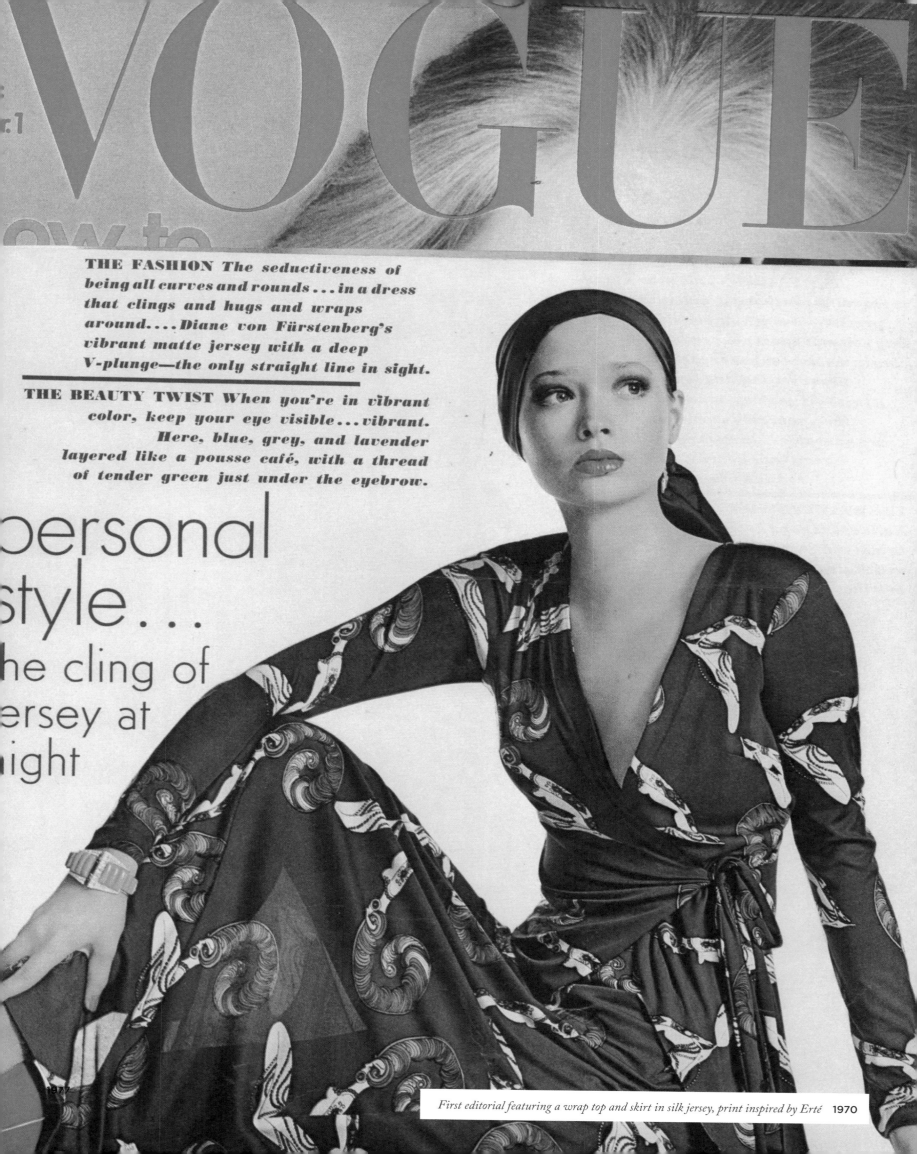

VOGUE

:.1

ow to

THE FASHION *The seductiveness of being all curves and rounds . . . in a dress that clings and hugs and wraps around. . . . Diane von Fürstenberg's vibrant matte jersey with a deep V-plunge—the only straight line in sight.*

THE BEAUTY TWIST *When you're in vibrant color, keep your eye visible . . . vibrant. Here, blue, grey, and lavender layered like a pousse café, with a thread of tender green just under the eyebrow.*

personal
style . . .
he cling of
ersey at
ight

1977

First editorial featuring a wrap top and skirt in silk jersey, print inspired by Erté 1970

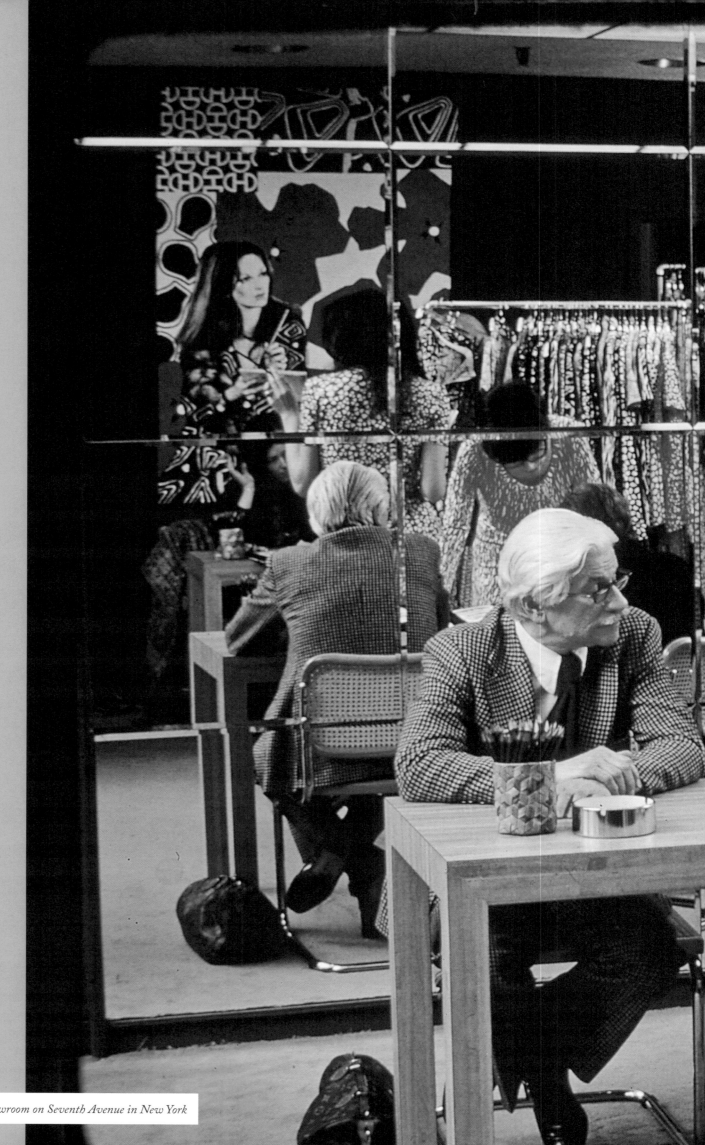

1973 *Diane in her first showroom on Seventh Avenue in New York*

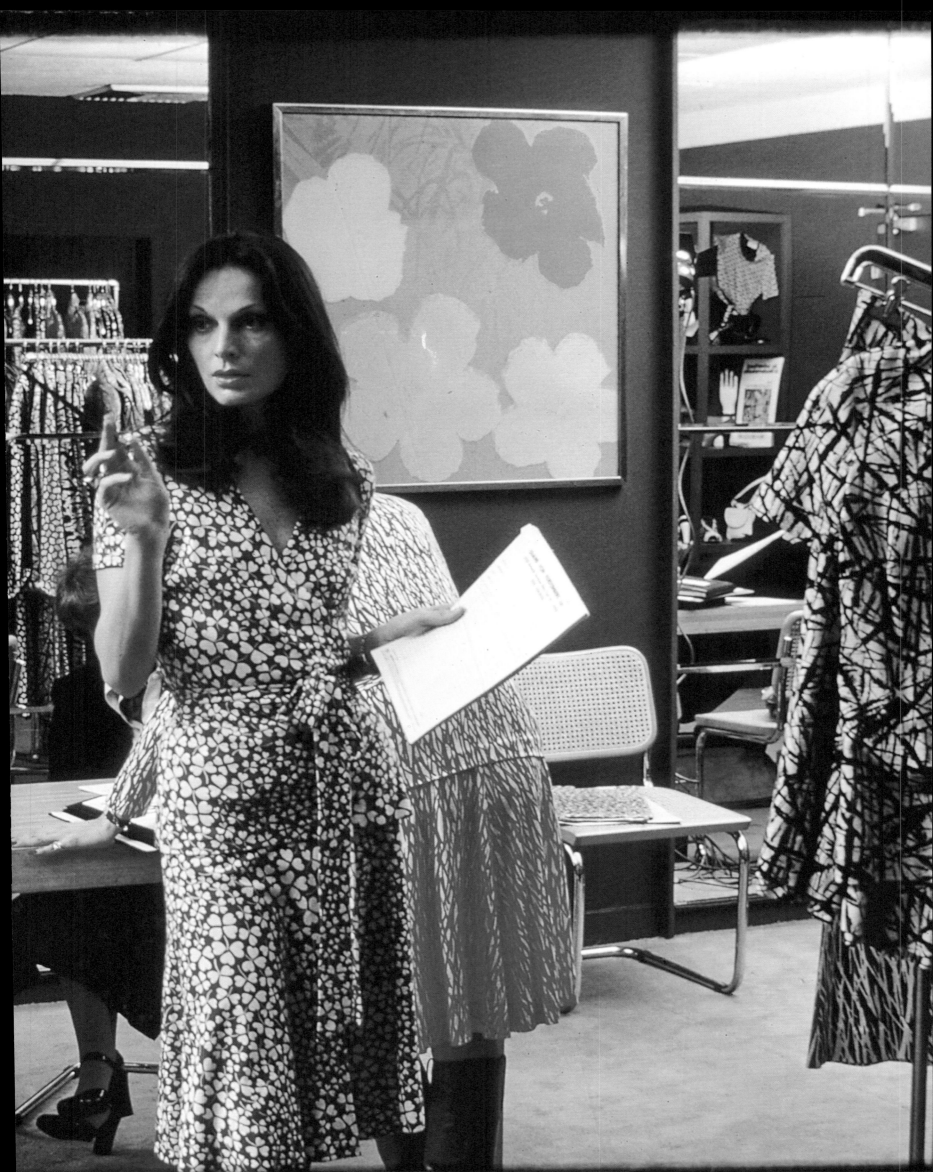

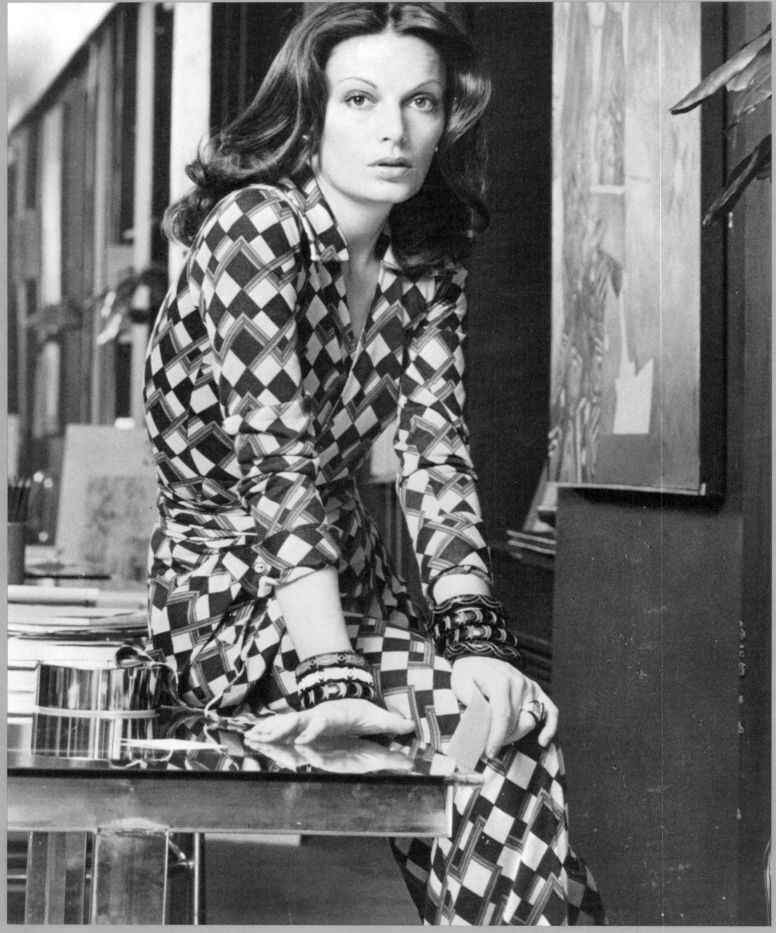

Diane in her showroom in New York

Cheryl Tiegs modeling a wrap top and pants in Vogue

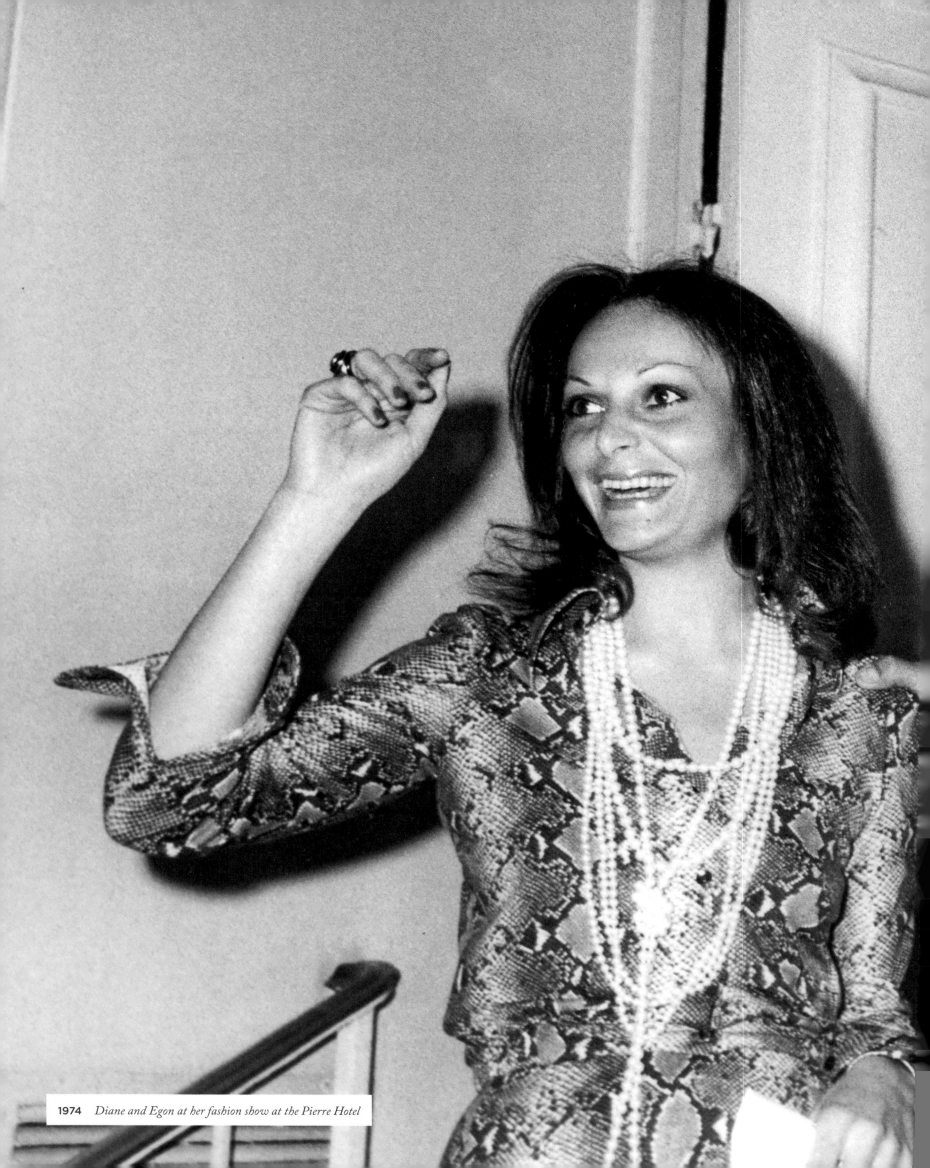

1974 *Diane and Egon at her fashion show at the Pierre Hotel*

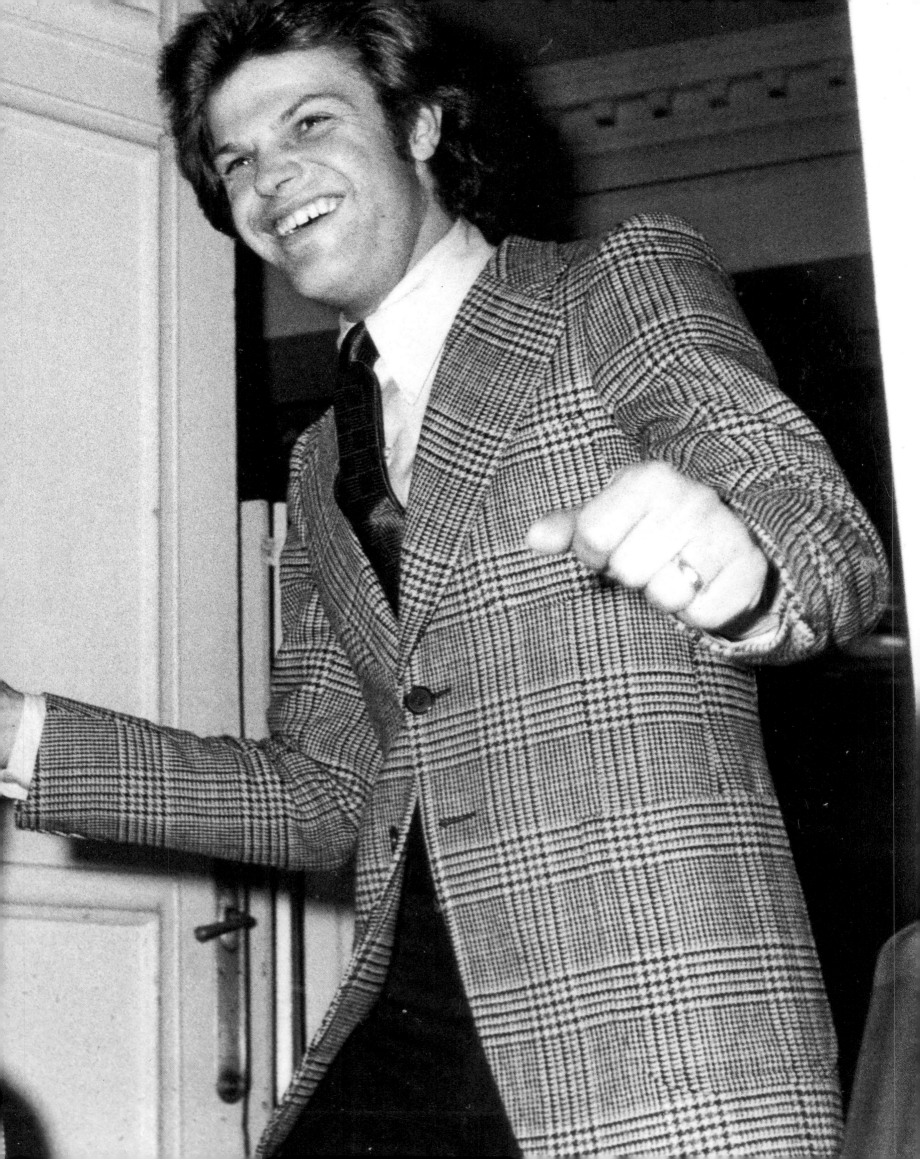

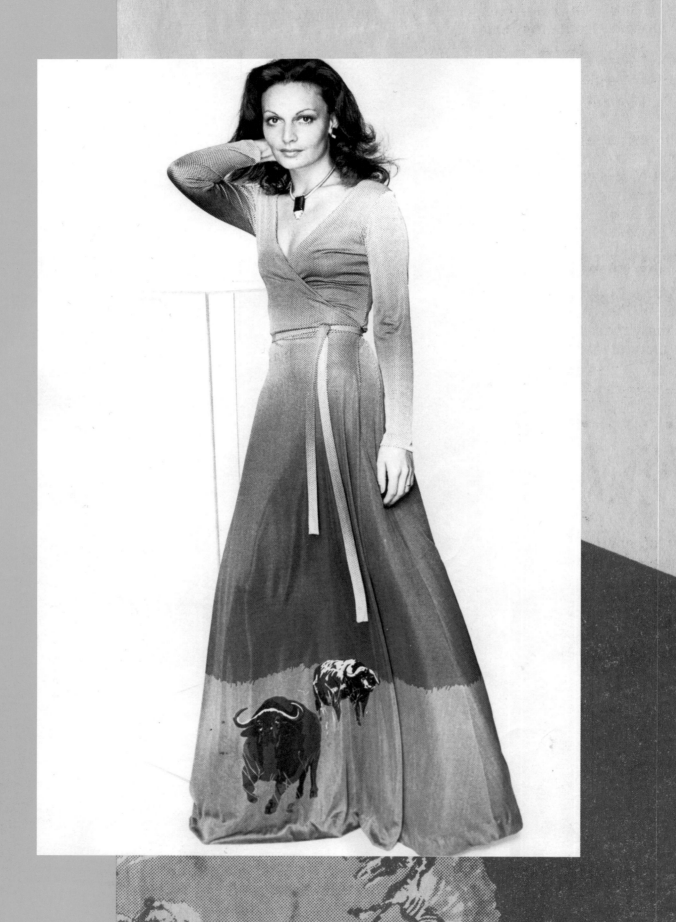

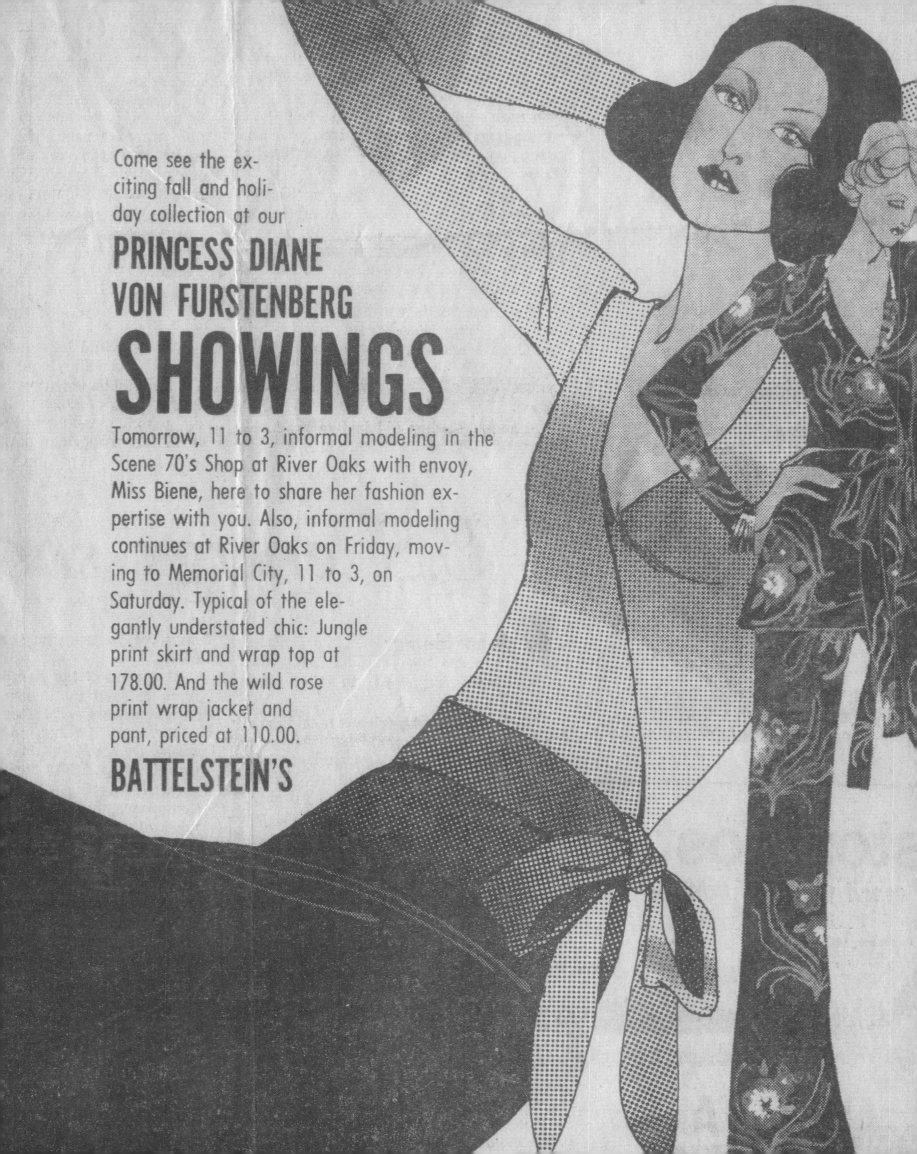

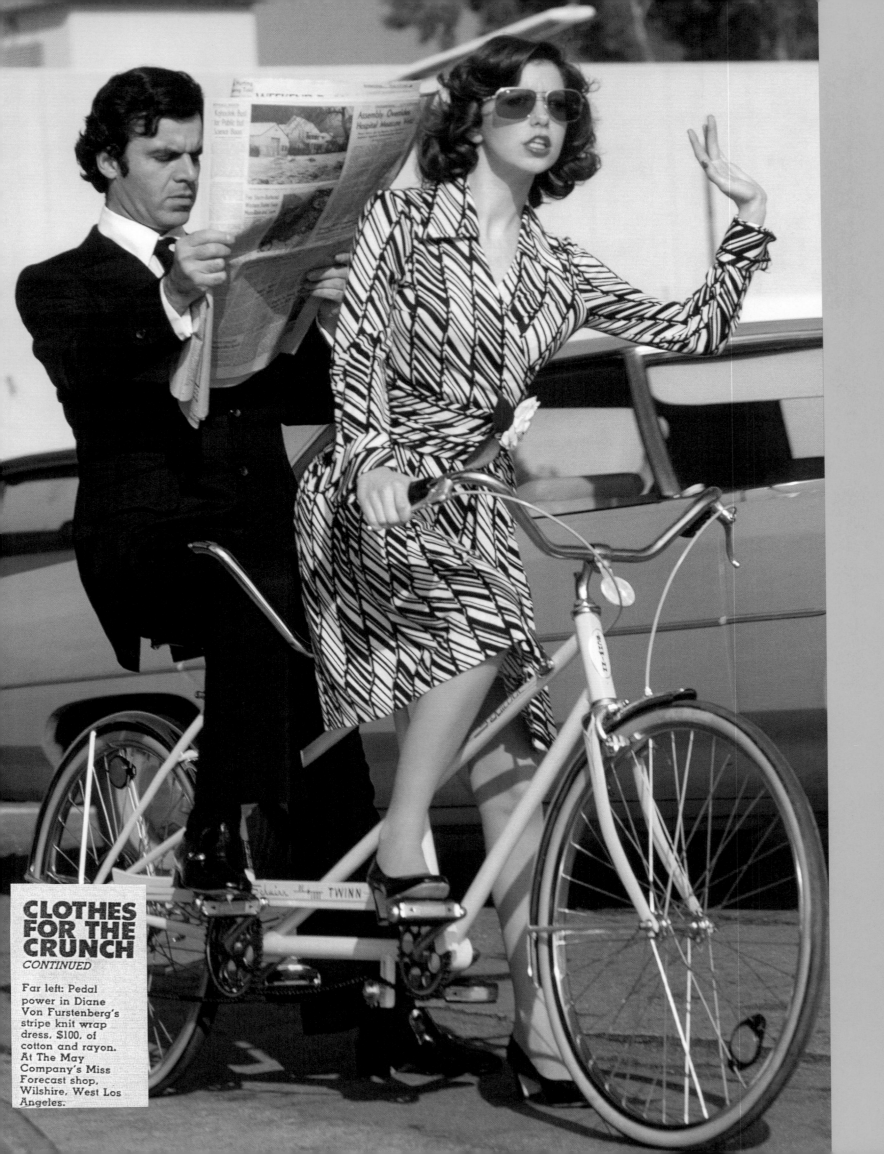

CLOTHES FOR THE CRUNCH
CONTINUED

Far left: Pedal power in Diane Von Furstenberg's stripe knit wrap dress, $100, of cotton and rayon. At The May Company's Miss Forecast shop, Wilshire, West Los Angeles.

STEINBERG·KASS INC.

450 seventh ave.,
new york, n.y.
10001

A
NATURAL
HABITAT

#1041

#1005

A two-piece wrap top and pants, and a wrap dress as shown in a buying office catalog

1974

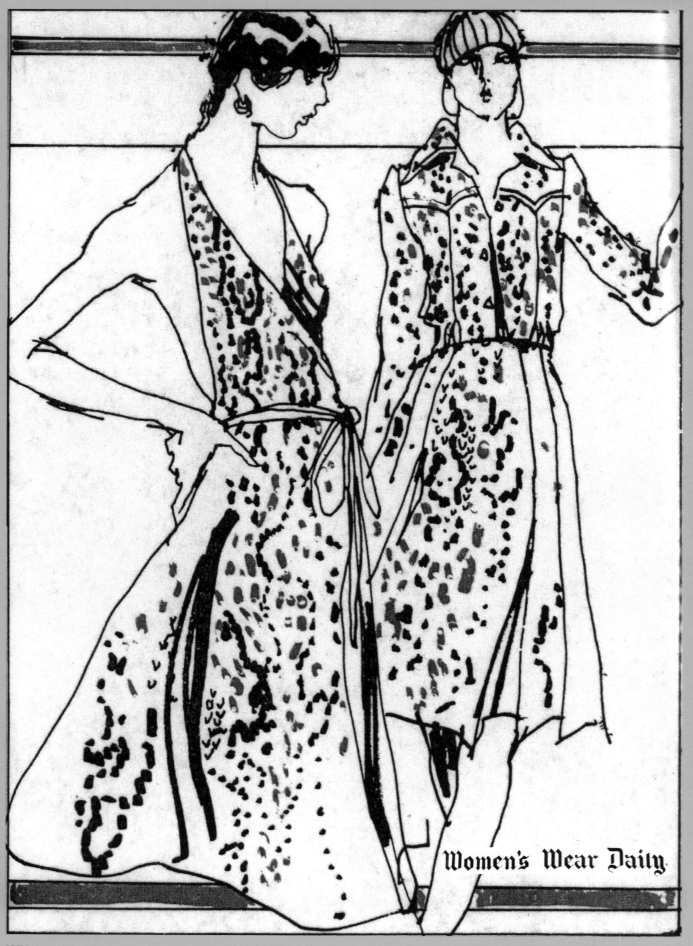

Women's Wear Daily

The first appearance of the wrap dress in Women's Wear Daily

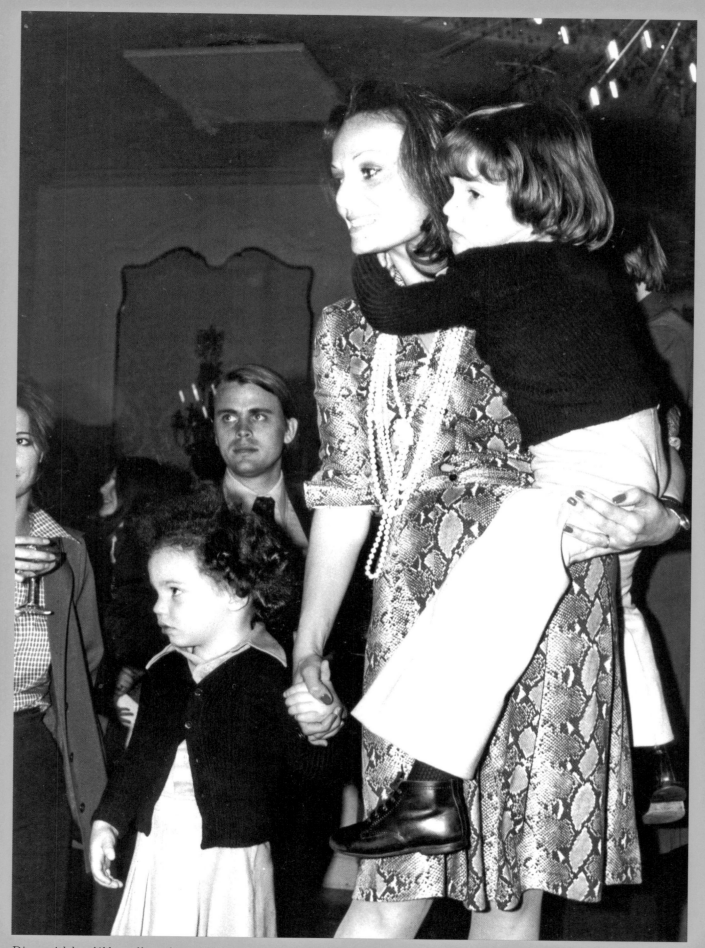

Diane with her children, Alexandre and Tatiana, at a fashion show at the Pierre Hotel in New York

1974

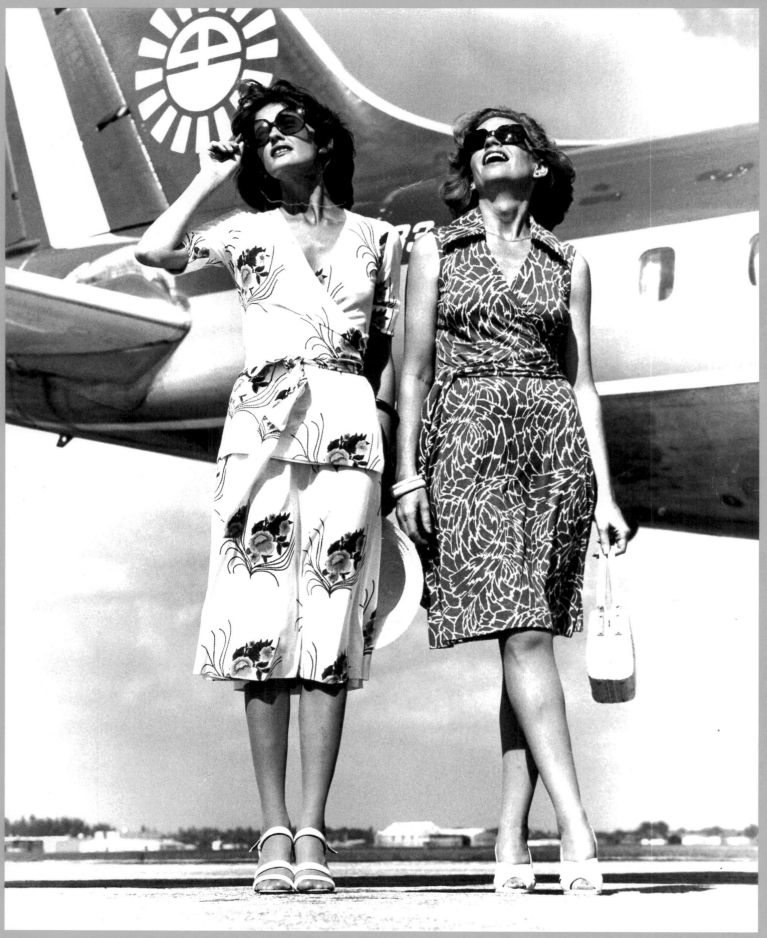

An advertisement featuring a sleeveless wrap dress and two-piece ensemble

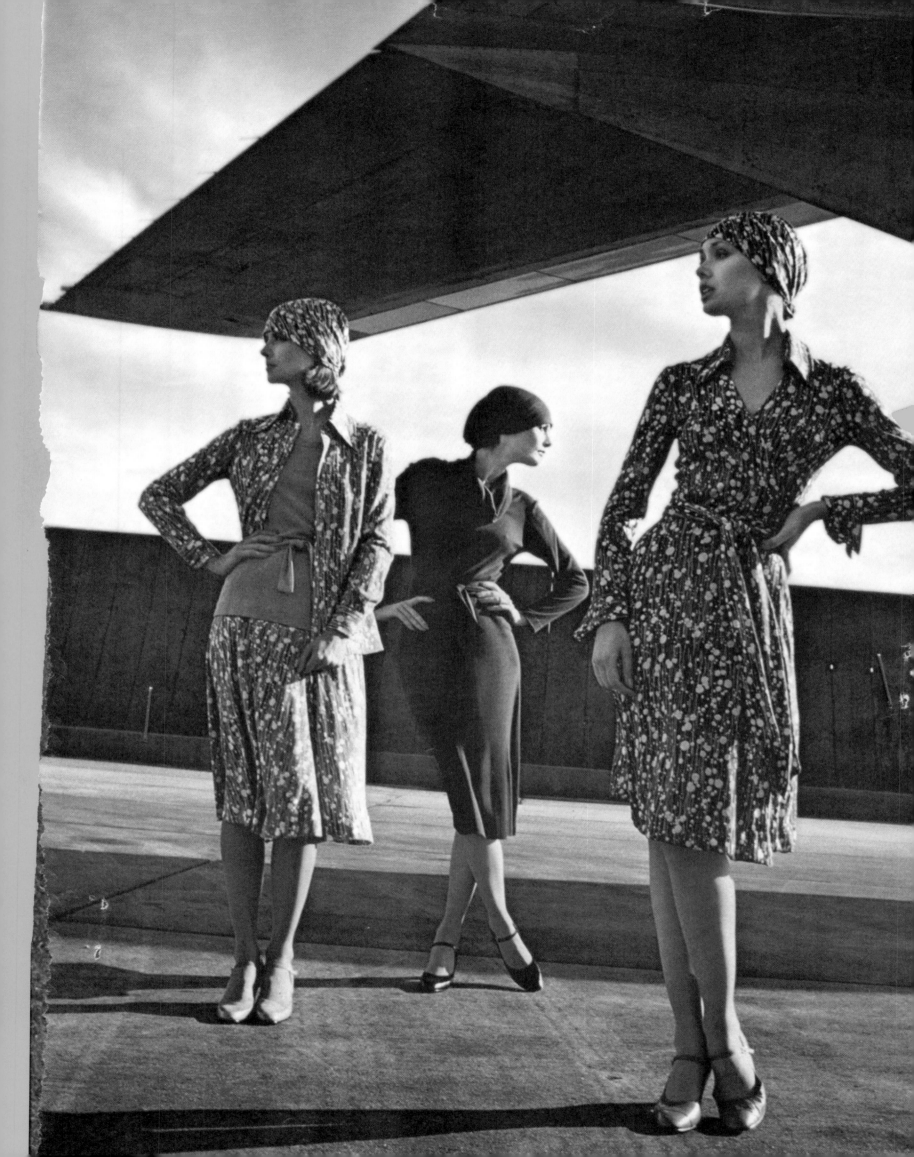

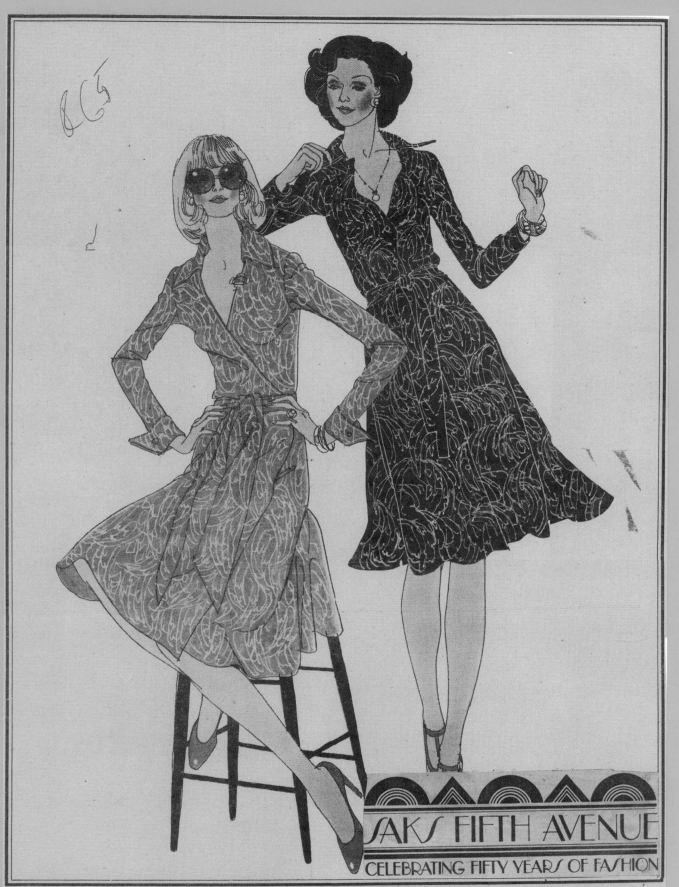

SAKS FIFTH AVENUE
CELEBRATING FIFTY YEARS OF FASHION

SOFT JERSEY SHIRTSHAPES KINDLE INTEREST EVERYWHERE

An impressionistic flame pattern flickers on fine jersey as it drapes around you. Totally relaxed, yet vital and energizing as only shirtshapes can be. Marvelous stamina starting out early, lasting late, and going around the seasons. Travel-bent because of the skinny resourcefulness of cotton and rayon jersey. For 6 to 16 sizes, two ways to go. The wrap, green or navy with white, $84. The classic updated, orange or green with white, $70. In our Sportdress Collections, on the Third Floor.

1974

A Saks Fifth Avenue advertisement

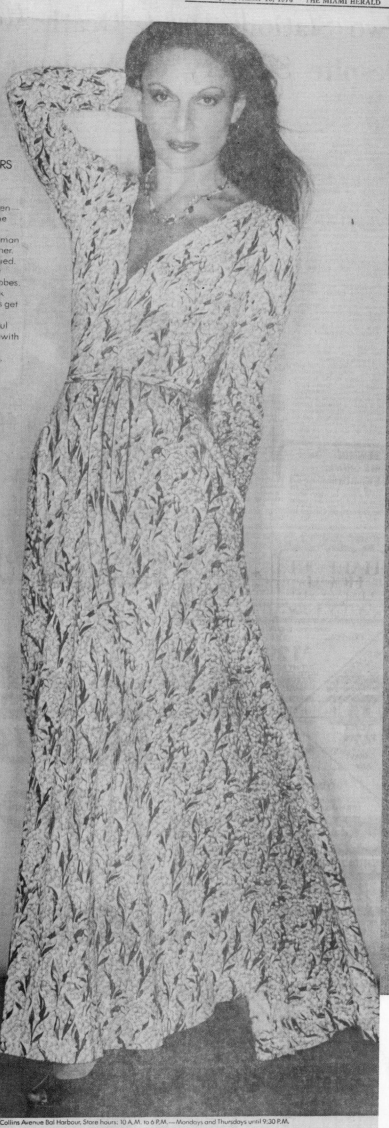

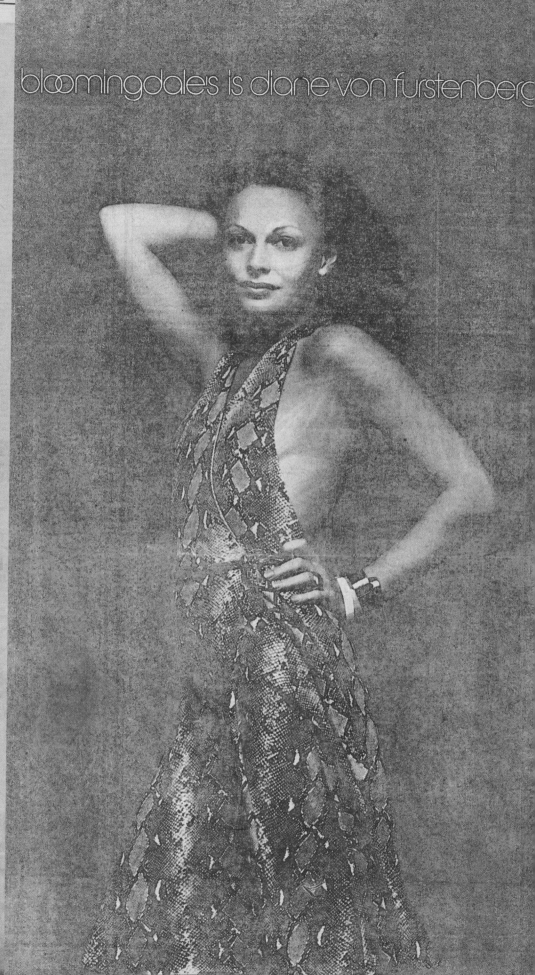

bloomingdale's is diane von furstenberg

1-2-3. That's how simple it is. To put on Diane's summery dress. And go.
Soft, thin cotton and rayon knit — perfectly cut so that it wraps around you just this way . . .
the curve of the body . . . the outline of waist, hip and leg . . . it's all there. Diane wears it with tanned skin . . .
masses of dark hair . . . her own cache of wonderful bracelets. You'll sharpen it with thin chains . . . strips-of-sandals . . . your own sense of style.
Either way, it couldn't be more flattering or more attractive. It's summer '74. Snakeskin-printed in green or brown, $70.00
for sizes 6 to 12 in Sutton Place, 3rd Floor, New York. Also at Bergen County, Garden City, Short Hills
and Stamford. Bloomingdale's, 1000 Third Avenue, New York, N.Y. 10022.
355-5900. Open late Monday and Thursday evenings.

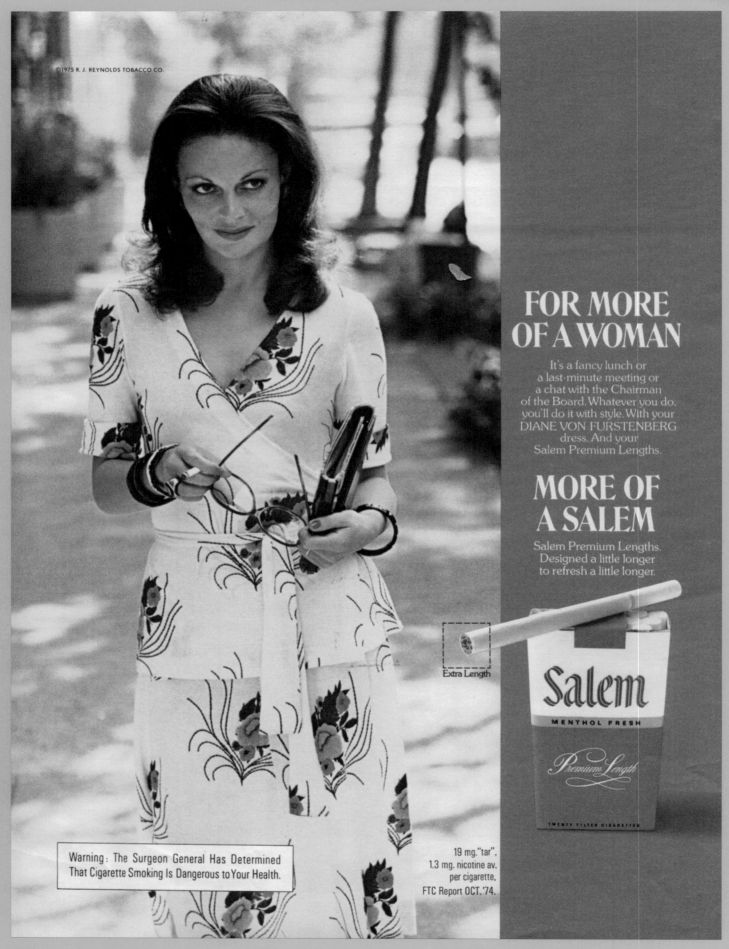

1974

Diane wearing a wrap top and skirt for a Salem cigarette ad

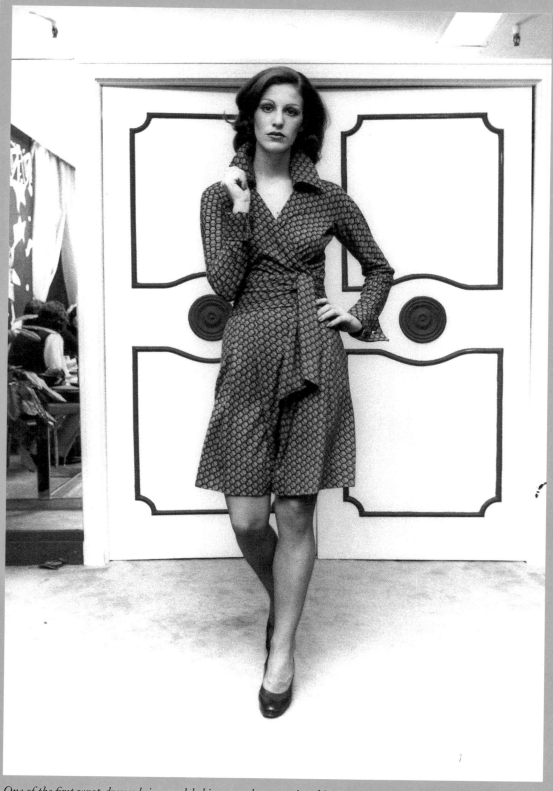

One of the first wrap dresses being modeled in an early promotional image **1974**

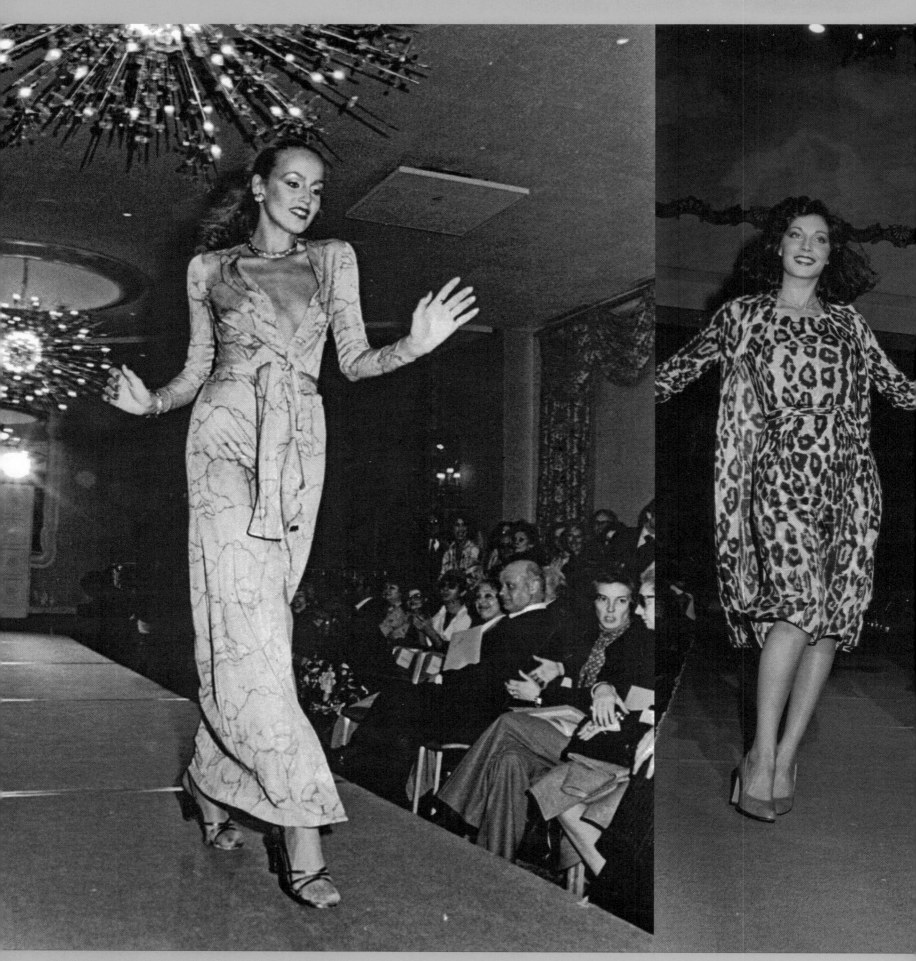

1975 *Jerry Hall modeling a wrap dress at a DVF fashion show at the Pierre Hotel in New York*

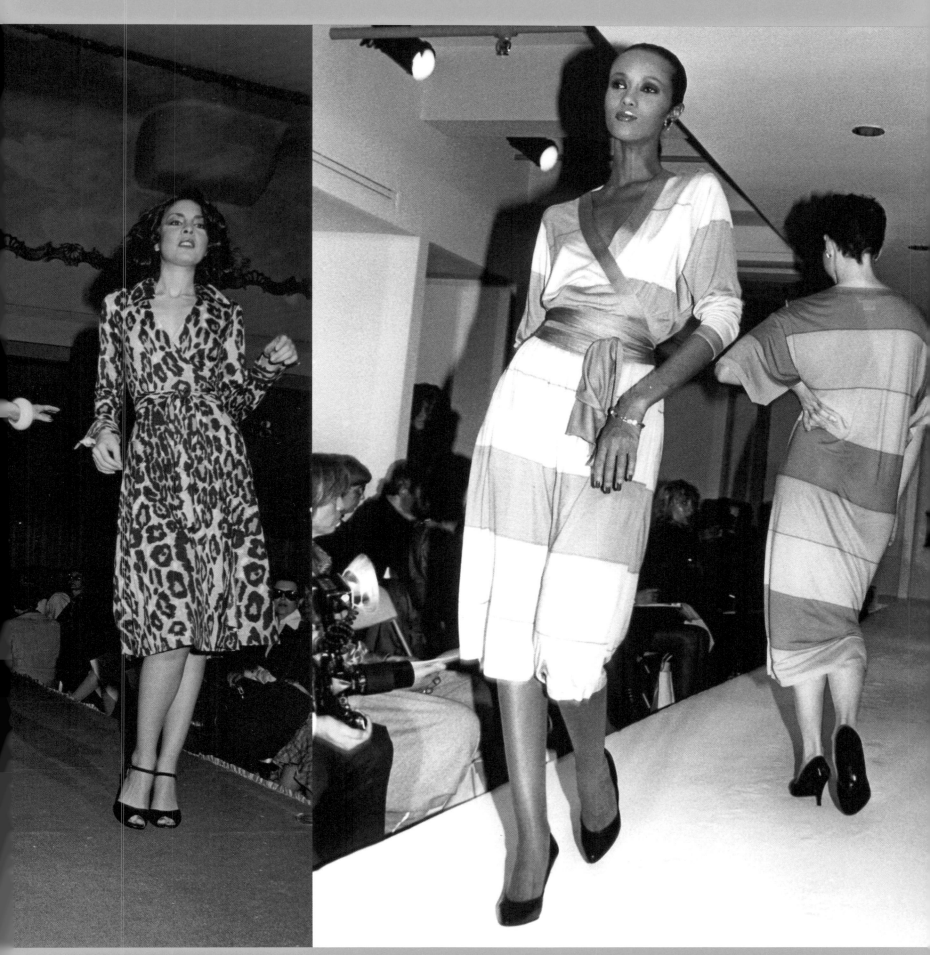

Iman walking the DVF runway 1980

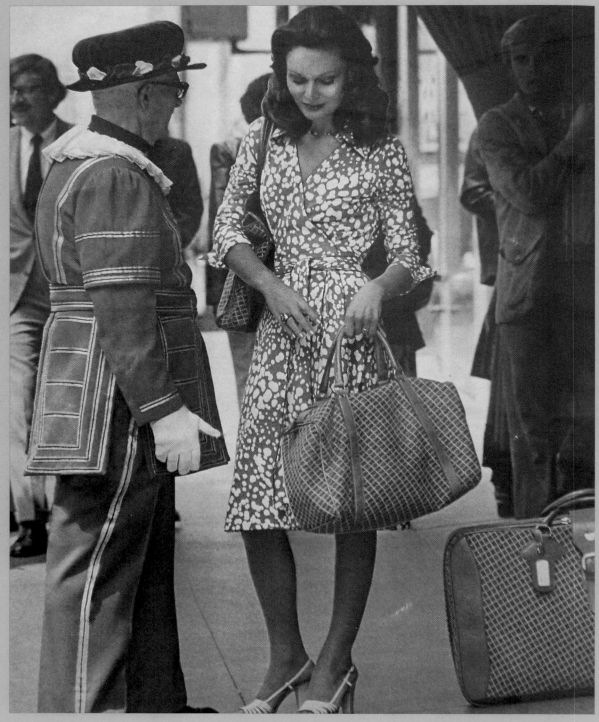

1976
Diane modeling a splatter print wrap dress in an early luggage advertisement

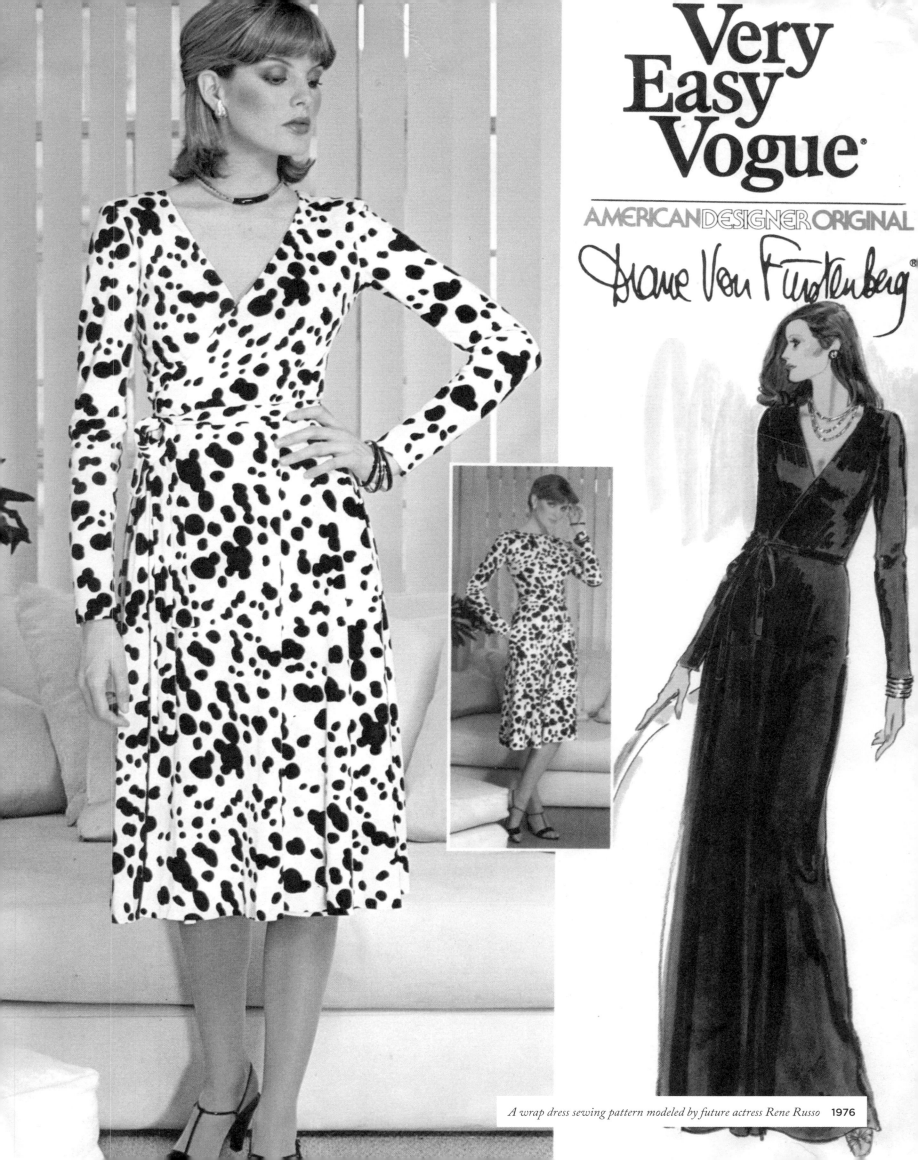

Very Easy Vogue

AMERICAN DESIGNER ORIGINAL

Diane Von Furstenberg

A wrap dress sewing pattern modeled by future actress Rene Russo 1976

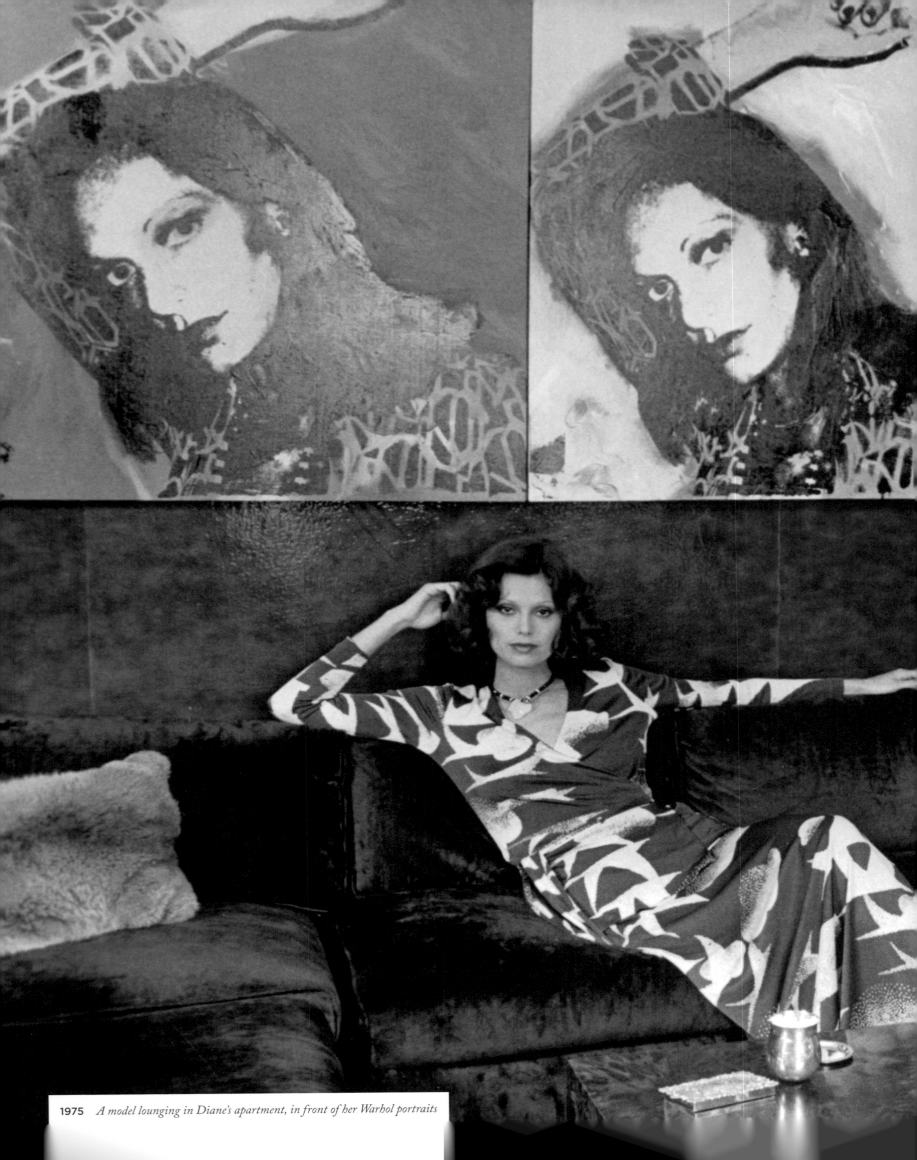

1975 *A model lounging in Diane's apartment, in front of her Warhol portraits*

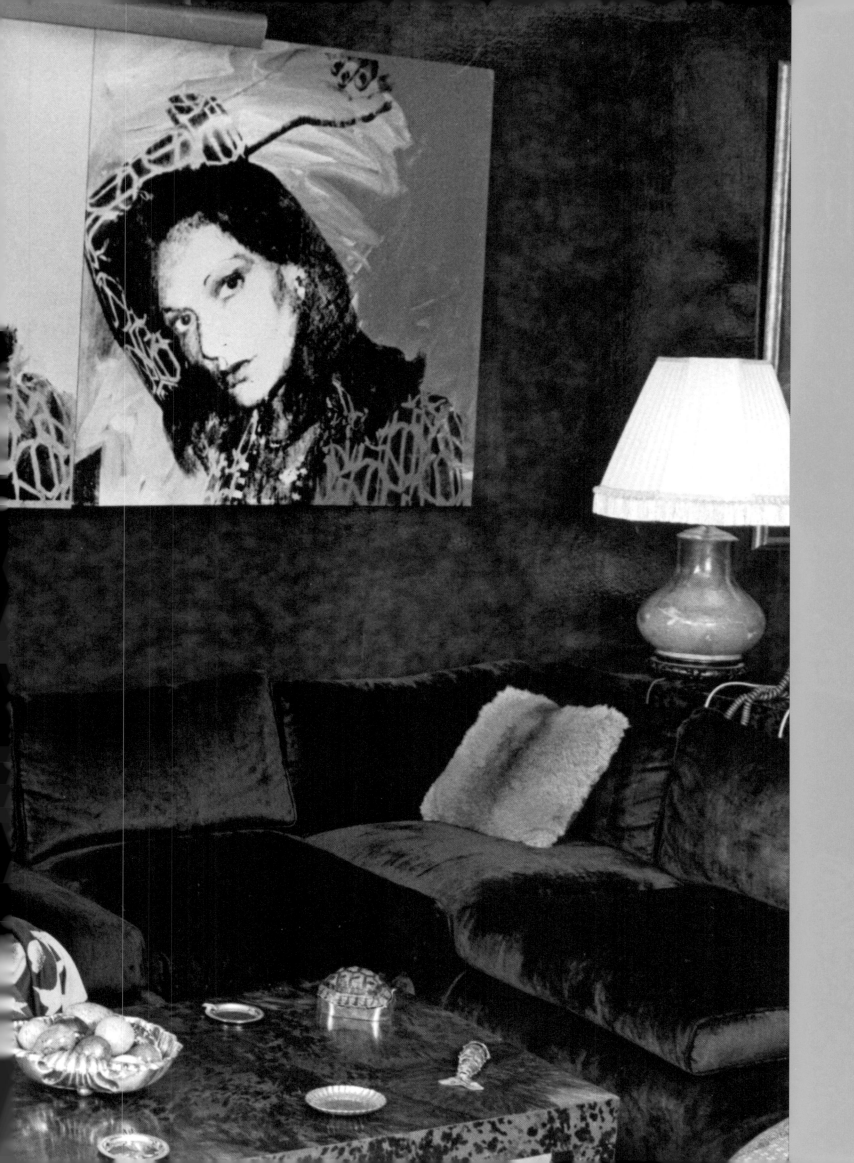

BONWIT TELLER

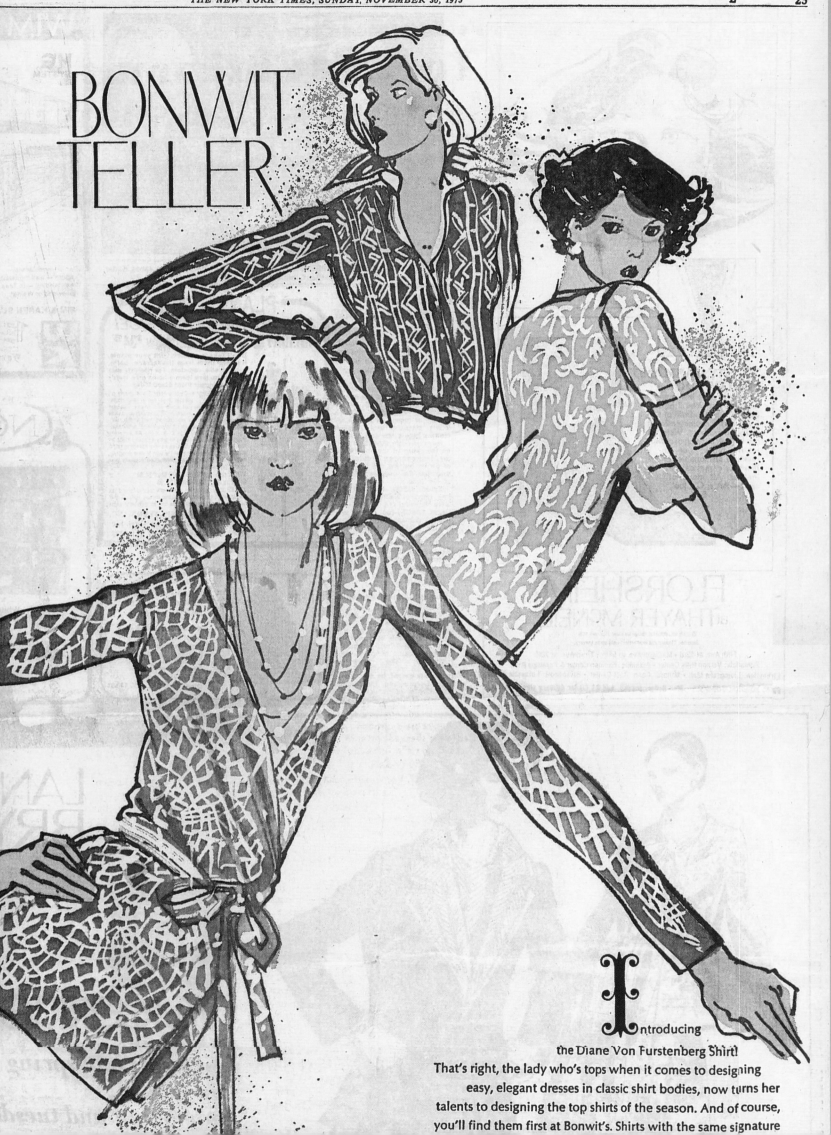

Introducing
the Diane Von Furstenberg Shirt!
That's right, the lady who's tops when it comes to designing
easy, elegant dresses in classic shirt bodies, now turns her
talents to designing the top shirts of the season. And of course,
you'll find them first at Bonwit's. Shirts with the same signature

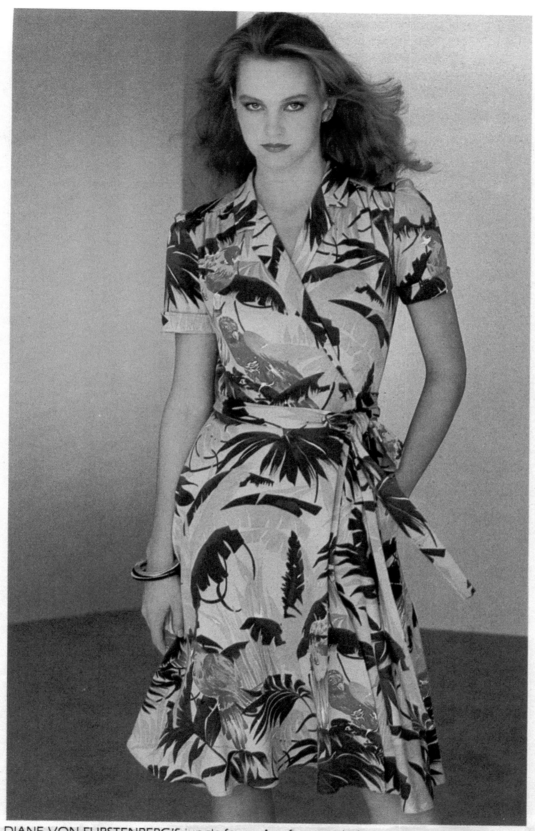

DIANE VON FURSTENBERG'S jungle fever. A soft cotton knit wrap in a wonderfully colorful print. For 4 to 14. ████ (2.95) S35-6A Miss Bergdorf Dresses, Fifth Floor

For fast ordering, call 24 hours a day, 7 days a week, TOLL FREE Nationwide 800-247-2477

A nature-inspired print wrap dress as featured in a Bergdorf Goodman catalog

1975

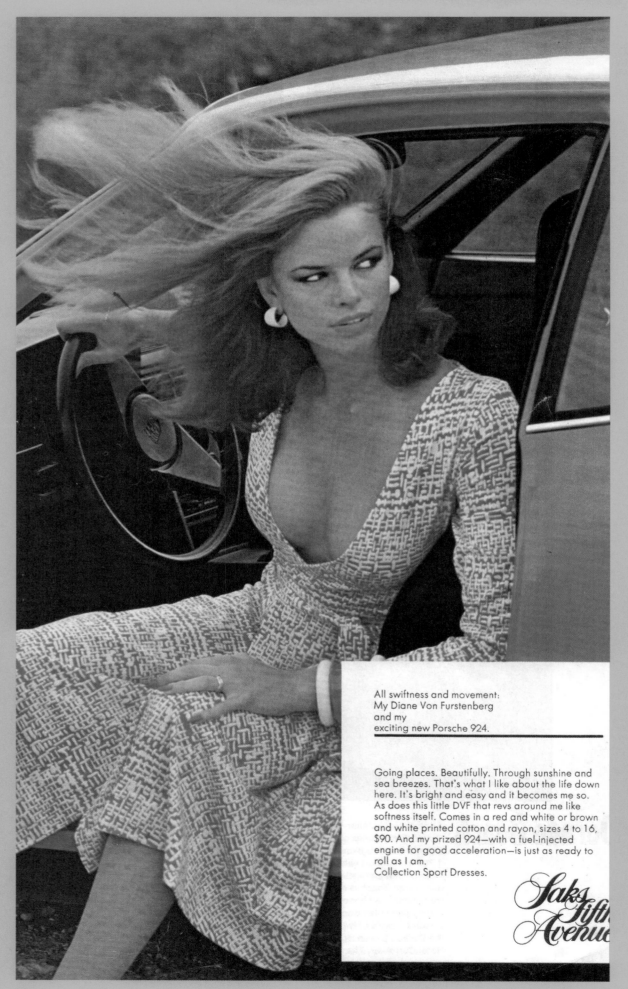

All swiftness and movement:
My Diane Von Furstenberg
and my
exciting new Porsche 924.

Going places. Beautifully. Through sunshine and
sea breezes. That's what I like about the life down
here. It's bright and easy and it becomes me so.
As does this little DVF that revs around me like
softness itself. Comes in a red and white or brown
and white printed cotton and rayon, sizes 4 to 16,
$90. And my prized 924—with a fuel-injected
engine for good acceleration—is just as ready to
roll as I am.
Collection Sport Dresses.

Saks Fifth Avenue

A Saks Fifth Avenue ad featuring Lisa Taylor wearing a white-and-red print wrap

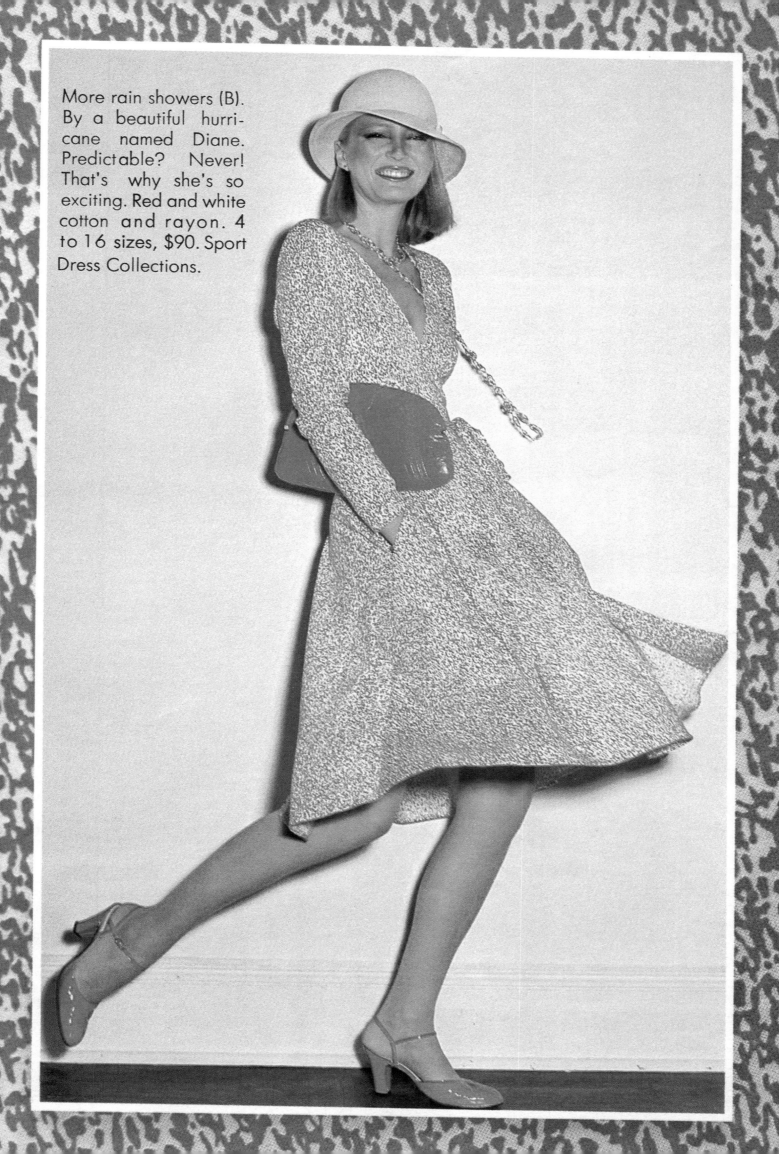

More rain showers (B). By a beautiful hurricane named Diane. Predictable? Never! That's why she's so exciting. Red and white cotton and rayon. 4 to 16 sizes, $90. Sport Dress Collections.

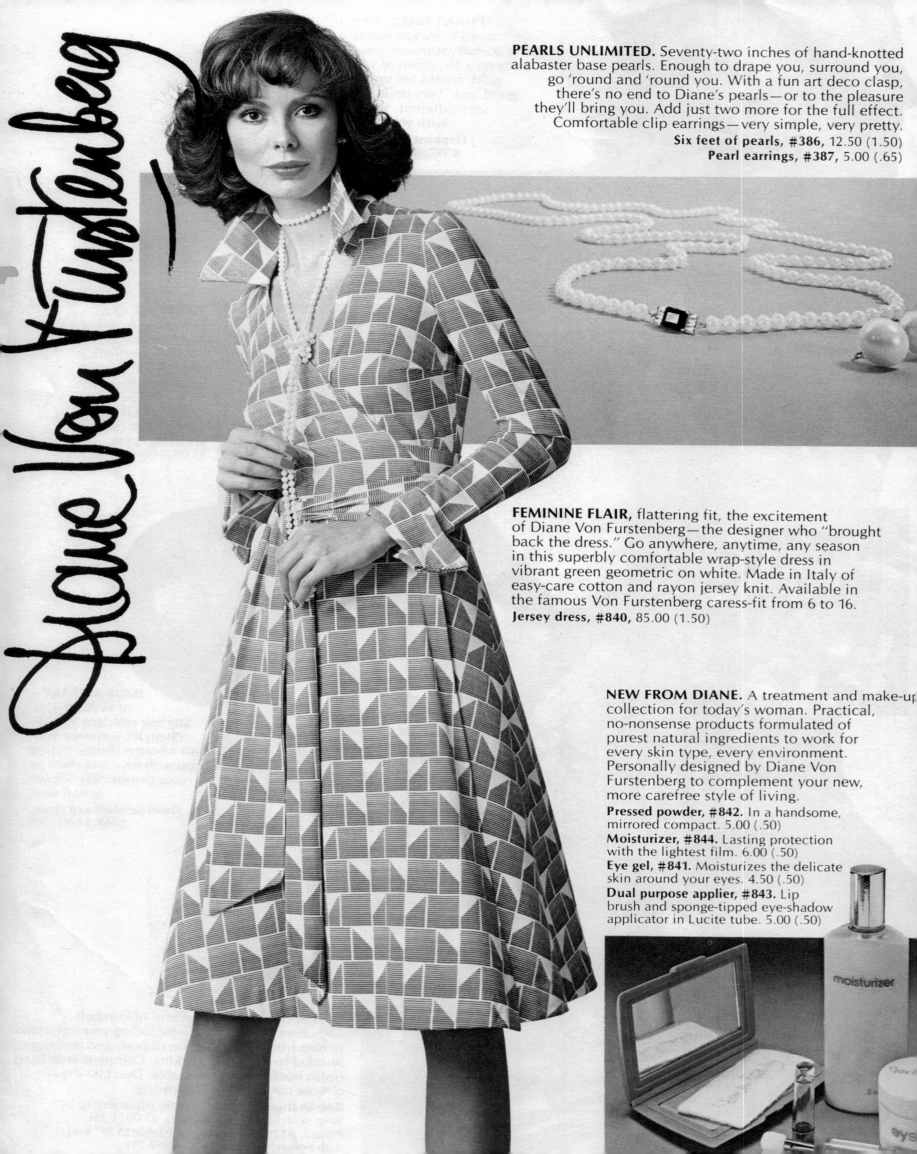

Diane Von Furstenberg

PEARLS UNLIMITED. Seventy-two inches of hand-knotted alabaster base pearls. Enough to drape you, surround you, go 'round and 'round you. With a fun art deco clasp, there's no end to Diane's pearls—or to the pleasure they'll bring you. Add just two more for the full effect. Comfortable clip earrings—very simple, very pretty.
Six feet of pearls, #386, 12.50 (1.50)
Pearl earrings, #387, 5.00 (.65)

FEMININE FLAIR, flattering fit, the excitement of Diane Von Furstenberg—the designer who "brought back the dress." Go anywhere, anytime, any season in this superbly comfortable wrap-style dress in vibrant green geometric on white. Made in Italy of easy-care cotton and rayon jersey knit. Available in the famous Von Furstenberg caress-fit from 6 to 16.
Jersey dress, #840, 85.00 (1.50)

NEW FROM DIANE. A treatment and make-up collection for today's woman. Practical, no-nonsense products formulated of purest natural ingredients to work for every skin type, every environment. Personally designed by Diane Von Furstenberg to complement your new, more carefree style of living.
Pressed powder, #842. In a handsome, mirrored compact. 5.00 (.50)
Moisturizer, #844. Lasting protection with the lightest film. 6.00 (.50)
Eye gel, #841. Moisturizes the delicate skin around your eyes. 4.50 (.50)
Dual purpose applier, #843. Lip brush and sponge-tipped eye-shadow applicator in Lucite tube. 5.00 (.50)

Wrap It.

In Diane Von Furstenberg's spring flowers. The low slung silhouette. The gentle shaping that wraps you into the prettiest season. The dress that shows you at your best, all day long. Choose deep peach tulips on a white ground, lucky white clovers on navy, or orange water lilies on a sea of green. Sizes 4 to 16. $86 each. Empire Salon, Downtown, Cherry Creek, Cinderella City, Boulder, Colorado Springs and **Neusteters II** in Buckingham Square. Mail and phone orders are invited by dialing 534-3311.

NEUSTETERS II, ALL NEW
IN BUCKINGHAM SQUARE.

NEUSTETERS

43

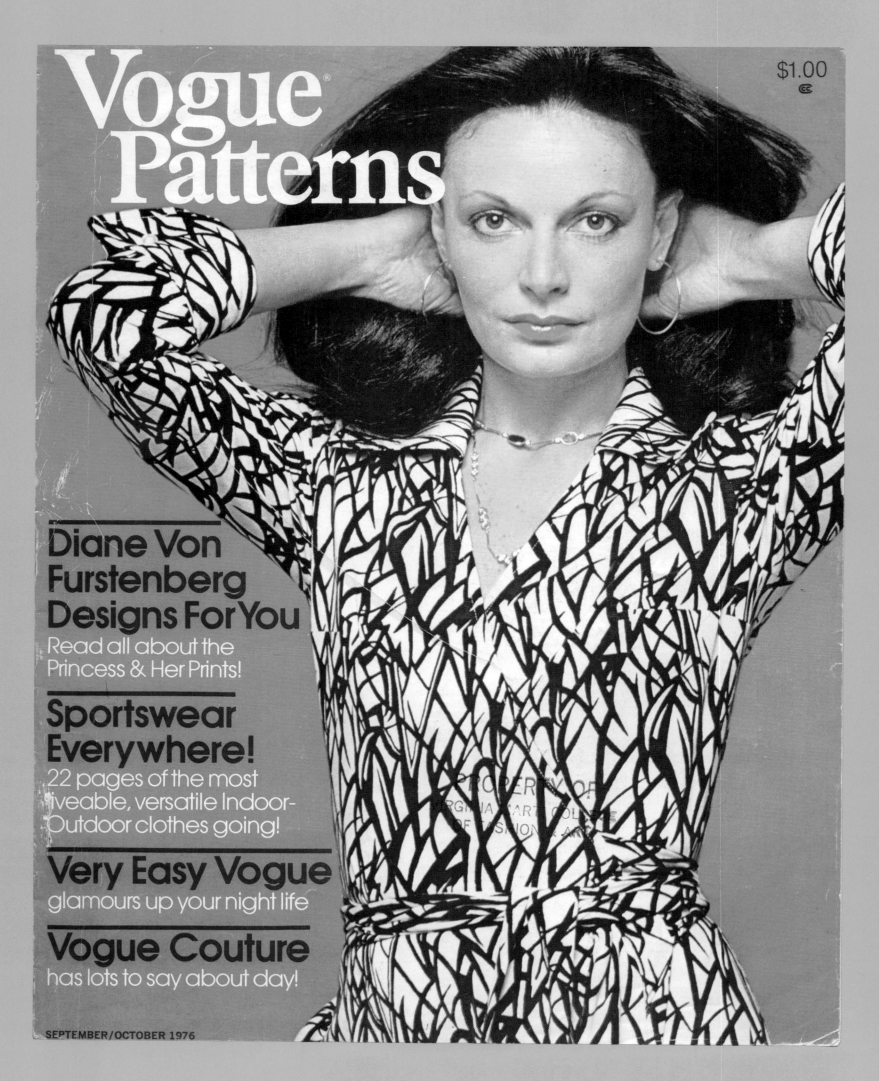

Vogue Patterns

$1.00

Diane Von Furstenberg Designs For You
Read all about the Princess & Her Prints!

Sportswear Everywhere!
22 pages of the most liveable, versatile Indoor-Outdoor clothes going!

Very Easy Vogue
glamours up your night life

Vogue Couture
has lots to say about day!

SEPTEMBER/OCTOBER 1976

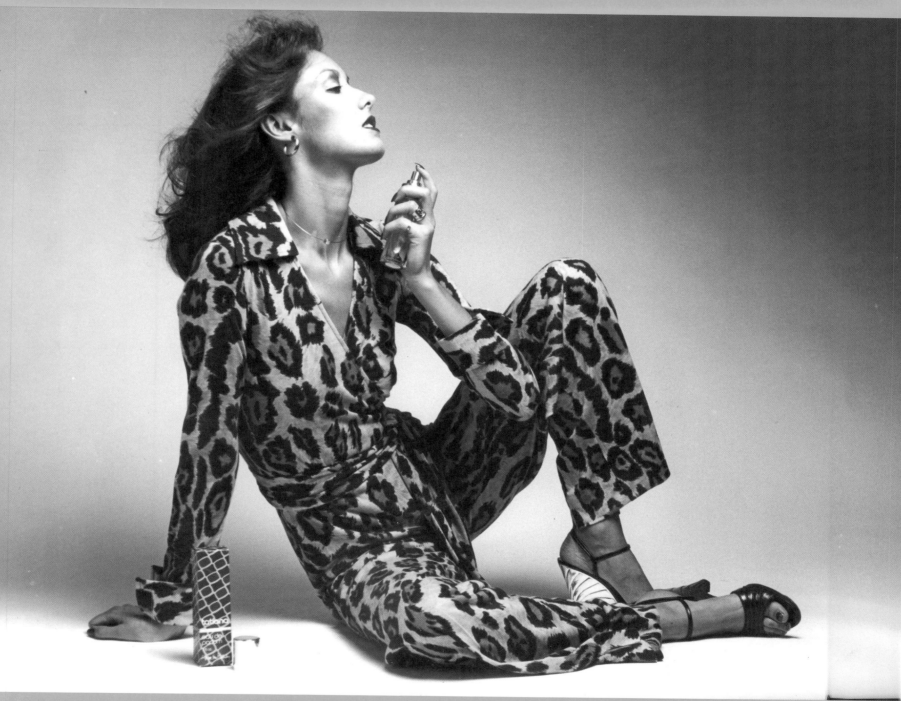

A Tatiana fragrance advertisement featuring a leopard print wrap top and pants

西武デパート
フロアーショウ
3月12日(土) 11:30A.M. 1:30P.M.

DIANE SCHDULE

	O4\|11 18:30	O4\|12 11:30.13:30.	O4\|13 13:00.15:00.	O4\|14 11:30.	O4\|14 14:00.15:30.	O4\|14 19:00-20:00
	Arriving	Seibu Department Store Floorshow	Tokyu Department Store Consultant Sale	Press Show at Hotel Okura	Isetan Department Store Floorshow	American Embas Reception

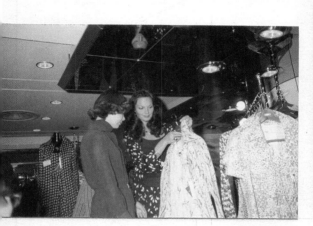

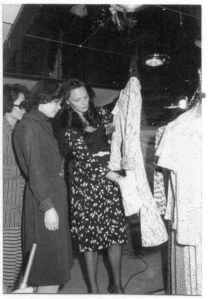

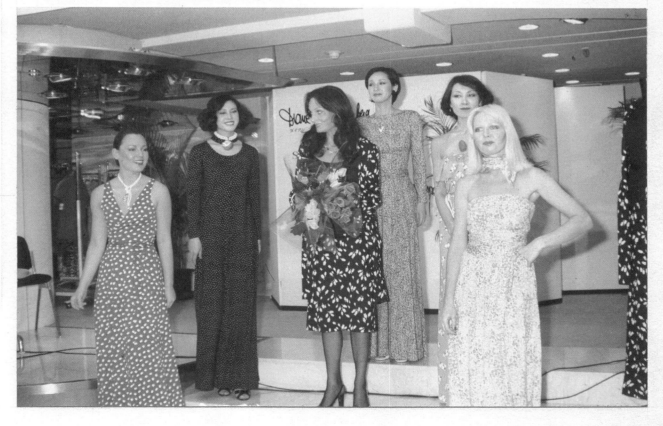

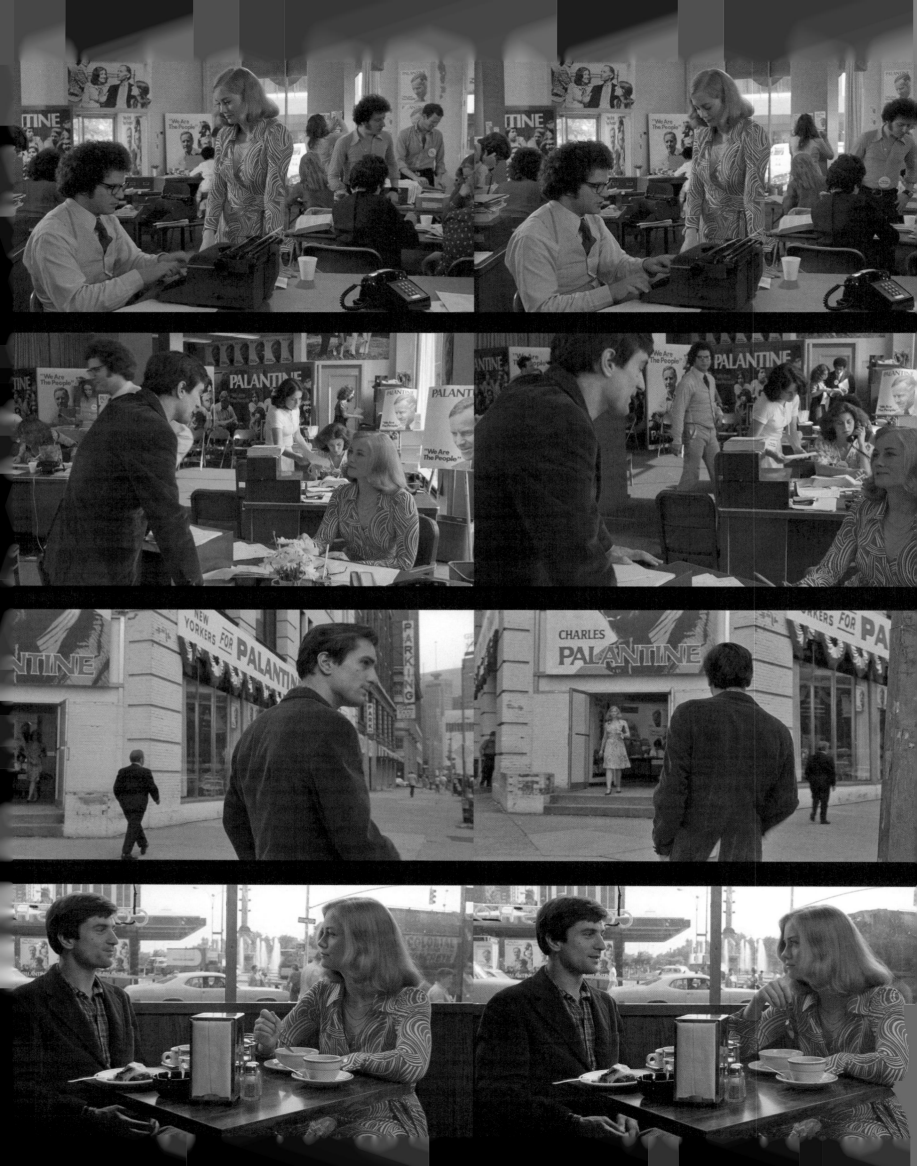

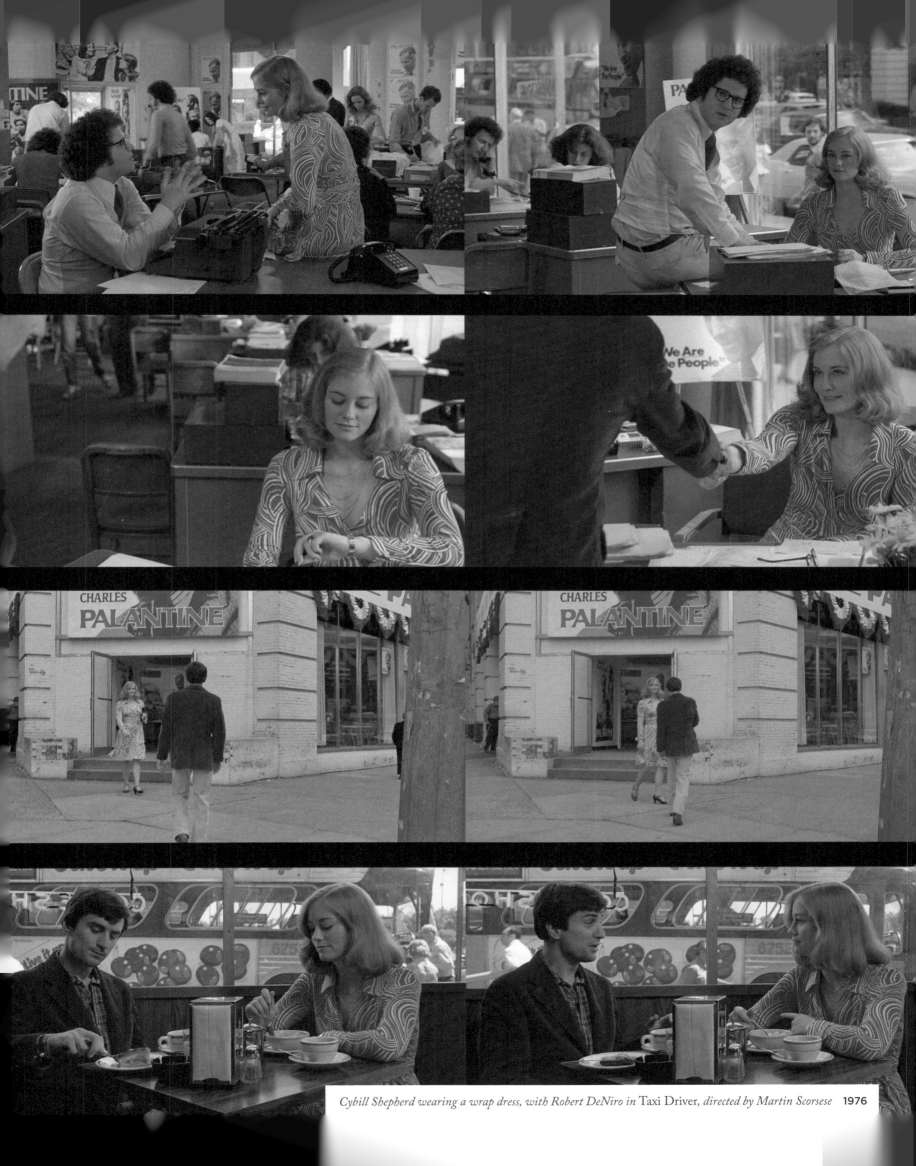

Cybill Shepherd wearing a wrap dress, with Robert DeNiro in Taxi Driver, *directed by Martin Scorsese* **1976**

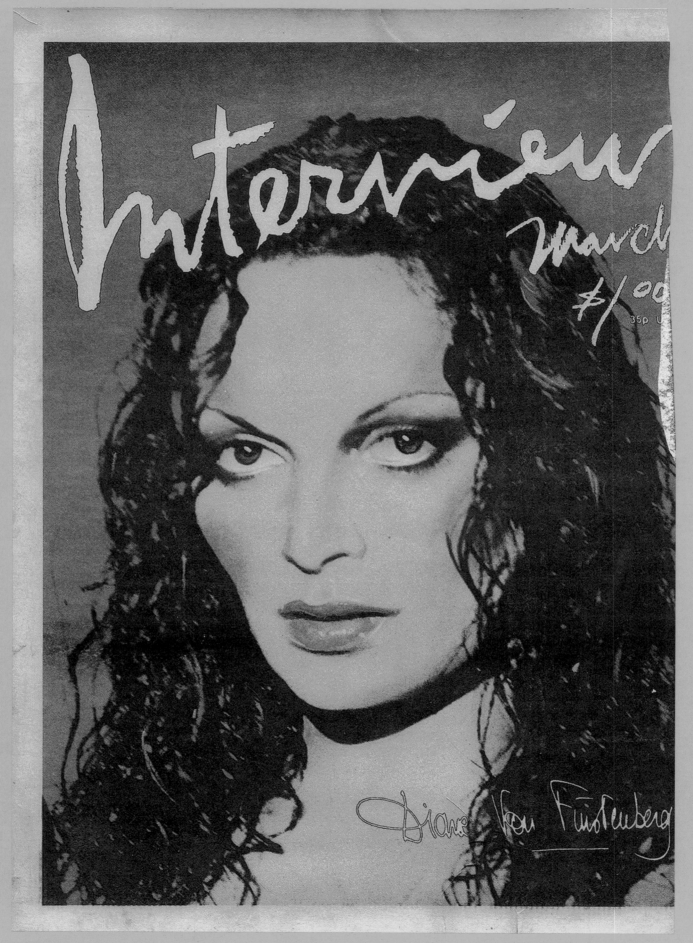

1976 Interview *cover, designed by Richard Bernstein*

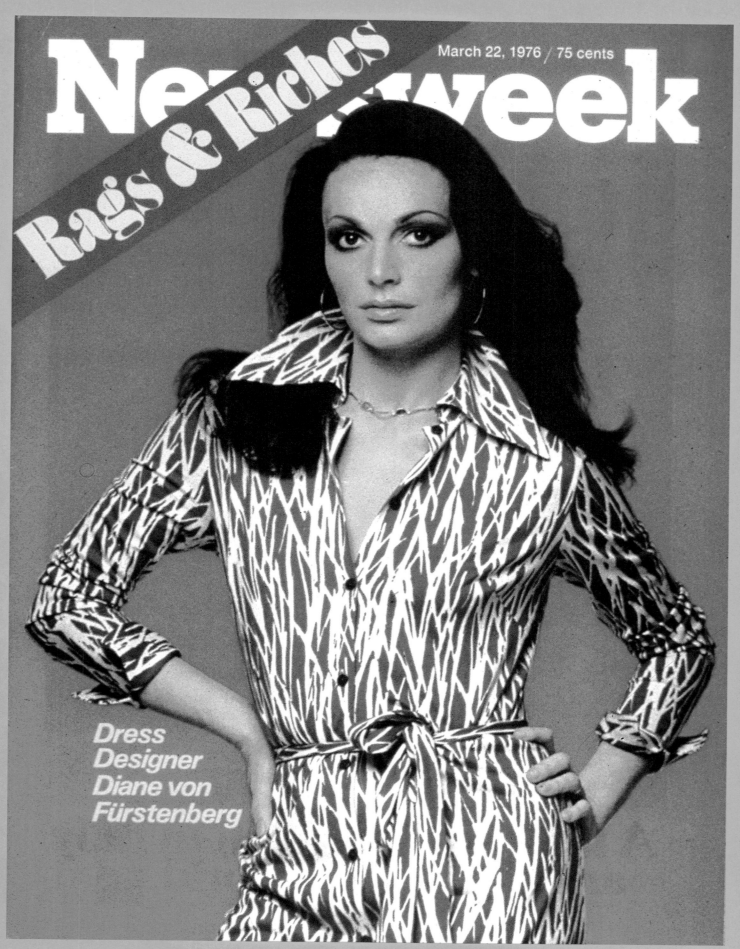

Newsweek *cover*

1976

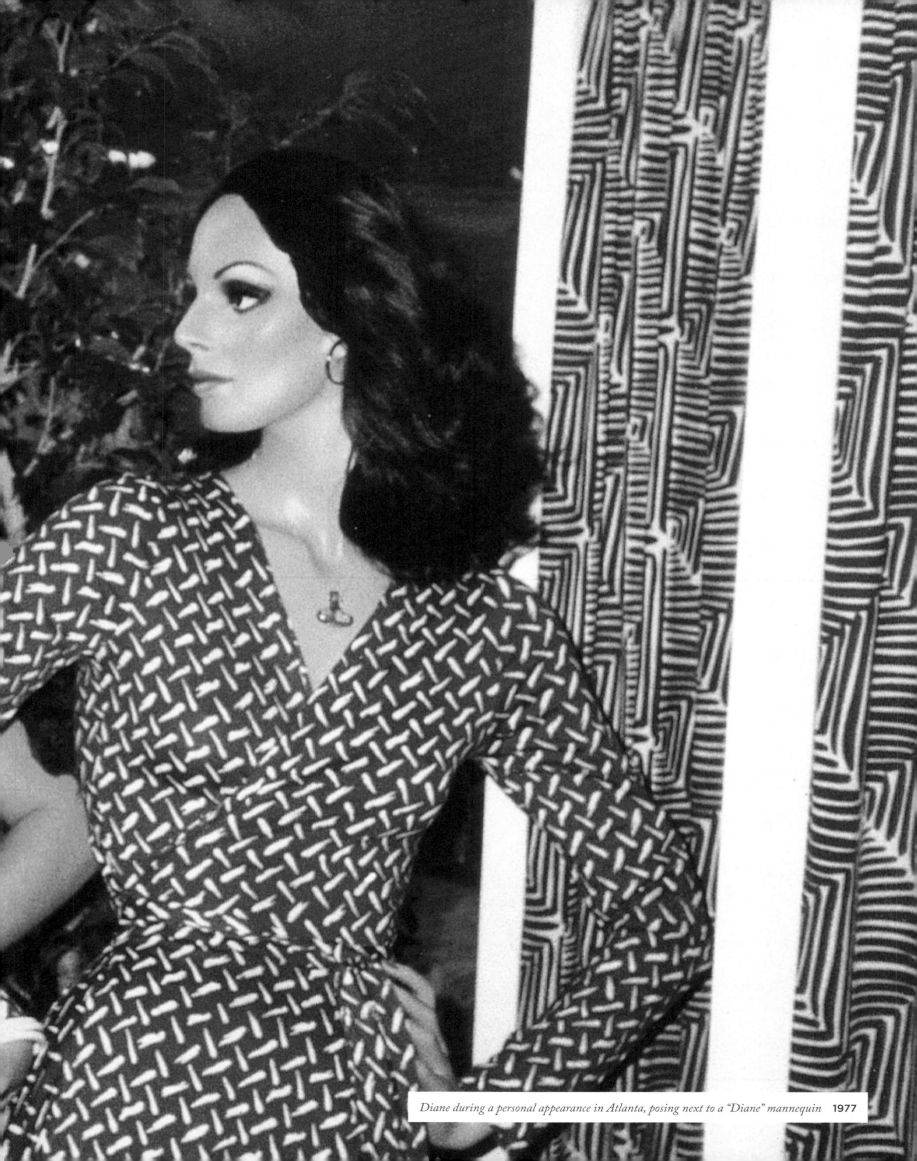

Diane during a personal appearance in Atlanta, posing next to a "Diane" mannequin 1977

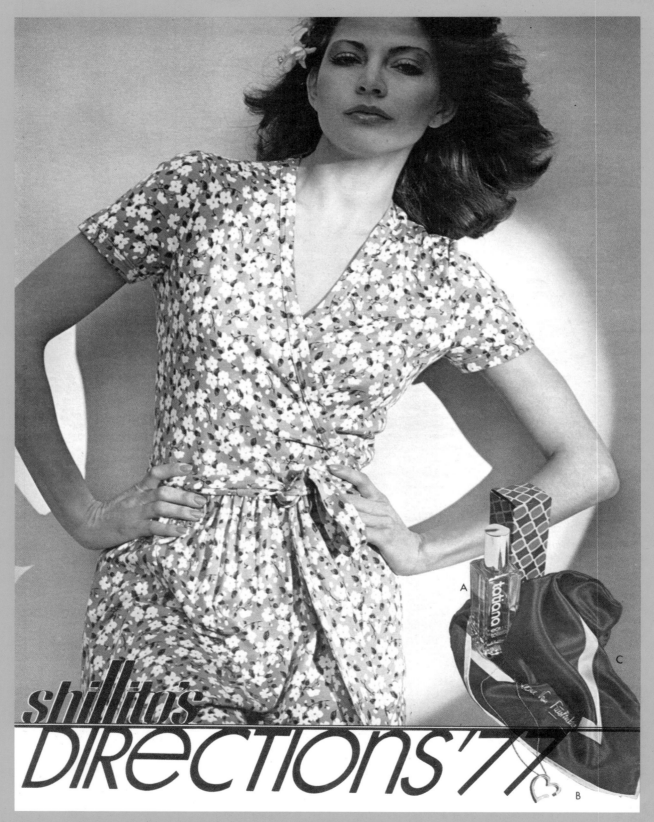

shillito's
DIRECTIONS'77

1977

A catalog page for Tatiana perfume featuring a wrap dress in a small floral print

THE HOLIDAY COLLECTIONS

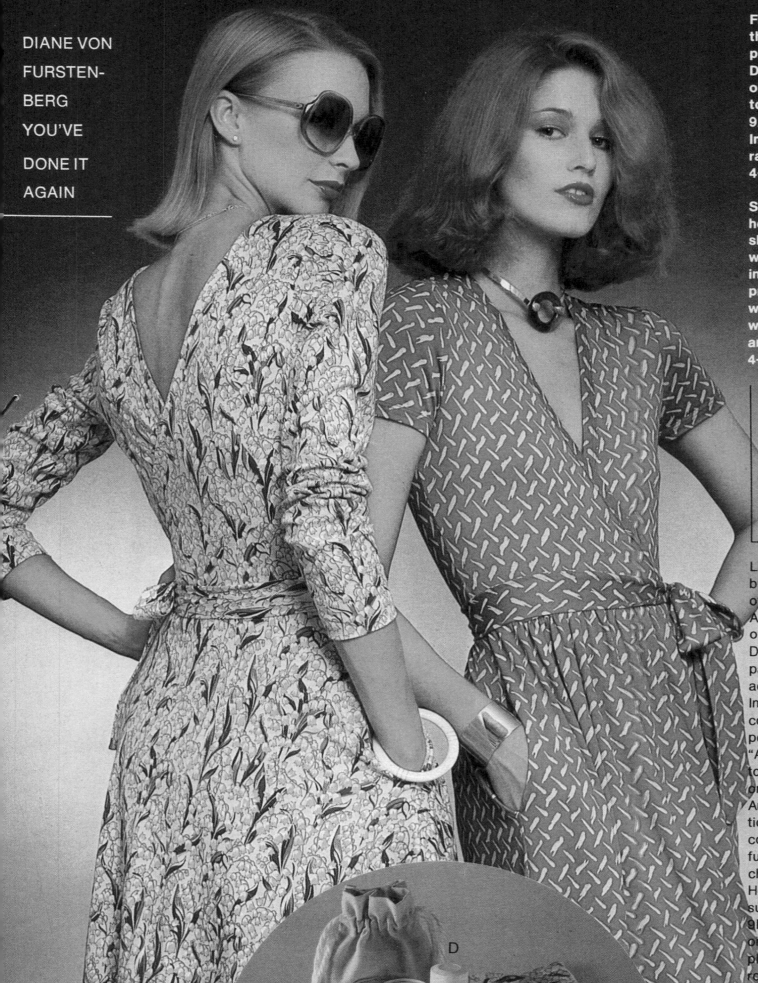

DIANE VON
FURSTEN-
BERG
YOU'VE
DONE IT
AGAIN

Freshly picked Lily of the Valley long-sleeved print wrap dress. And Diane has given us the option of wrapping it to the front or back. 9A/Buttercup yellow. Imported cotton and rayon jersey. 4-16, $90.

Simply sensational– her terrific looking short-sleeved front wrap dress. Designed in a stunning abstract print. 9B/Green and white; turquoise and white. Imported cotton and rayon jersey. 4-16. $80.

BRAVOS FOR DIANE VON FURSTENBERG'S FABULOUS FASHION ACCESSORIES

Like this yellow buttercup print scarf of pure silk. 9C/ Also in pink, peach or blue, $15. Diane's sportabout package for the active woman. 9D/ Includes Tatiana® cologne 2½ oz., powder 4 oz. and "After Sport" canvas tote. All for only $10. An ingenious creation. 9E/ Metal neck collar with 3 colorful rings to interchange, $15. Her sunsational sunglass shape. 9F/DVF signature on frames of rose plum, rose moss or rose tangerine, $28.

D

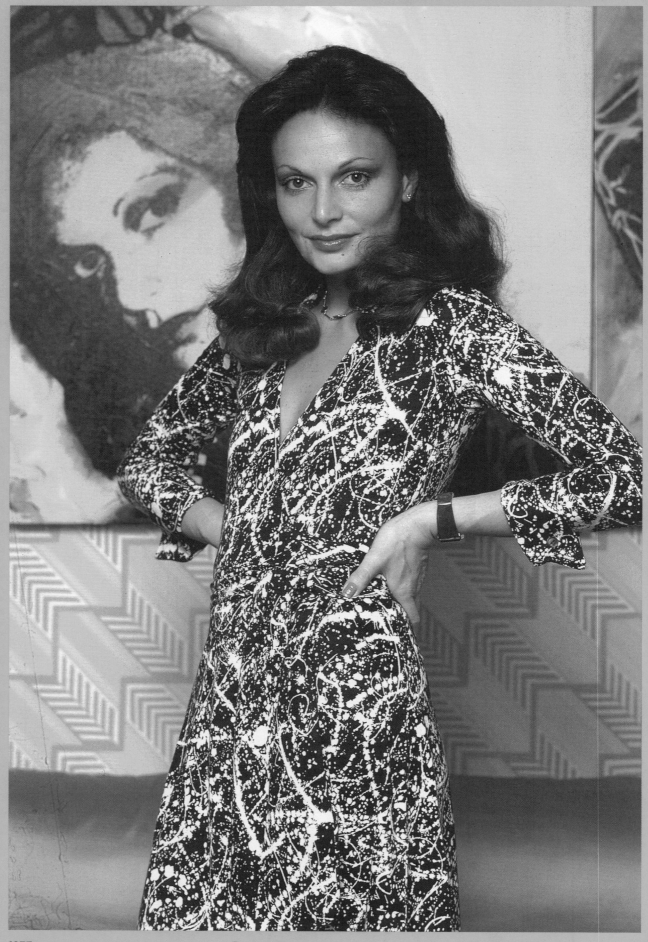

1977

Diane wearing a wrap dress in her Park Avenue apartment in front of her first Warhol

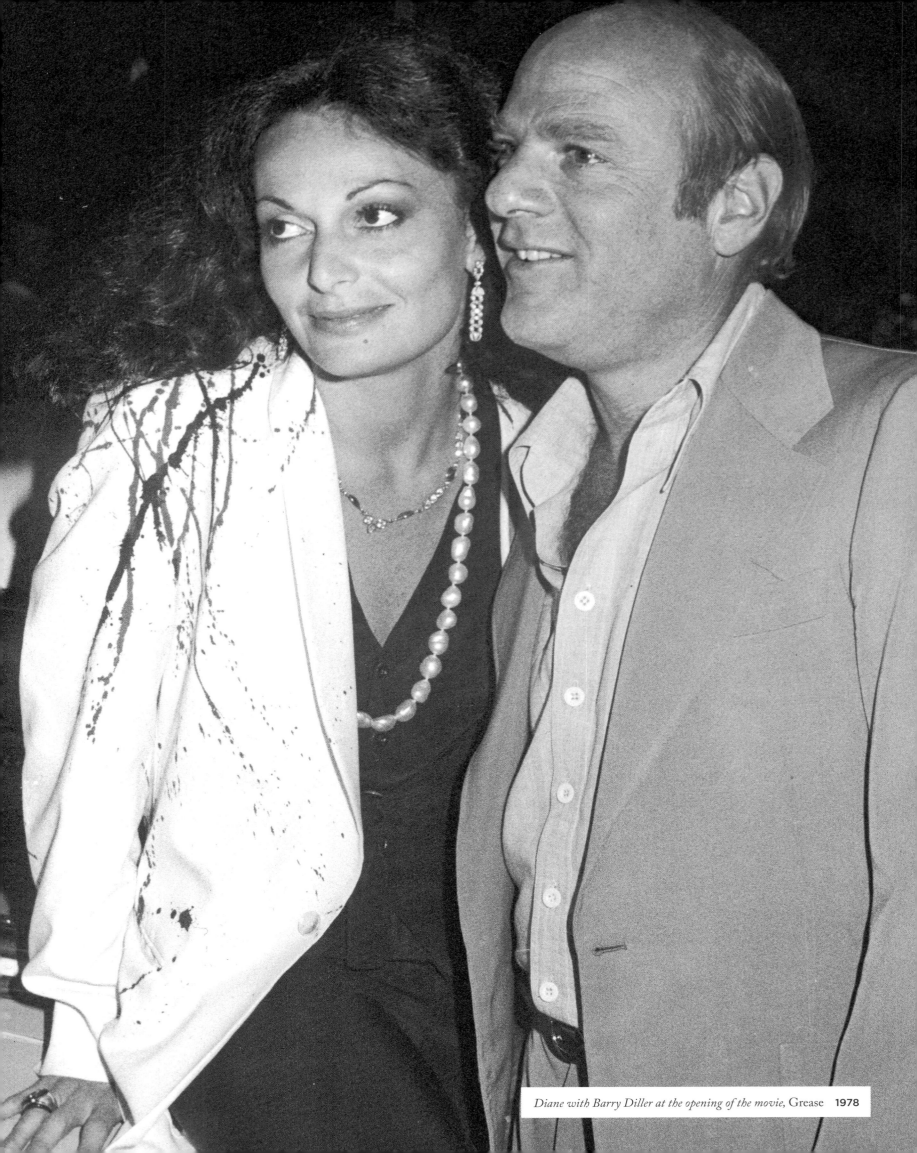

Diane with Barry Diller at the opening of the movie, Grease **1978**

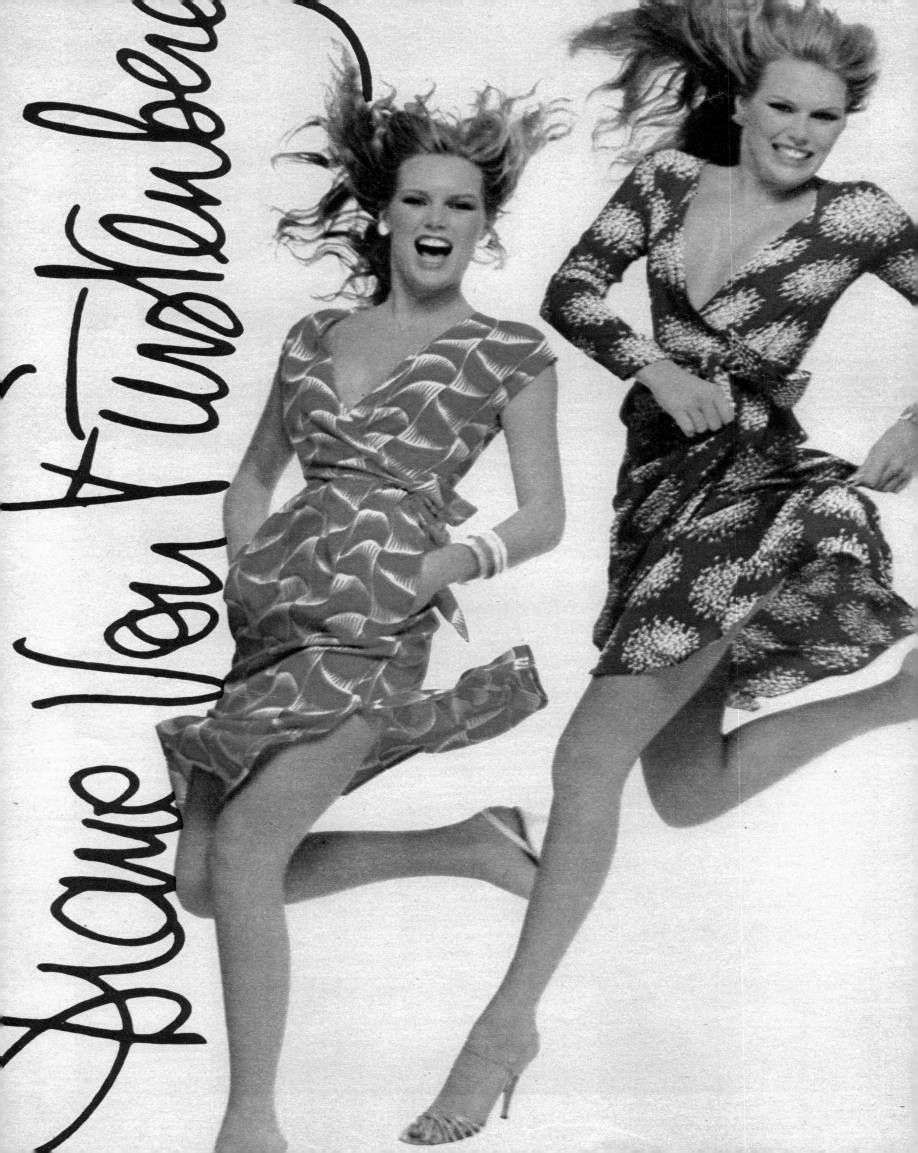

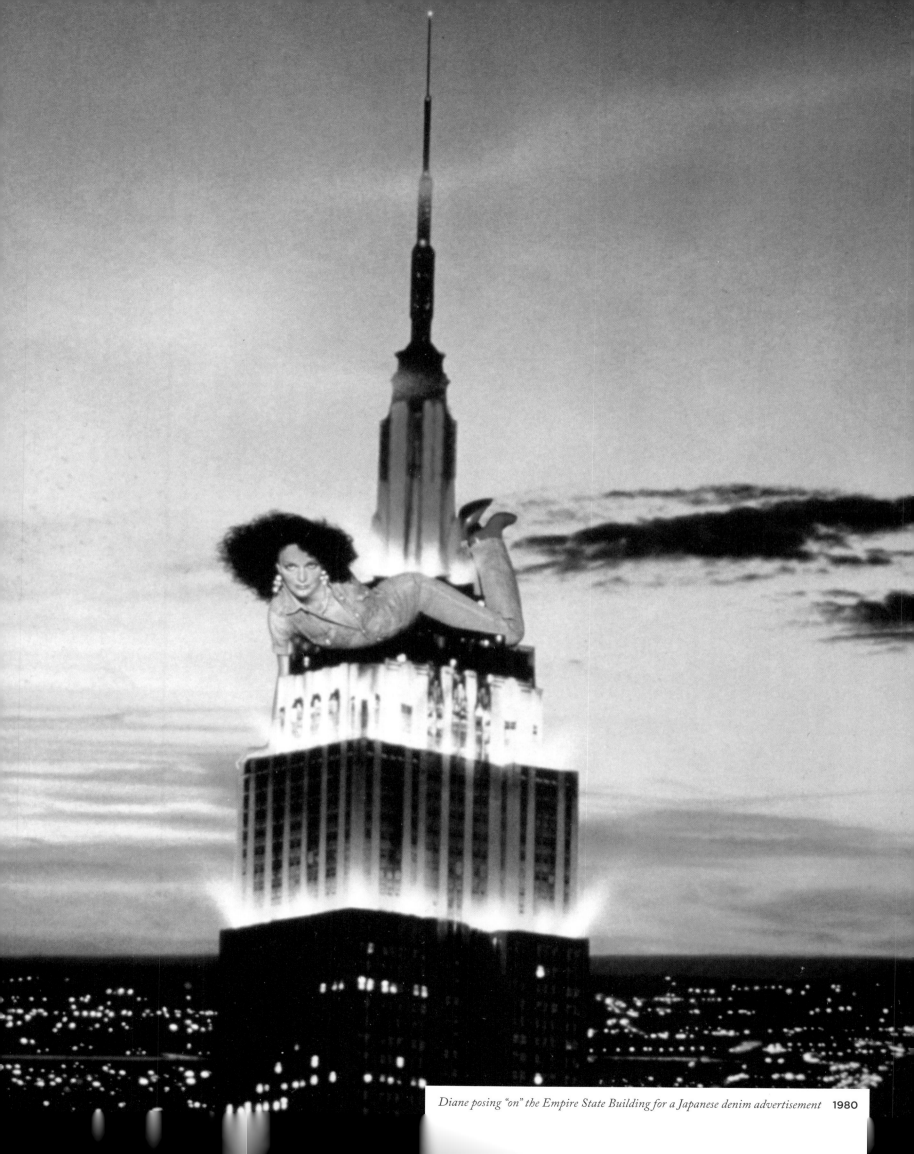

Diane posing "on" the Empire State Building for a Japanese denim advertisement 1980

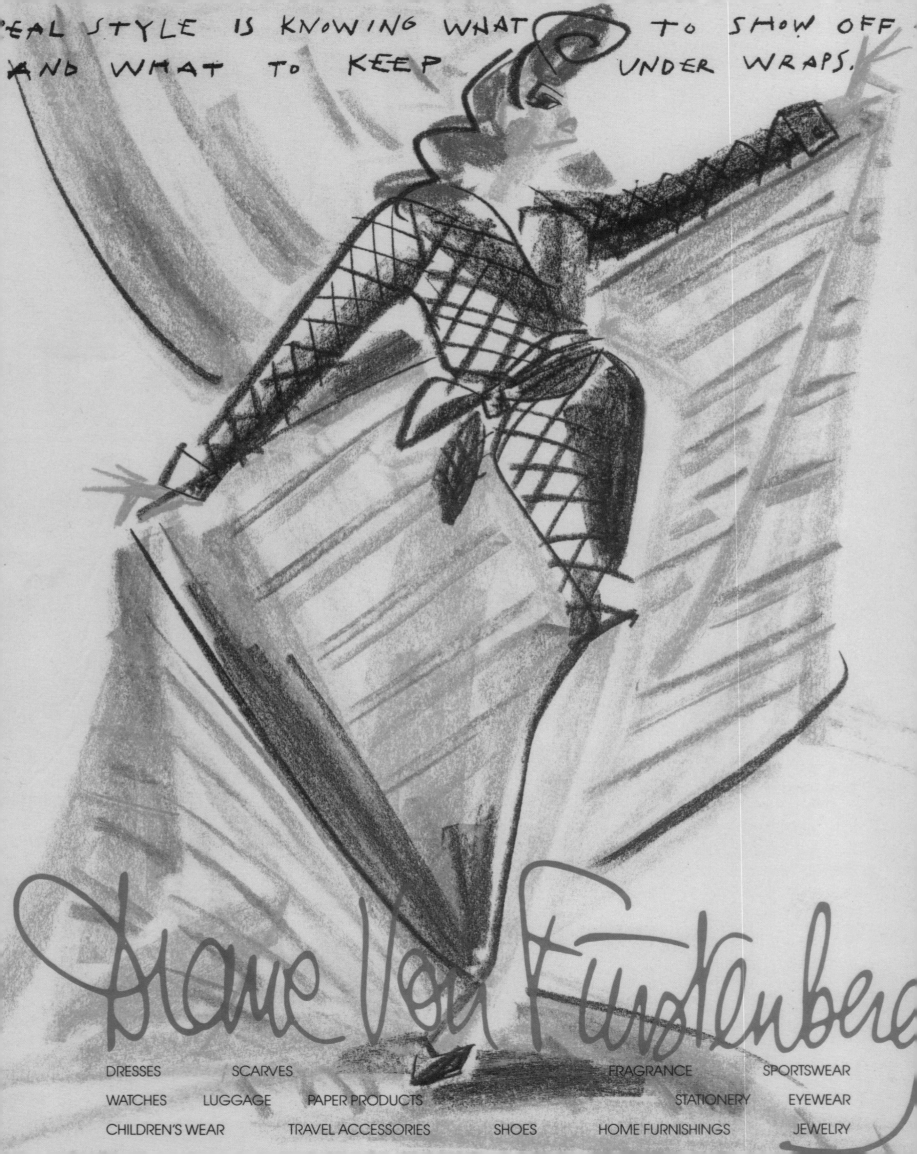

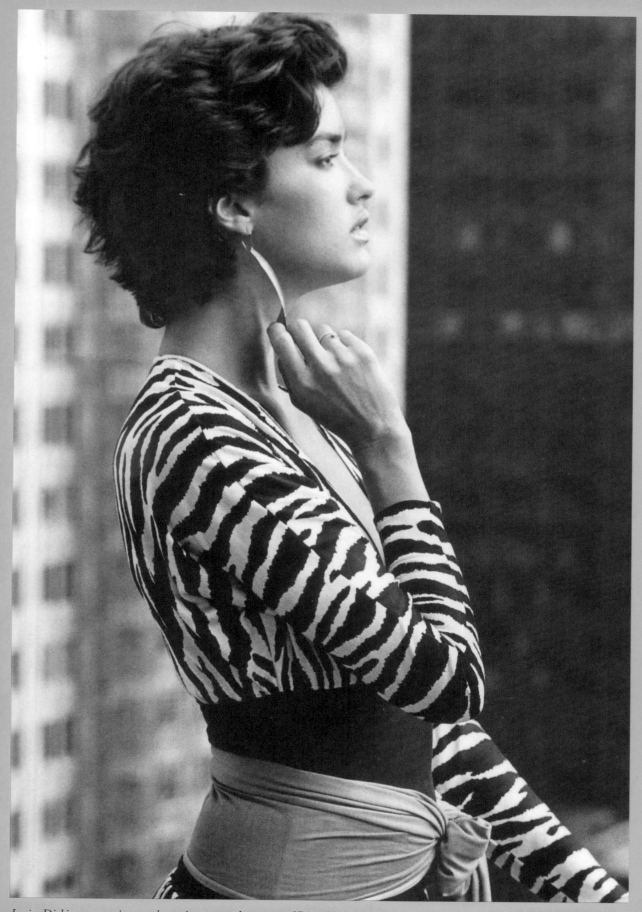

Janice Dickinson wearing a zebra print top on the terrace of Diane's office at 745 Fifth Avenue in New York **1980**

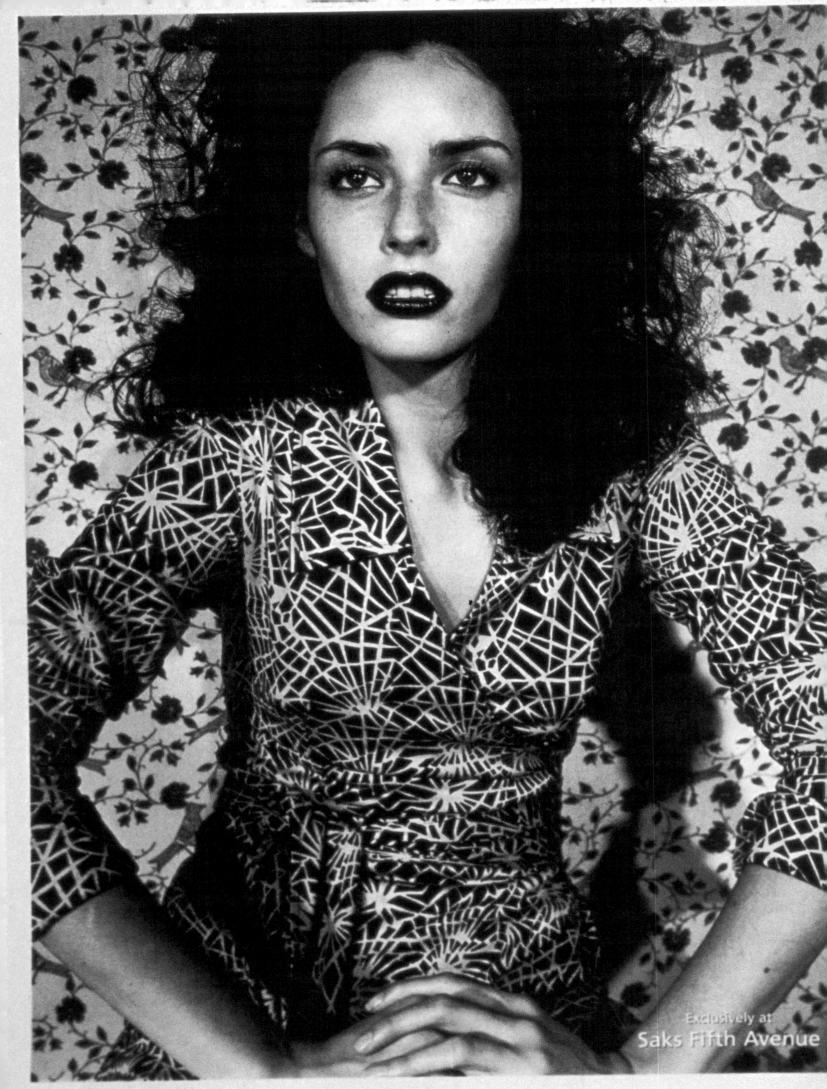

He stared at me all night. Then he said...

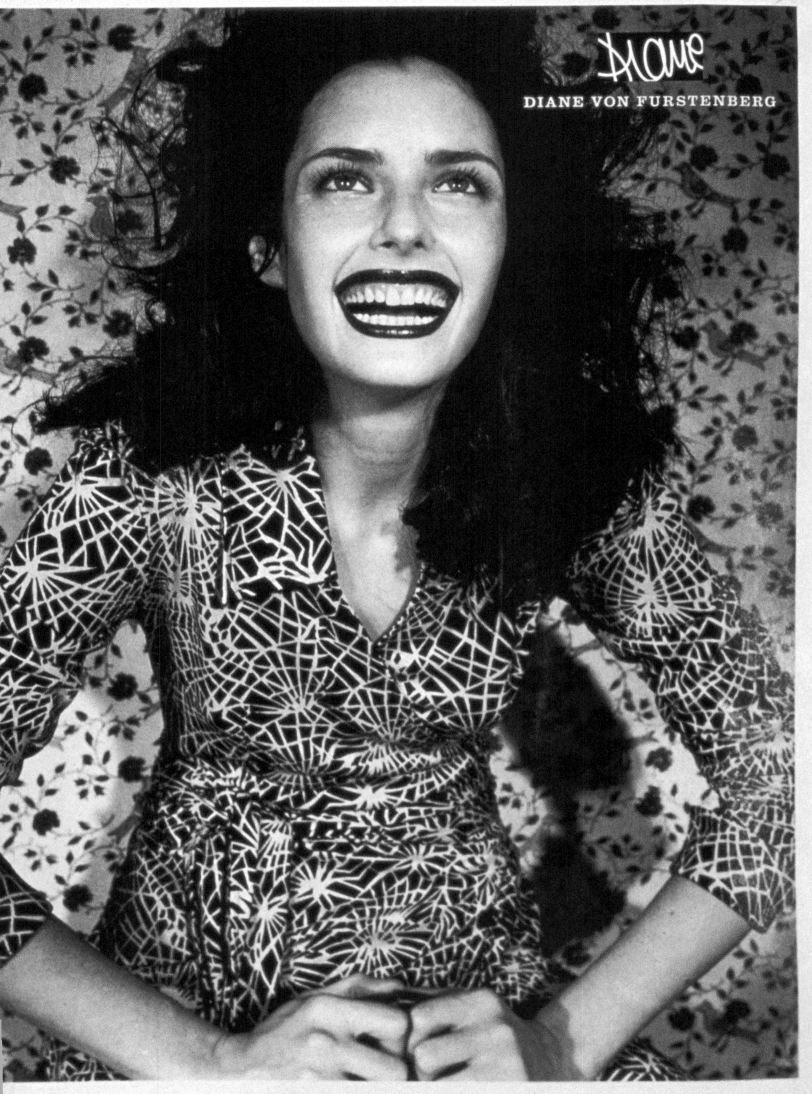

Diane

DIANE VON FURSTENBERG

"Something about you reminds me of my mother."

1998

Diane with then daughter-in-law, Alexandra, re-launching the wrap dress

Journey of a Dress

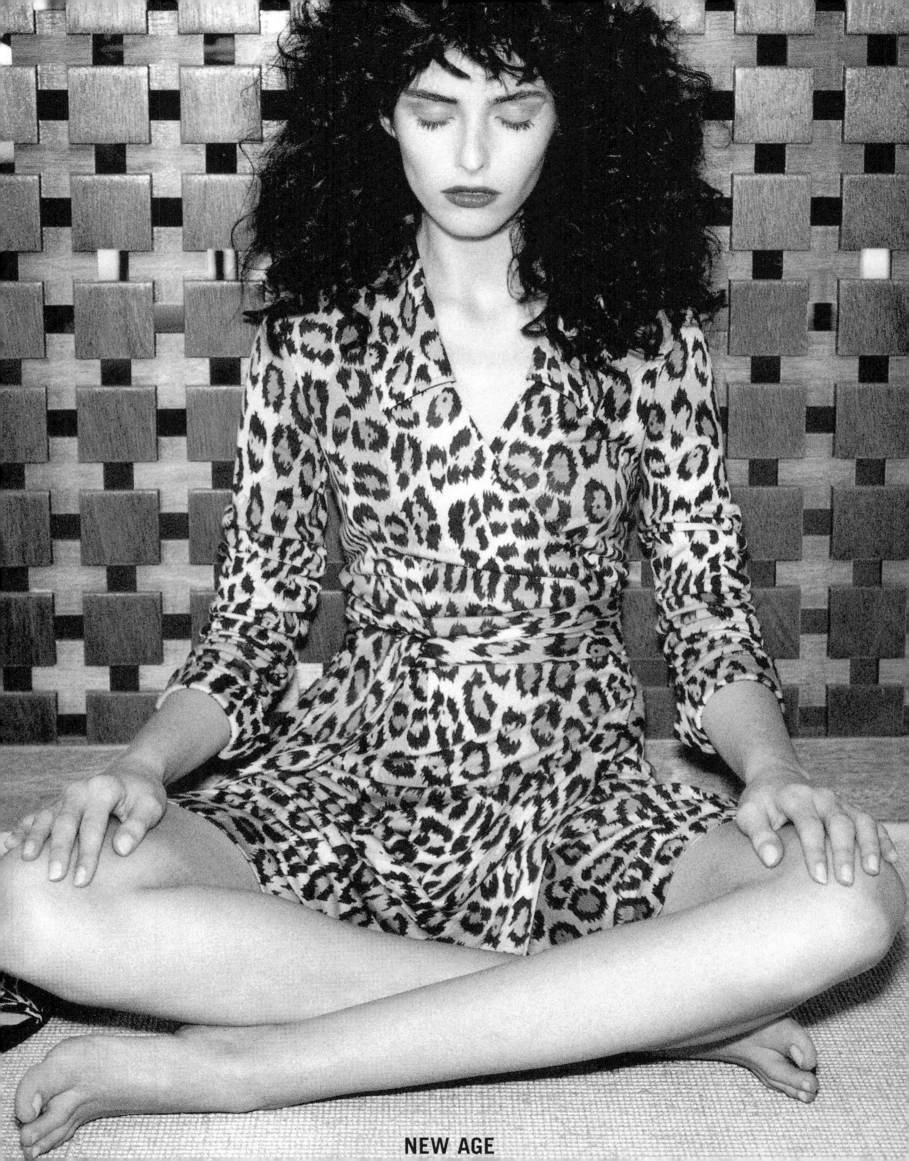

NEW AGE

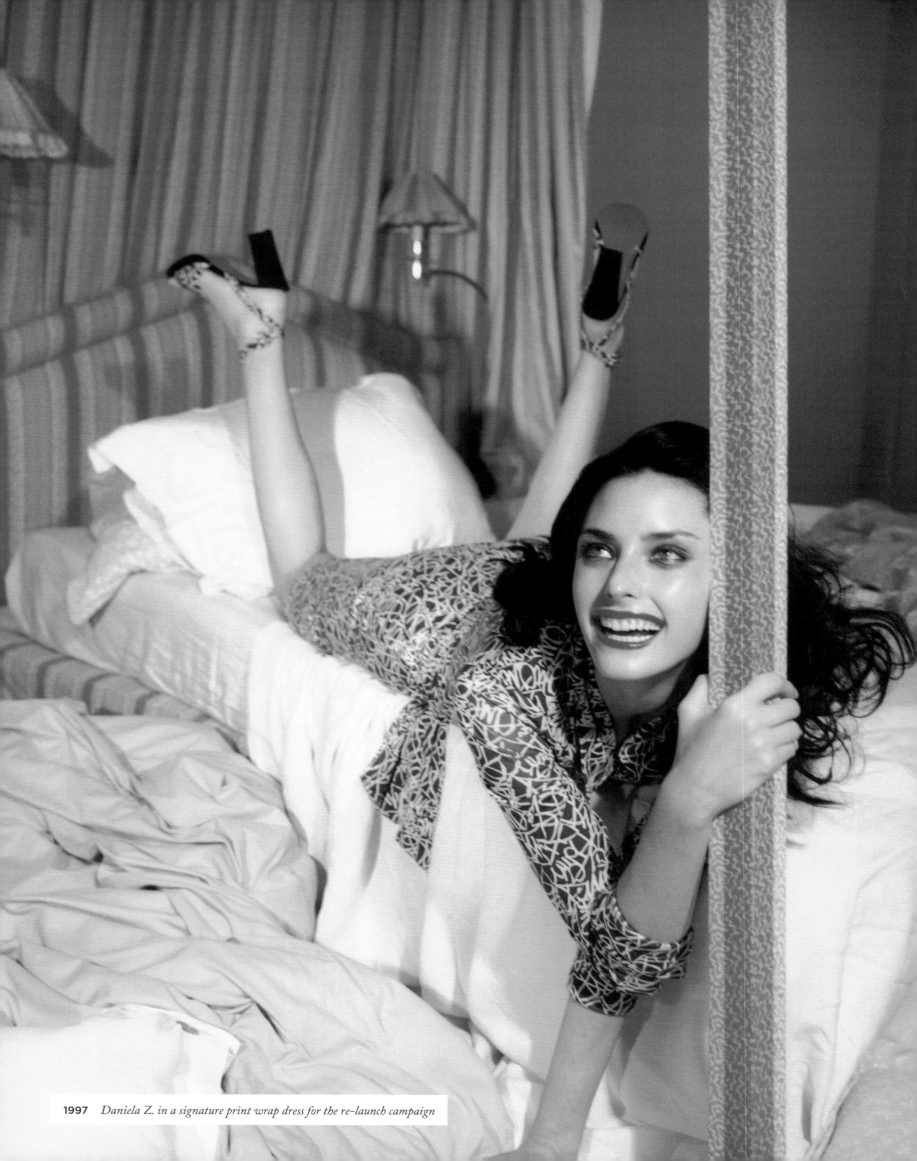

1997 *Daniela Z. in a signature print wrap dress for the re-launch campaign*

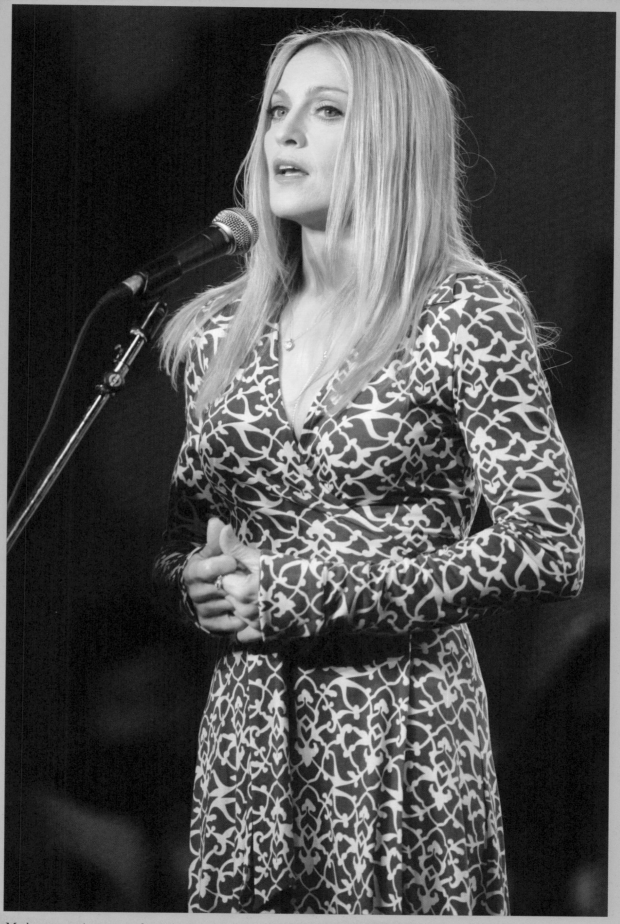

Madonna, wearing a wrap dress, giving a speech in Tel Aviv

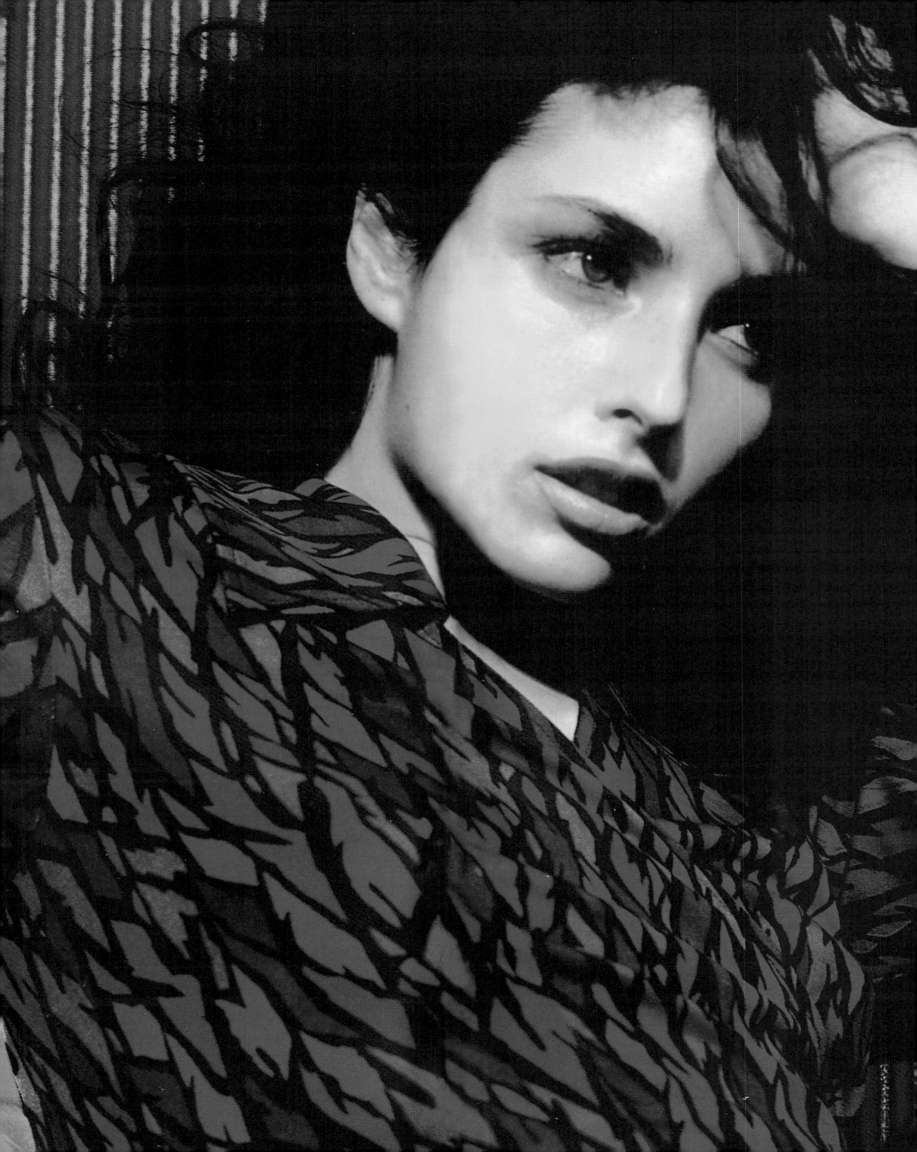

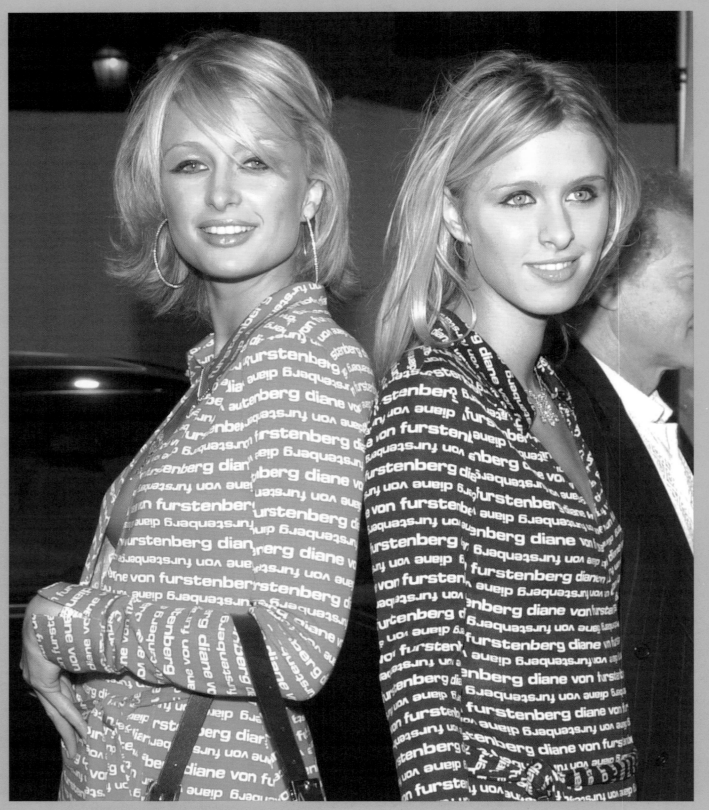

Paris and Nicky Hilton wearing wrap dresses in DVF logo print

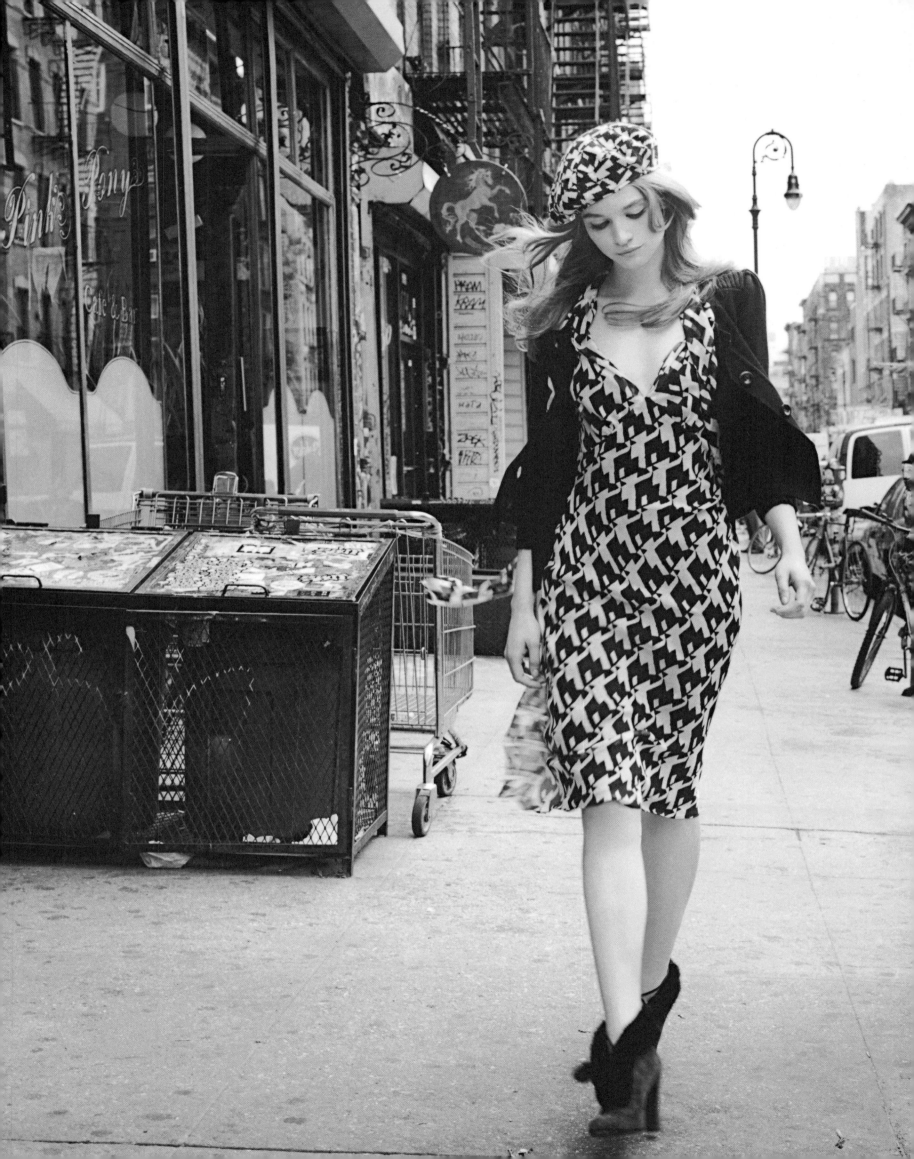

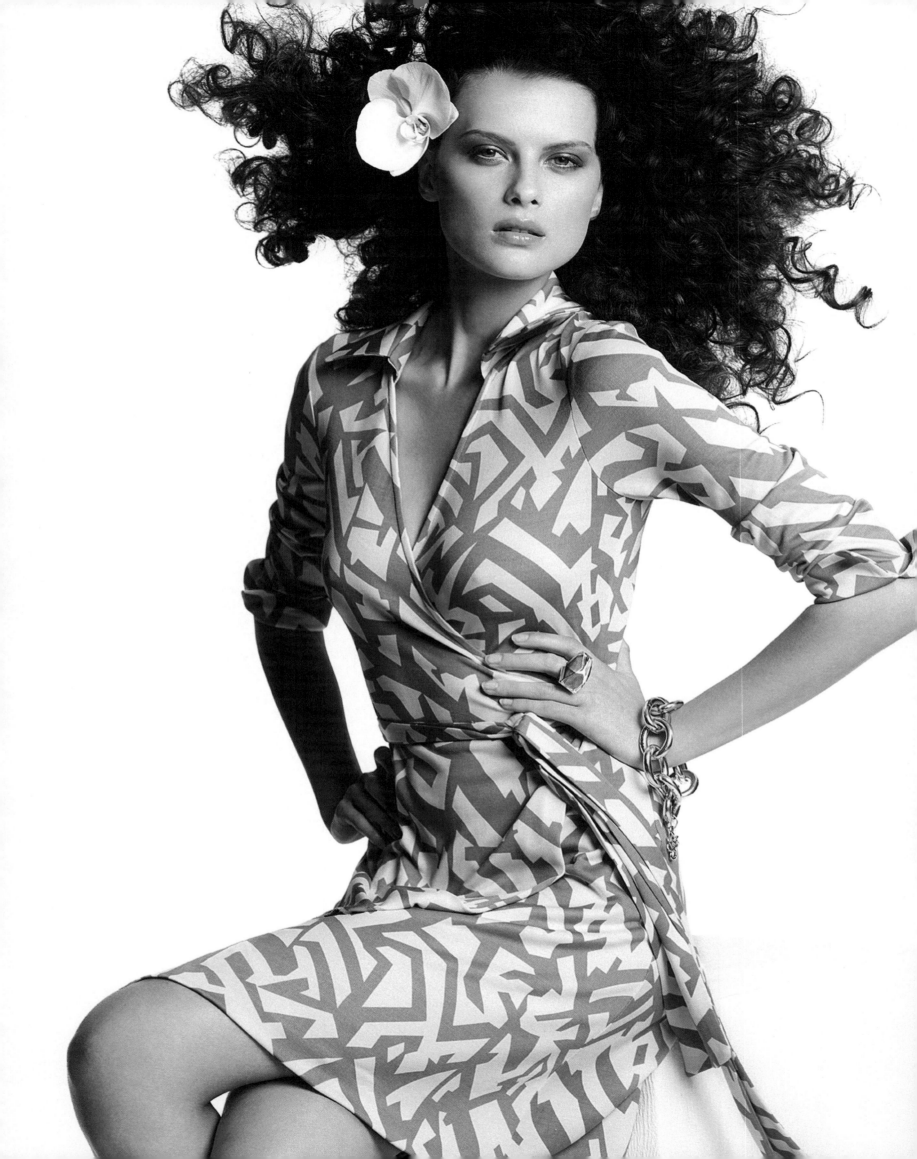

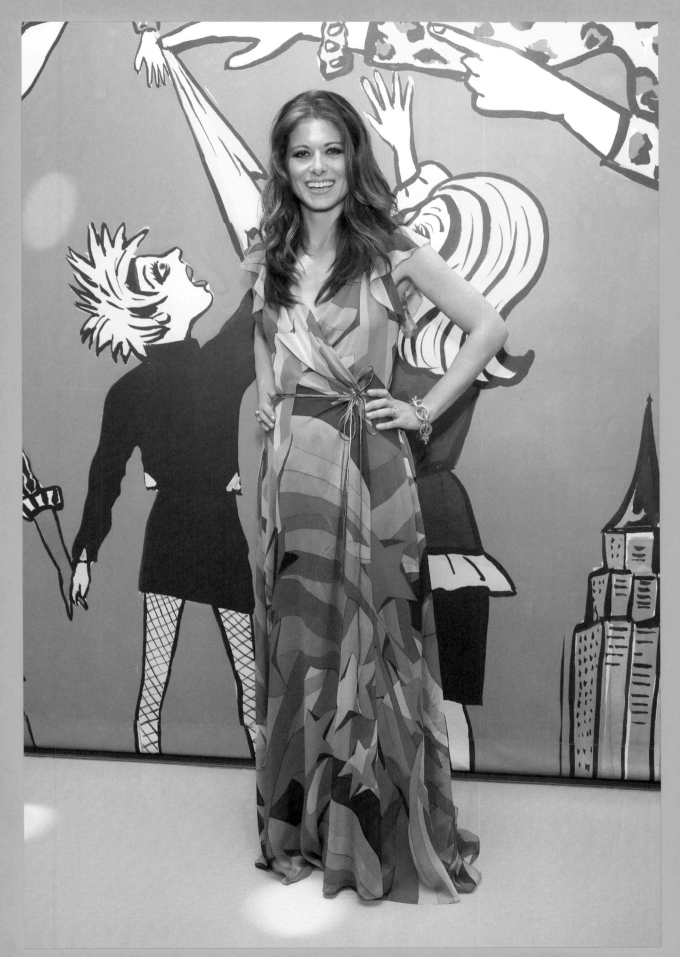

Debra Messing in front of Konstantin Kakanias illustrations for the "Wonder Woman" comic book

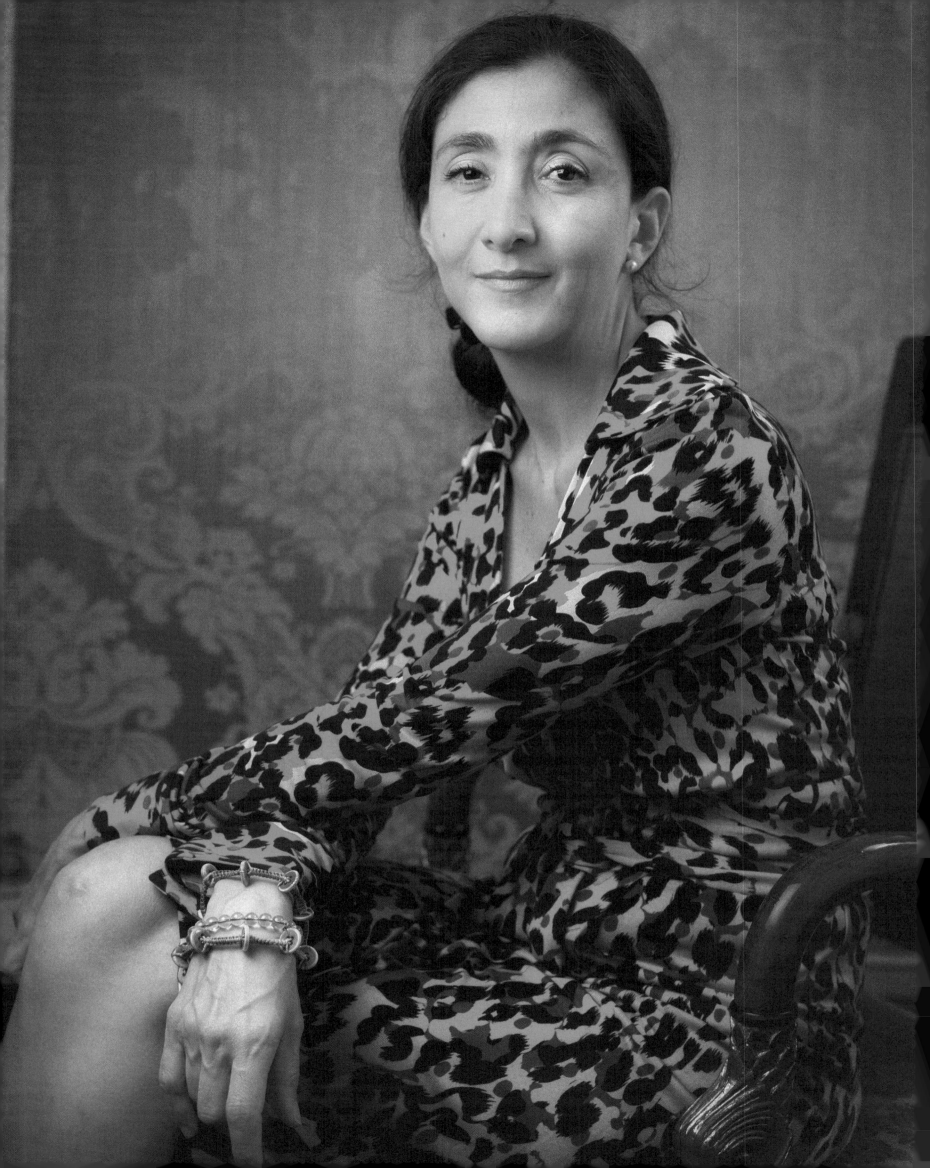

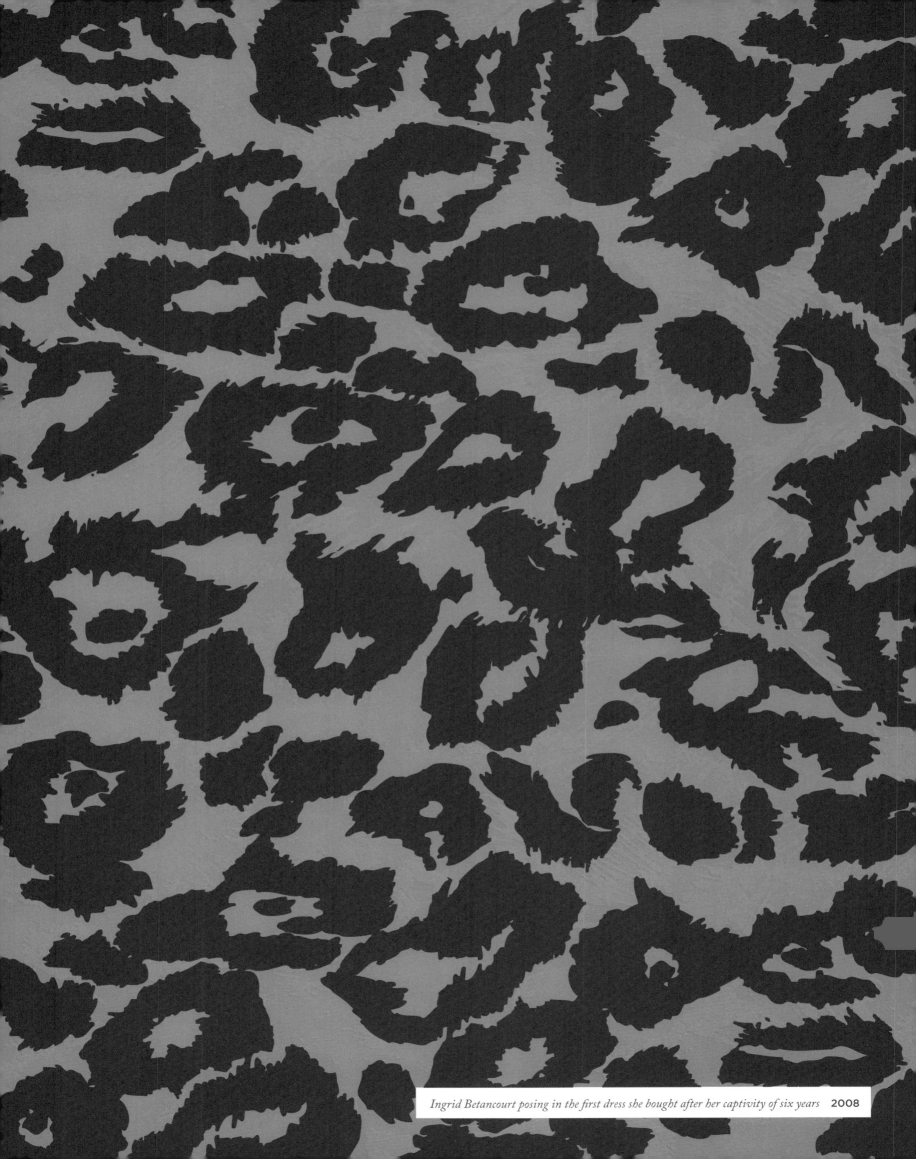

Ingrid Betancourt posing in the first dress she bought after her captivity of six years 2008

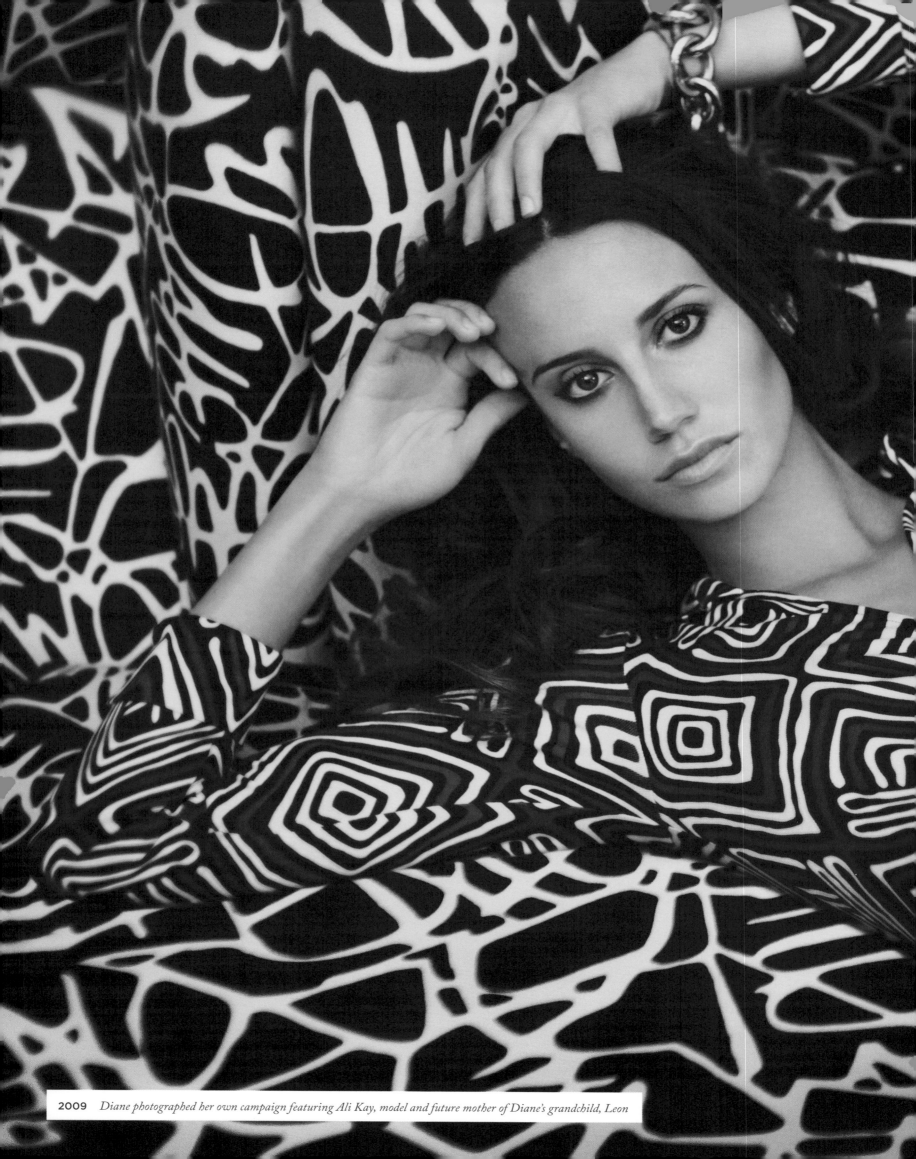

2009 *Diane photographed her own campaign featuring Ali Kay, model and future mother of Diane's grandchild, Leon*

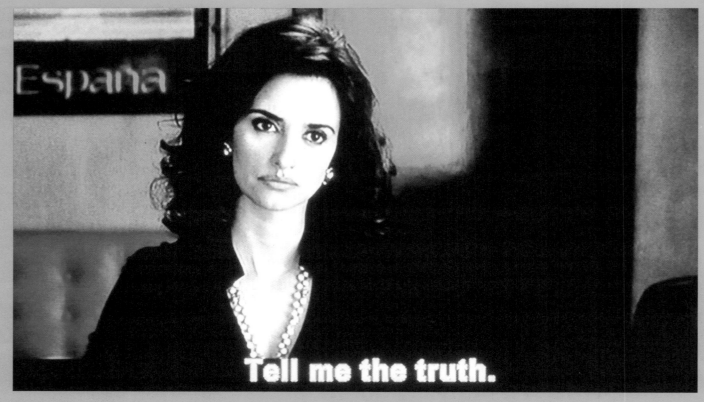

2009

Penélope Cruz wearing a wrap dress in Broken Embraces, *directed by Pedro Almodóvar*

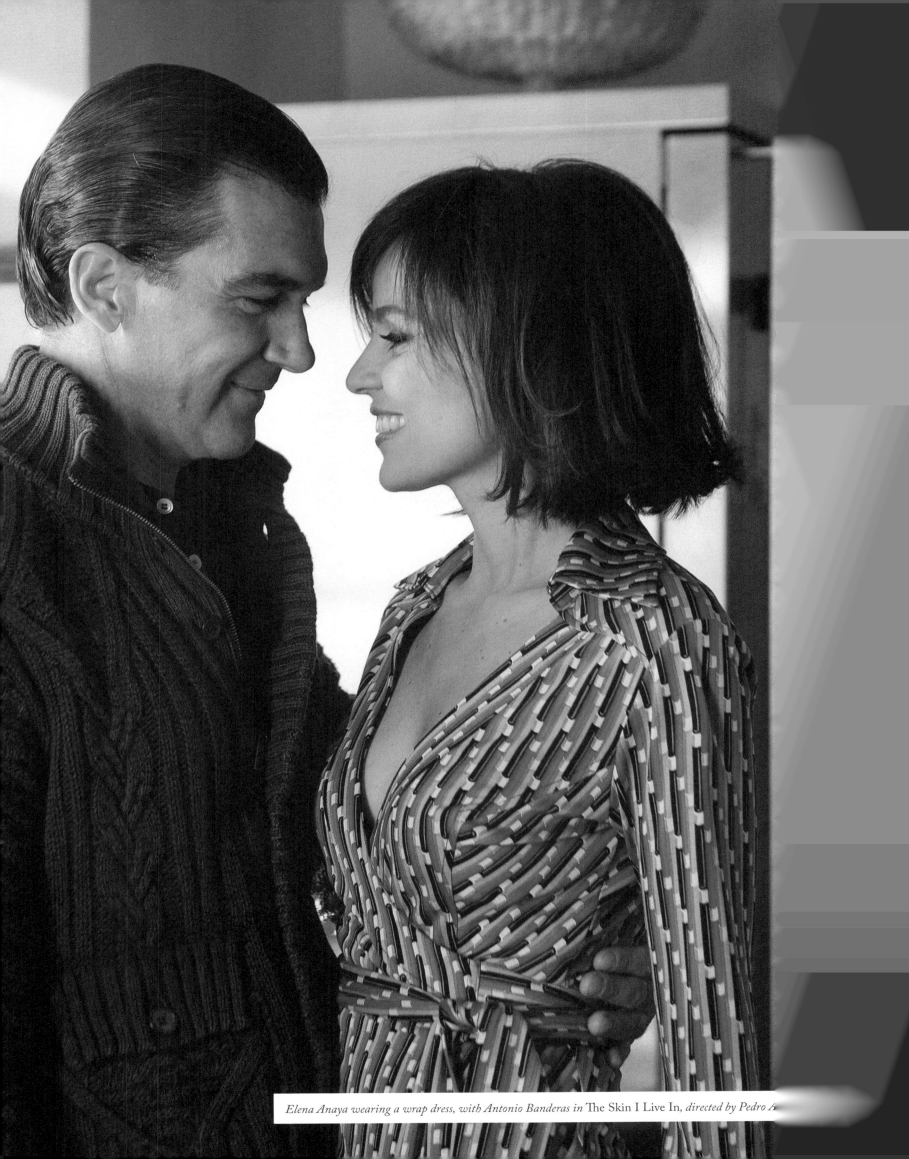

Elena Anaya wearing a wrap dress, with Antonio Banderas in The Skin I Live In, *directed by Pedro A*

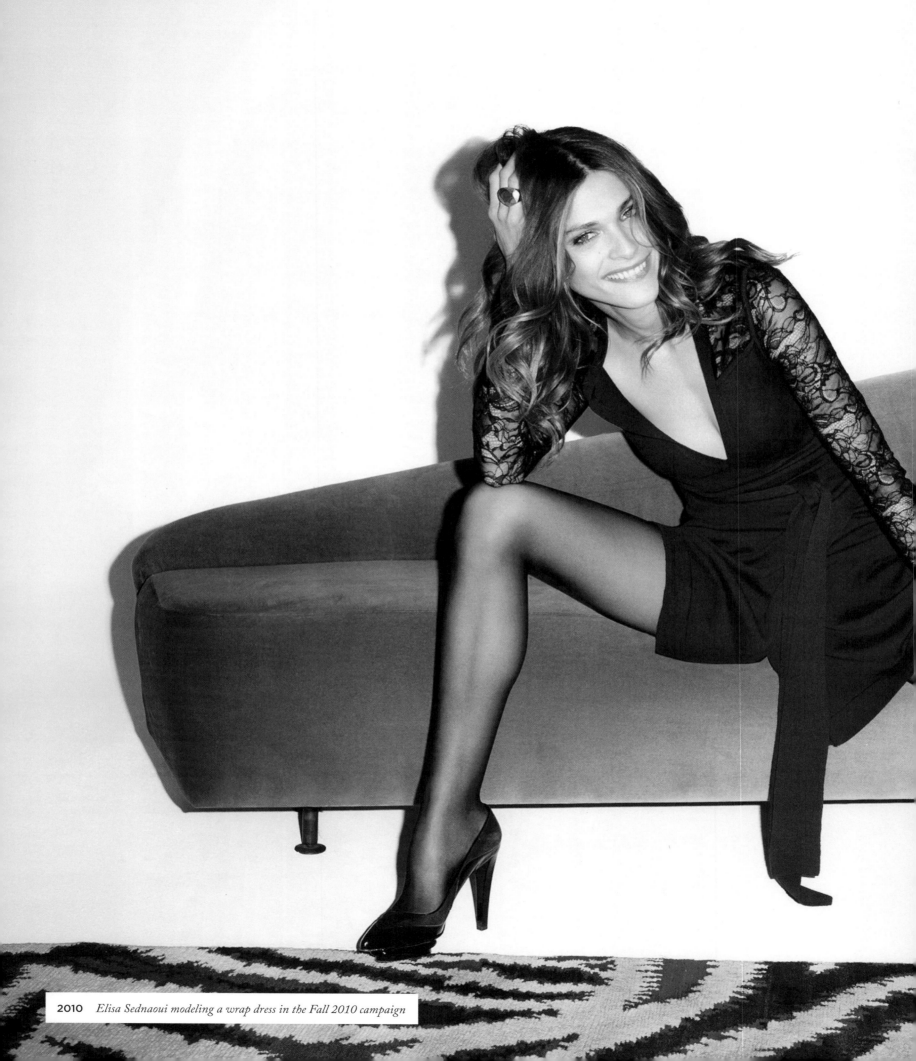

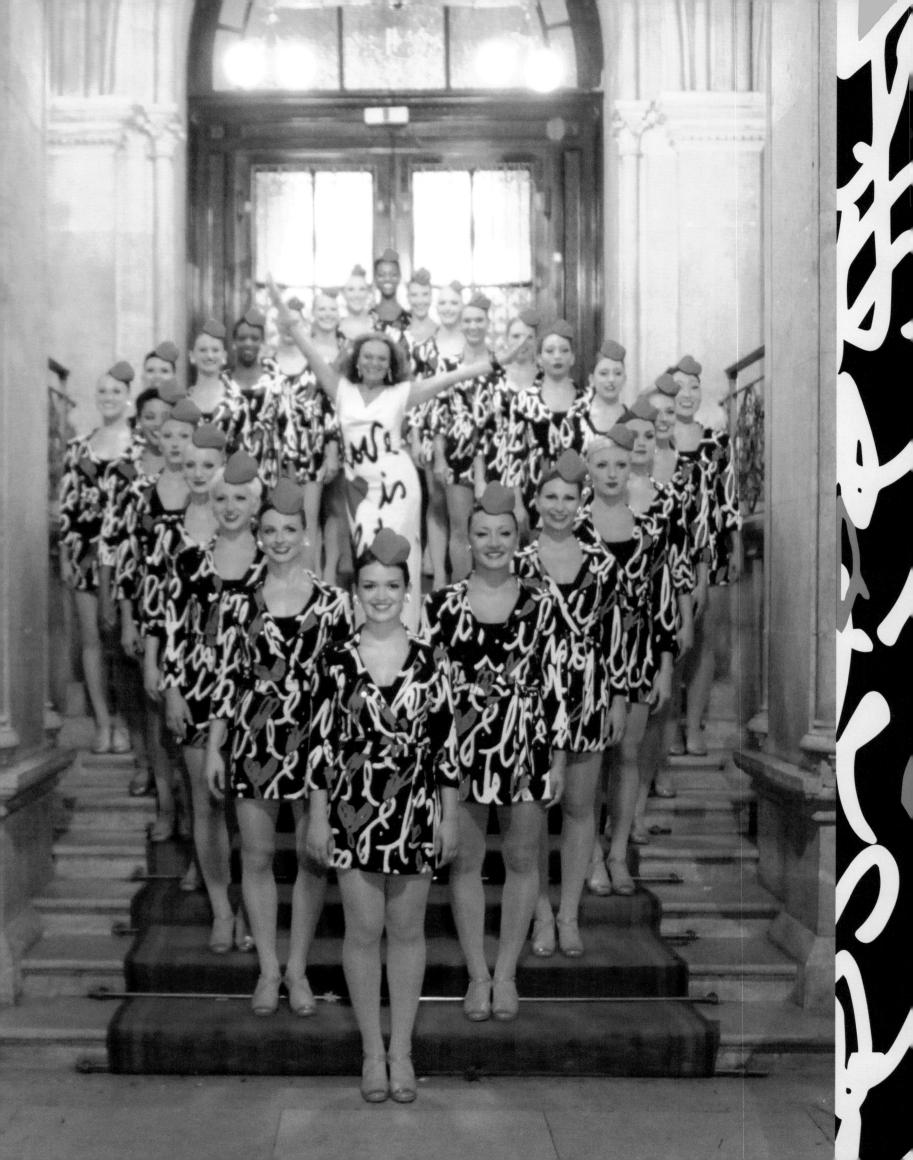

Diane surrounded by a crowd of Rockettes, all wearing Love is Life print wrap dresses, in Vienna **2010**

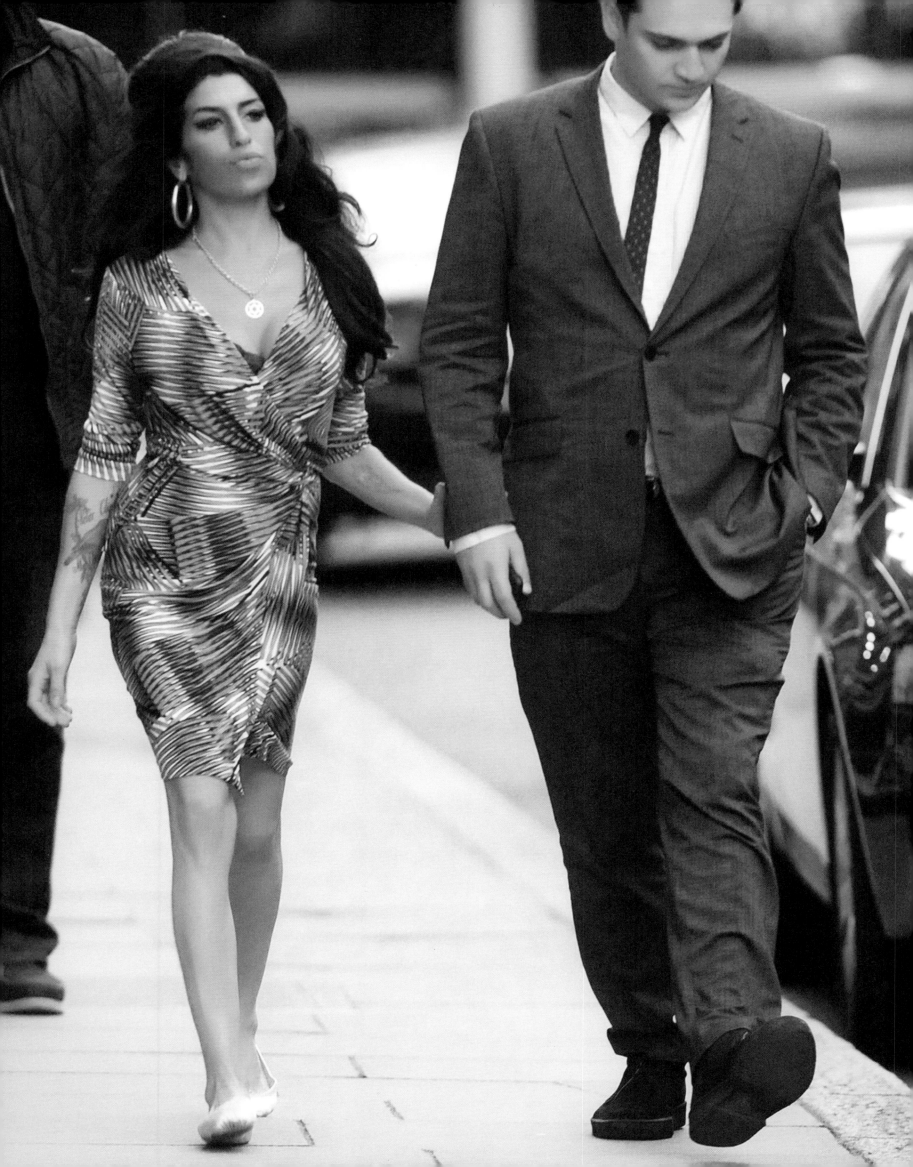

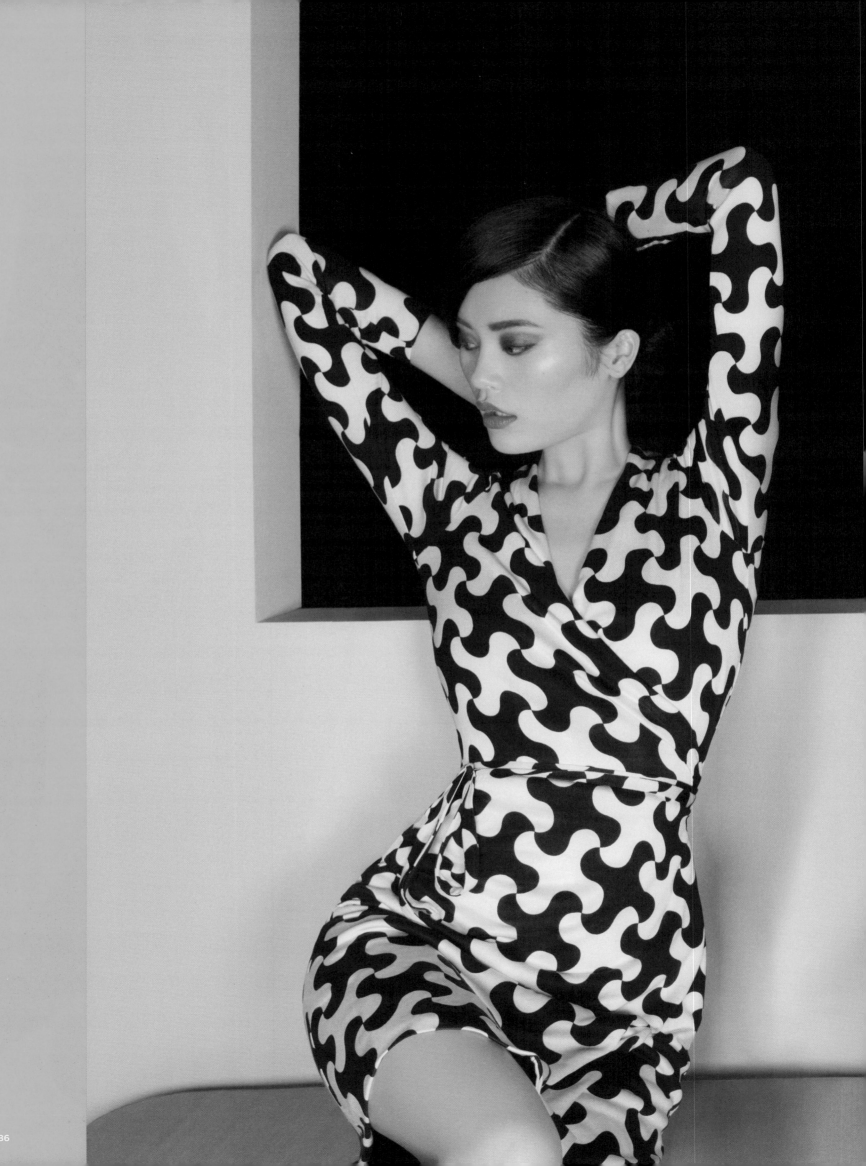

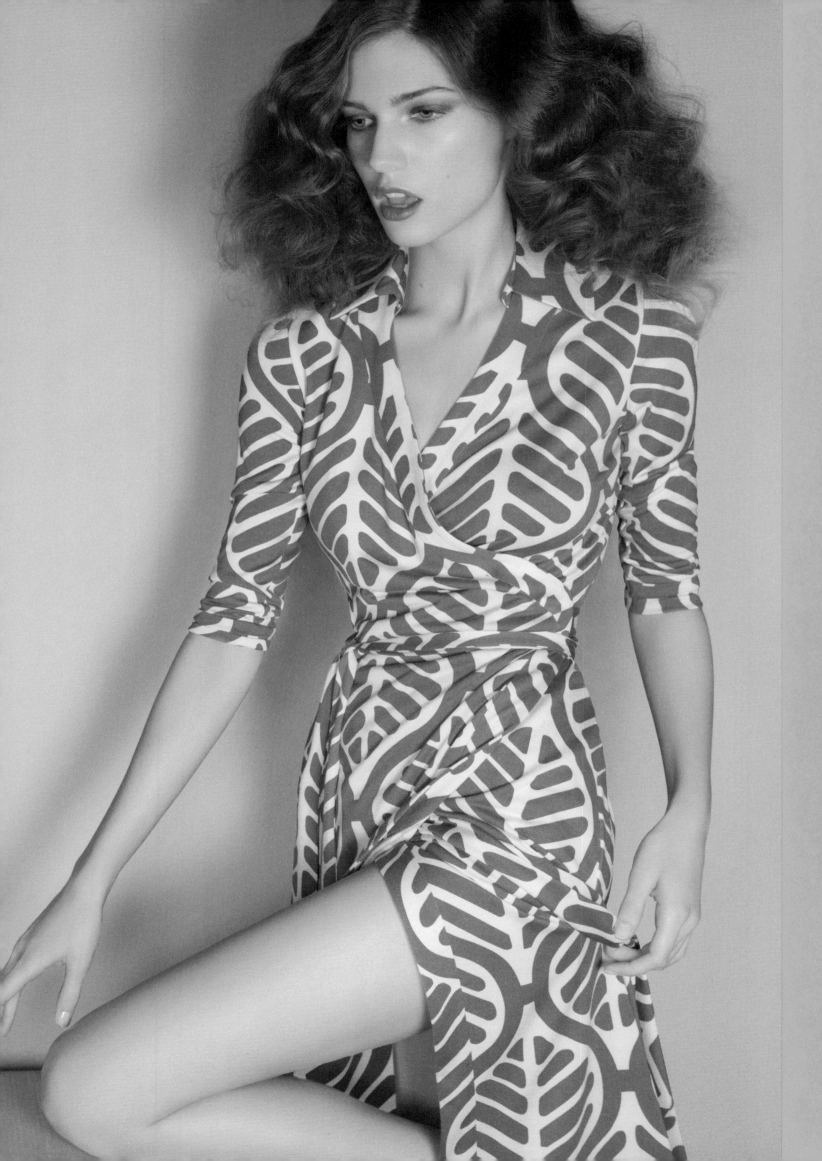

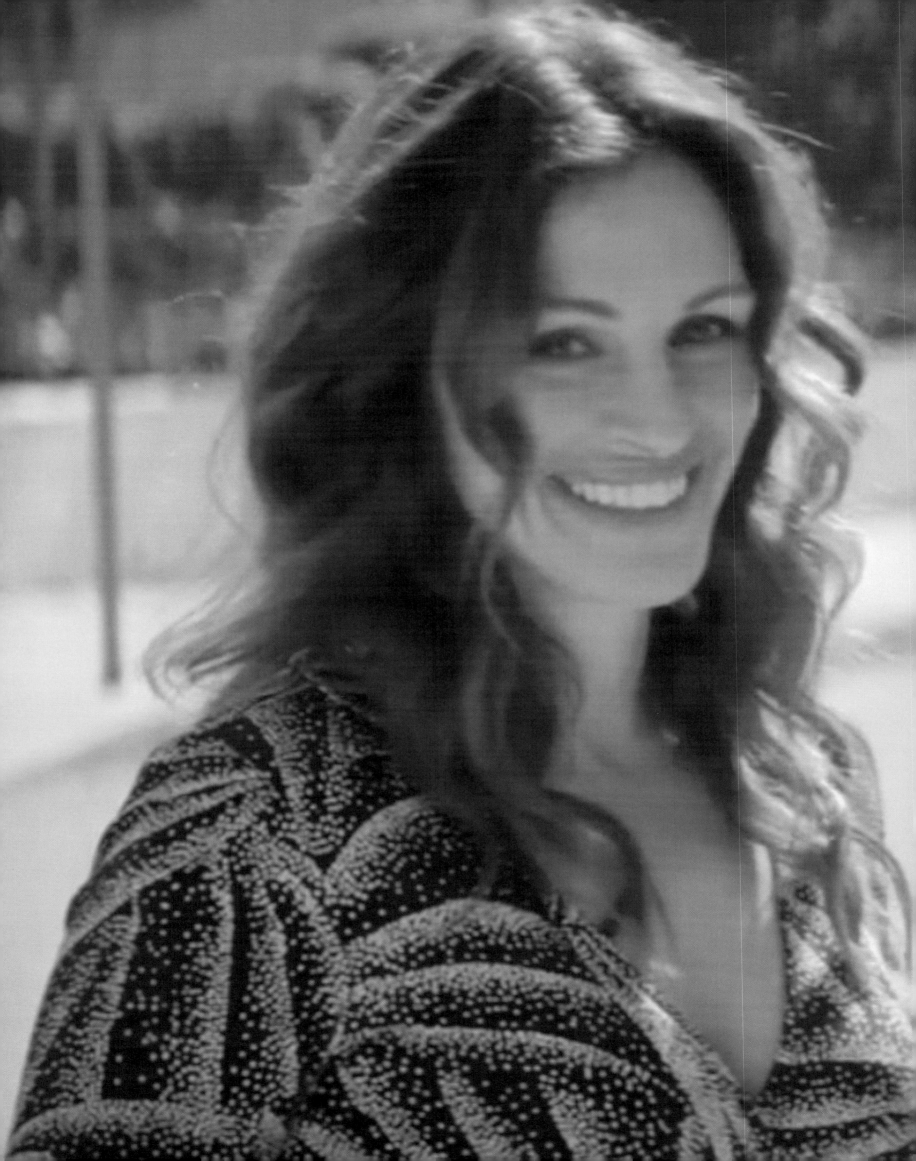

Julia Roberts wearing a wrap dress in Larry Crowne, *directed by Tom Hanks* **2011**

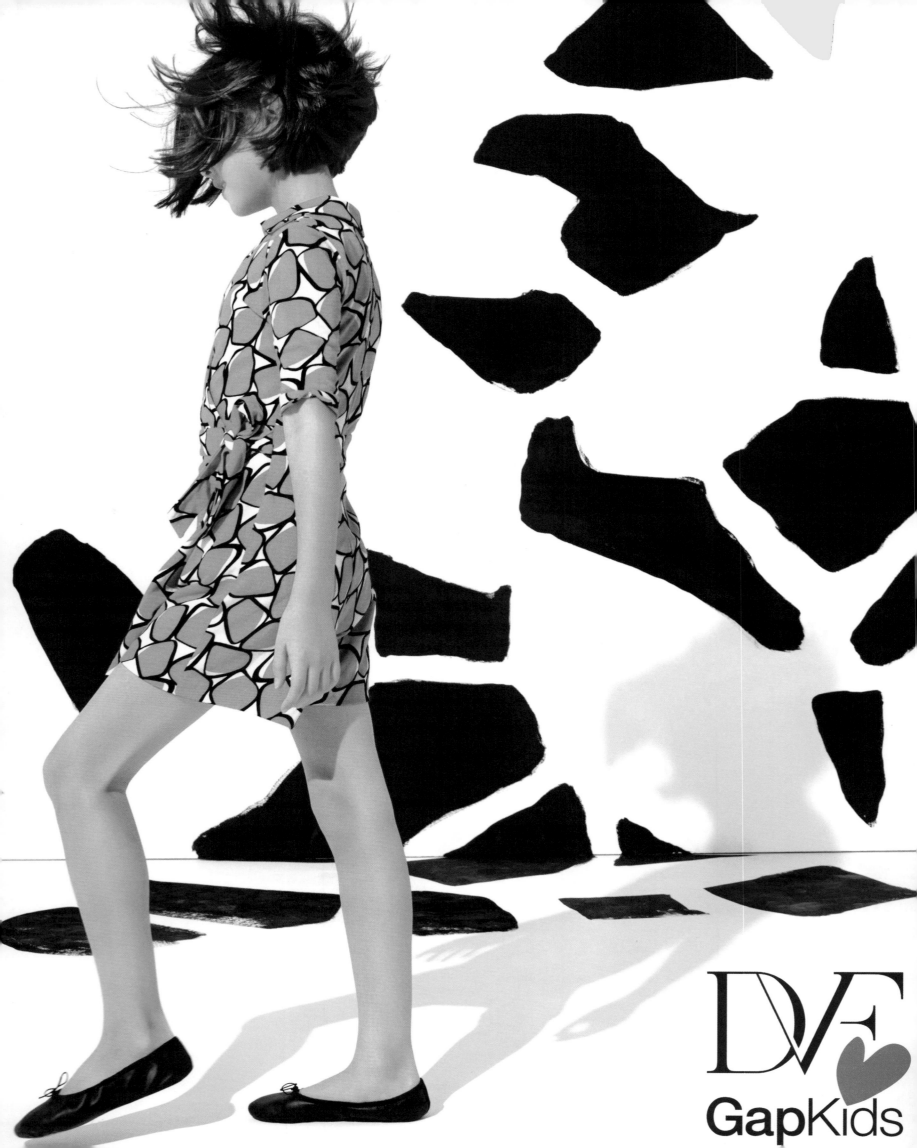

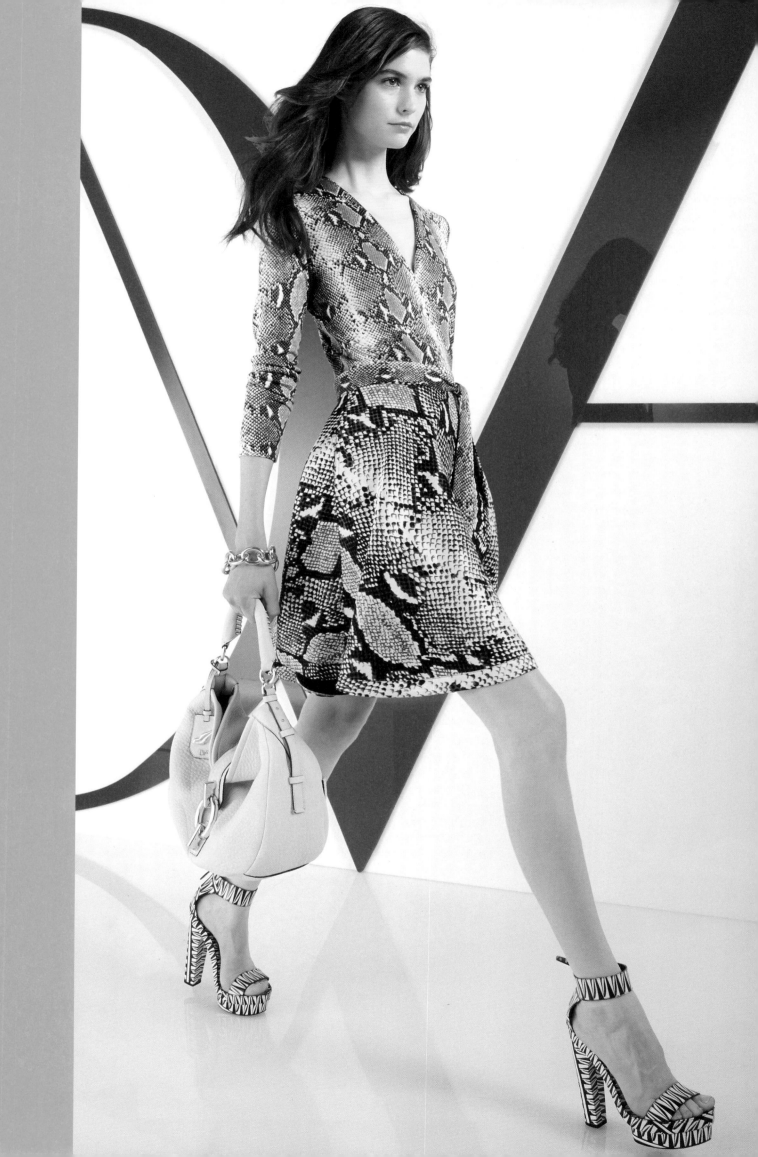

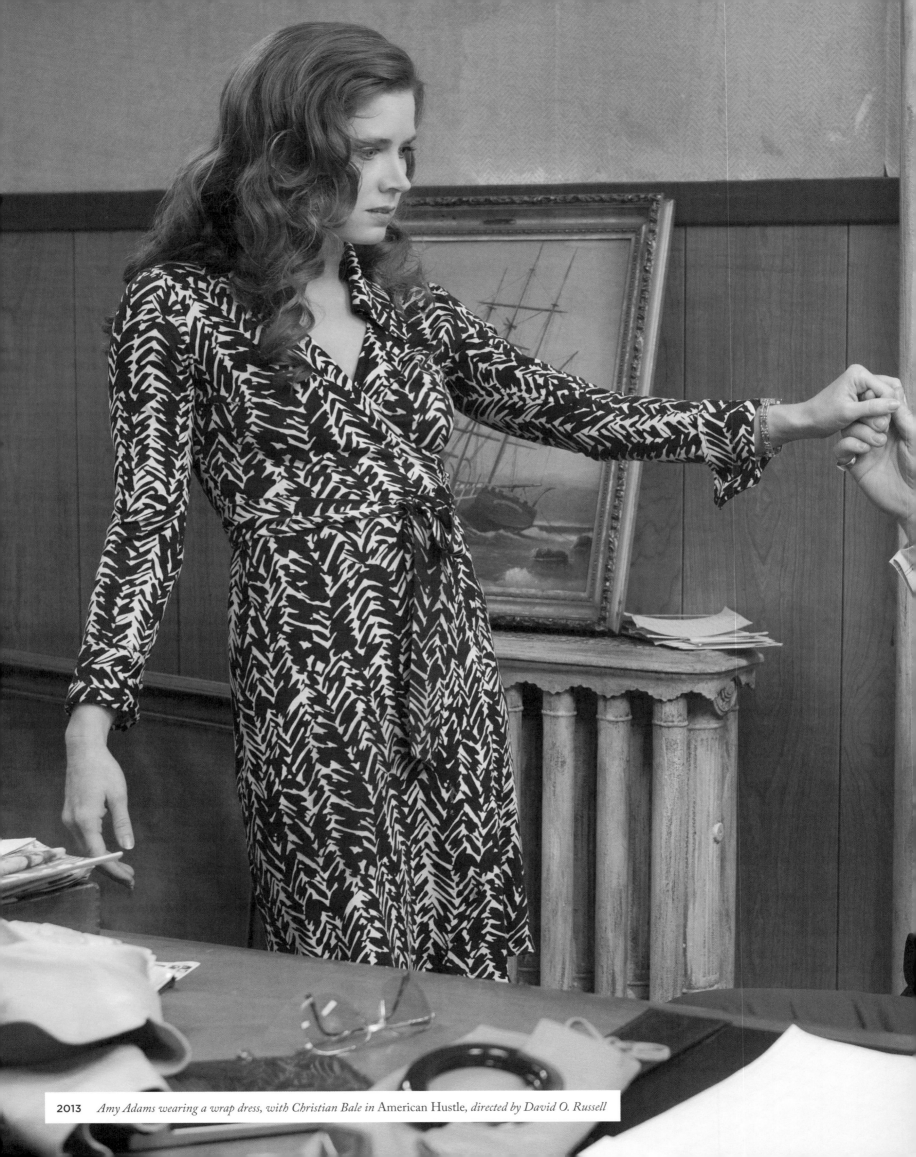

2013 *Amy Adams wearing a wrap dress, with Christian Bale in* American Hustle, *directed by David O. Russell*

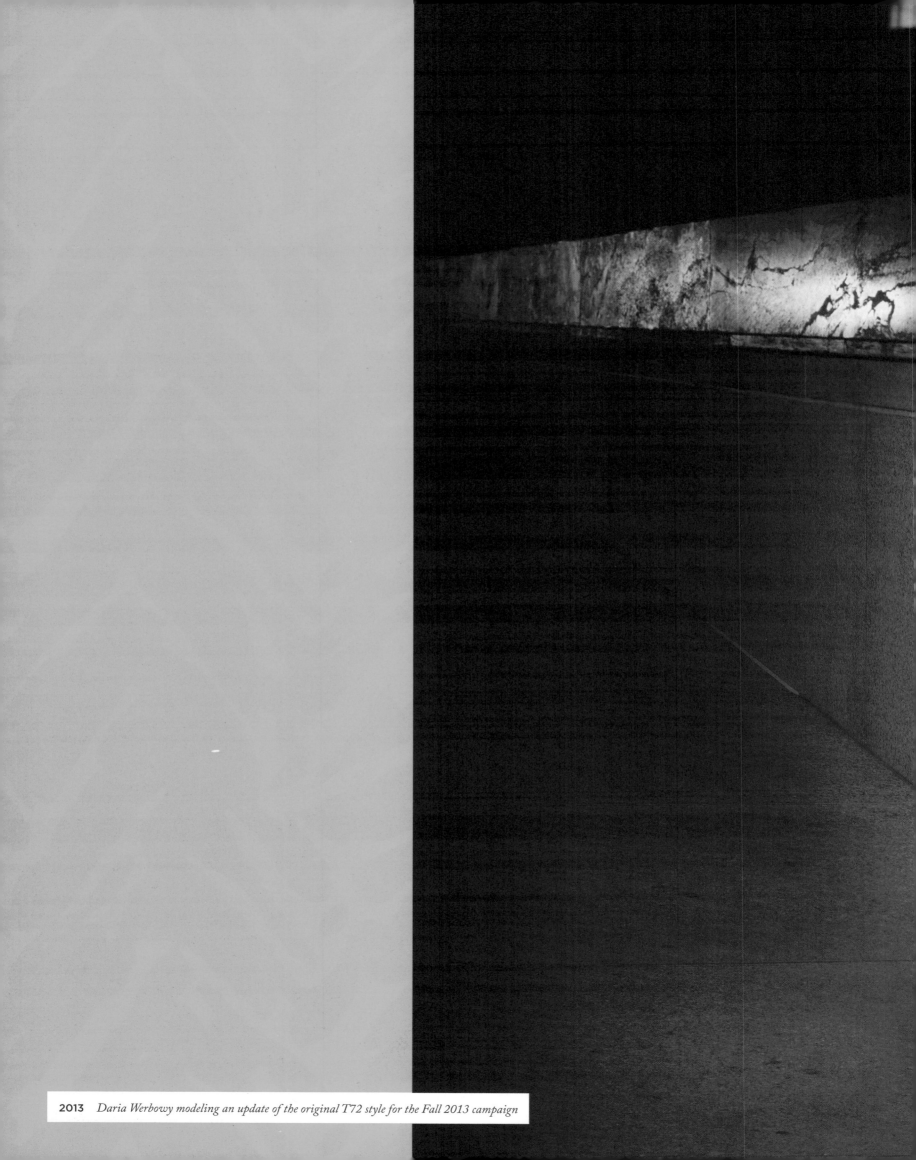

2013 *Daria Werbowy modeling an update of the original T72 style for the Fall 2013 campaign*

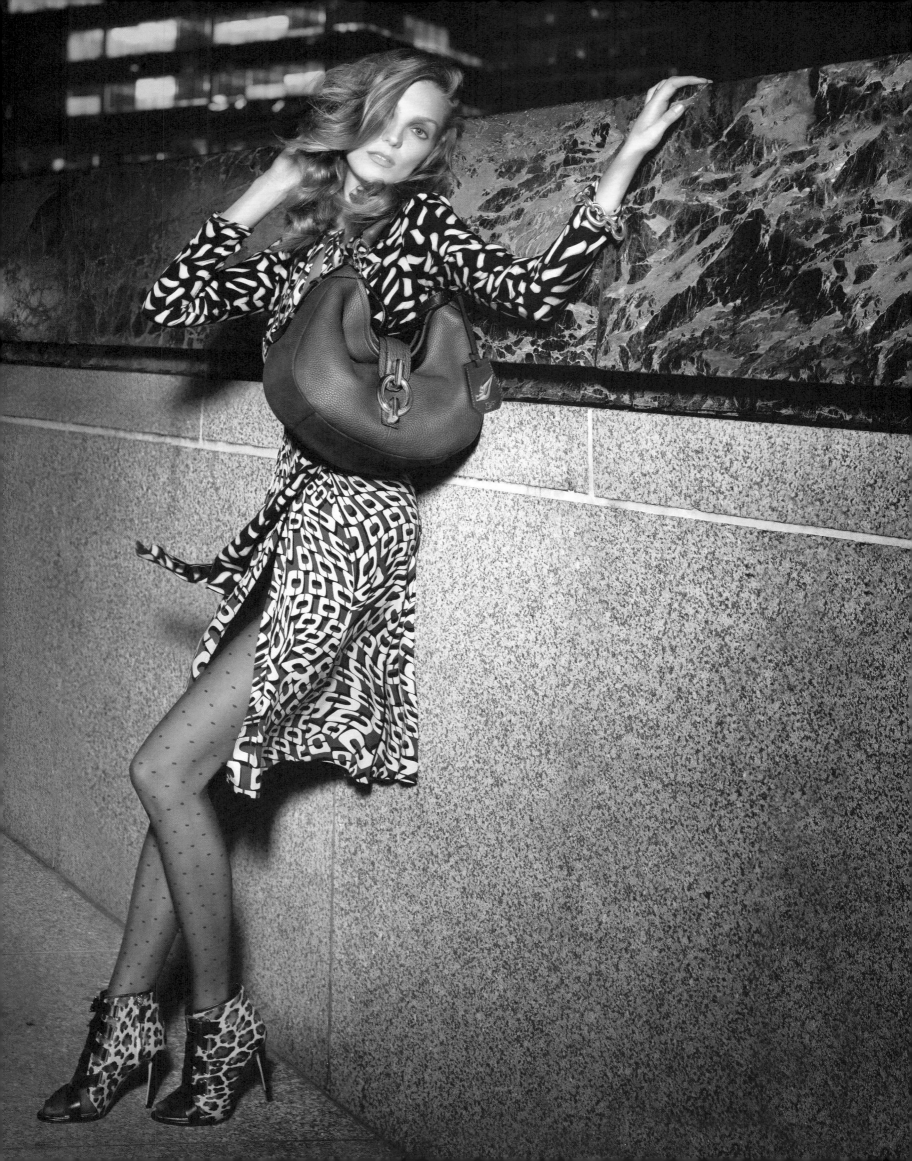

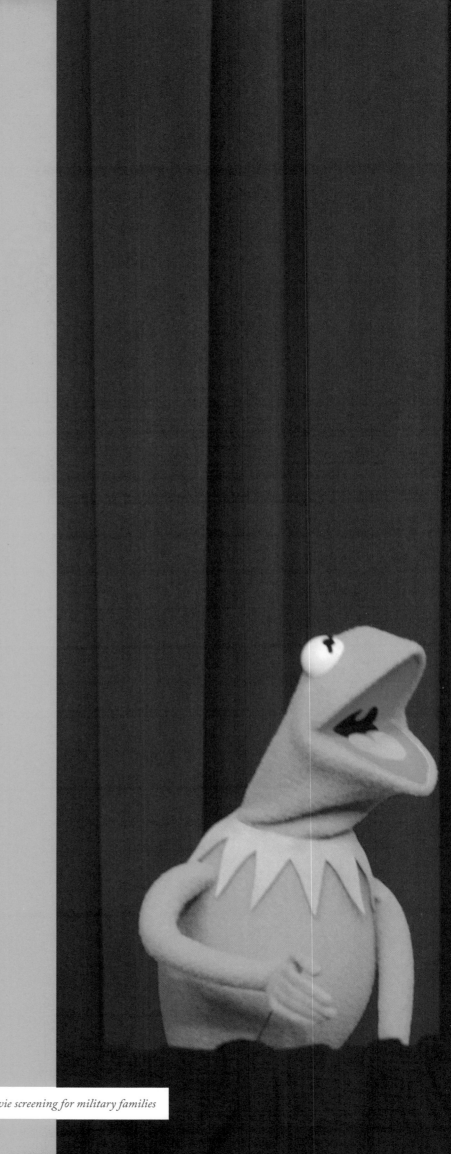

Michelle Obama wearing a classic chain link print wrap dress at a movie screening for military families

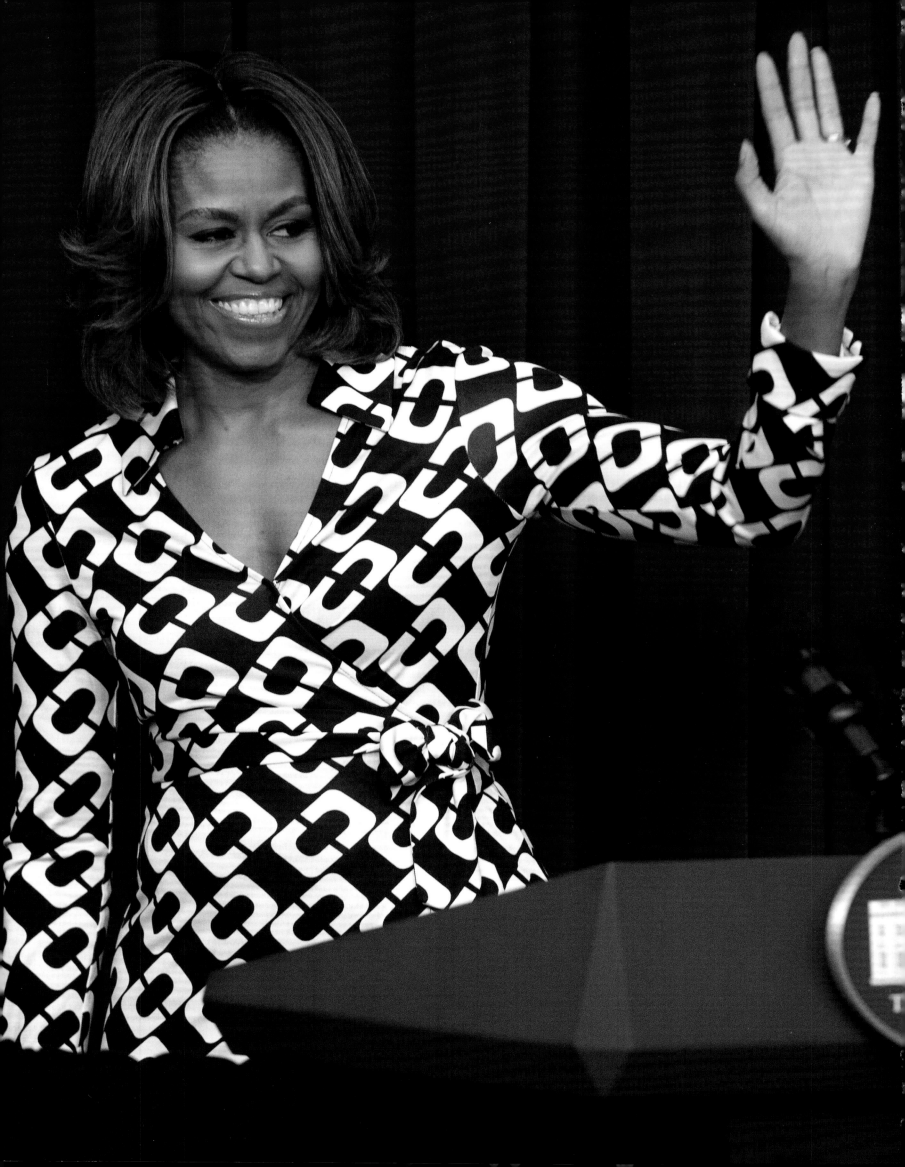

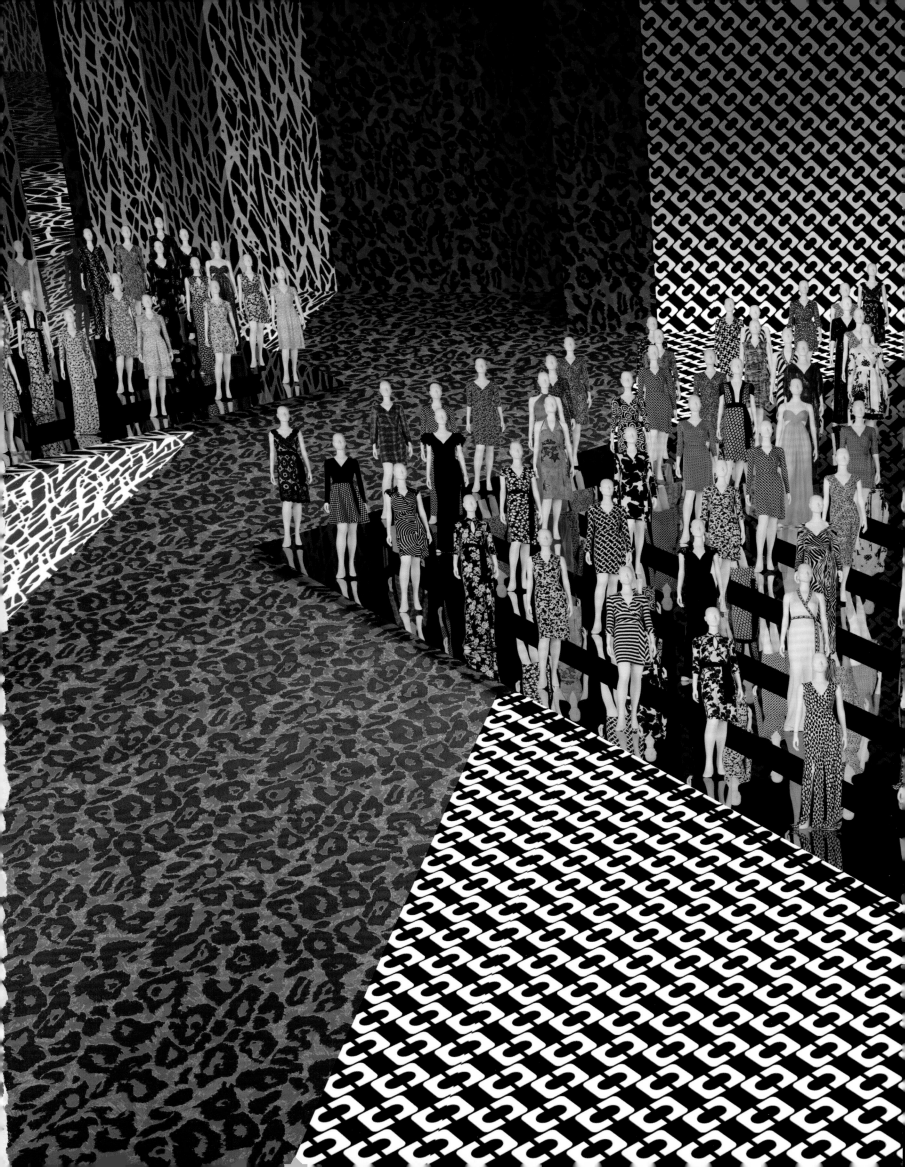

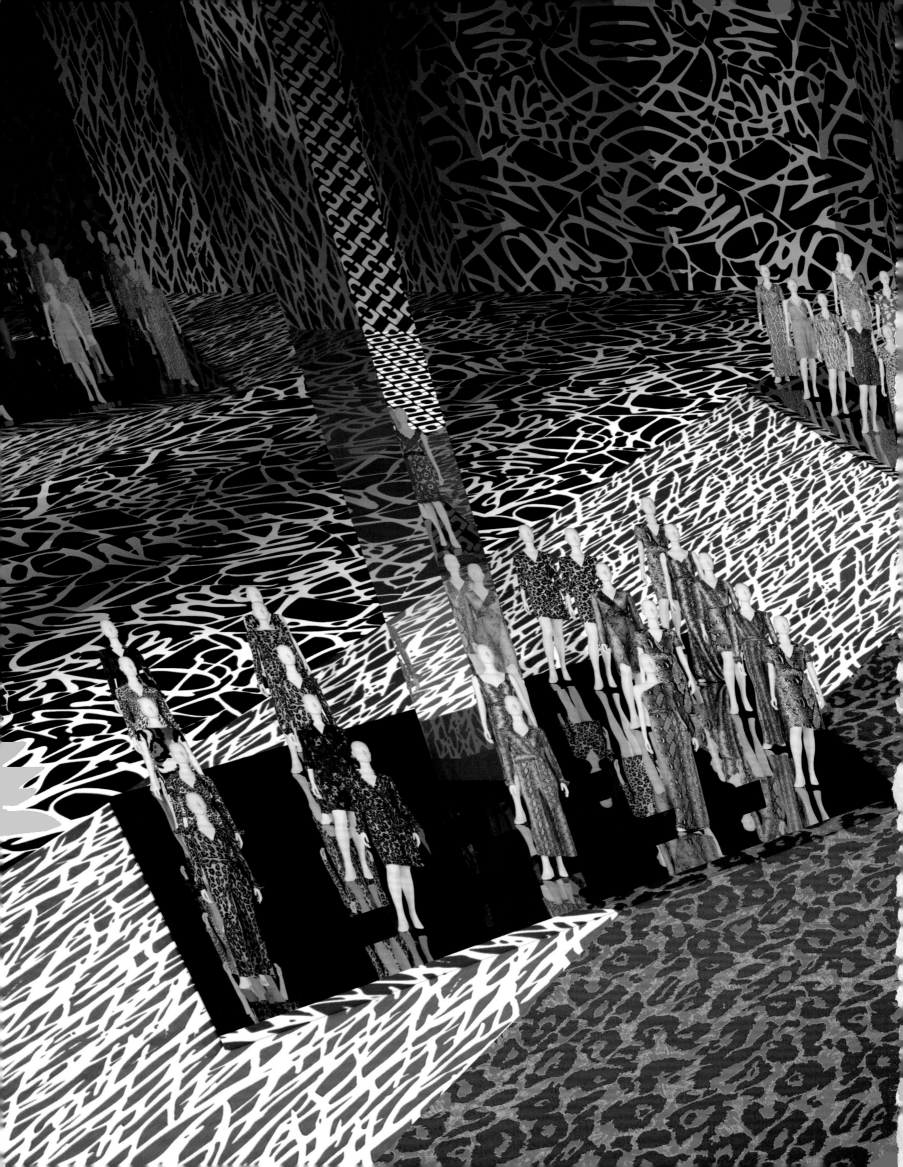

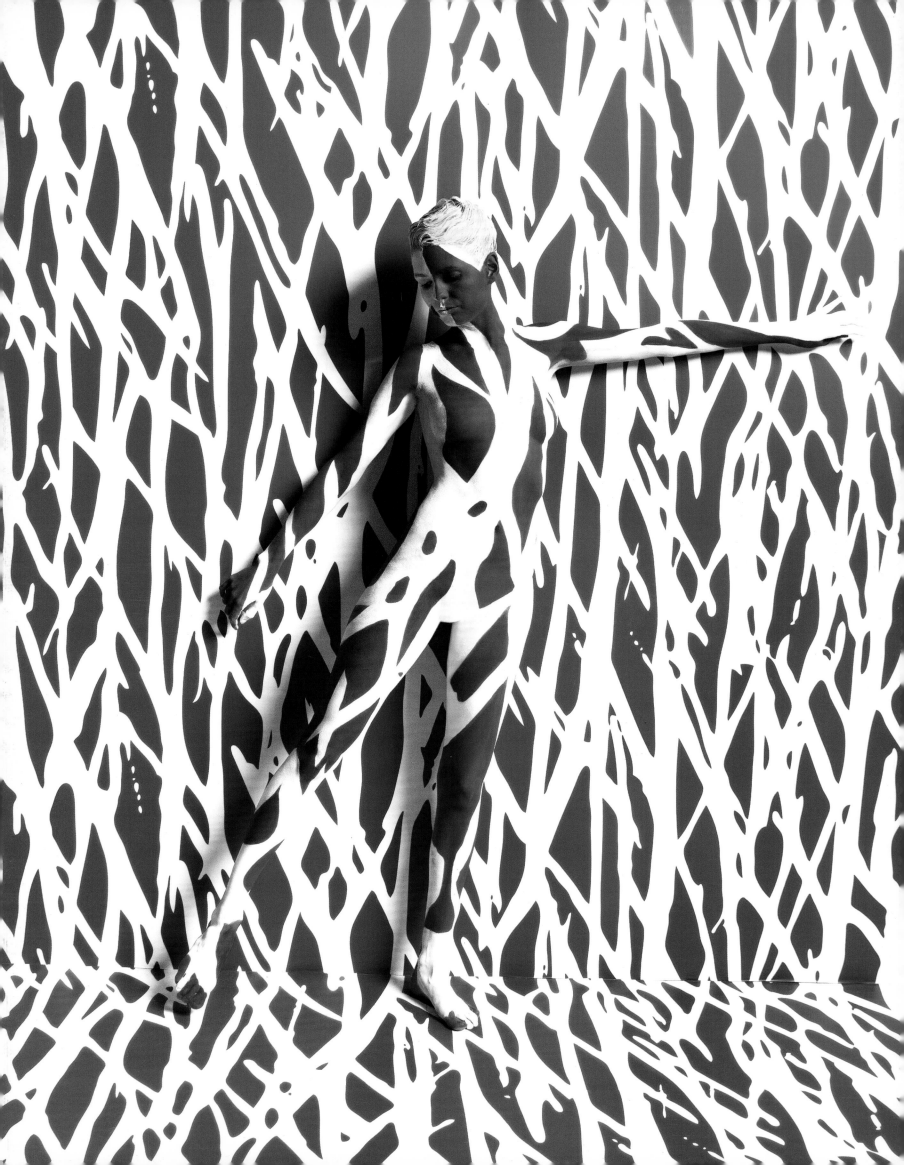

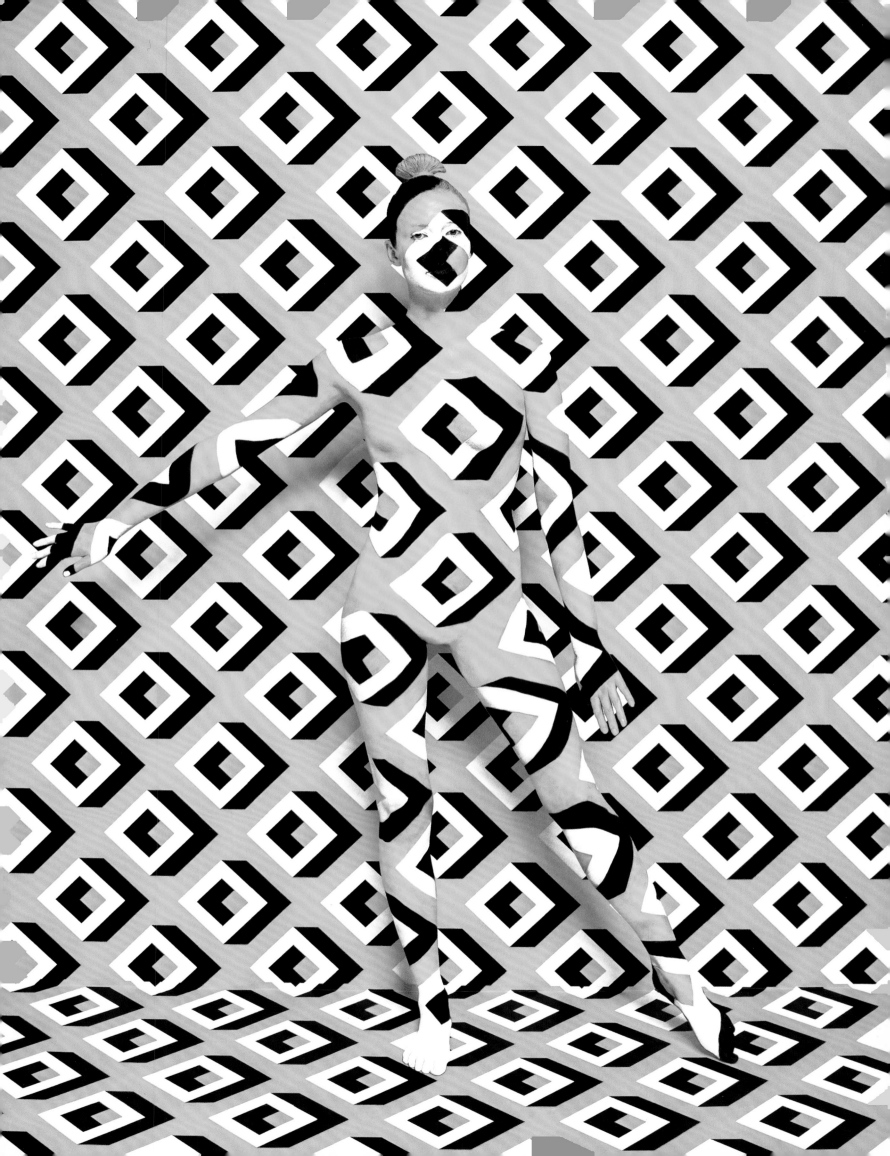

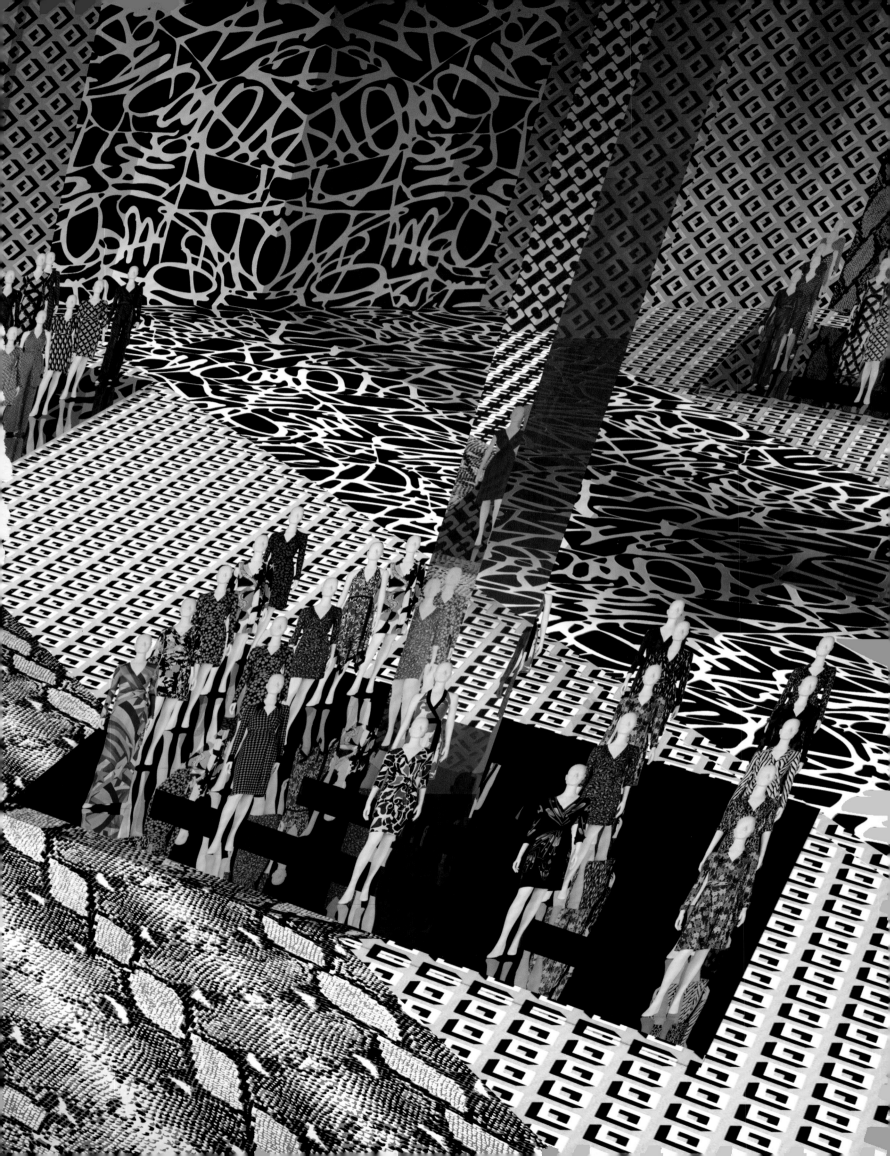

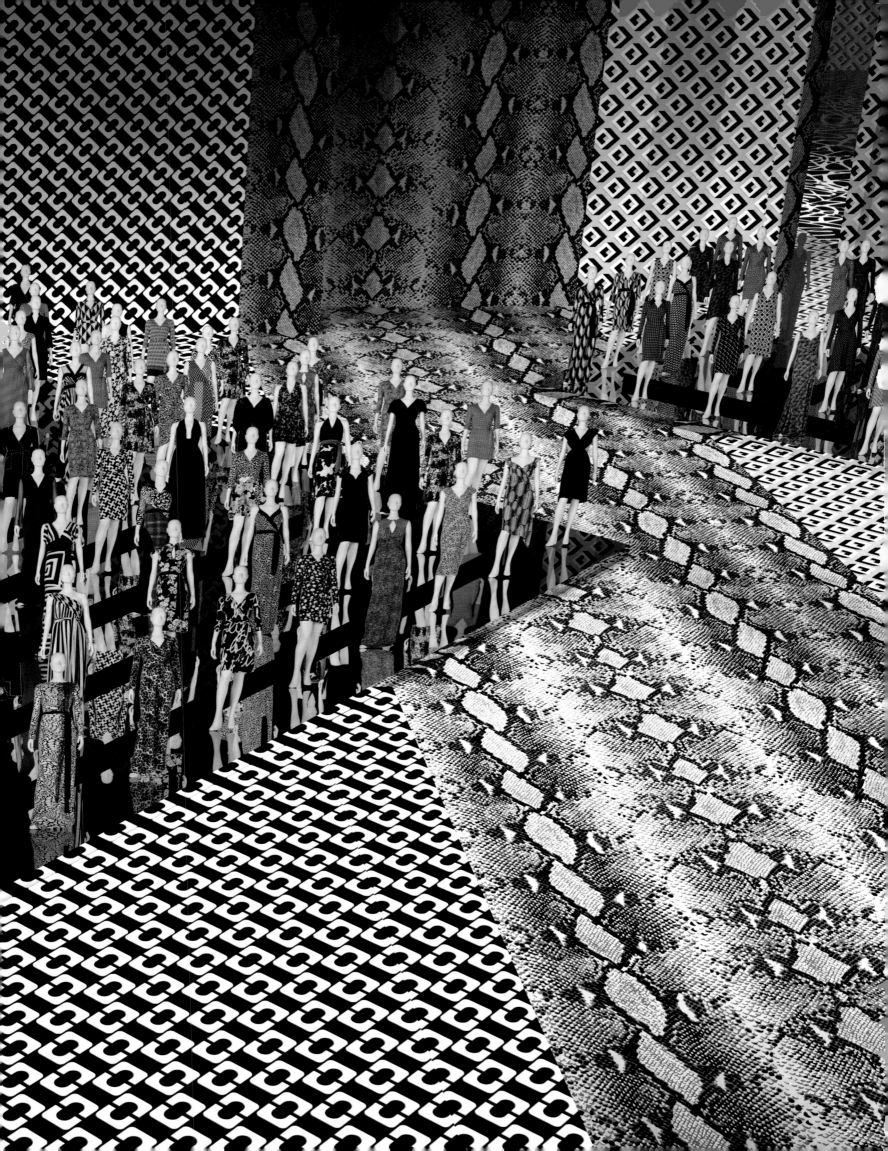

1974

The Dress That Started It All

A Warhol in the library—it was one of the first things I noticed upon entering Diane's apartment in Paris. The year was 2002 and I was about to interview the woman who played the leading role in *Diane: A Signature Life*, the book she had just published. "Come in and do sit down," Diane said, as I was searching for my first question—for although I had been a fashion journalist for almost fifteen years and at the time was teaching costume history at the fashion department of the Antwerp Academy, I hadn't ever heard about the wrap dress.

I didn't know it at the time, and even today, it seems silly to write this down, but that first encounter with Diane changed my life. I not only started going to New York Fashion Week after that interview, and thus broadened my very European view on the international fashion scene, but I also started dressing in a different way. DVF conquered my wardrobe, so to speak, one wrap dress after the other. I was never the journalist who would go crazy over the next "It" bag or designer, but it thrilled me to look in the mirror and just admit: "Yes, this is me. In yet another DVF look."

Every fashion week, I got my time slot: fifteen minutes in Diane's office. At first, I only asked questions related to her collection. Diane always answered with great quotes, all the while dressing her "lips" sofa with those eternal legs of hers. With each season, our conversations began to evolve as we talked about people and places, and about fashion in a much larger context. I introduced her to young Belgian designers or artists who caught my eye. I brought her books on fabrics that I thought would interest her. And whenever I published a book myself, I was sure to take one to her studio. In return, she opened doors for me to other important American fashion players, be it Marc Jacobs or the Mulleavy sisters of Rodarte—designers whose PR offices would never return the call when a journalist from a small country asked for an interview.

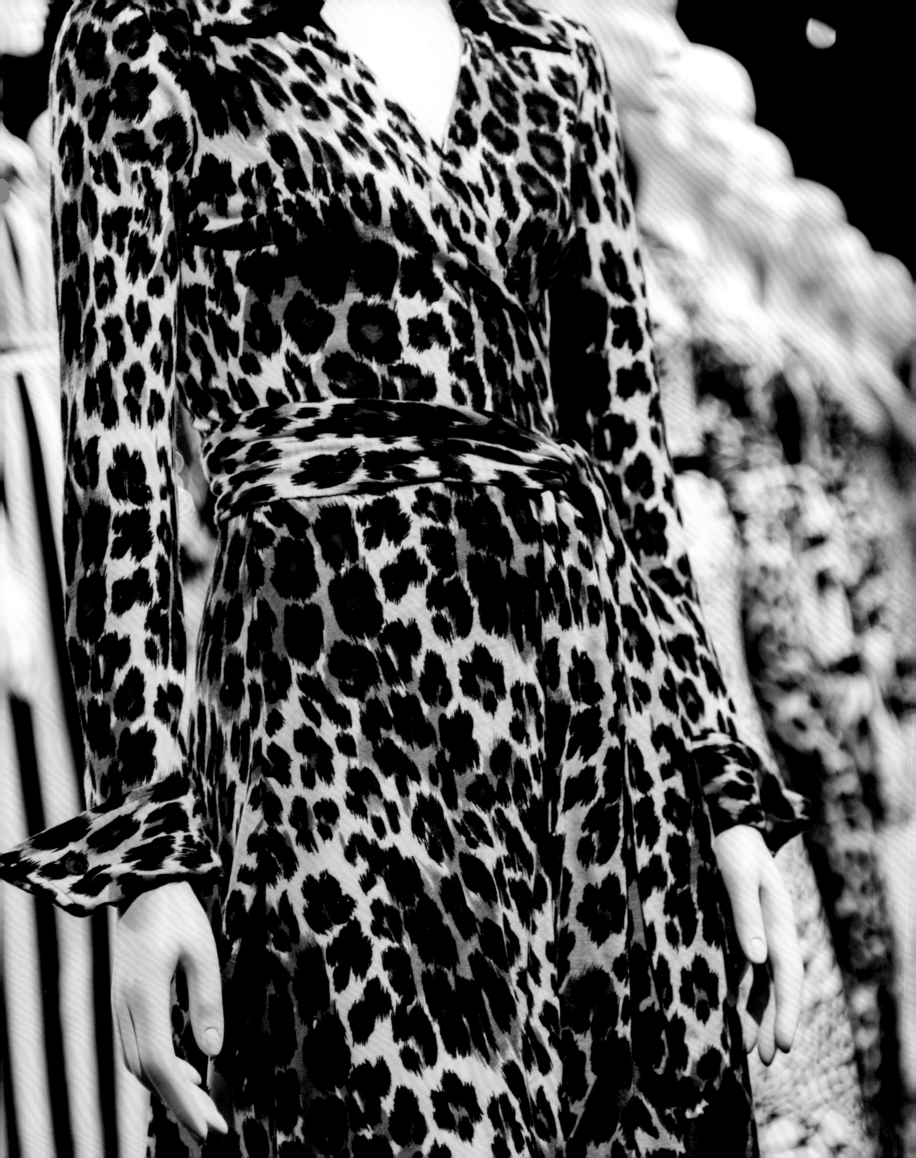

When Diane first showed her cruise collection in Florence in 2008 (an absolute first for DVF to show on European grounds), I was present. I wore one of her wrap dresses, in a burgundy-brown vintage print. I will never forget how one of my fellow journalists looked me in the eye as I strolled on the wonderful grounds of Giardino Torrigiani in Florence and said I looked stunning. I felt like a woman more than ever, and the short stroll from my hotel to the amazing show venue made me wonder what a walk on a red carpet would be like, in Cannes, Hollywood, or at the Met Ball. I felt the same thing thousands of other women must have felt before. Wearing the wrap, it's the woman who's glowing, not the dress.

I guess my story is not much different from the ones so many other women have told. We all love clothes that make us feel good. We don't want to feel too dressed up, at least I don't. And we want to shine. What is so special about this dress is that it captured the hearts of so many different women, all around the globe. When Ingrid Betancourt was freed after six years of captivity, the wrap was the first dress she bought. Madonna wore one to the launch of one of her children's books in Tel Aviv. On her first Christmas card as First Lady, Michelle Obama was wearing one, too. And so did hundreds of thousands of other women when they got to work, went to a party, or first embraced their future lovers. The strange thing is, the wrap dress has nothing in common with high-end couture gowns that involve intricate patterns, five days of embroidery, and loads of tulle. The design is as simple as can be. It's lightweight, easy to put on, and a marvel to pack.

Was DVF's wrap dress an original? Not completely. Diane's design looks like a variation of Claire McCardell's shirtwaist dress but features a much leaner silhouette and a far more dramatic outcome: a focus on a woman's hips and cleavage. At the time it was the Wonderbra *avant la lettre*, but without the constraints of pushing and pulling, and without its slogan, "Hello boys." Diane may have called it "the little bourgeois dress" in that famous *Newsweek* cover story of 1976, but it is so much more. The dress is chic, practical, and seductive, and the answer to what women wanted, both then and now. "If traveling has taught me anything, it's that women are so alike wherever they live," Diane once told me. It's true. Women share the same questions about life and happiness, doubts, and insecurity, whether they live in a huge apartment on the Upper East Side of New York or in a small village in Belgium.

Of course, the dress comes with a great story. In the 1970s, it lived a bohemian, anti-elitist way of life in the love and peace era, with sexual liberation included. A cultural phenomenon overnight, it was always around, whether you stepped off the Métro or went dancing at Studio 54. The story still surrounds any wrap dress anywhere in the world. But women feel they can add their own stories to it. Whether their's are tales of love or power, of sensuality or just great vibes, women have the impression the dress was there at important moments in their lives and has become part of who they are. That aspect should never be forgotten as it's the essence of all great successes.

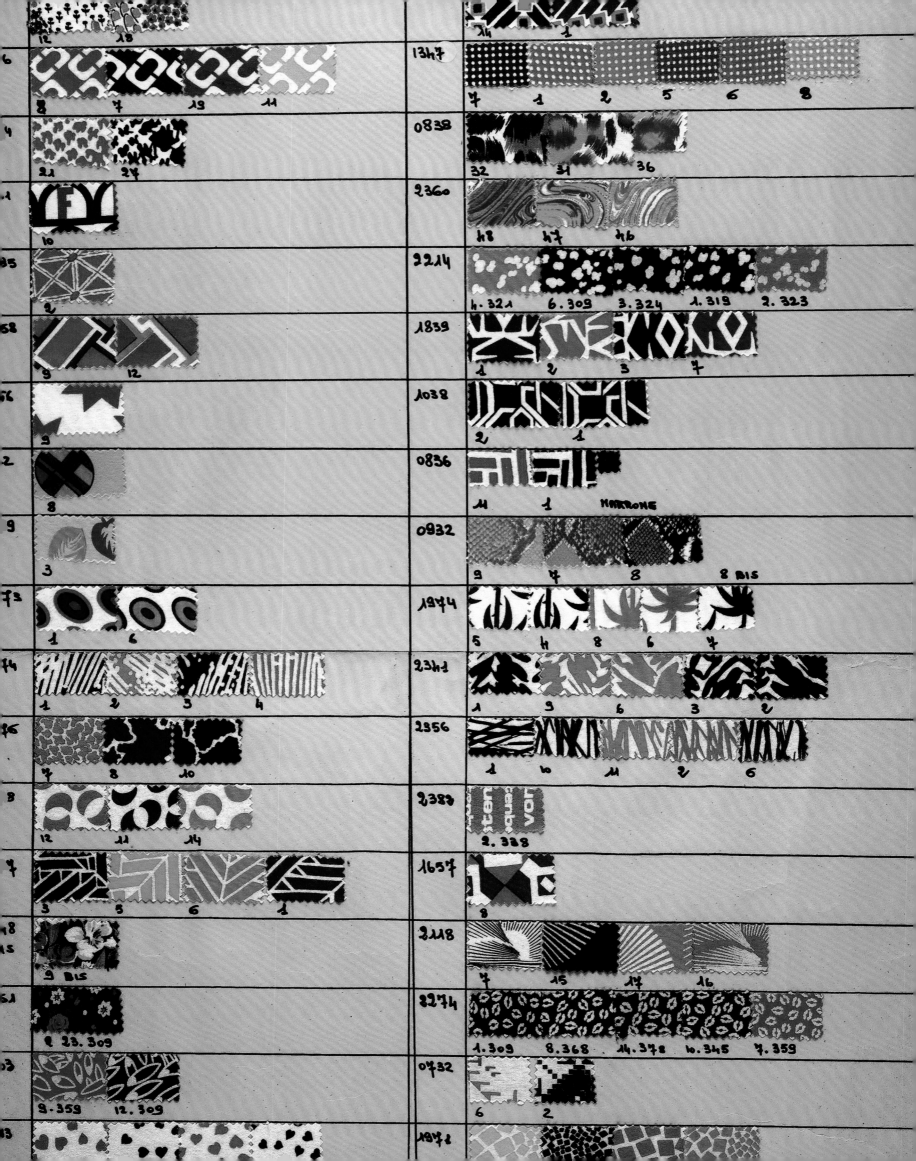

And the wrap dress is much more than meets the eye: it stands for affordable luxury, carrying a democratic price tag that allows women, regardless of the size of their bank account, to join in. That accessibility may be the basis for the reason why more than three generations have embraced the wrap. For some it is another great vintage find, for others it is the true classic they could and would never give up. Compared to the first wrap dresses from the early 1970s, the dress hasn't even changed that much over the years. New prints were introduced, of course, and the lapel, the arm length, or the length of the dress itself has varied. But the concept of wrapping is here to stay.

Timeless, the wrap is a kind of *passe-partout* that always lives up to the moment, thus reminding me of Coco Chanel's little "Ford" dress, which conquered the world as the little black dress (LBD). Mademoiselle Chanel launched it in 1926 and it would become the symbol of 1920s style and women's liberation. Chanel designed it for women, like her, who enjoyed short, clipped hair and a gorgeous tan (in an age when sunshine was to be avoided at all times). It seems that Diane had that same yearning for ease and comfort—and sexiness. She knew what the dress did for her personally and convinced thousands of other women all over the United States to try it out for themselves. And just as Coco did, Diane wore her own dresses, which was one of the smartest things she could do. The dress even played a crucial role in her own quest for freedom. Feeling oppressed in Europe, at the end of the 1960s, she welcomed New York with open arms—and the wrap dress quickly helped her in establishing her newly found freedom.

"The dress paid all my bills," Diane said during the press conference of Journey of a Dress, the exhibition in Los Angeles that celebrated the fortieth anniversary of the wrap dress. It certainly did in the beginning, when Diane did everything including designing the prints, showing her clothes to buyers, taking orders, checking payments, and even sorting out the shipments in a dreary warehouse at JFK airport. I will keep all this in mind the next time I have to mount the more than thirty steps to her studio in New York. Undoubtedly, I will be wearing yet another DVF dress because, honestly, the dress just makes me walk differently. It has me—and thousands of other women—thinking about our own femininity, our own lives, and the way we want to live them.

Veerle Windels

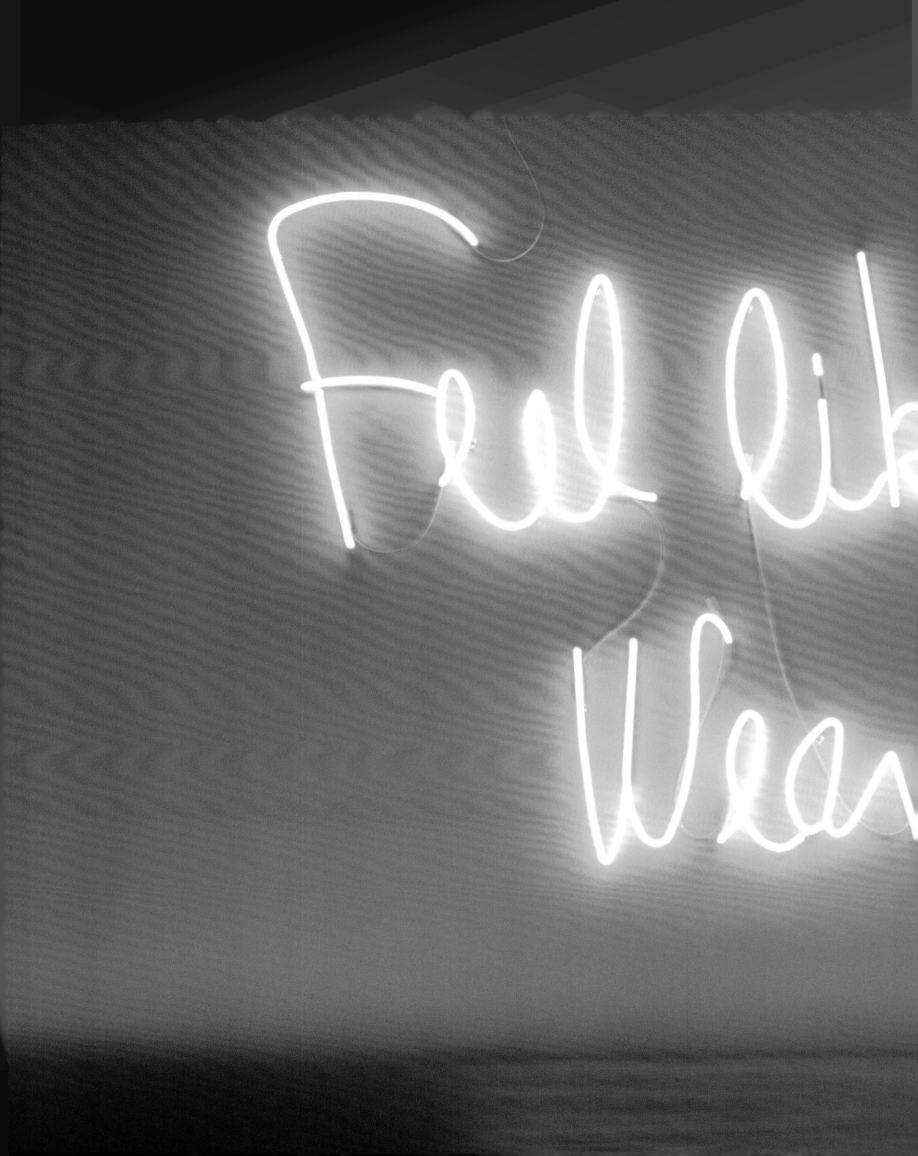

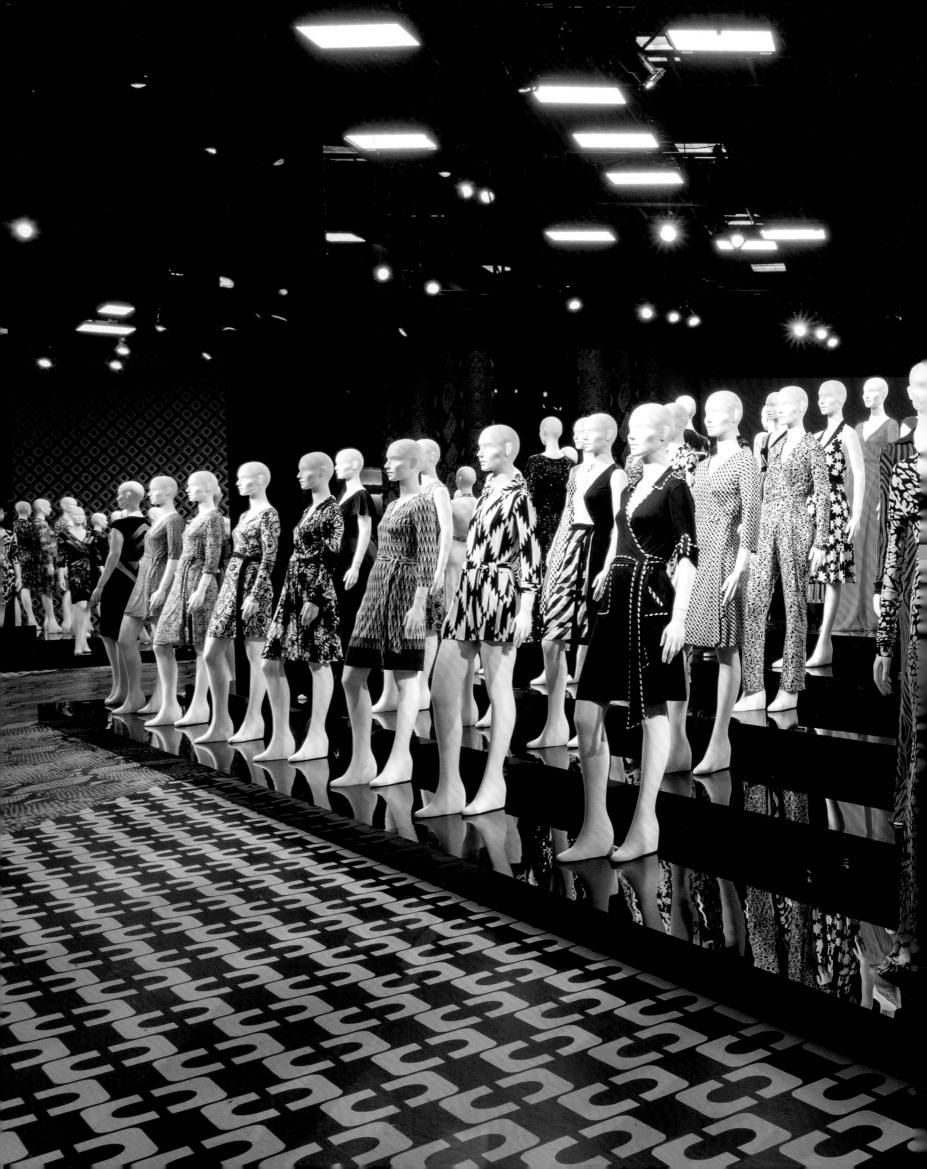

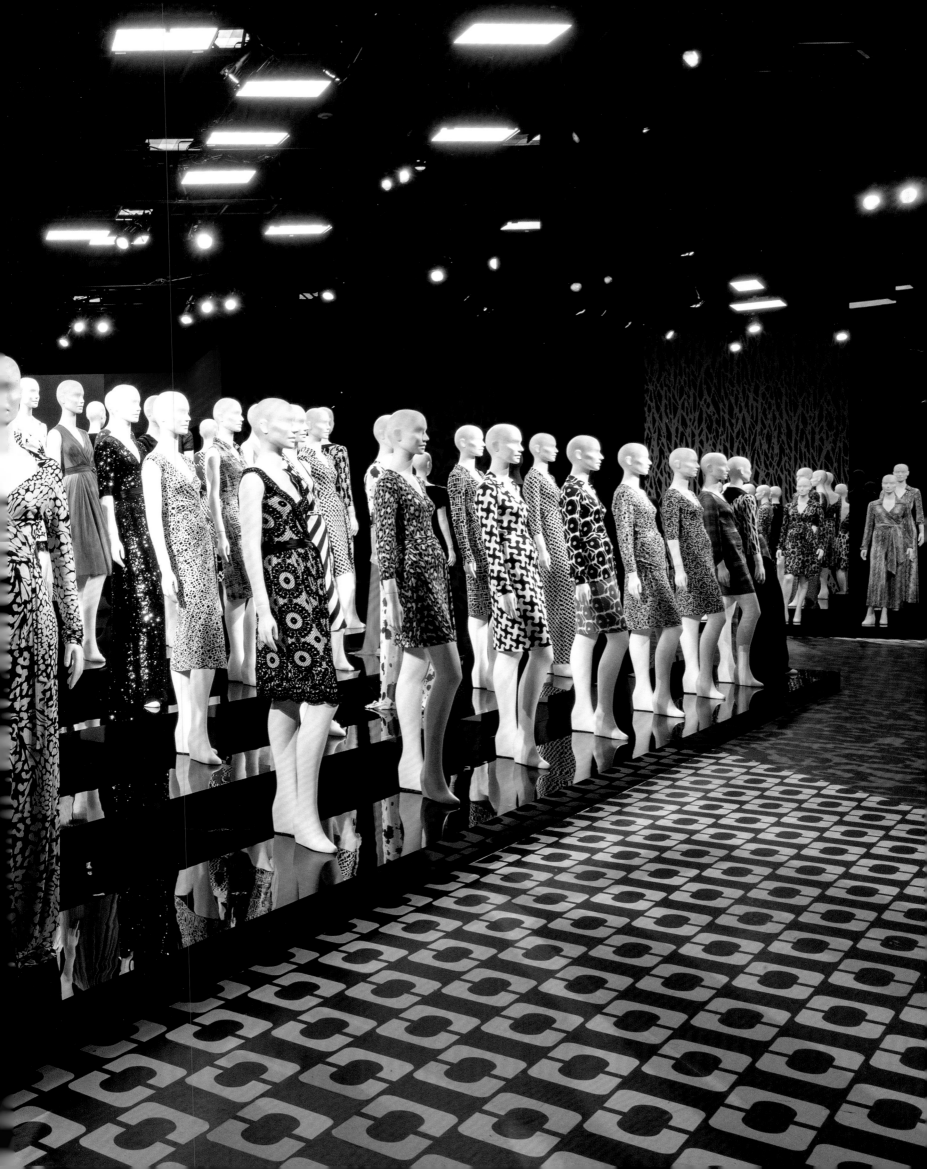

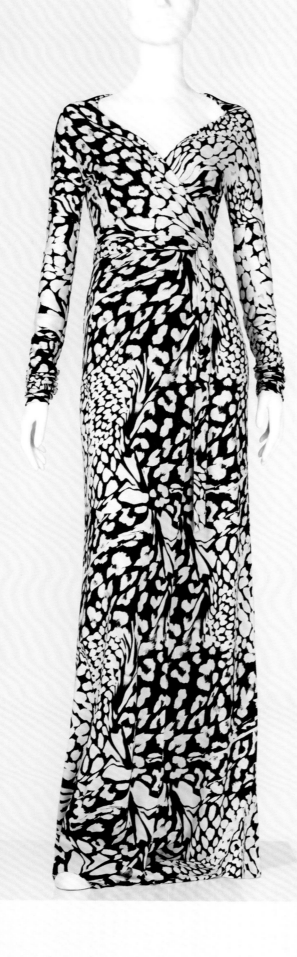

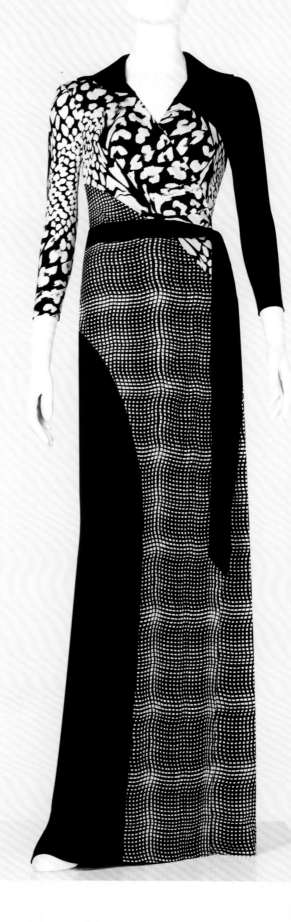

2014

2014

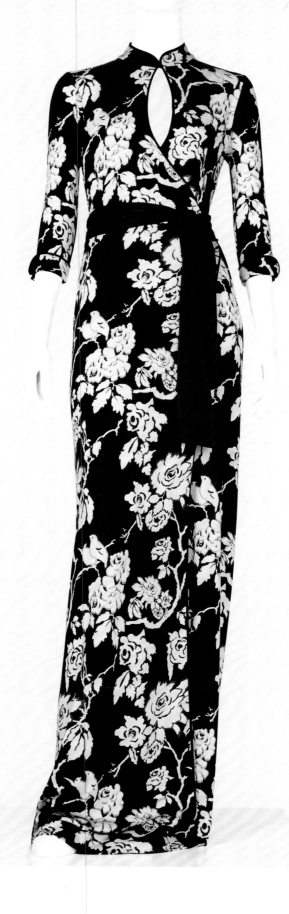

2014

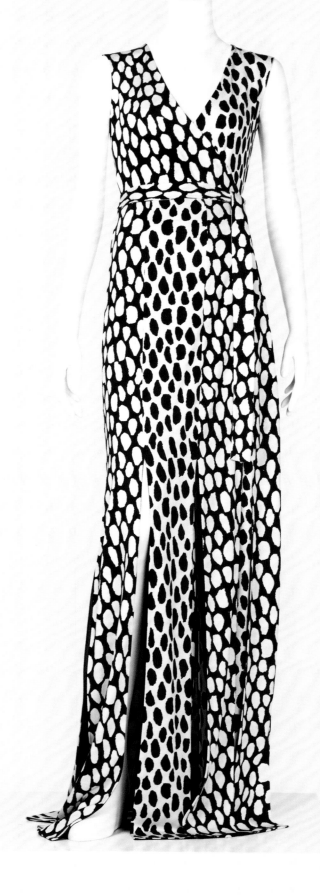

2014

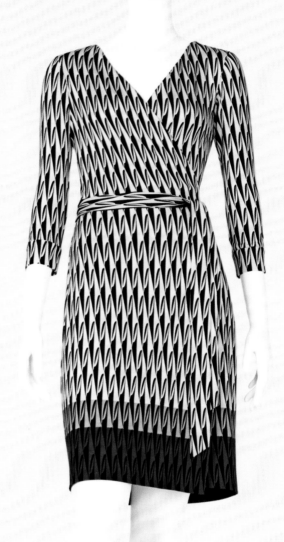

2013

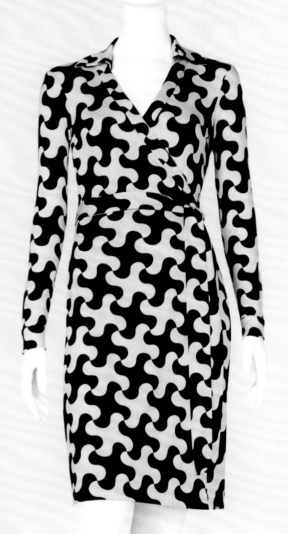

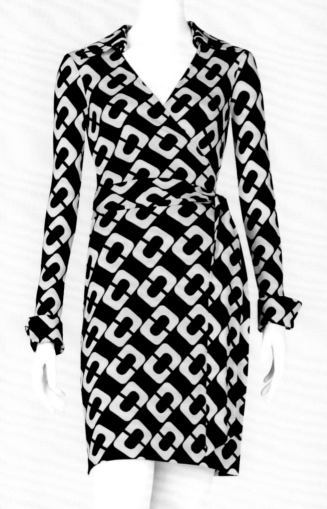

2011

2004

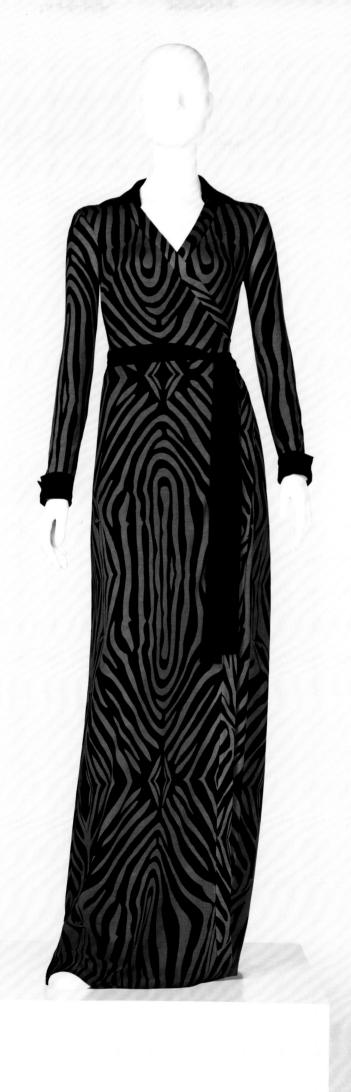

2013

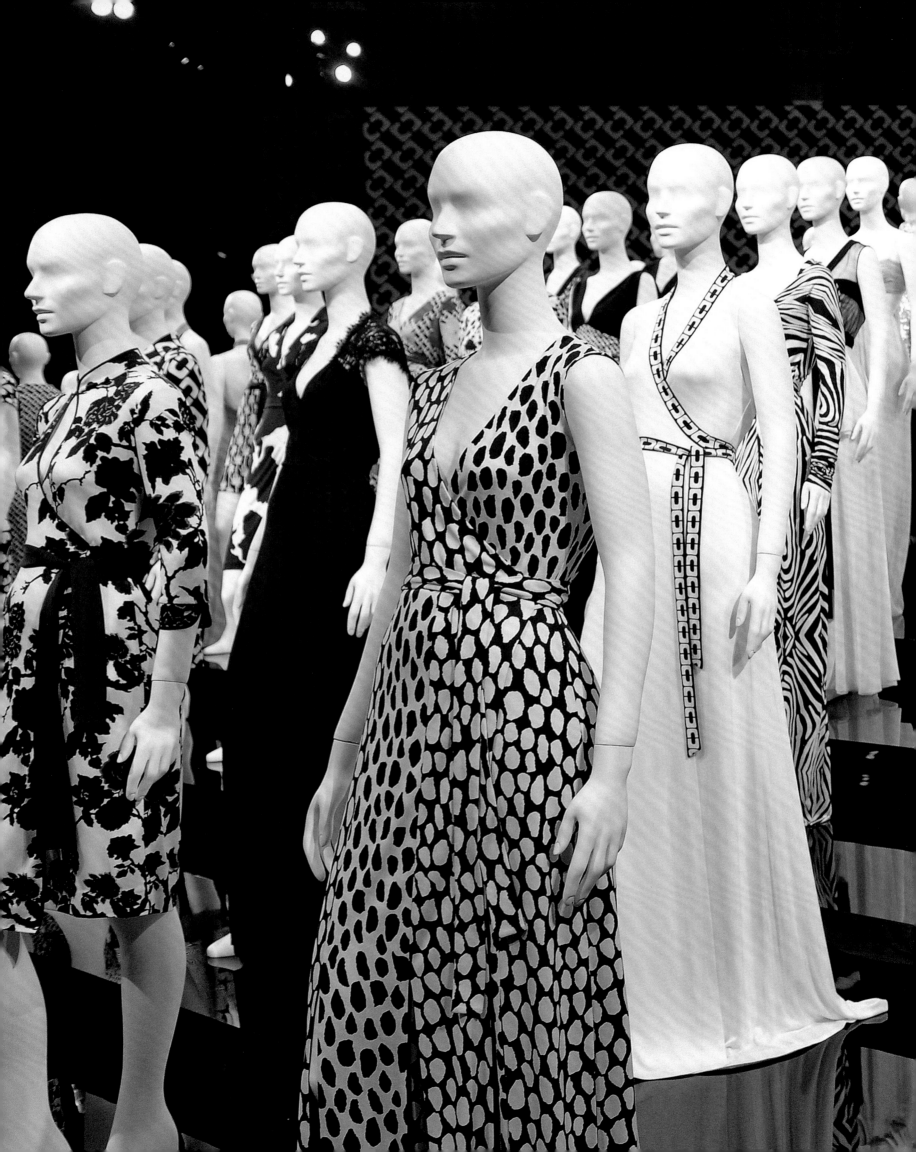

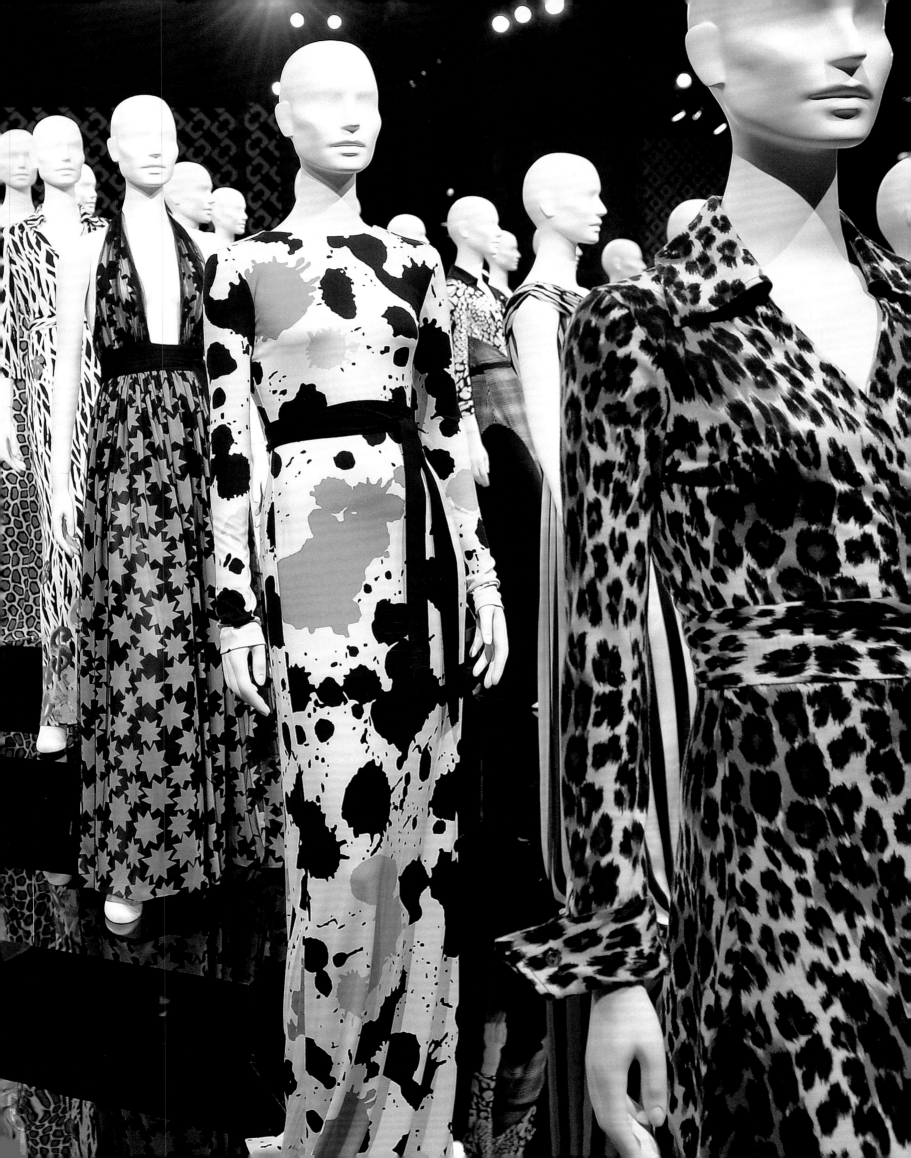

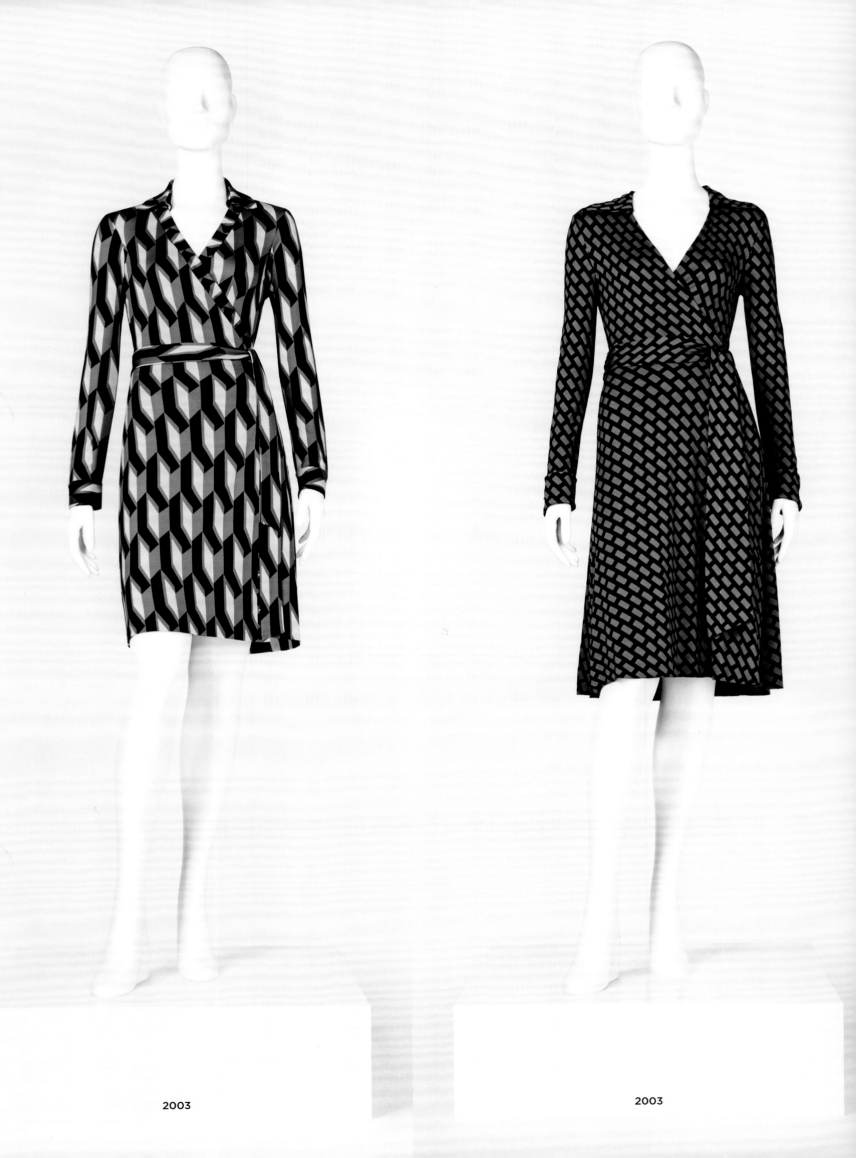

2003

2003

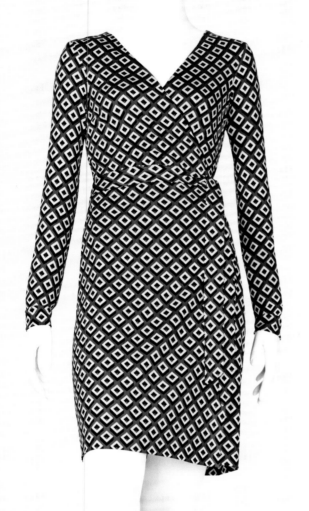

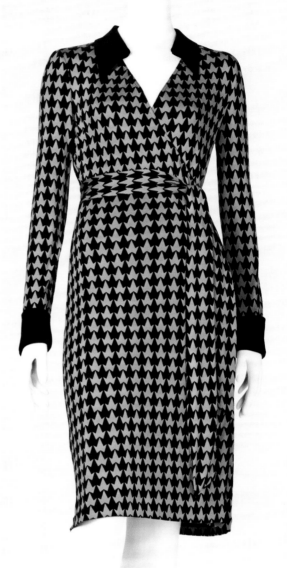

2011

2005

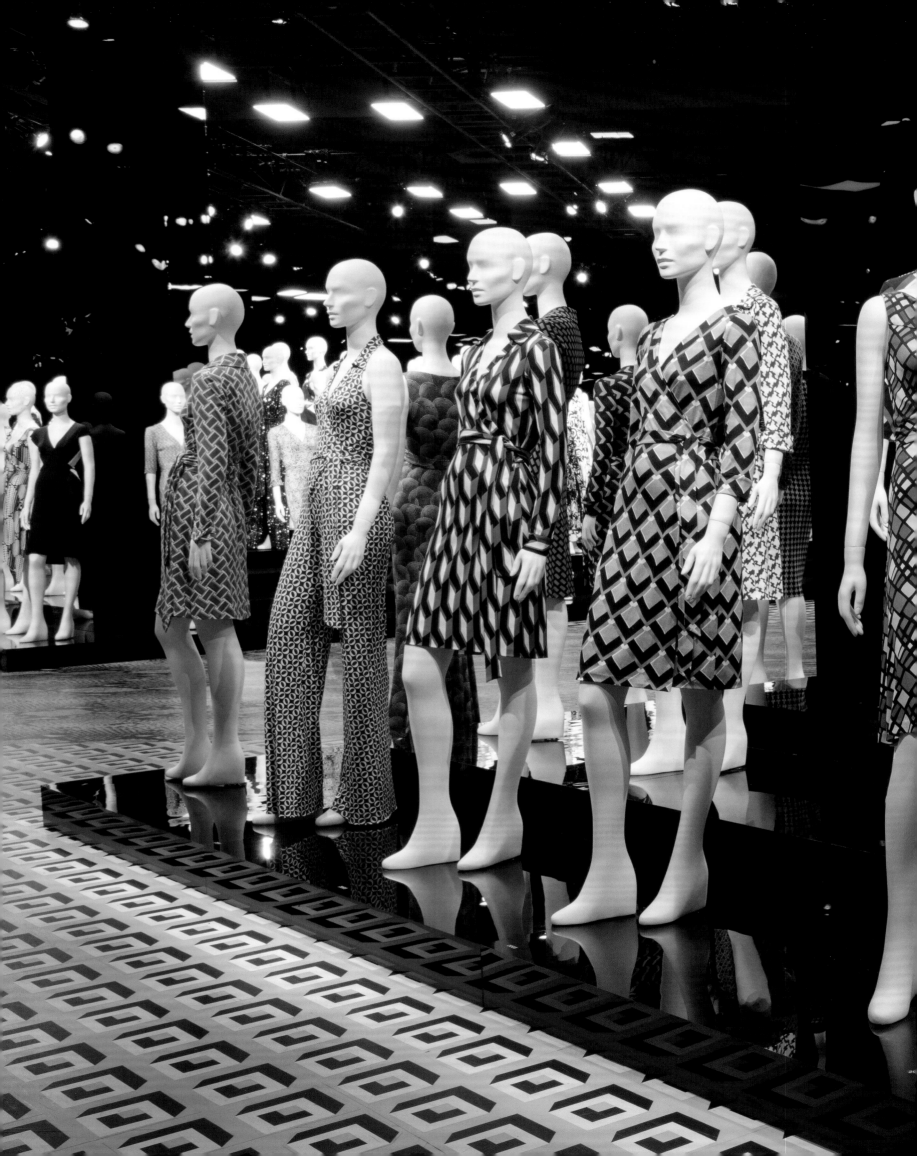

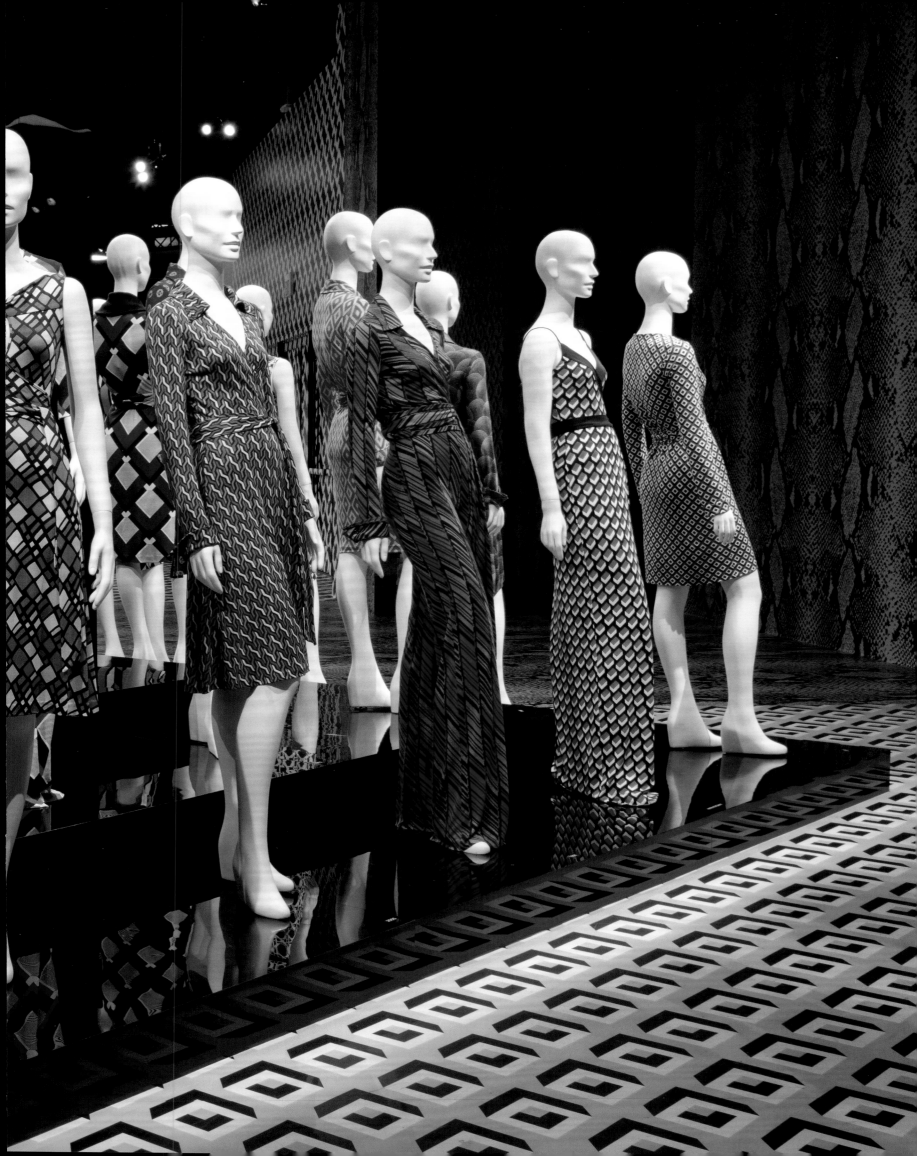

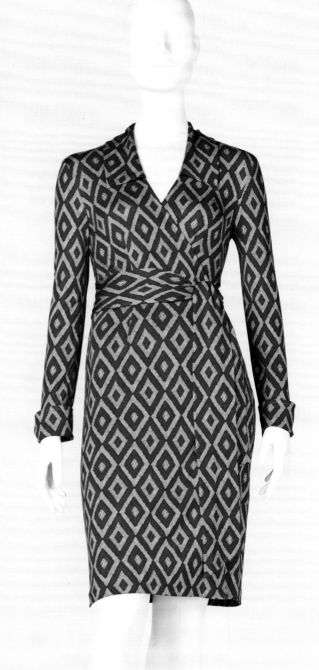

1999

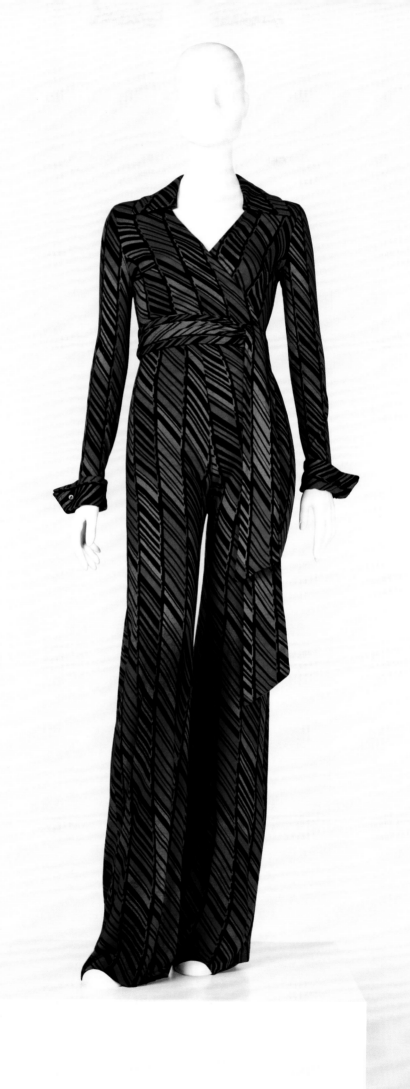

1974

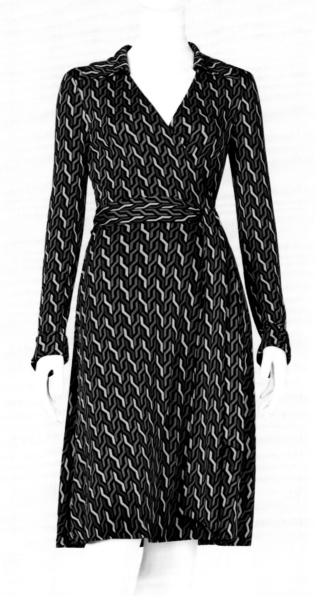

2005

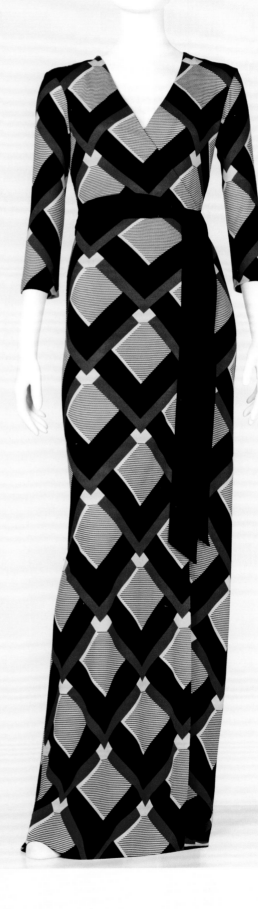

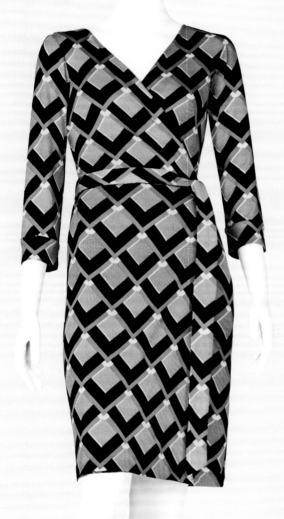

2014

2003

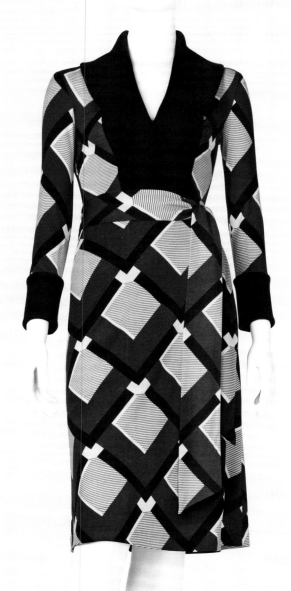

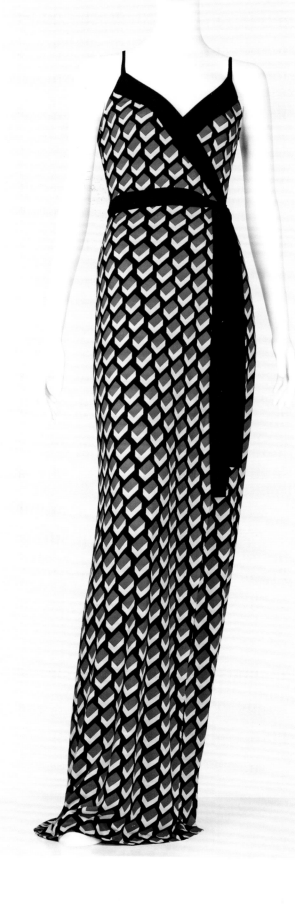

2014

2014

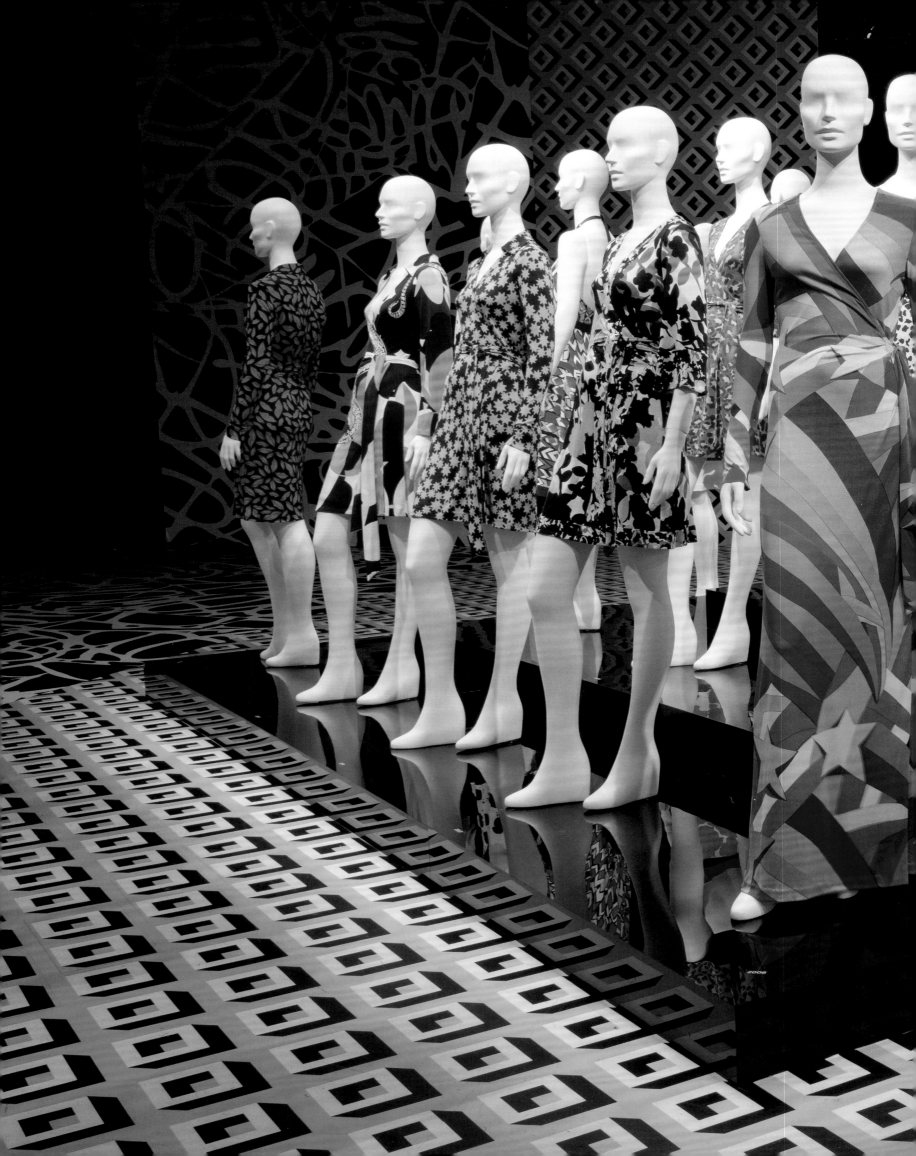

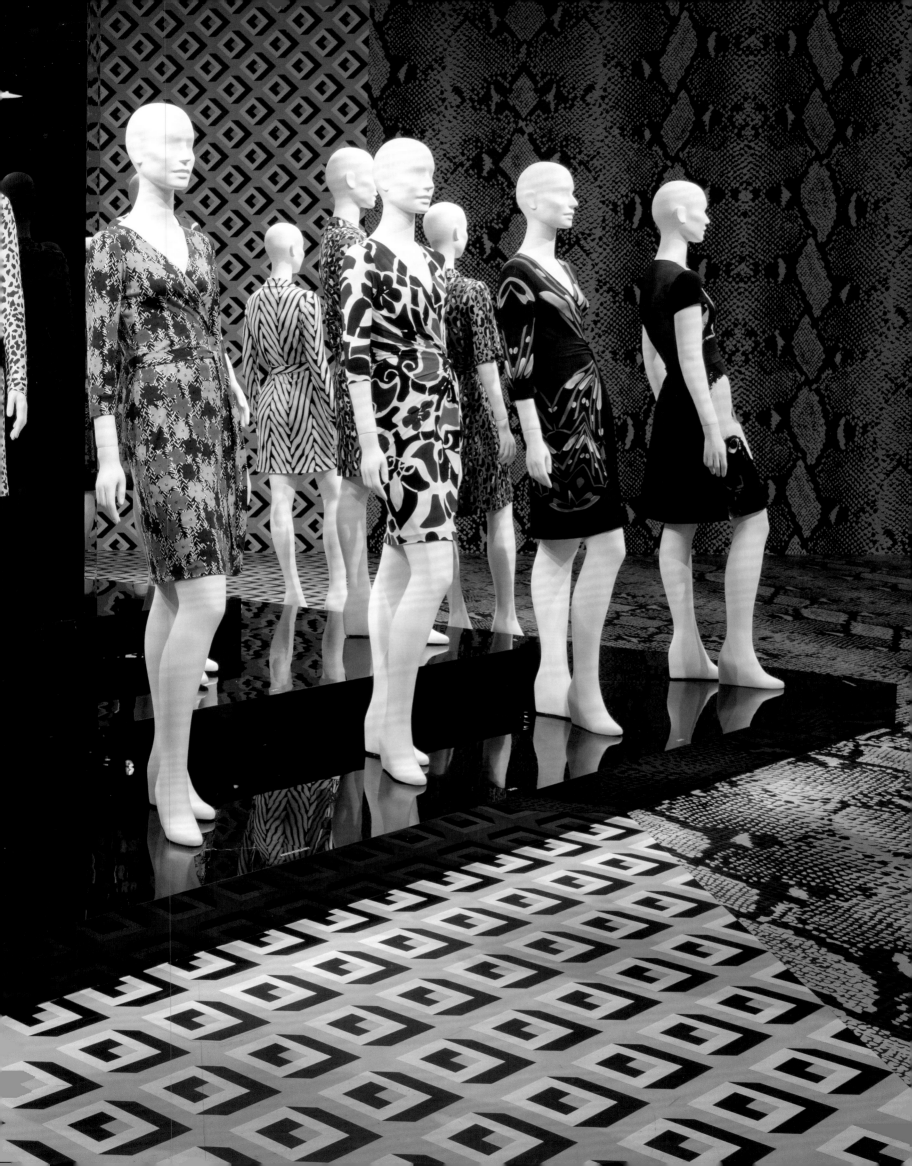

2011

2014

2014

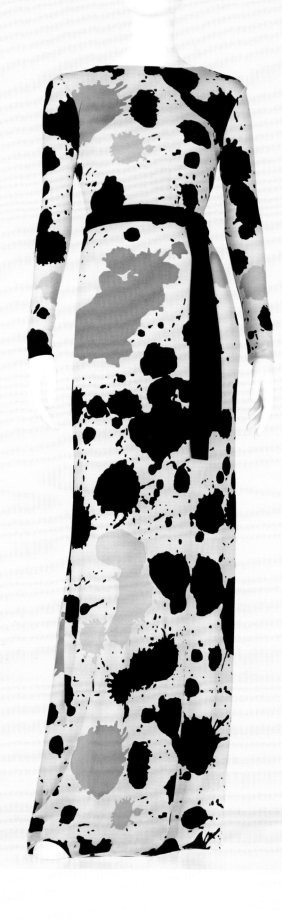

2014

2009

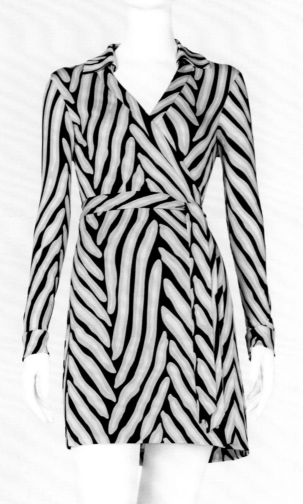

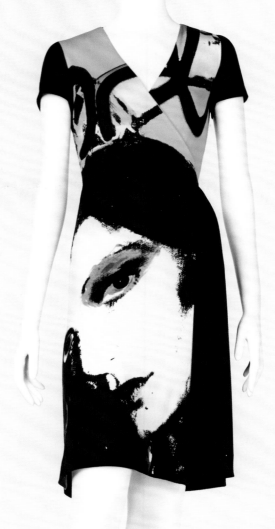

2013

2014

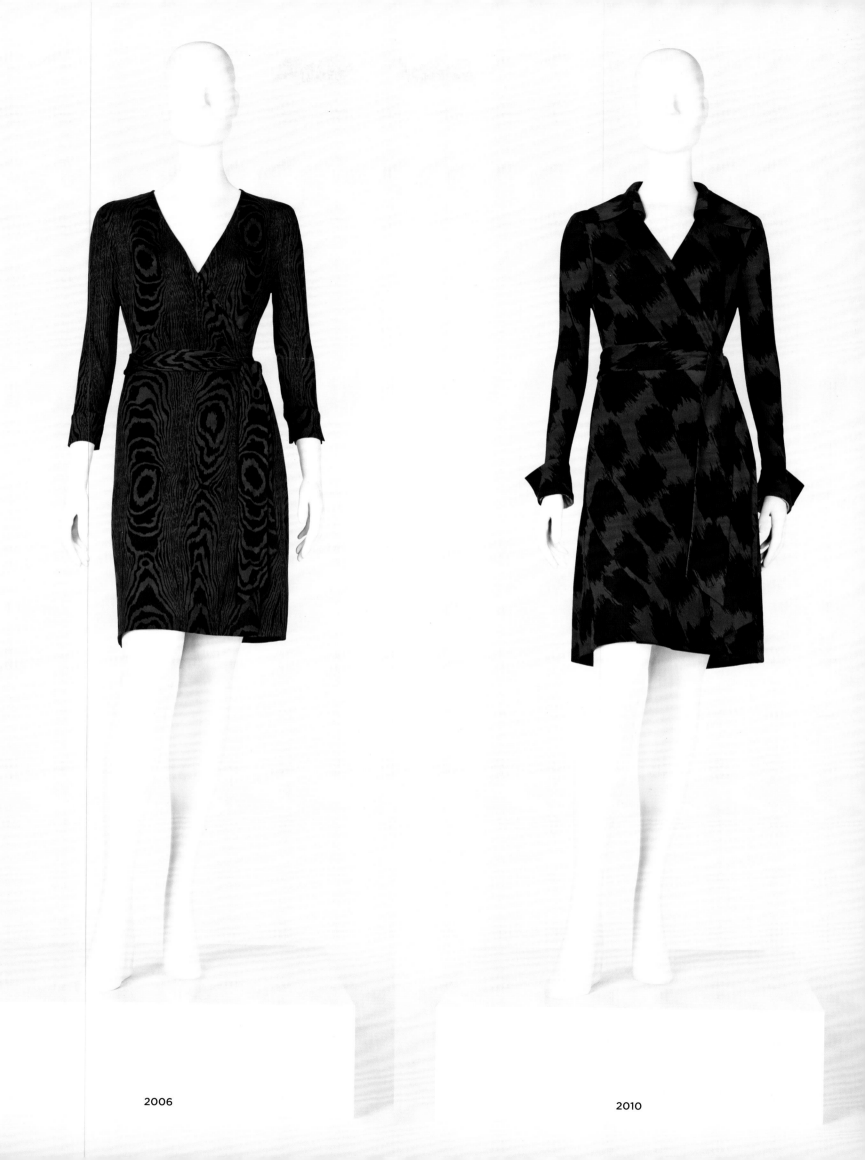

2006

2010

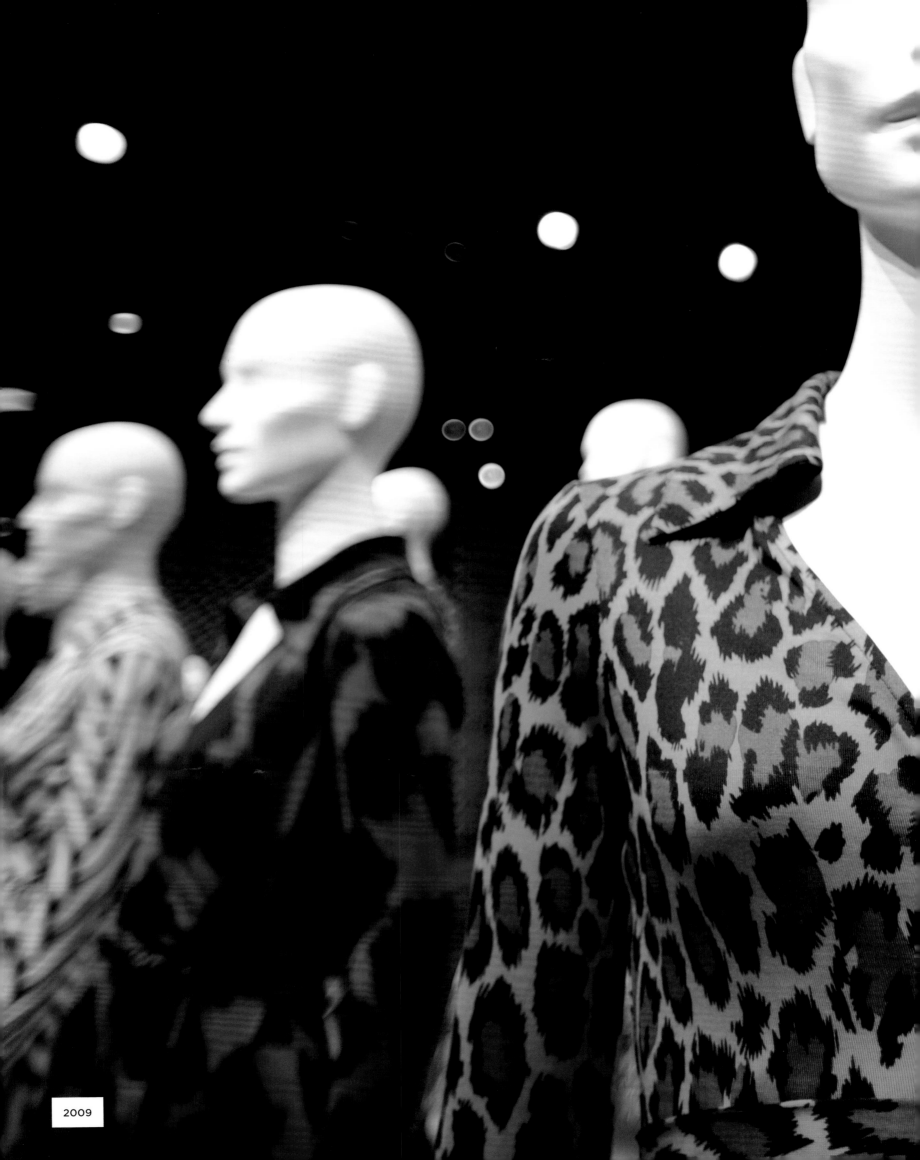

2009

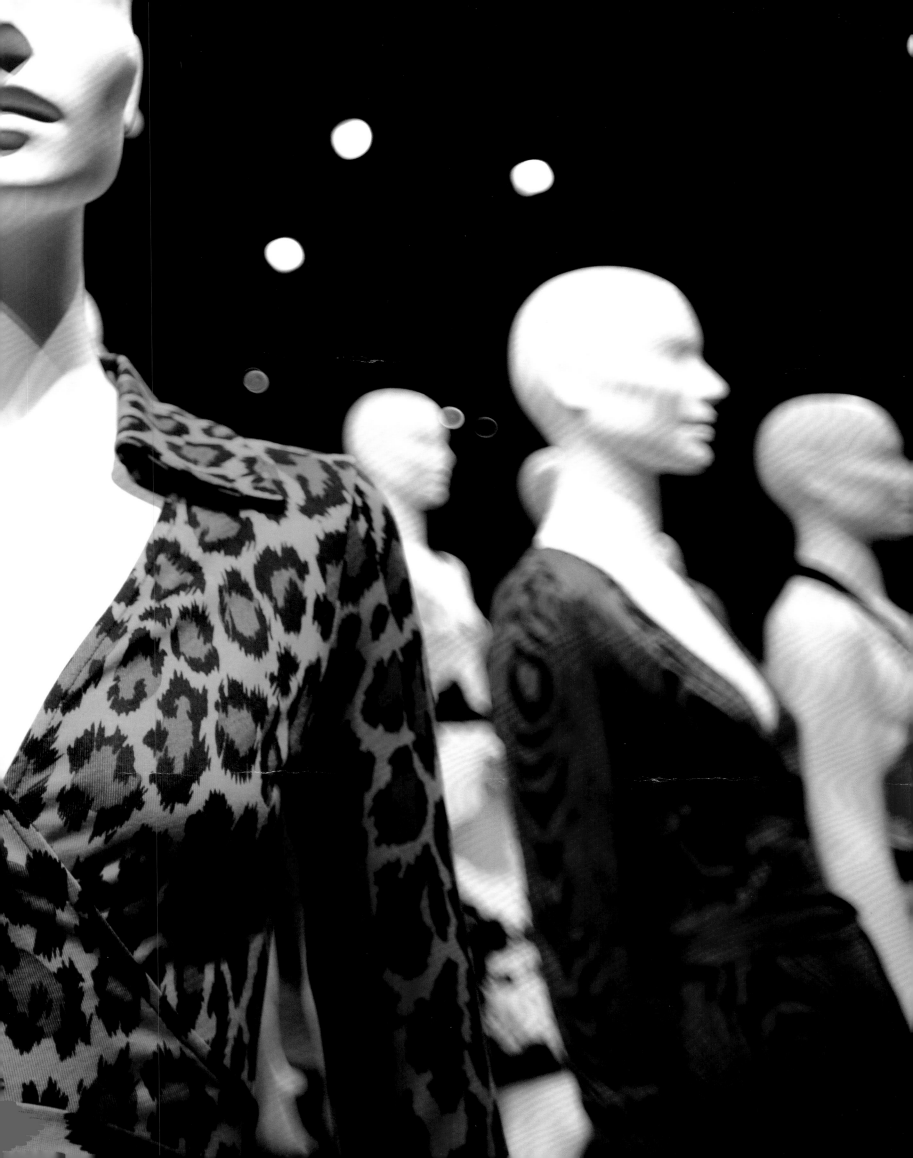

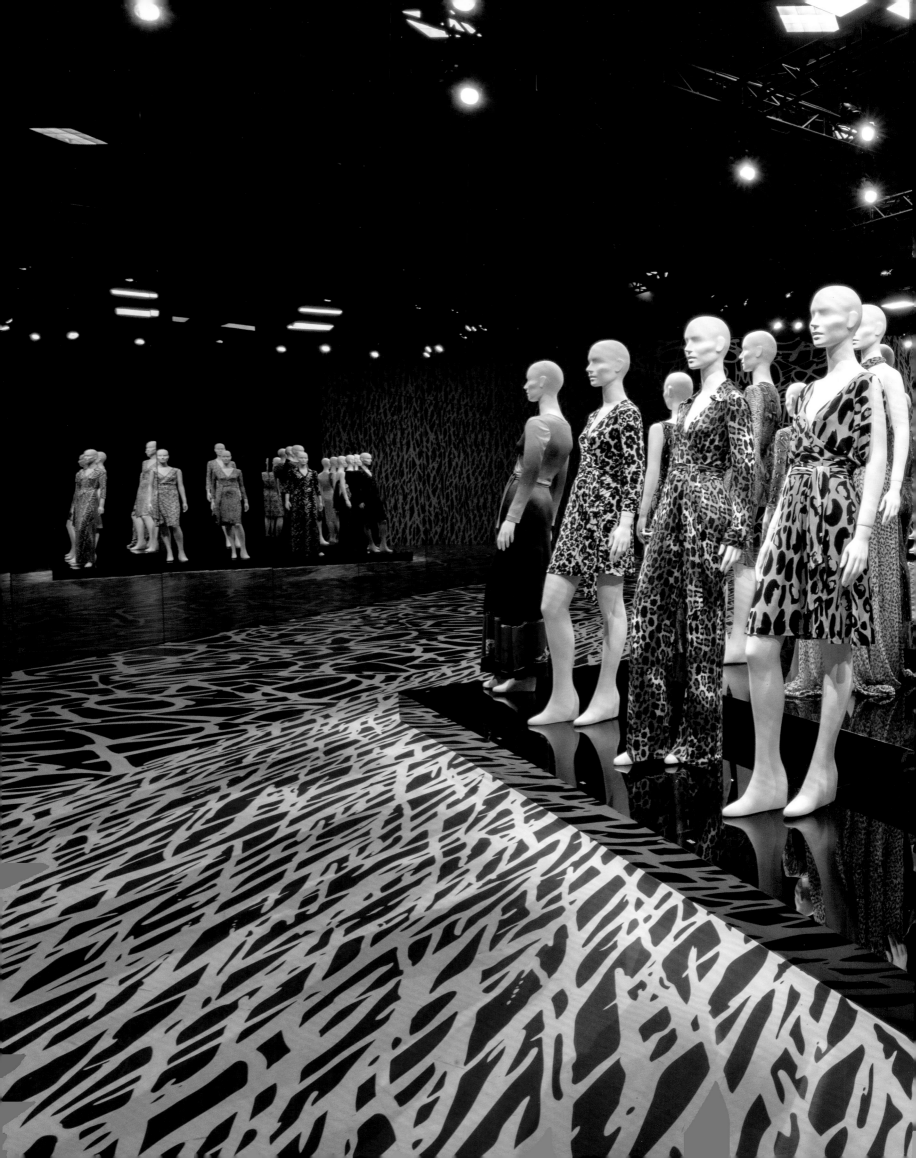

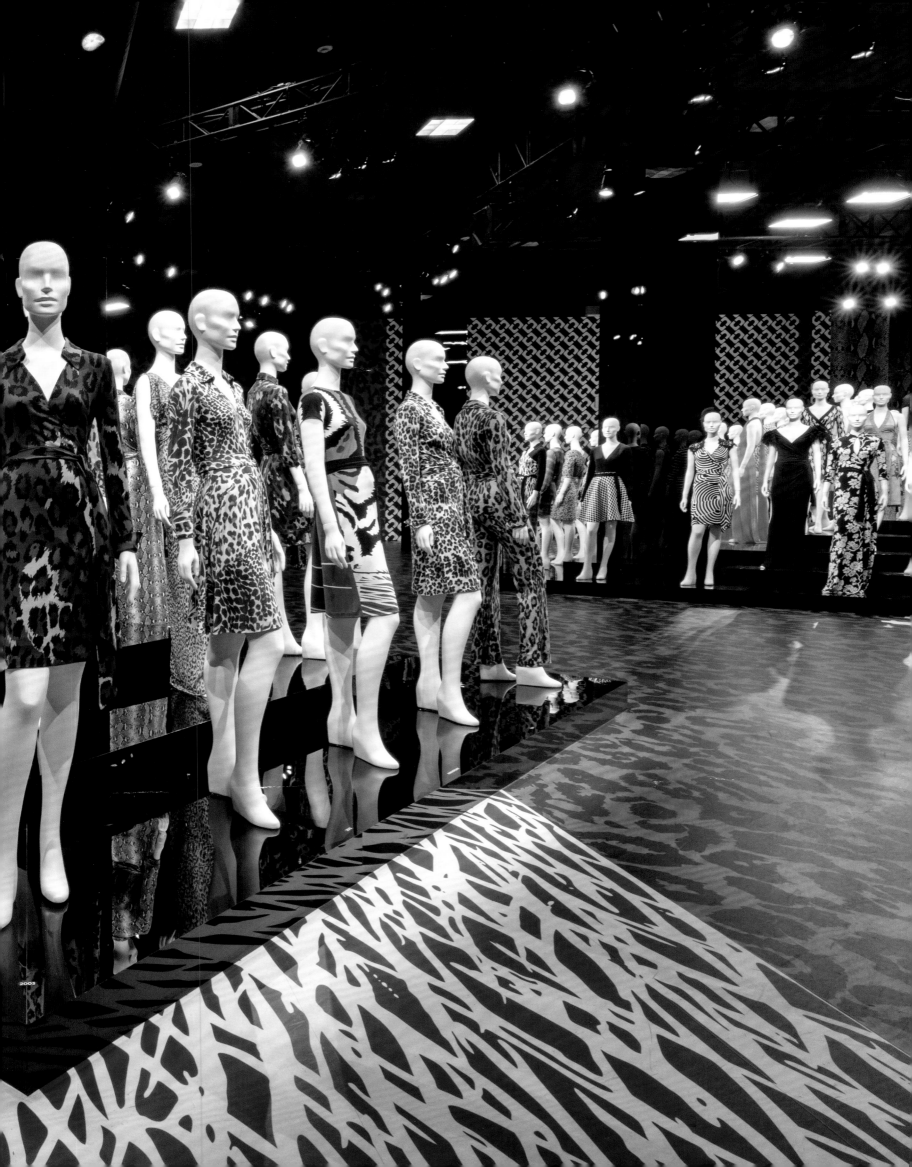

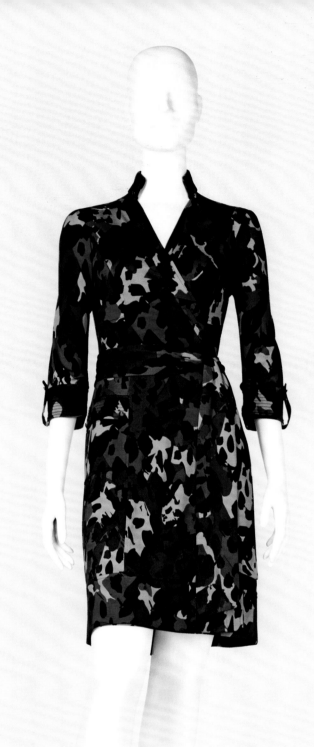

2014

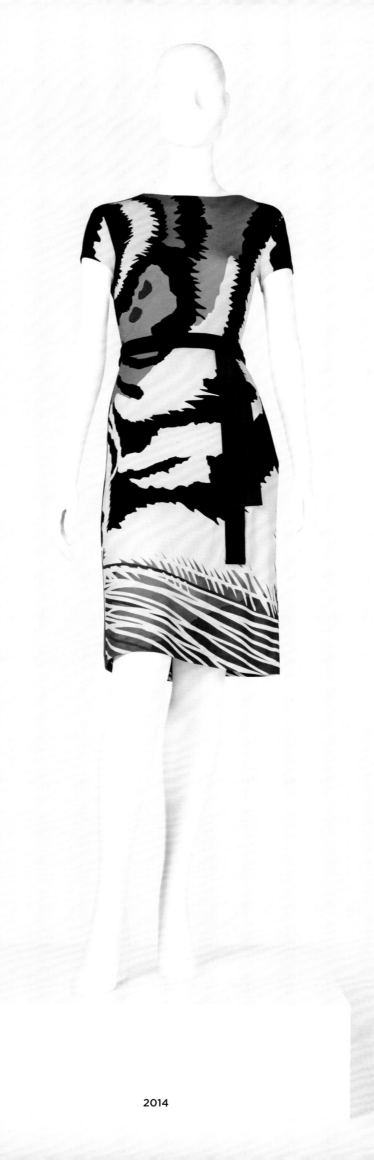

2014

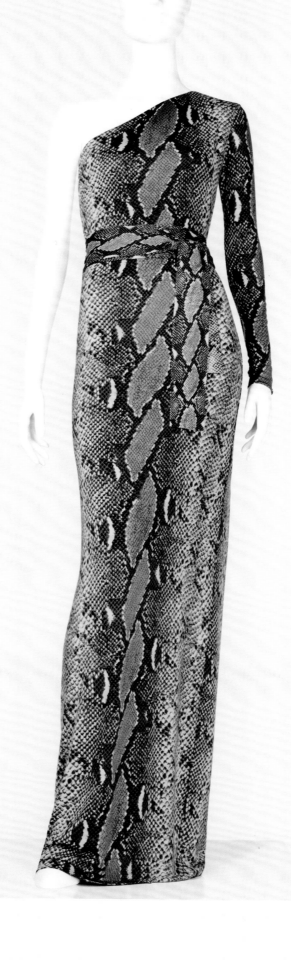

2014

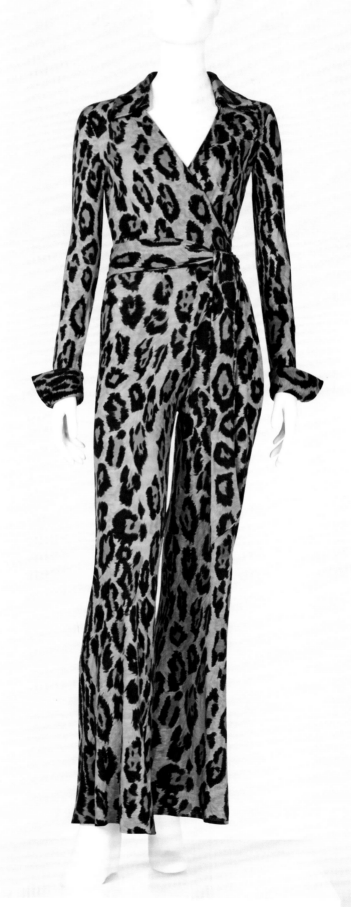

1974

2013

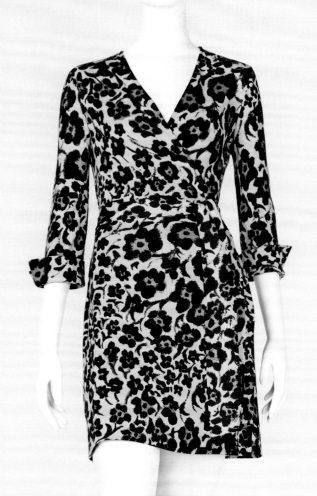

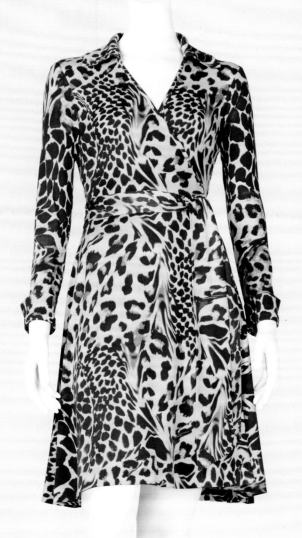

2014

2013

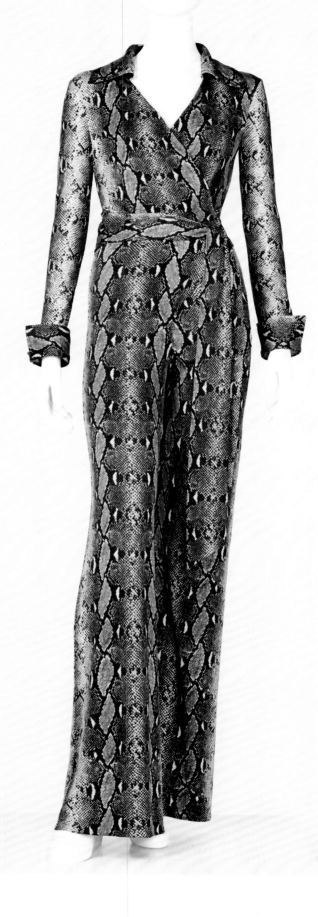

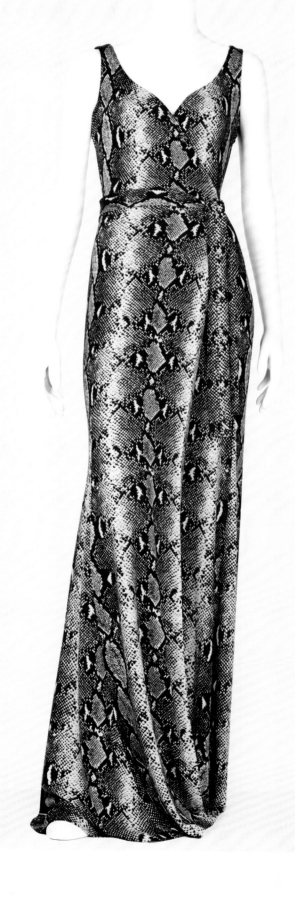

1974

2014

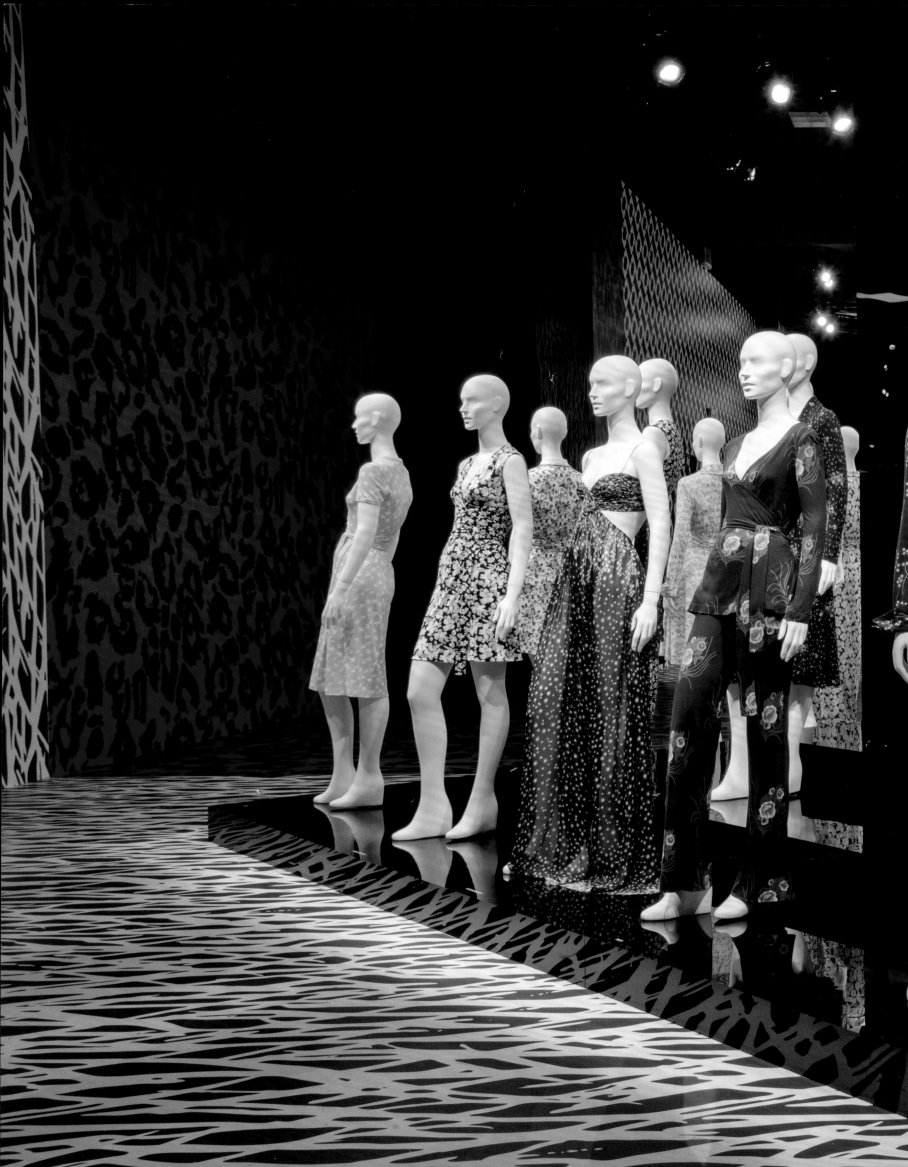

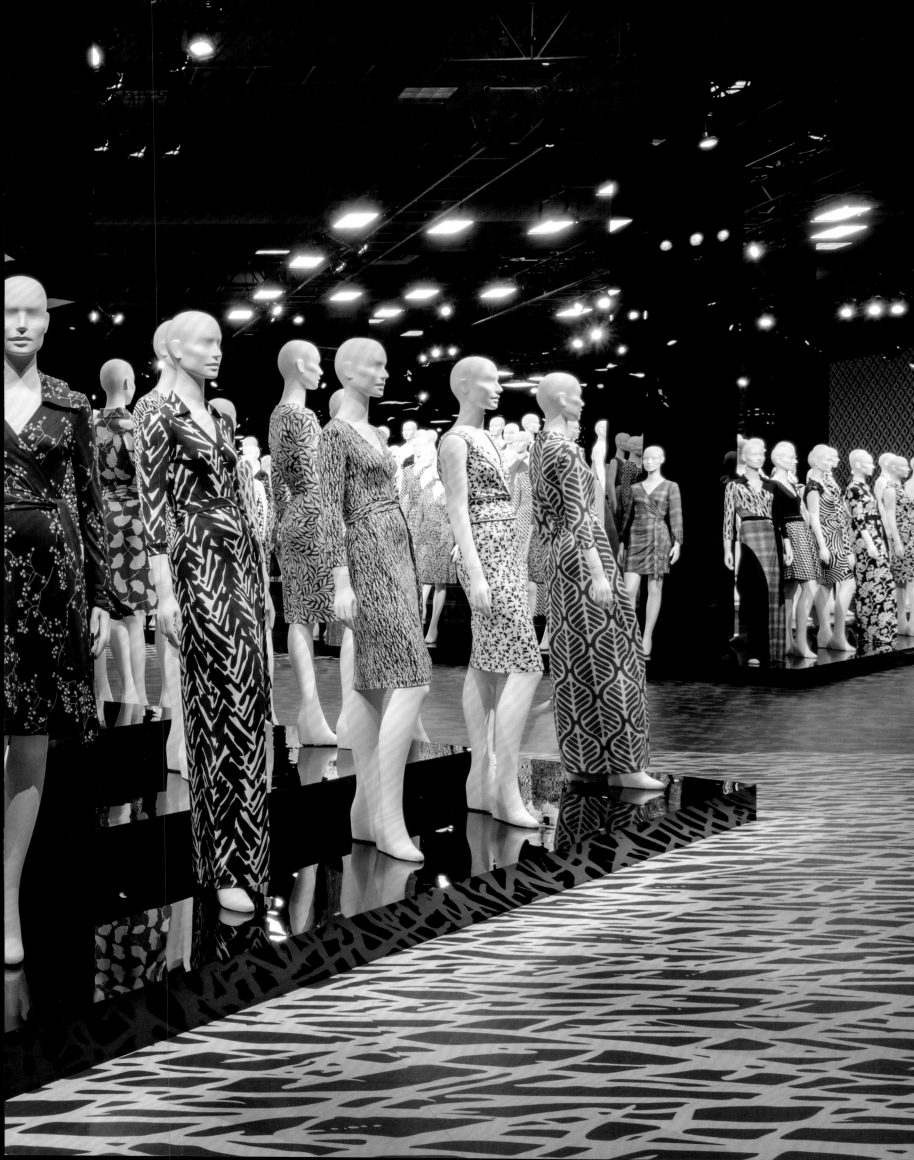

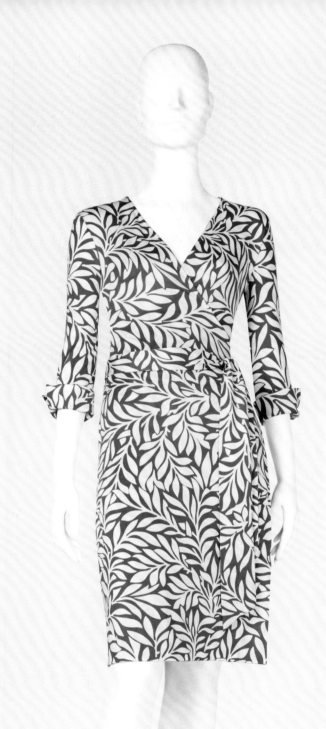

2011

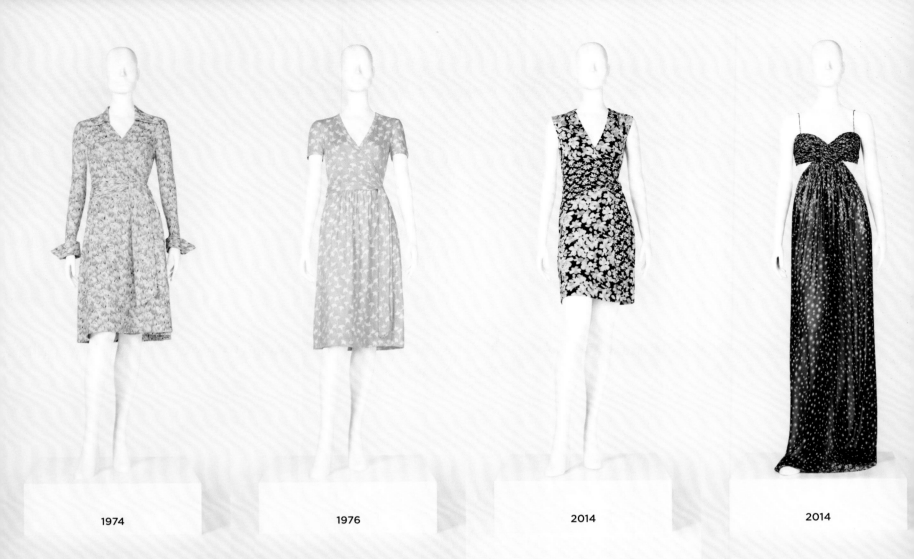

1974

1976

2014

2014

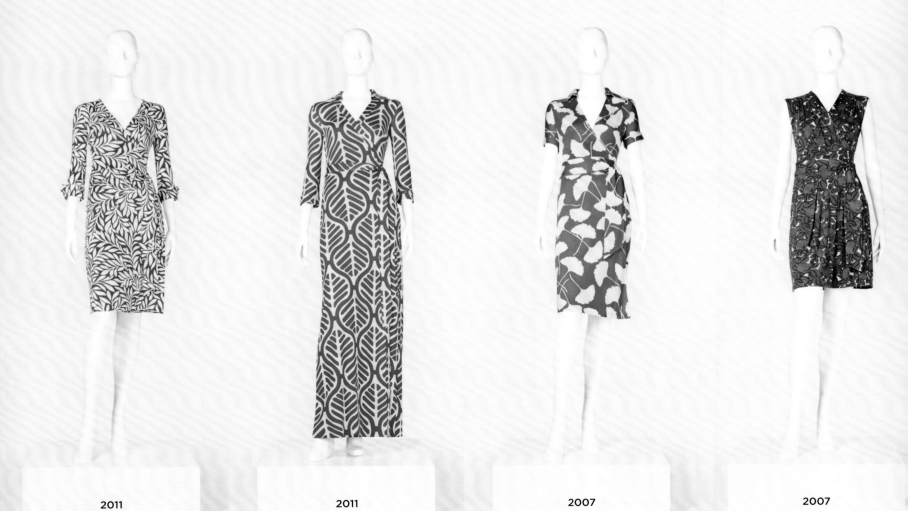

2011

2011

2007

2007

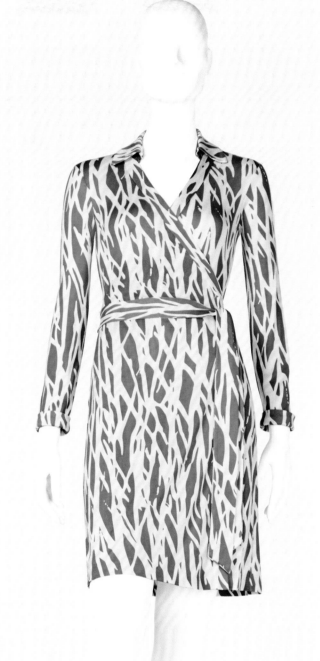

2003

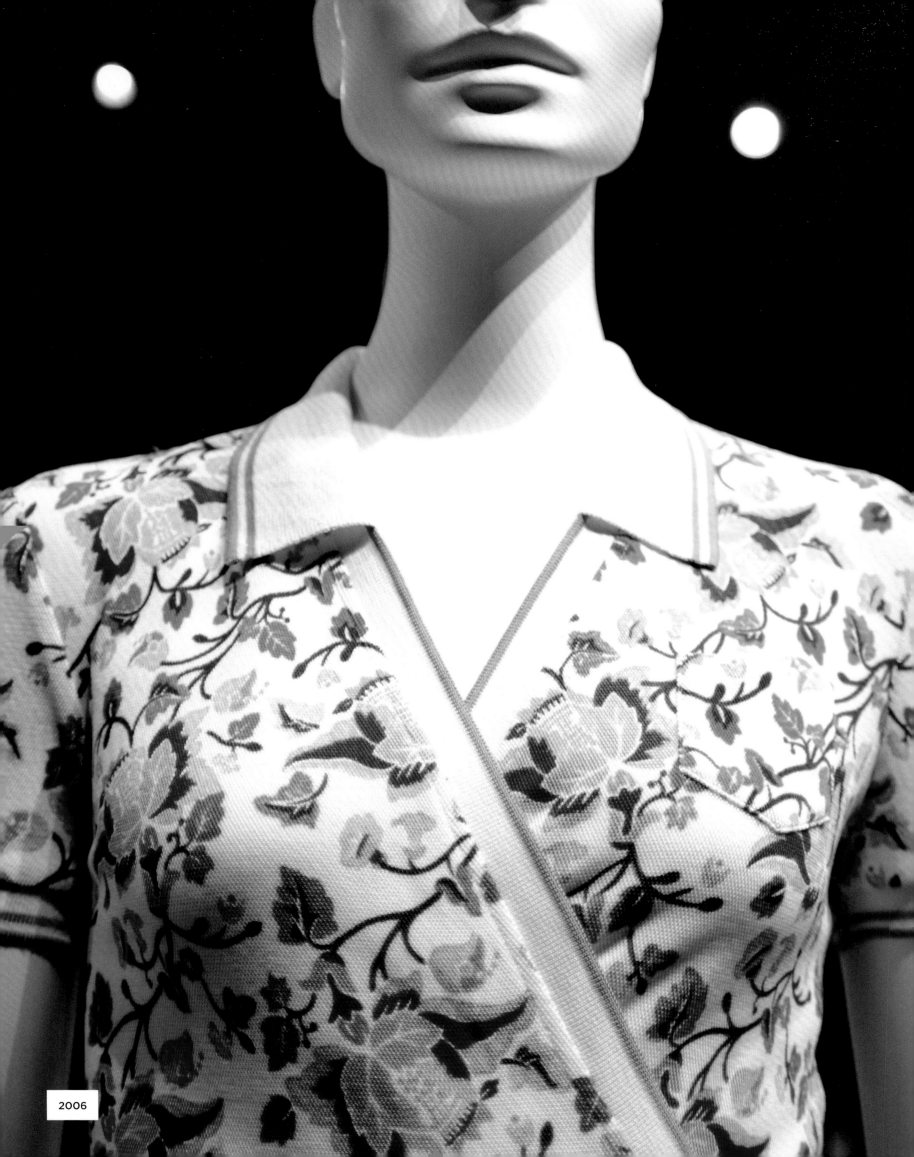

2006

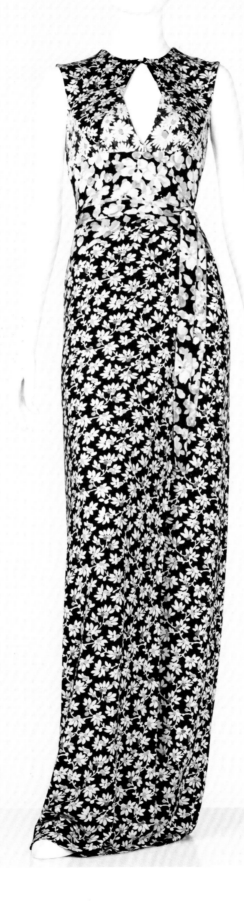

2014

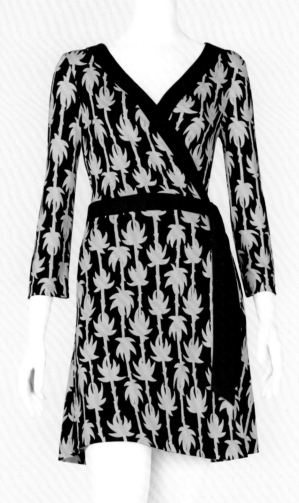

2006

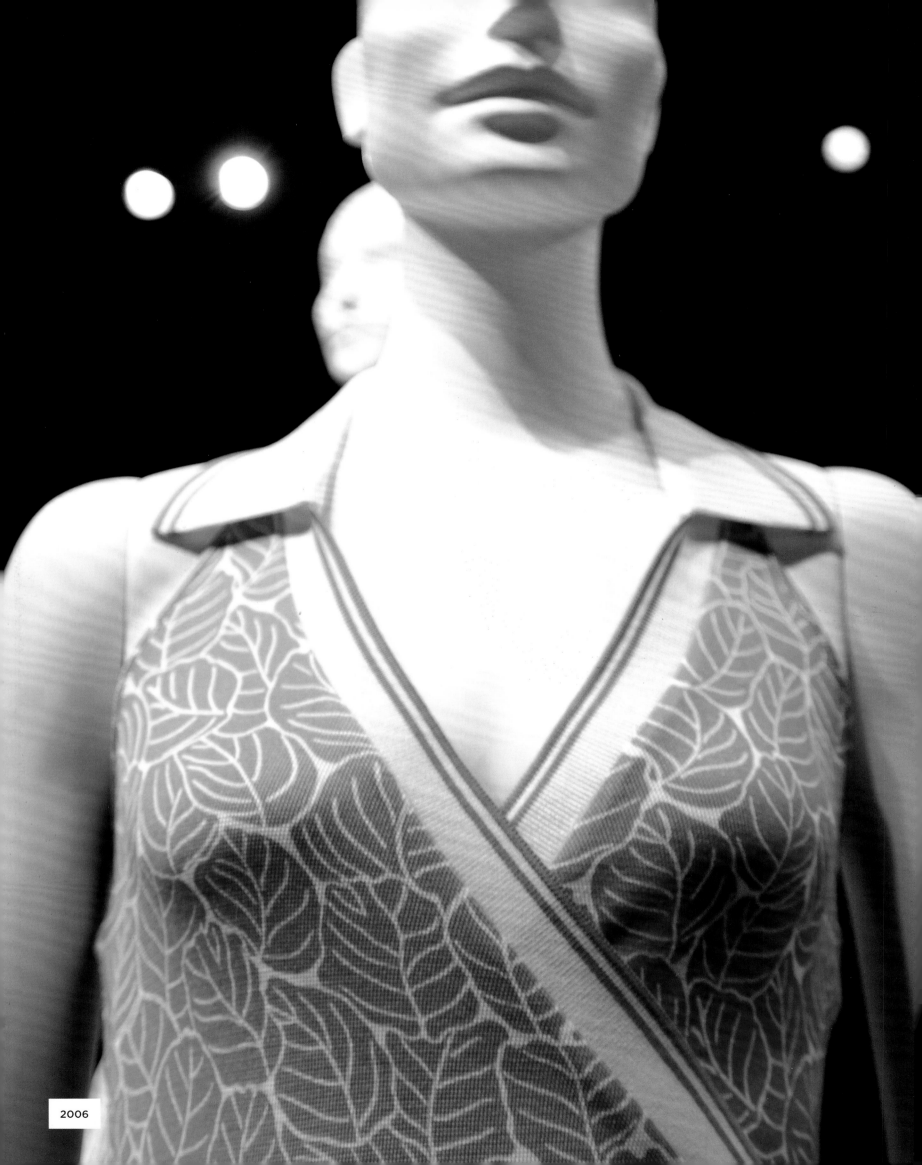

2006

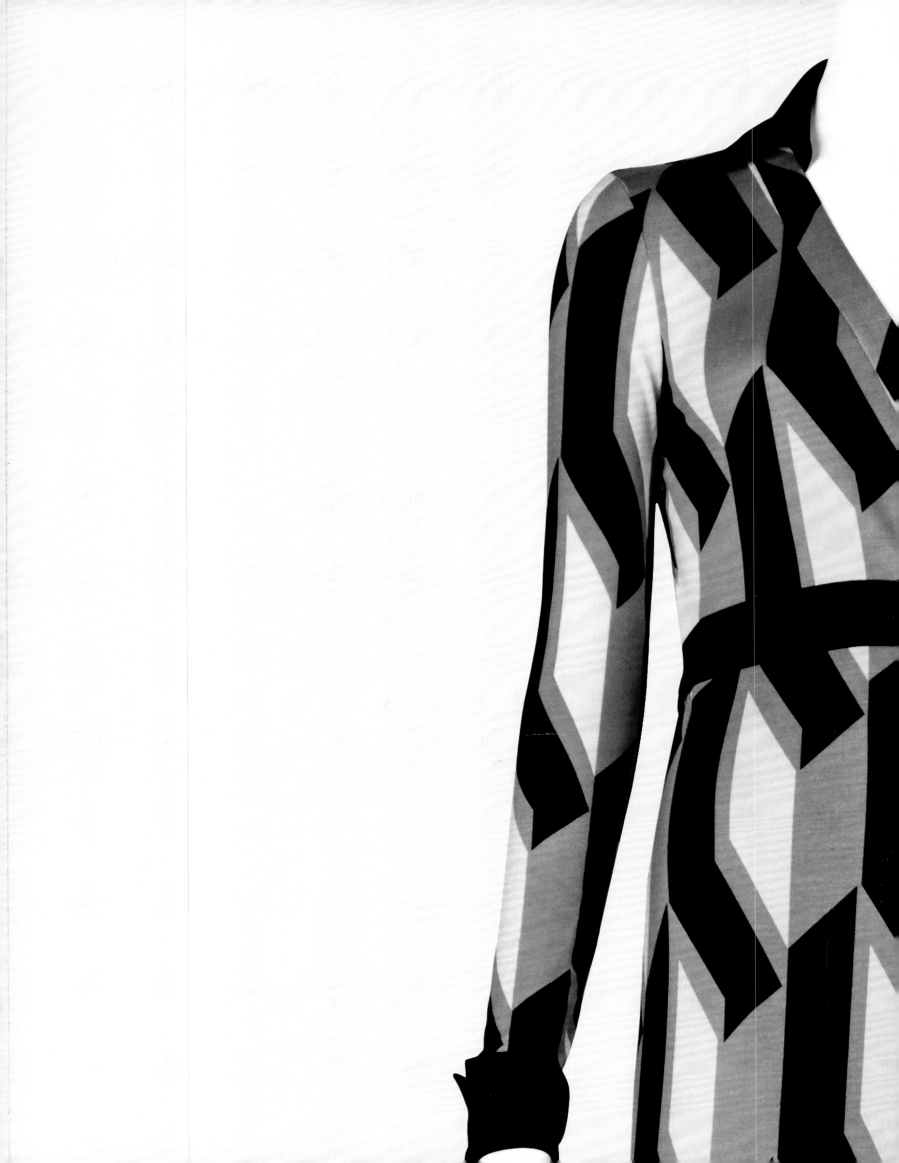

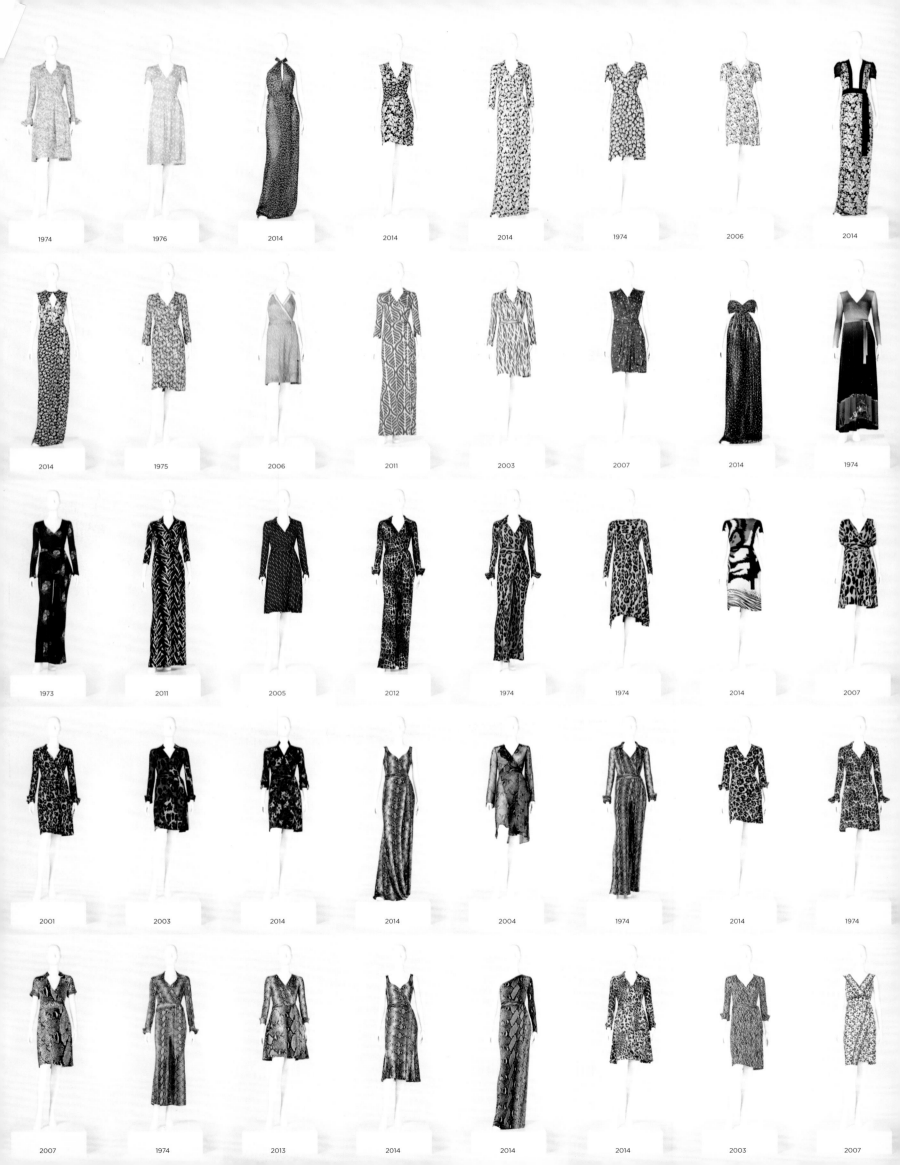

1974 1976 2014 2014 2014 1974 2006 2014

2014 1975 2006 2011 2003 2007 2014 1974

1973 2011 2005 2012 1974 1974 2014 2007

2001 2003 2014 2014 2004 1974 2014 1974

2007 1974 2013 2014 2014 2014 2003 2007

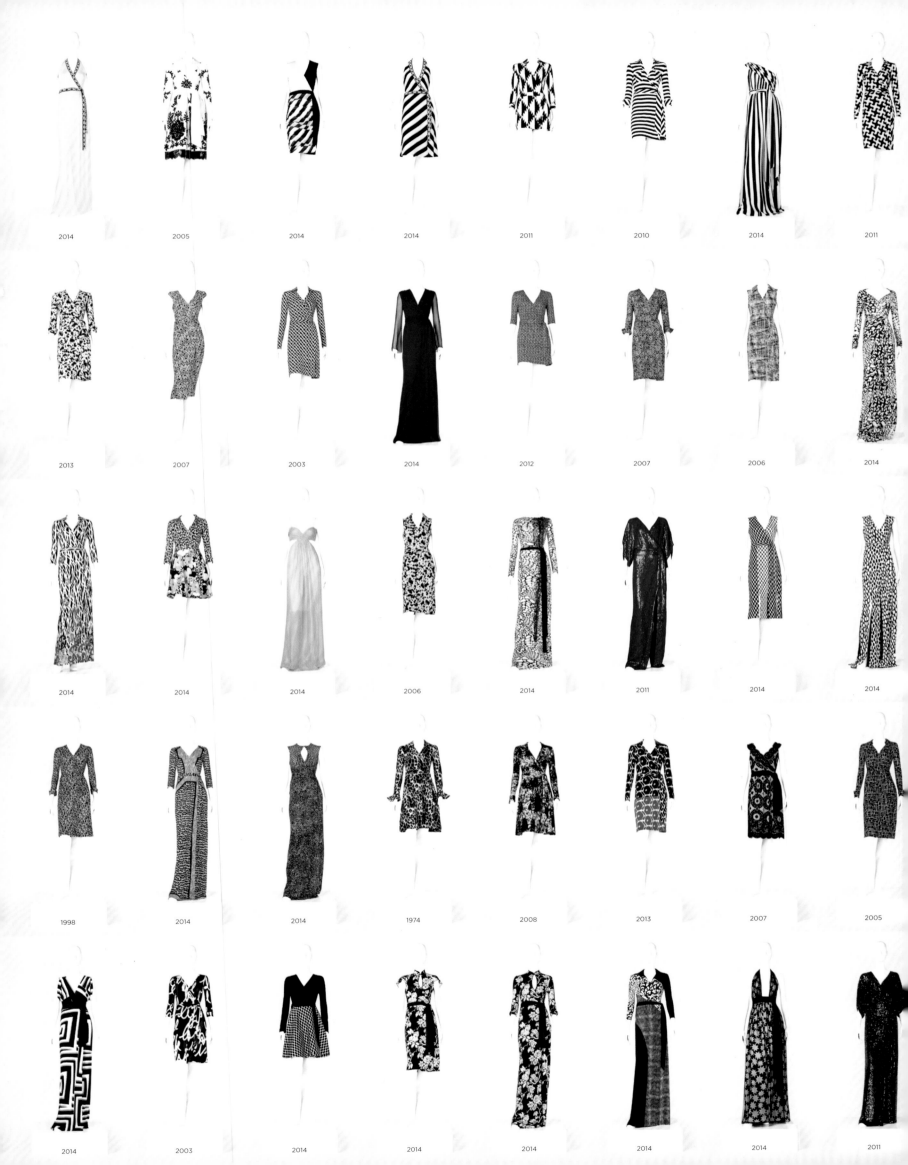

2014　2005　2014　2014　2011　2010　2014　2011

2013　2007　2003　2014　2012　2007　2006　2014

2014　2014　2014　2006　2014　2011　2014　2014

1998　2014　2014　1974　2008　2013　2007　2005

2014　2003　2014　2014　2014　2014　2014　2011

2003

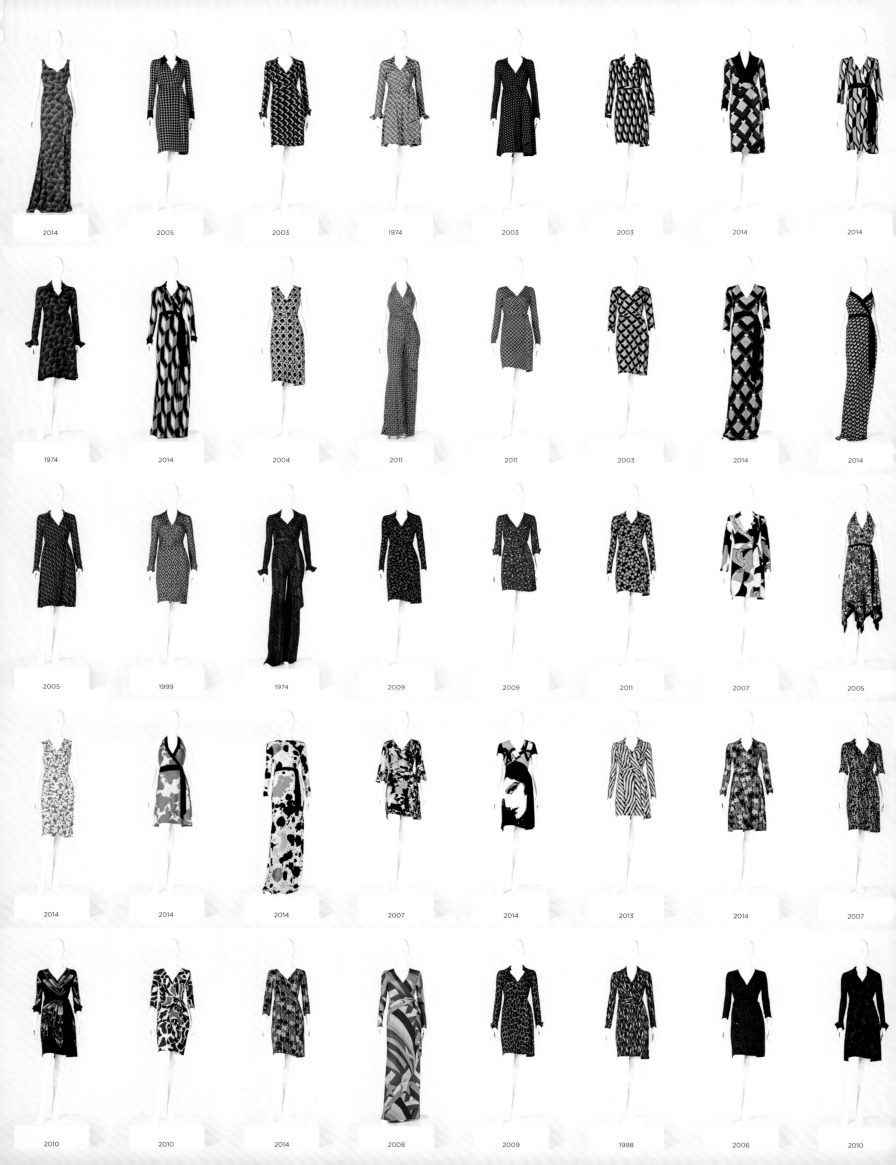

2014 2005 2003 1974 2003 2003 2014 2014

1974 2014 2004 2011 2011 2003 2014 2014

2005 1999 1974 2009 2009 2011 2007 2005

2014 2014 2014 2007 2014 2013 2014 2007

2010 2010 2014 2008 2009 1998 2006 2010

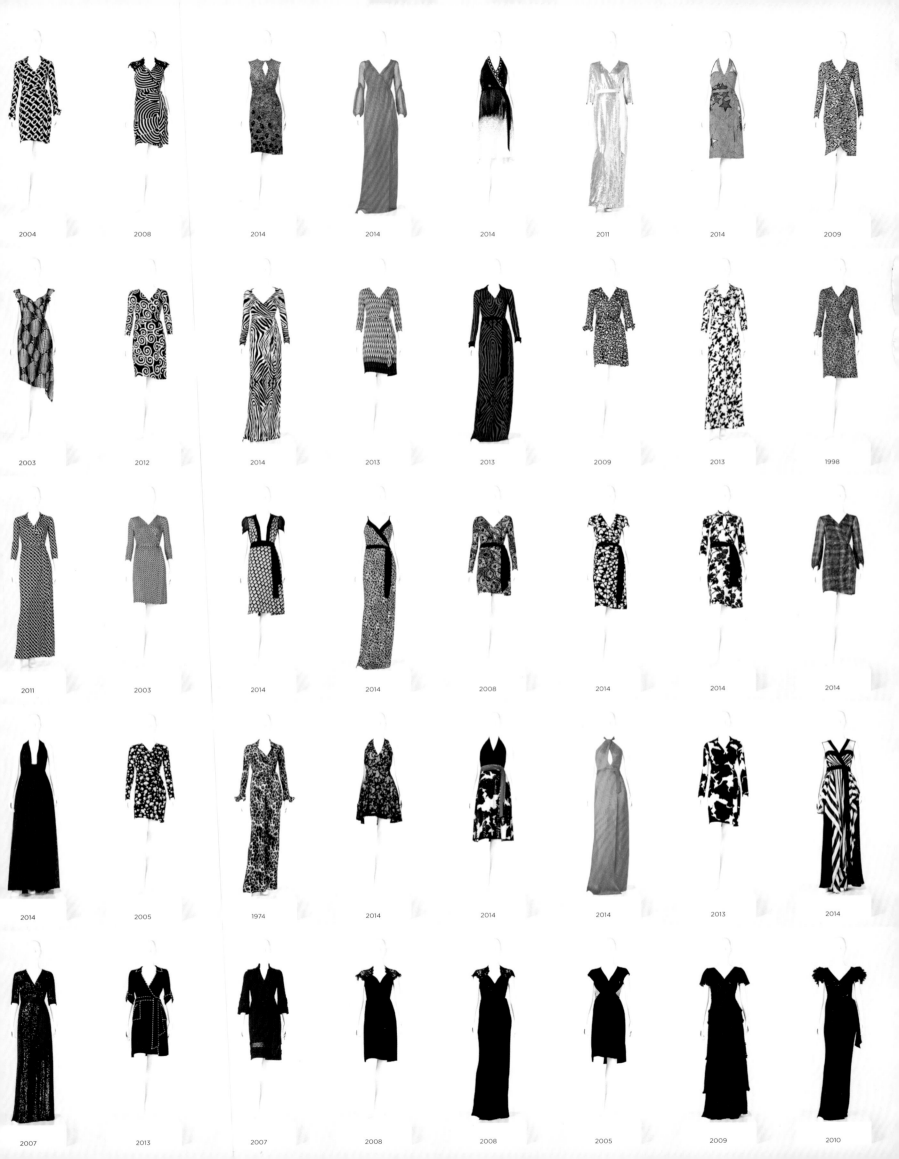

2004　　2008　　2014　　2014　　2014　　2011　　2014　　2009

2003　　2012　　2014　　2013　　2013　　2009　　2013　　1998

2011　　2003　　2014　　2014　　2008　　2014　　2014　　2014

2014　　2005　　1974　　2014　　2014　　2014　　2013　　2014

2007　　2013　　2007　　2008　　2008　　2005　　2009　　2010

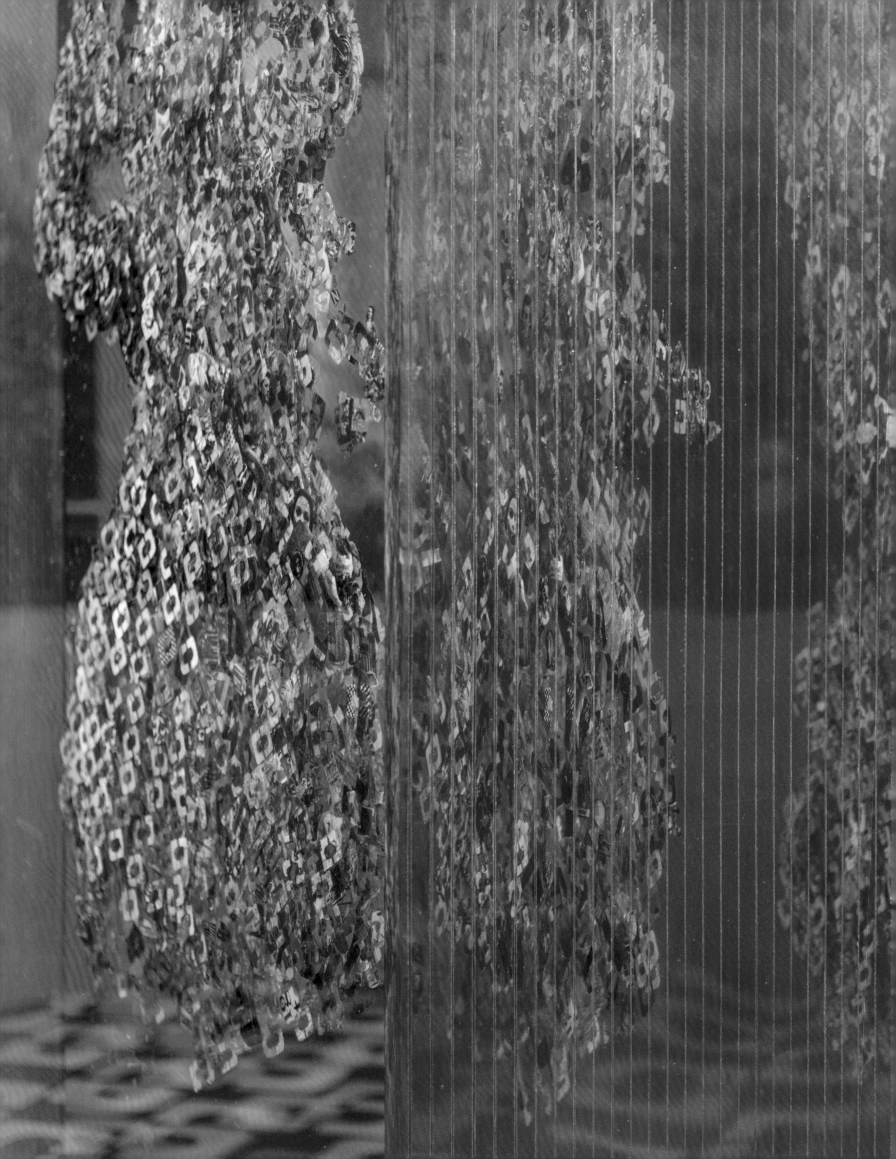

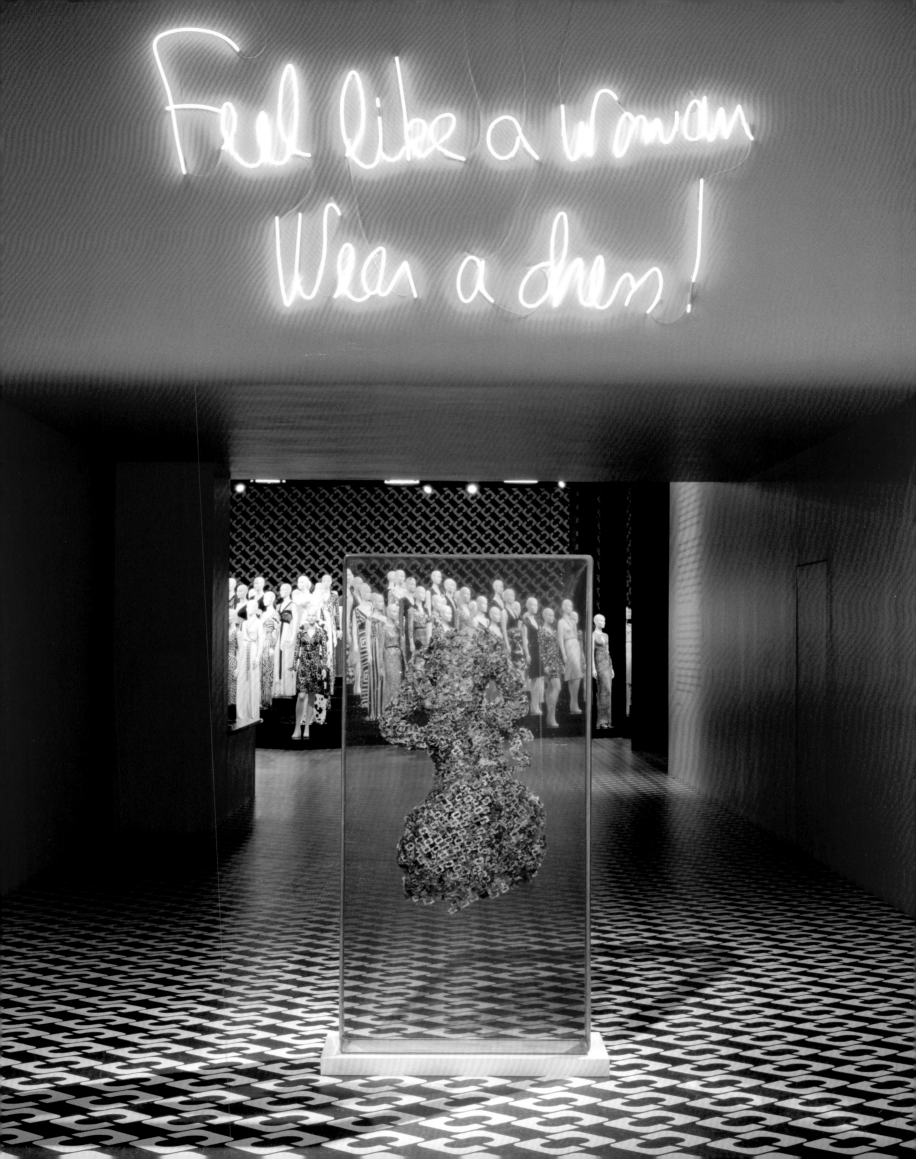

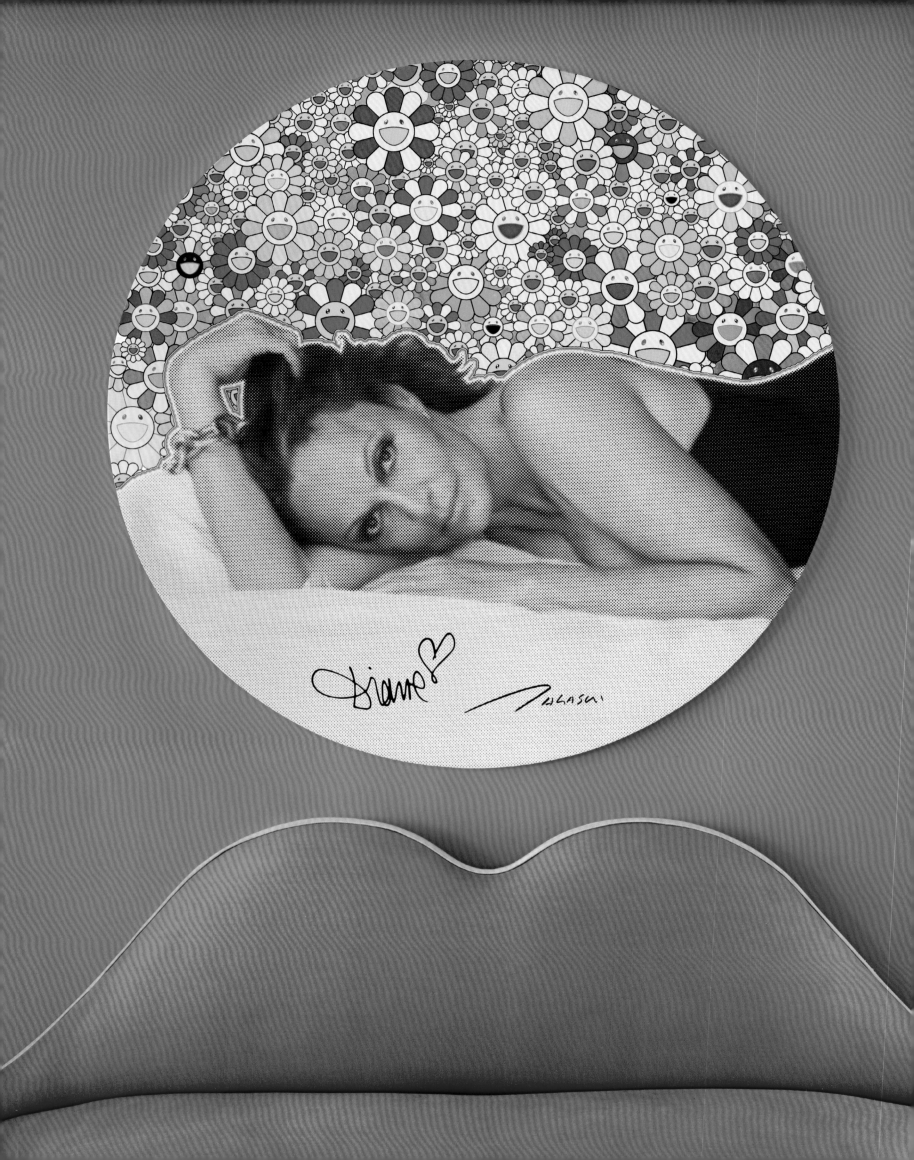

The Journey of *Journey of the Dress*

While working on the first exhibition of *Journey of a Dress*, we discovered that there were, in fact, two journeys: one of the history of the wrap dress and a second journey of the life of the woman who designed the dress. As Diane's professional and personal life evolved over the forty years since she created the dress, these two paths grew in parallel ways and informed one another.

That first exhibition took place in Moscow at the Manege, a large oblong building that had been a riding hall and then a space where balls took place. The next venue, in São Paulo, was on the top of a luxury shopping complex, just below a helicopter landing pad. It was in São Paulo that the expansion of the exhibition revealed a third journey—that of the many women who wore the dress. The exhibition was further clarified at the Pace Gallery in Beijing, in a classic gallery space that was organized into three distinct areas. It was there that the idea of a salon within the exhibition was formalized.

The version of *Journey of a Dress* that is the subject of this book was presented in a former May Company department store, a handsome building that is now part of the campus of the Los Angeles County Museum of Art. At the heart of the exhibition were two hundred examples of the wrap dress from all the periods of its existence. To get to this centerpiece, the audience passed through a "timeline": a hundred-foot-long gallery papered with poster-size images of women in all walks of life wearing the dress. They formed a parade of some of the most distinguished and powerful women of their eras, demonstrating Diane's early mantra: "Feel like a woman—wear a dress." Adjacent to this avenue was the salon, a gallery of portraits devoted to the woman who invented a dress as timeless as a toga.

Diane commissioned all the portraits in the salon at various points in her life and they reflect her vision of herself. She was able to inspire the strongest expressions of the artists' own personalities, yet each portrait evokes her distinctive identity. She was at once a muse and a collaborator. Her choice of the artists was another example of the intuitive, quicksilver creativity with which she has designed both her life and her image. Diane is the architect of DVF—the woman she wanted to be.

Bill Katz

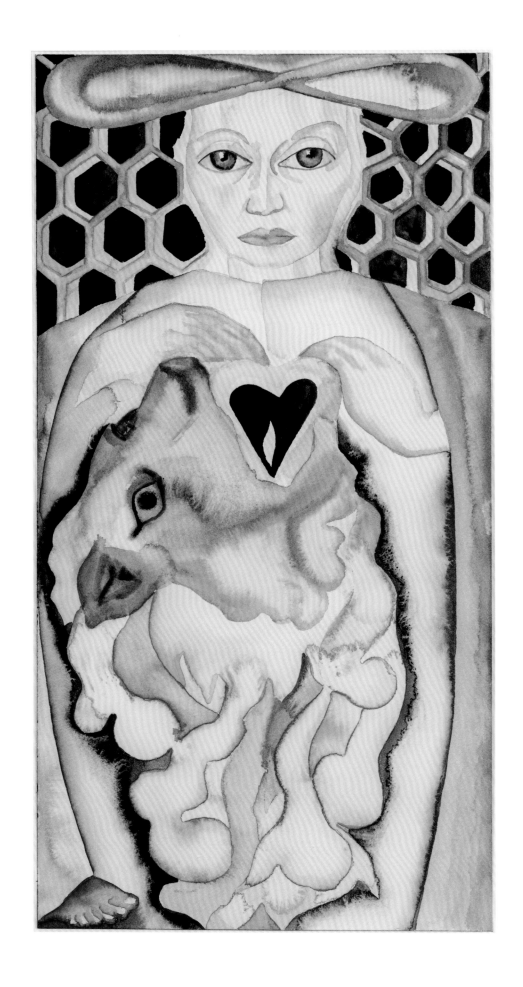

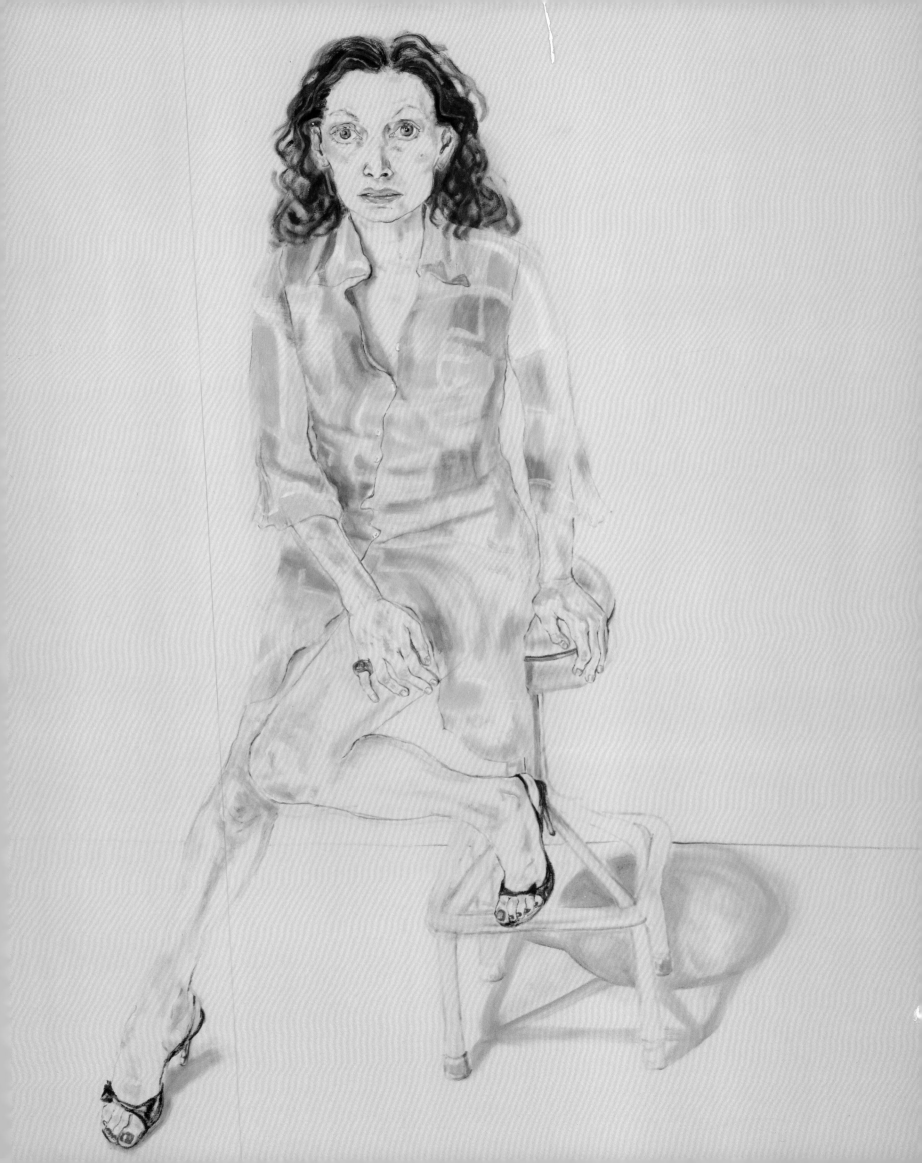

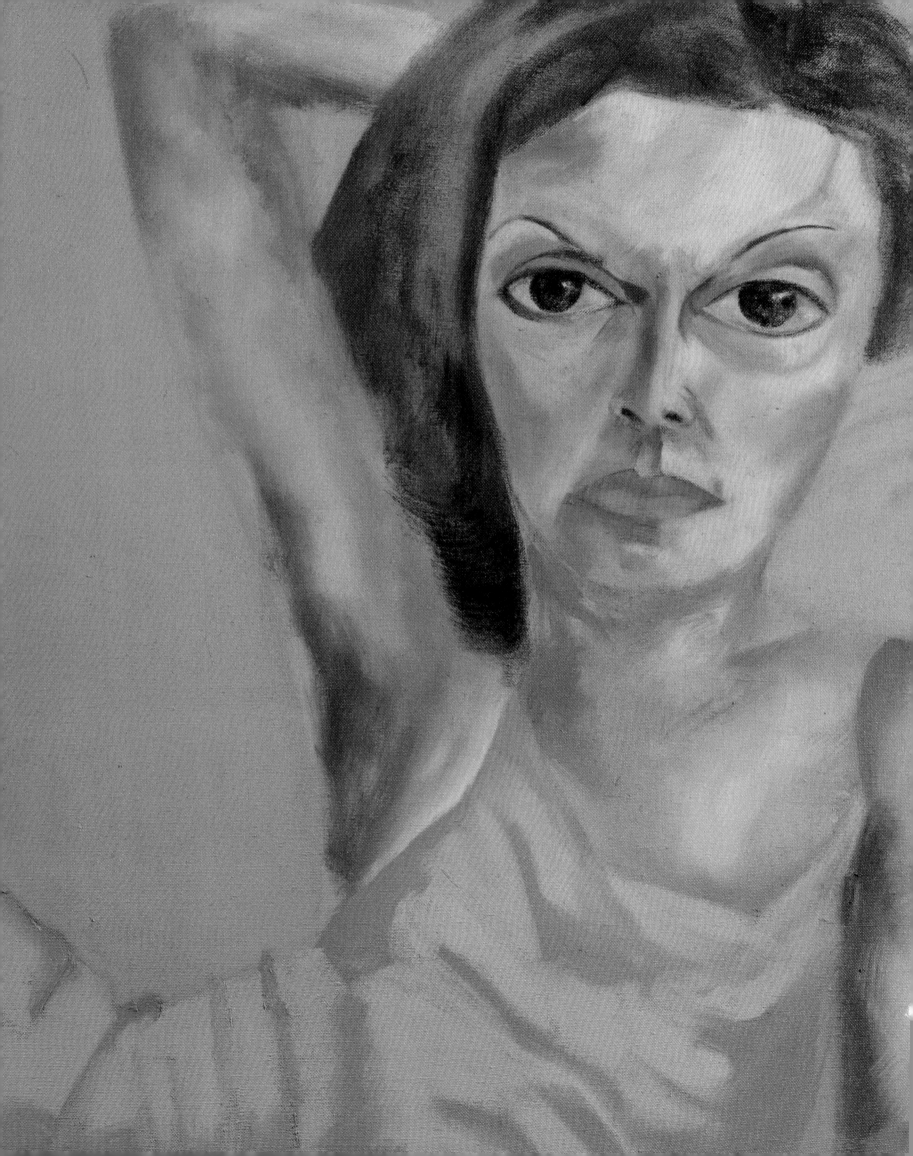

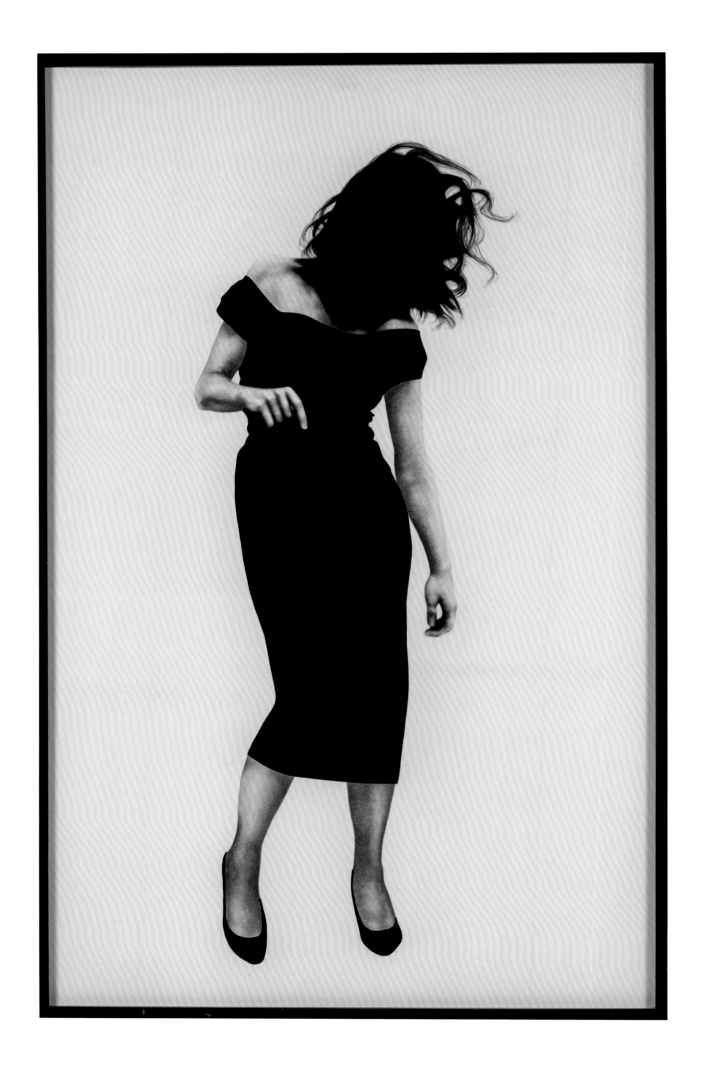

Journey of a Dress

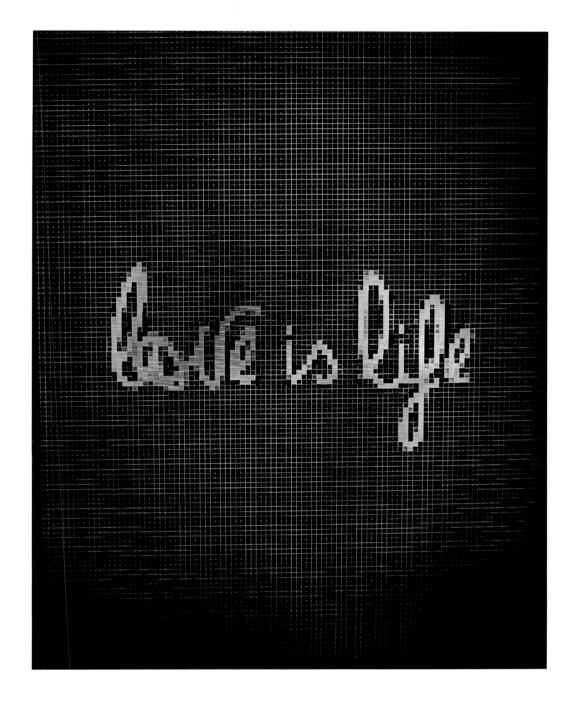

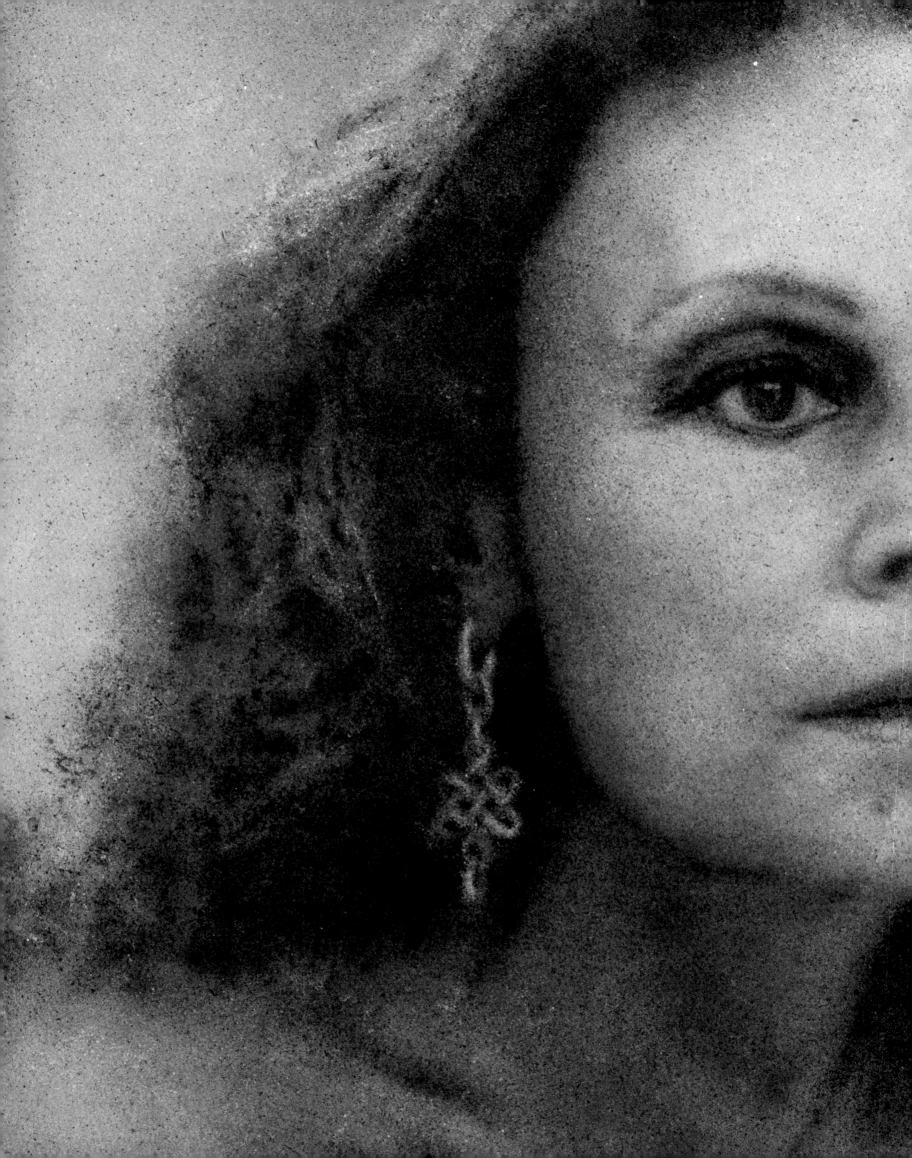

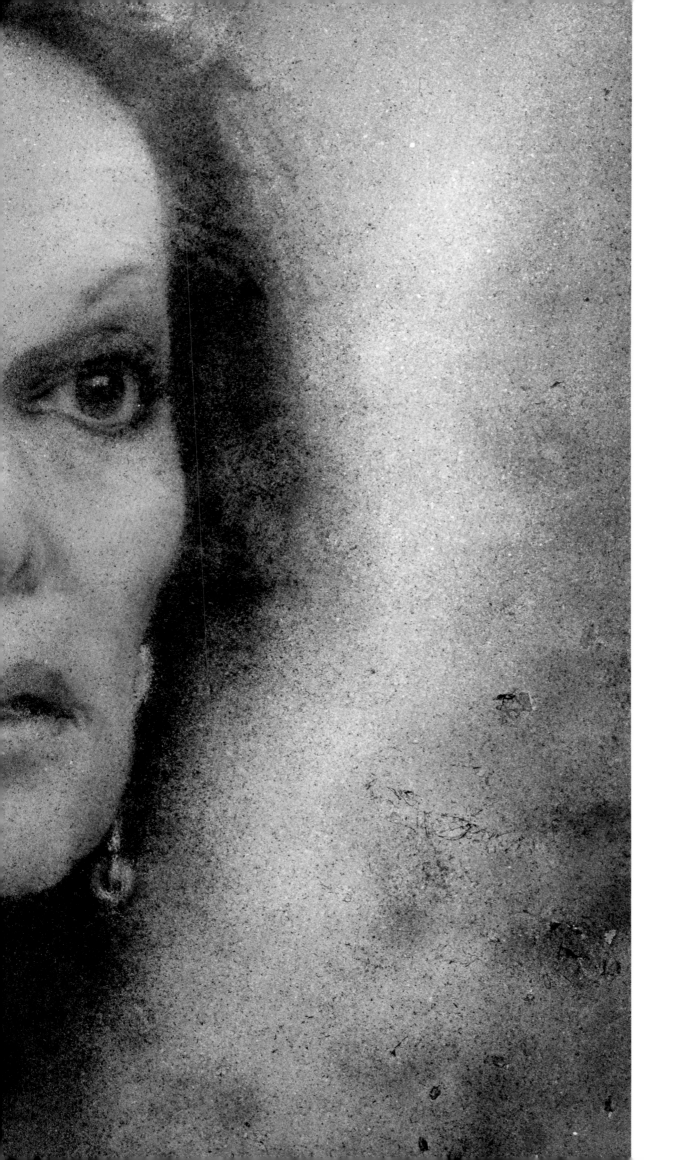

STUDIO

54

№ 13110

STUDIO

VIP

COMPLIMENTARY

DRINKS

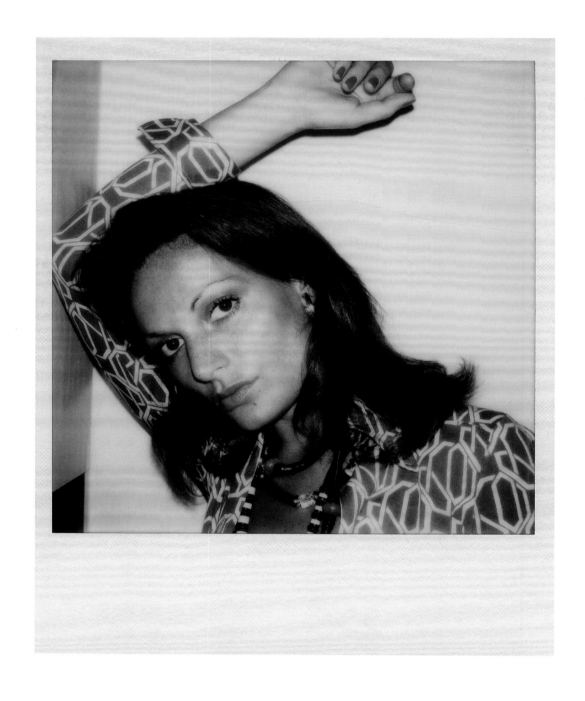

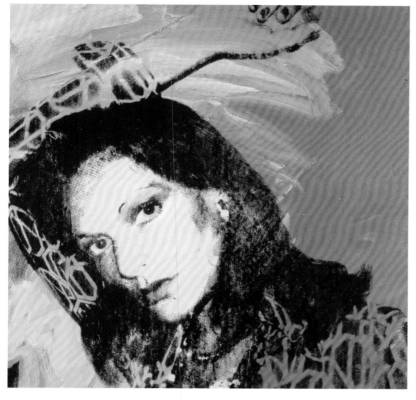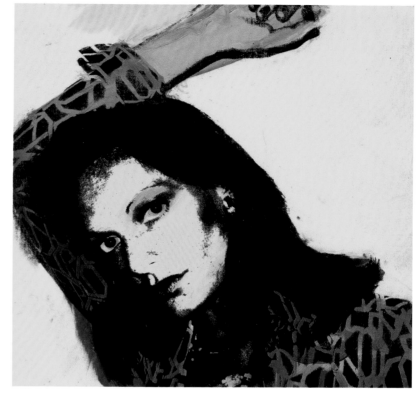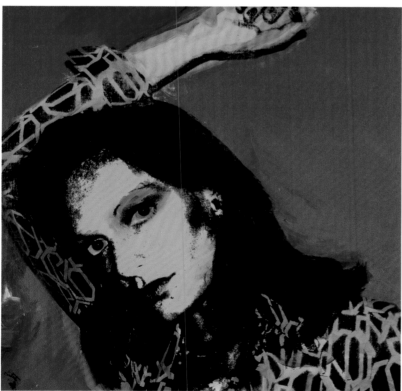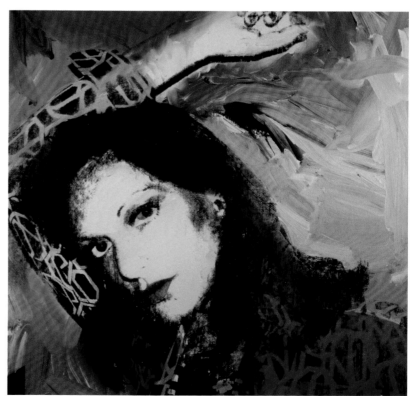

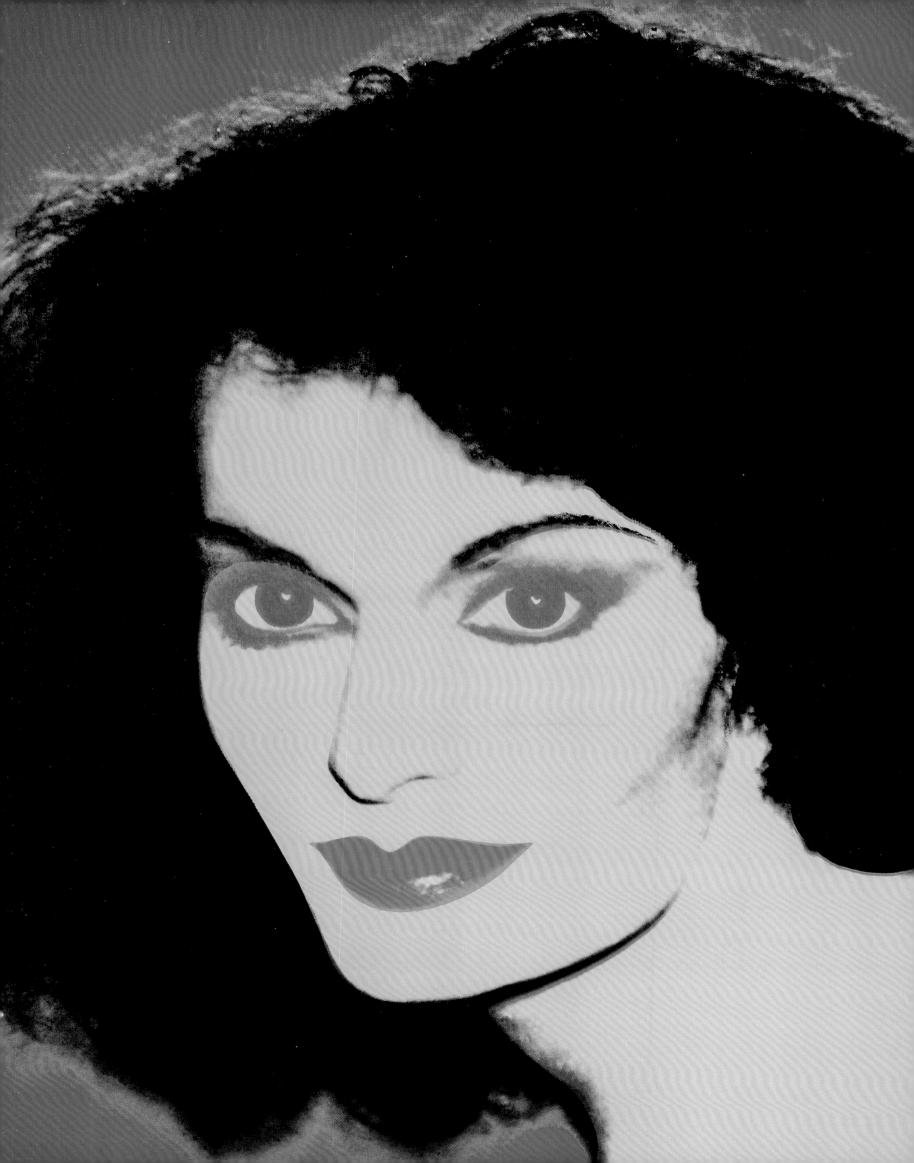

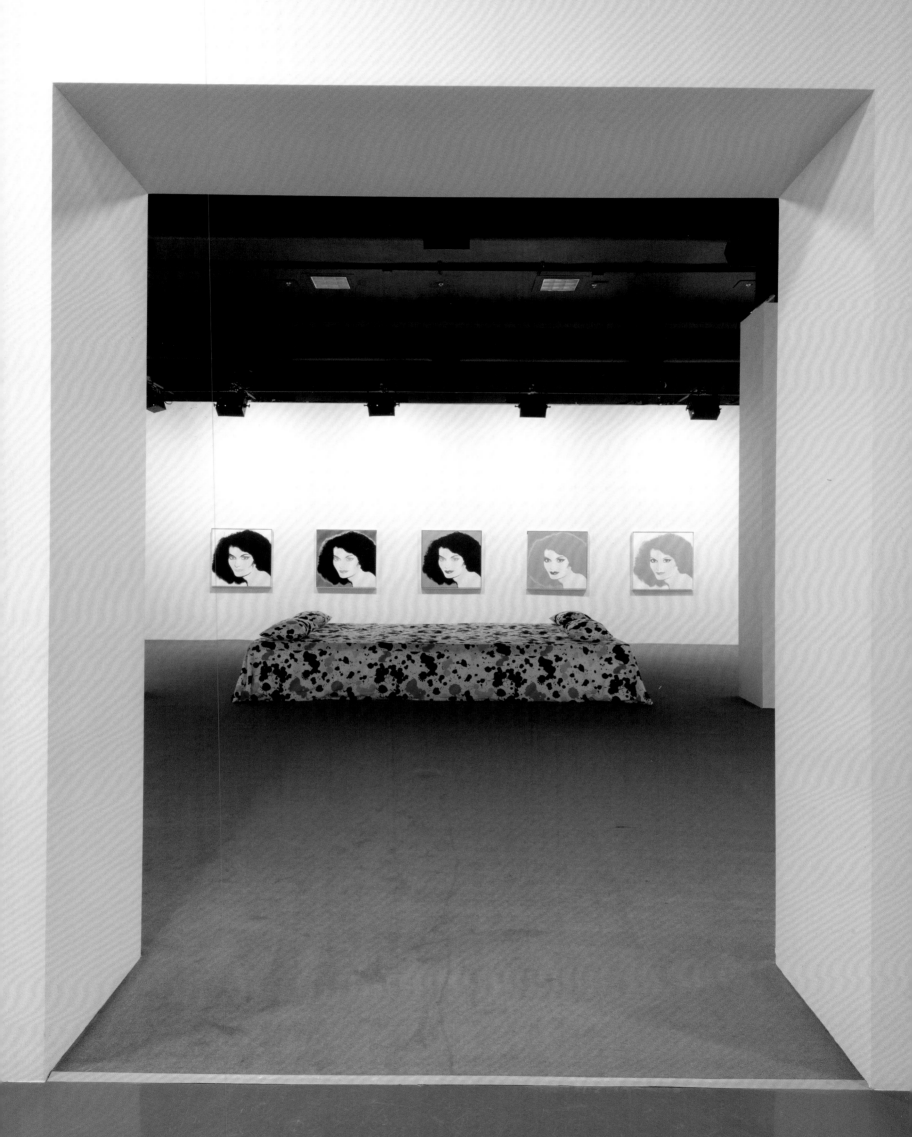

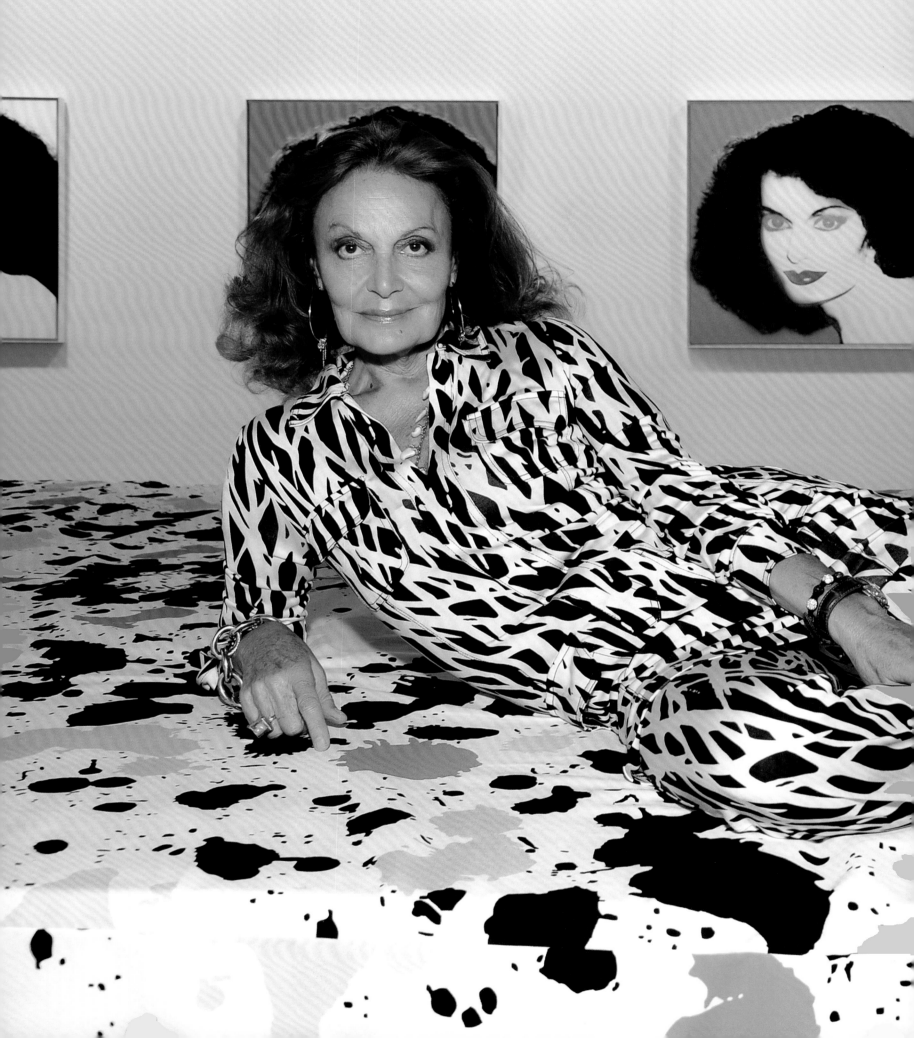

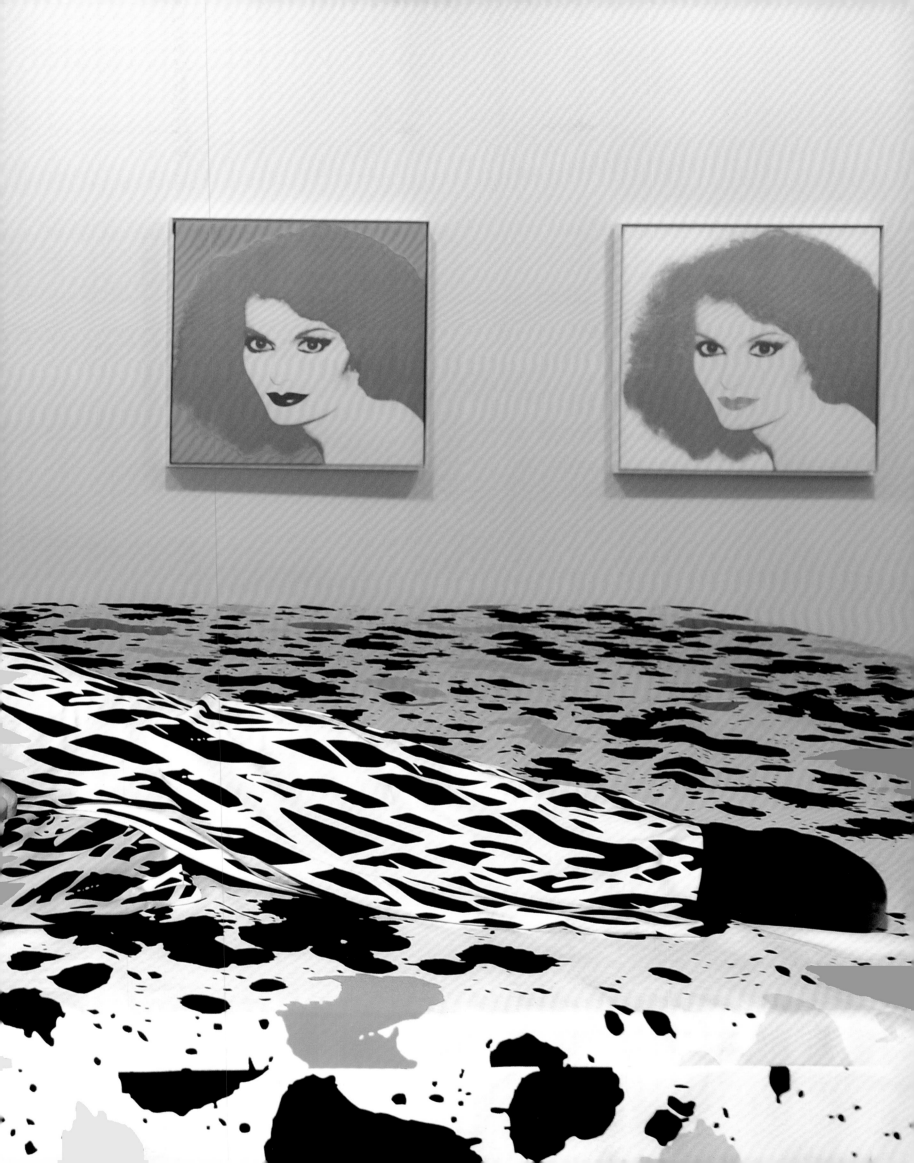

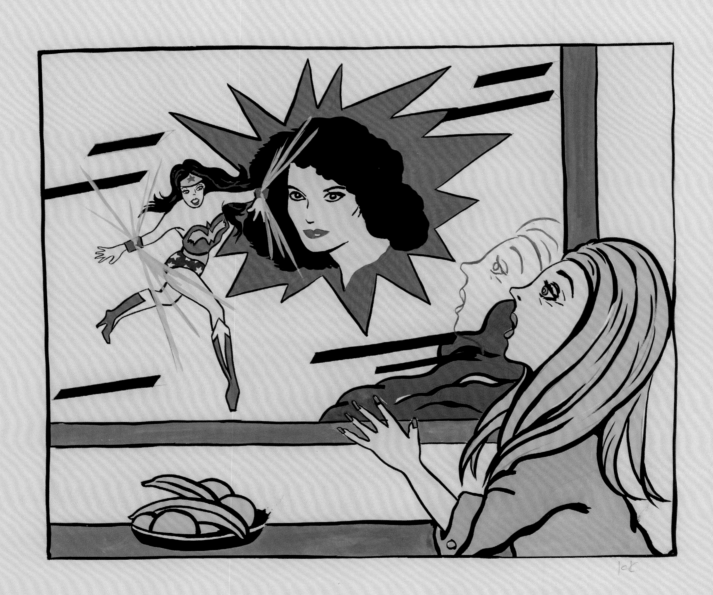

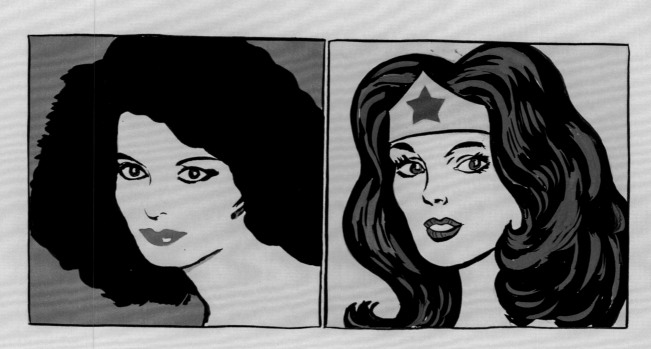

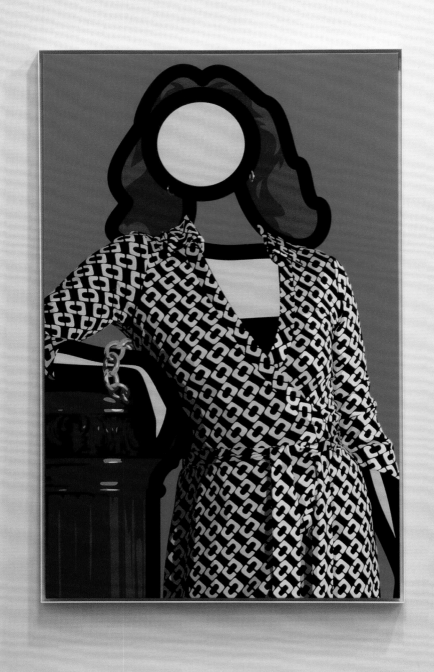

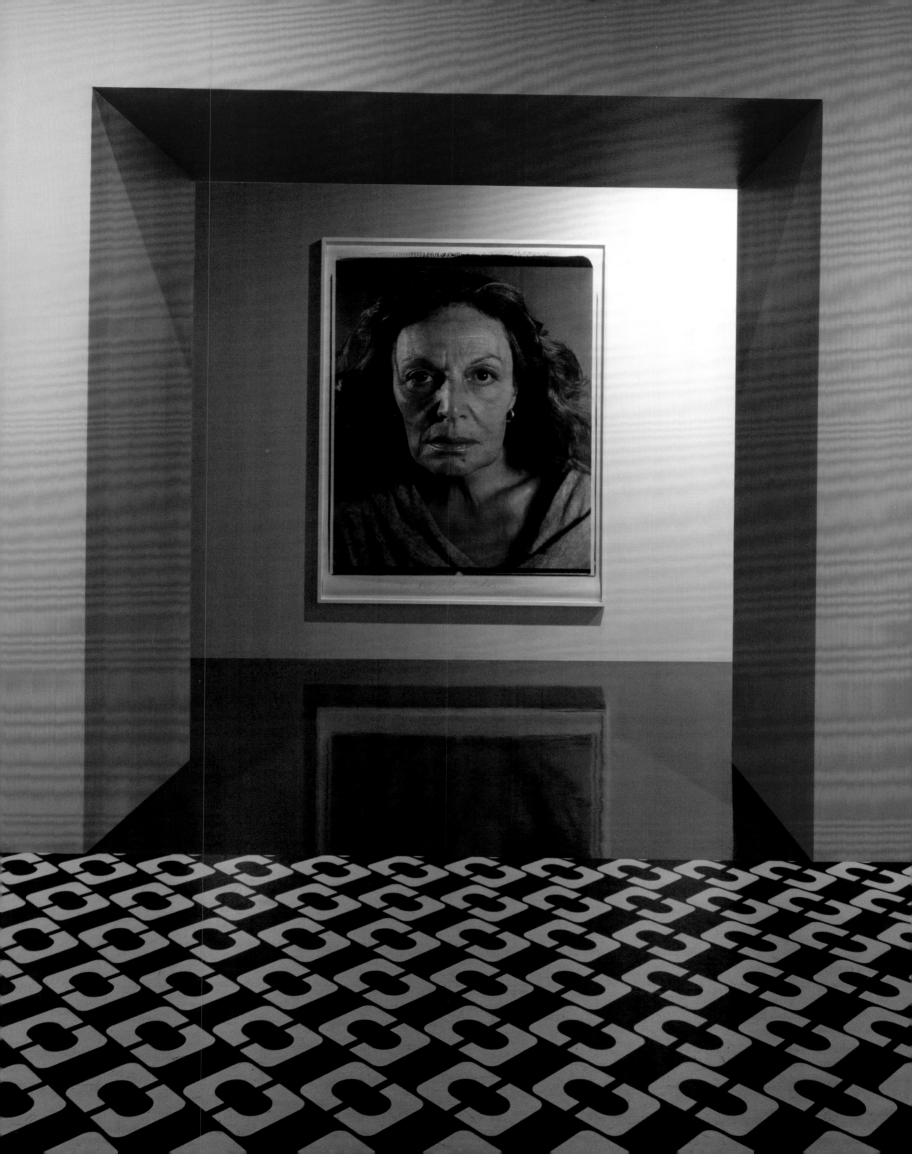

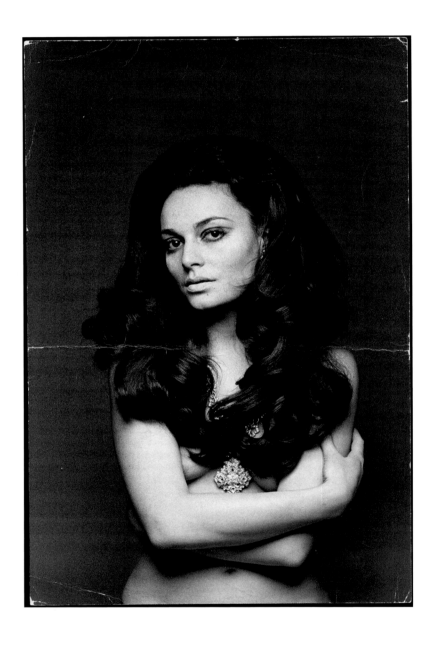
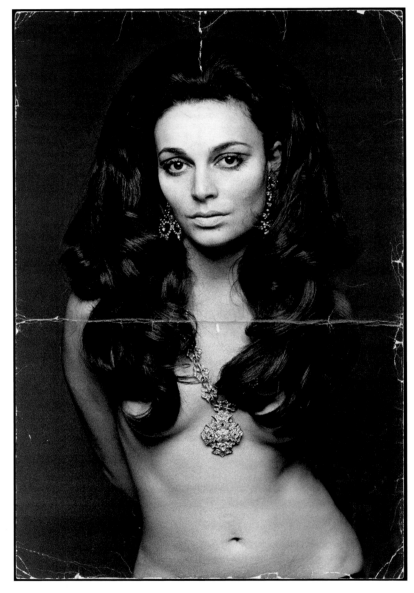

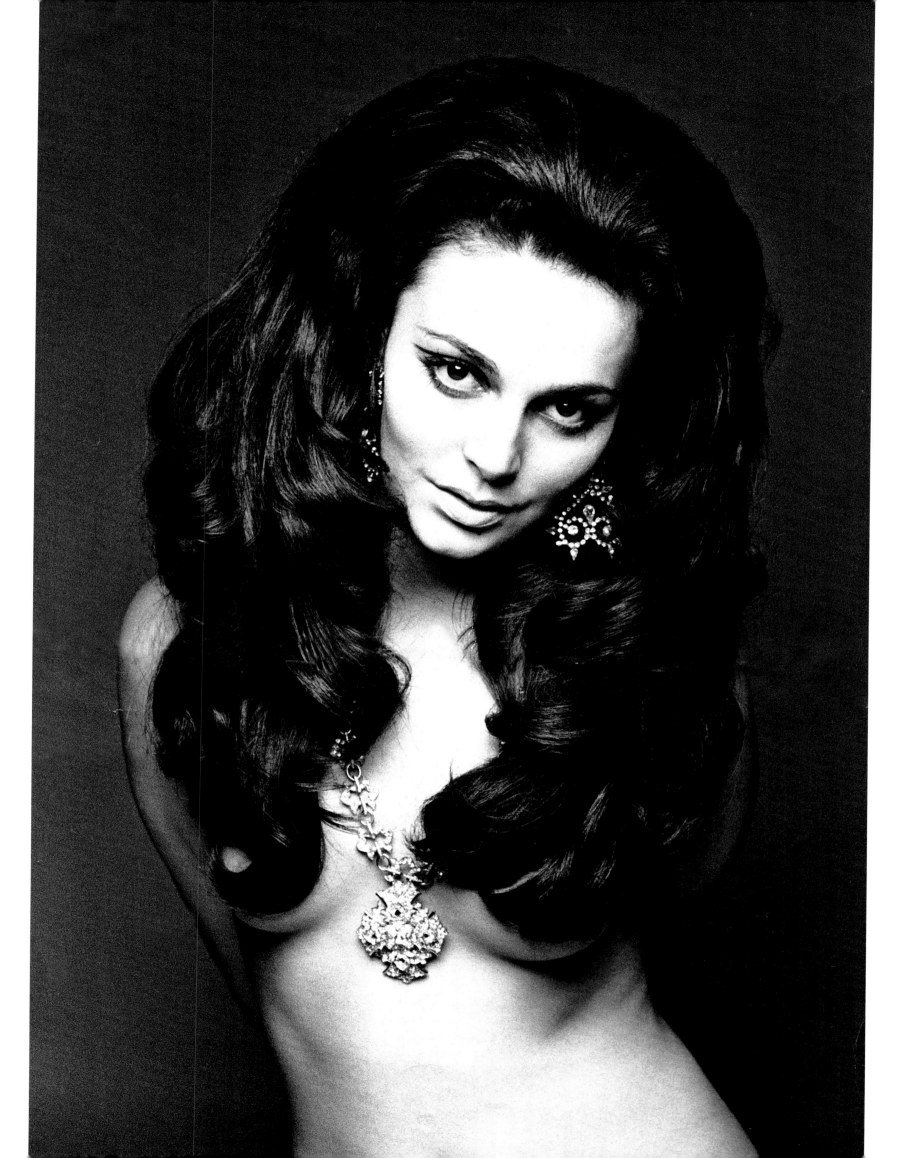

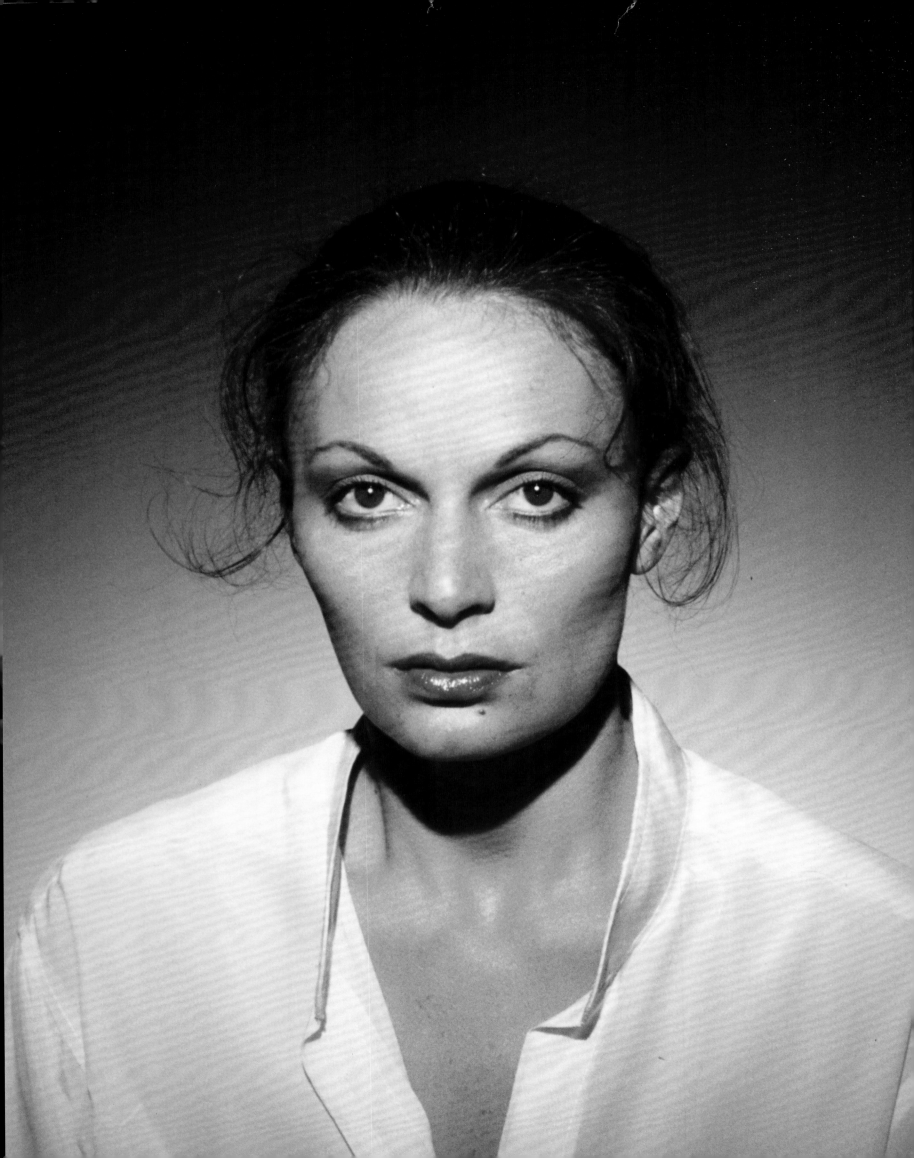

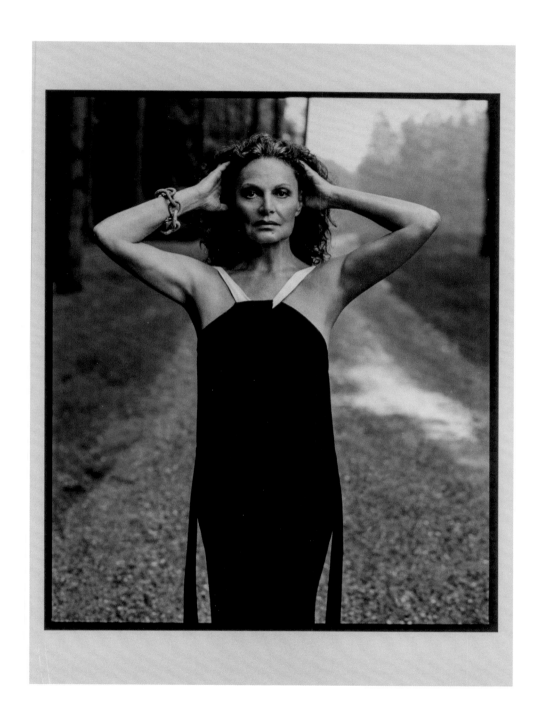

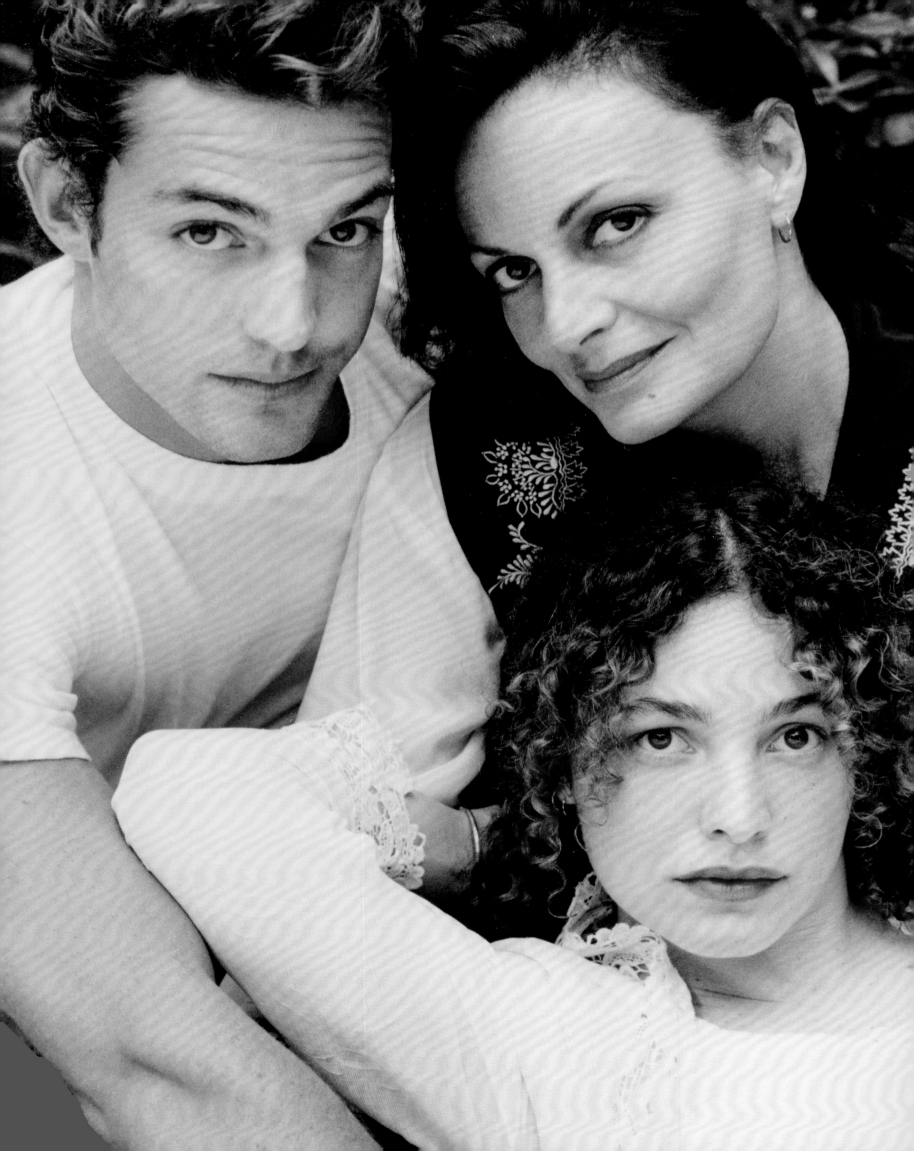

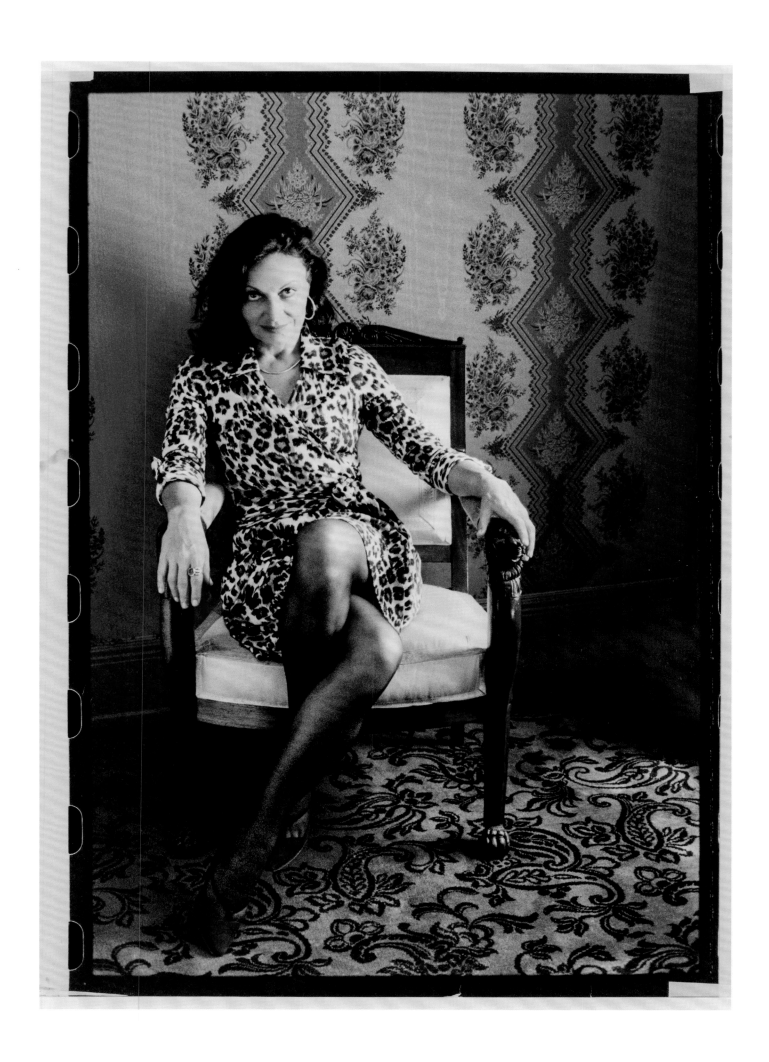

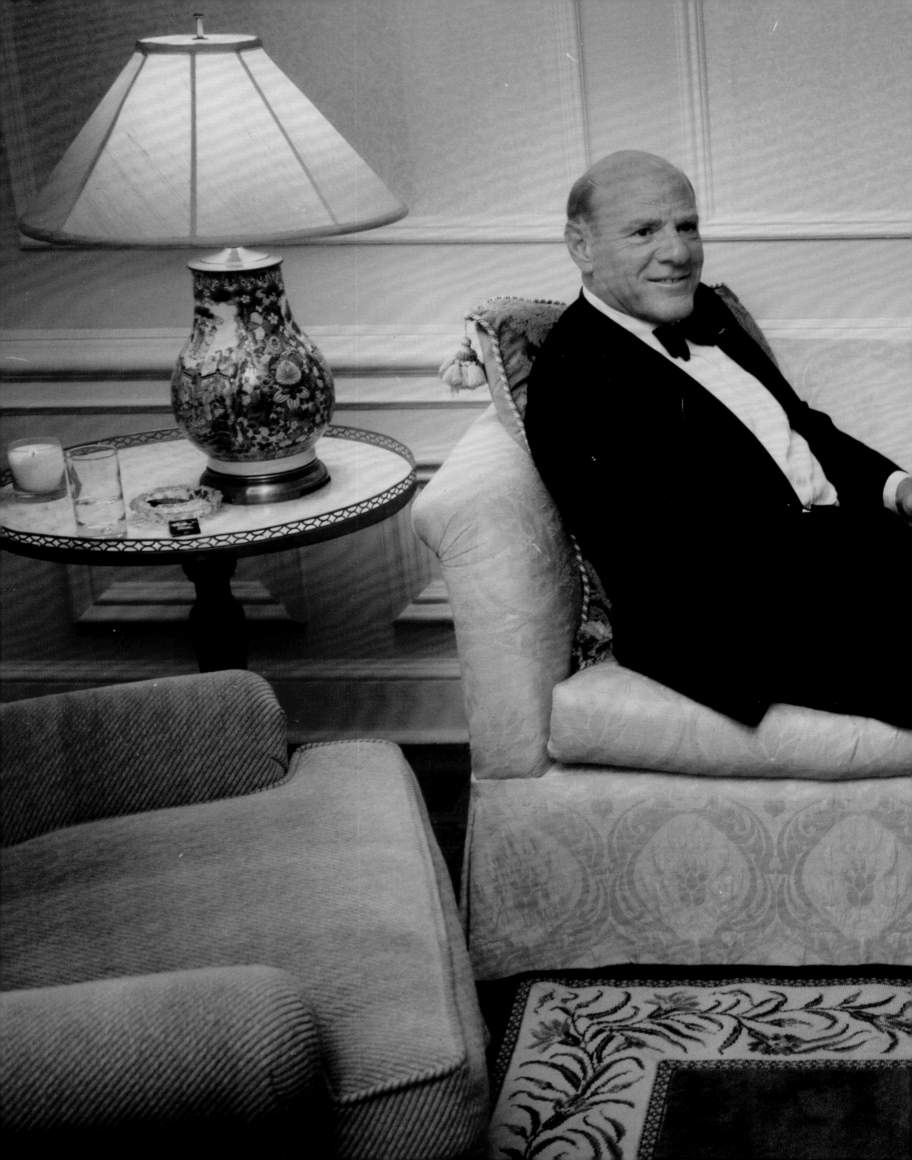

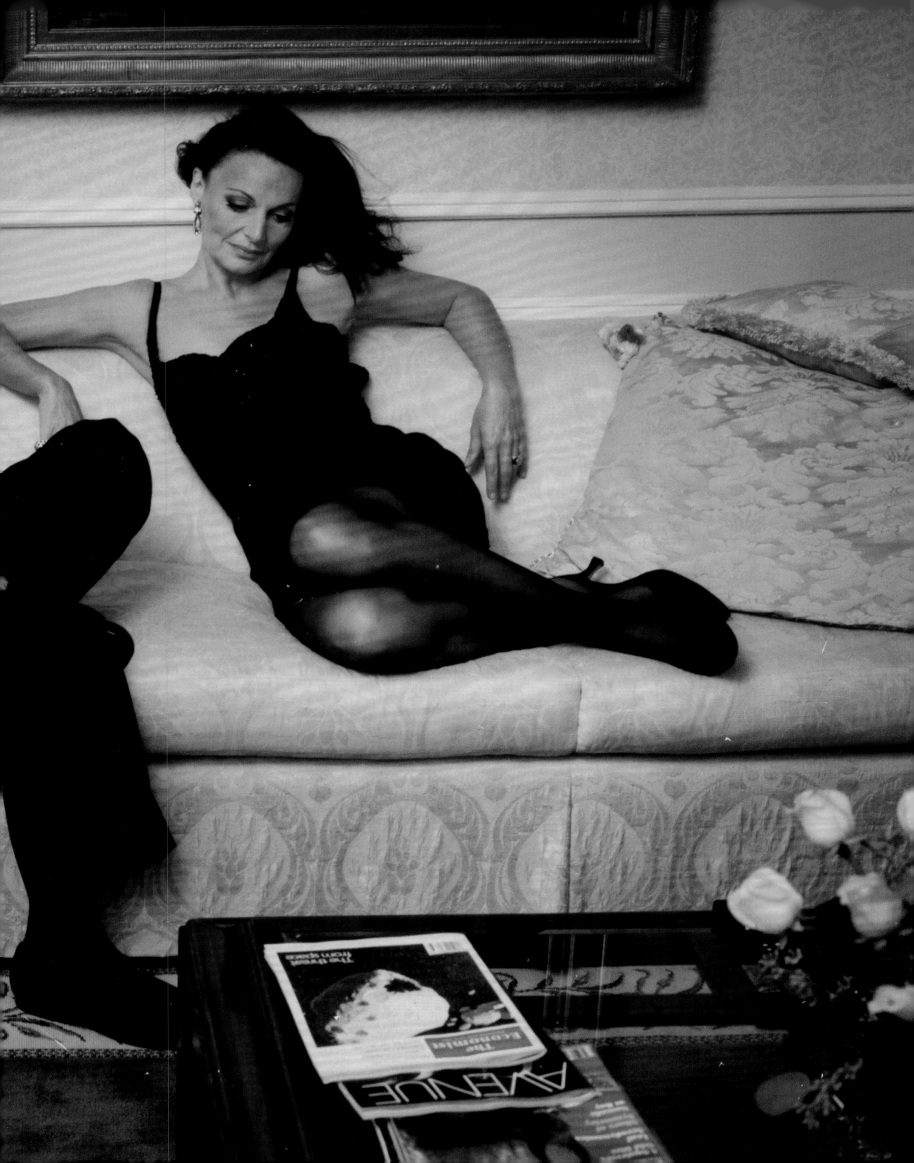

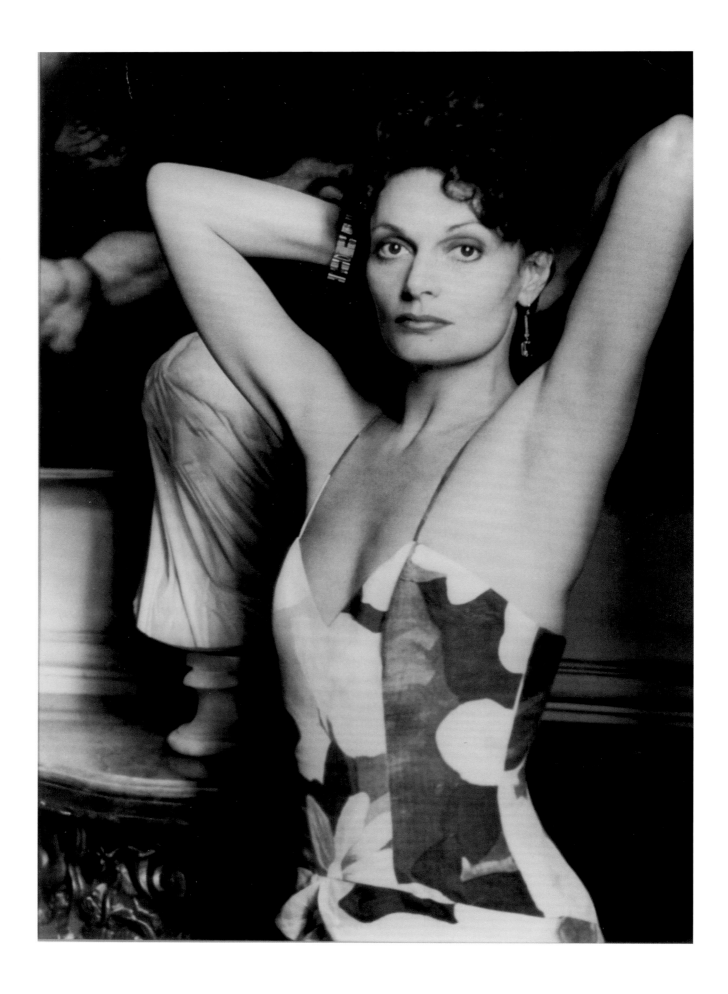

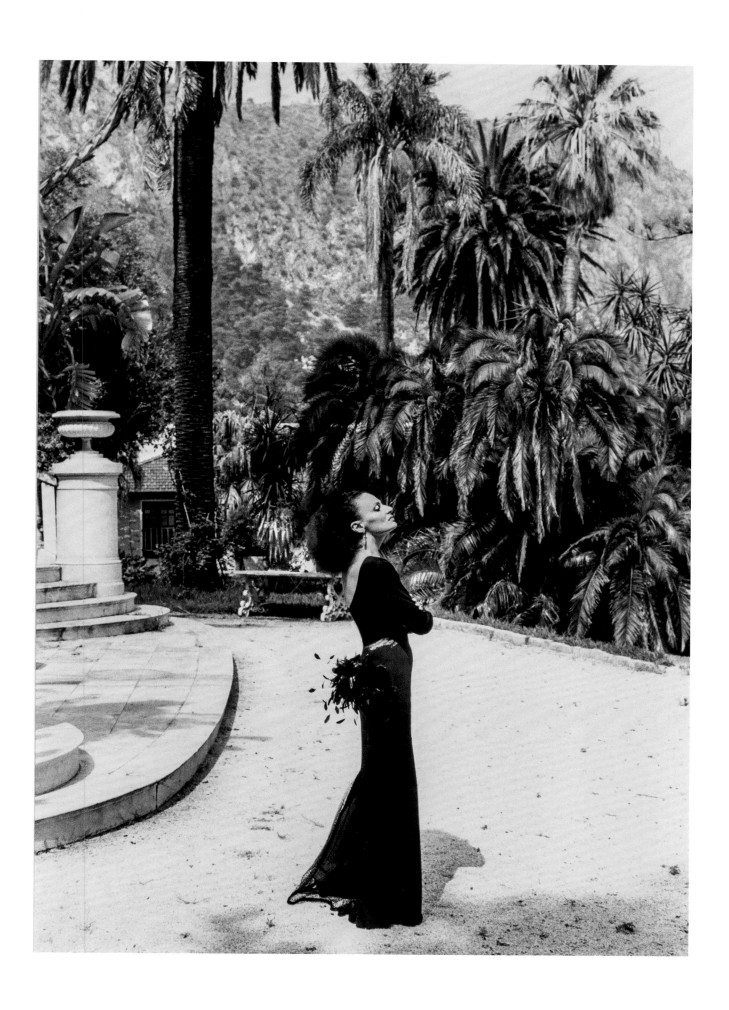

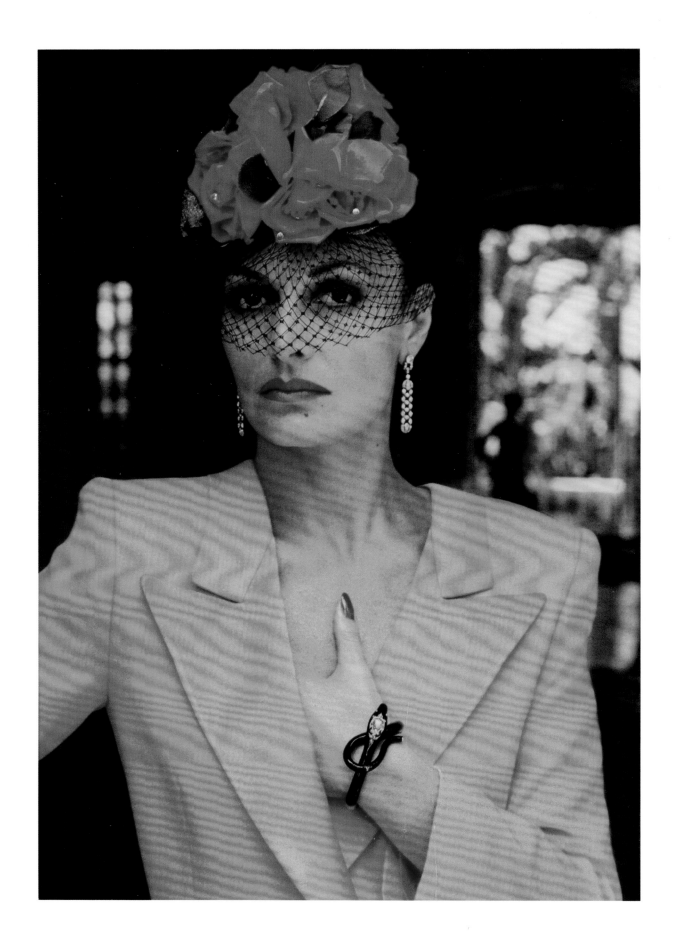

Journey of a Dress

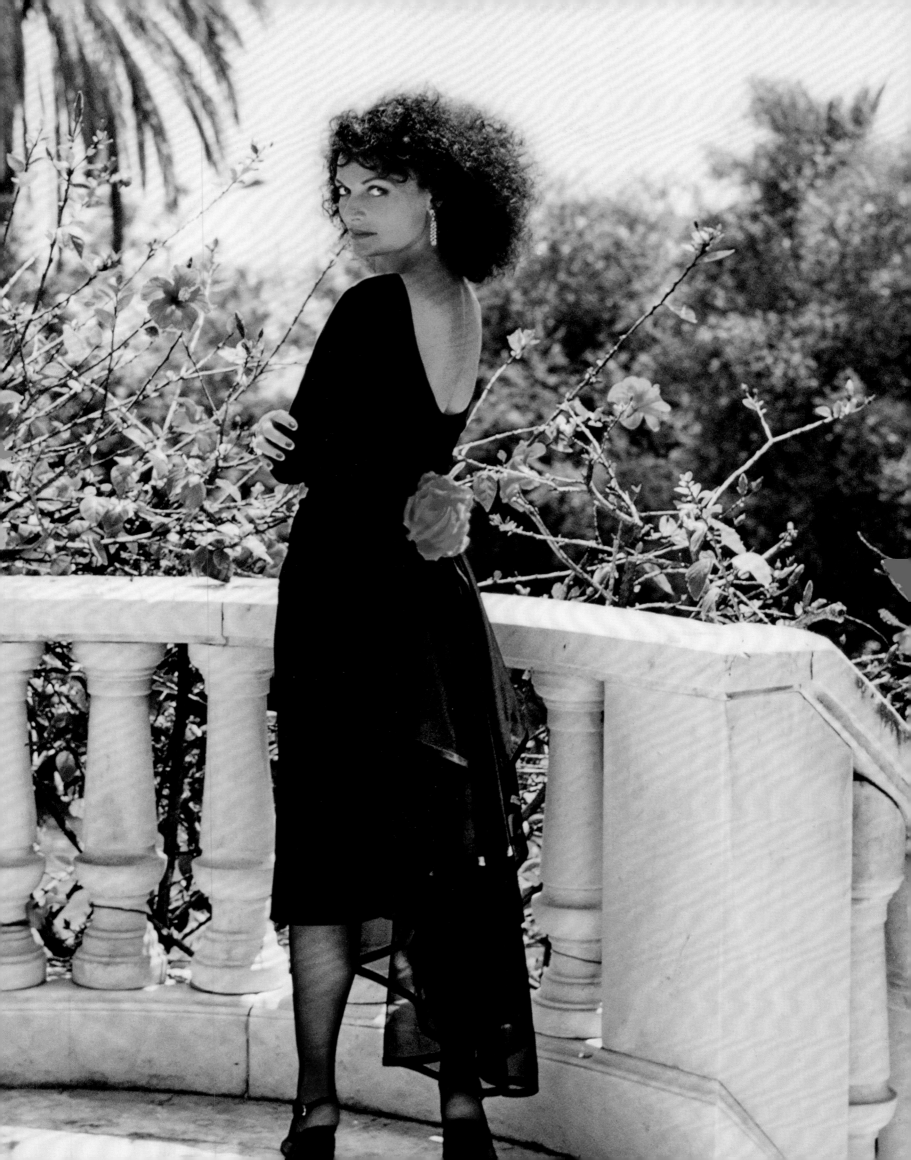

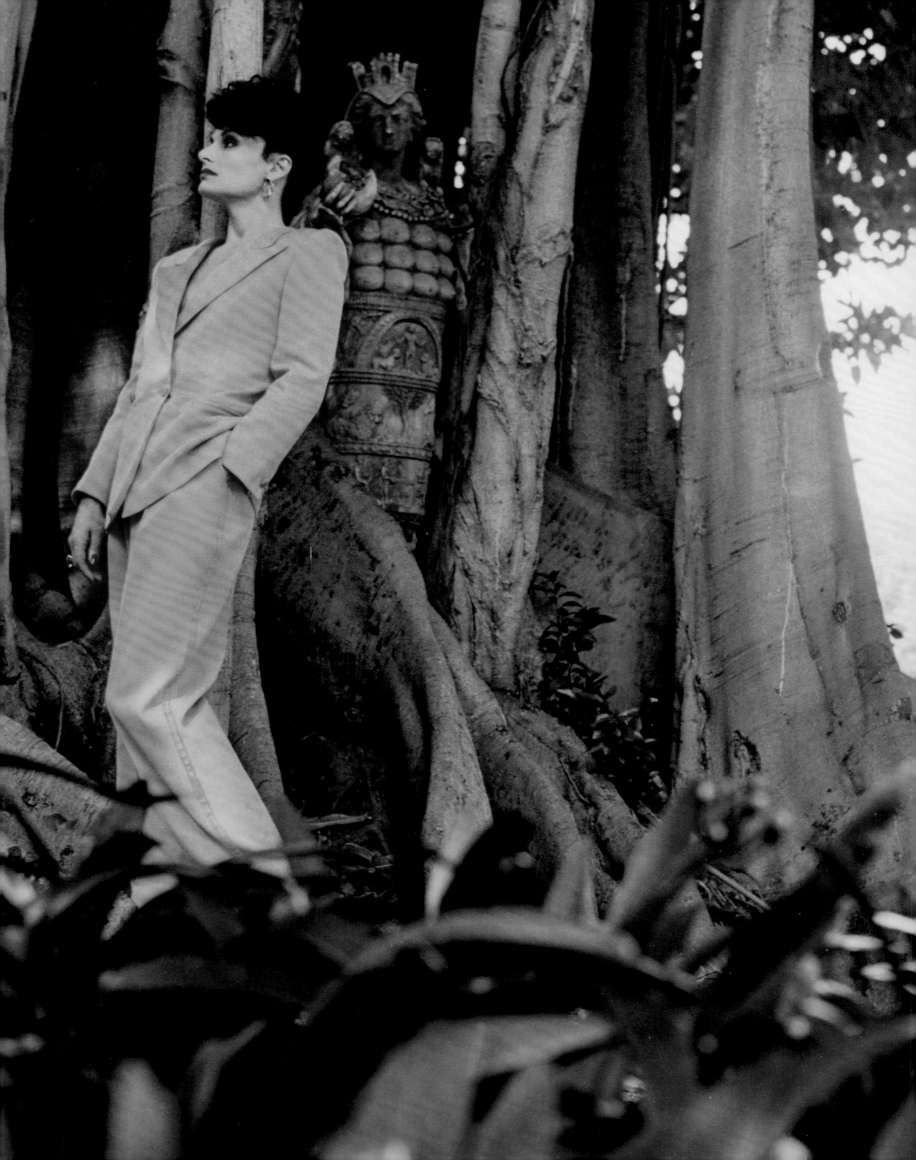

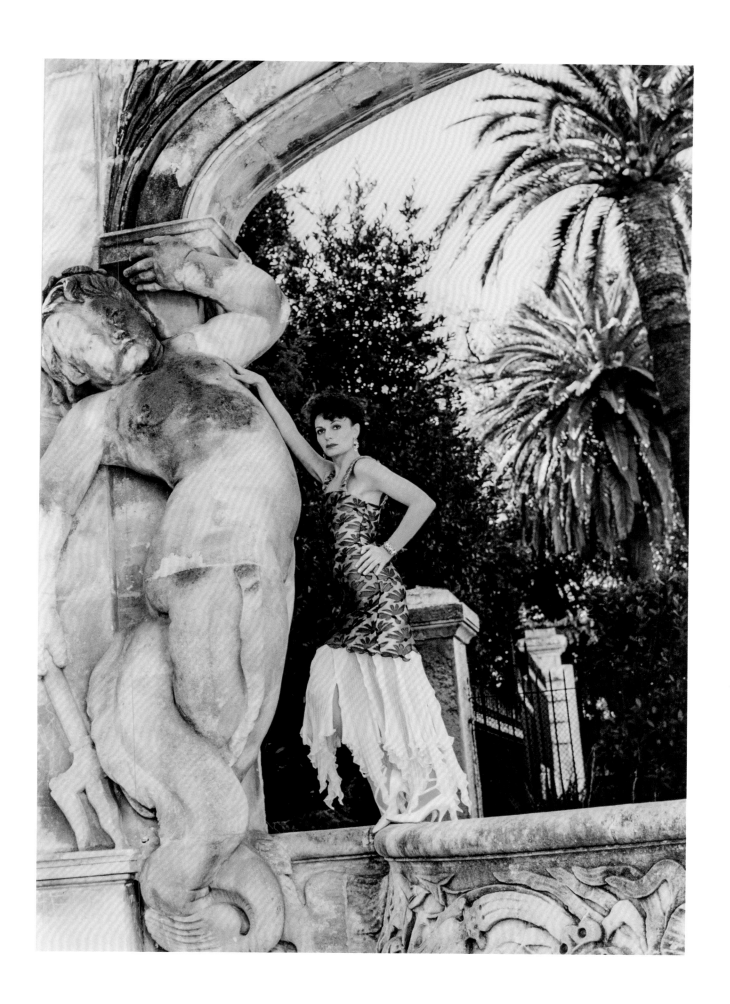

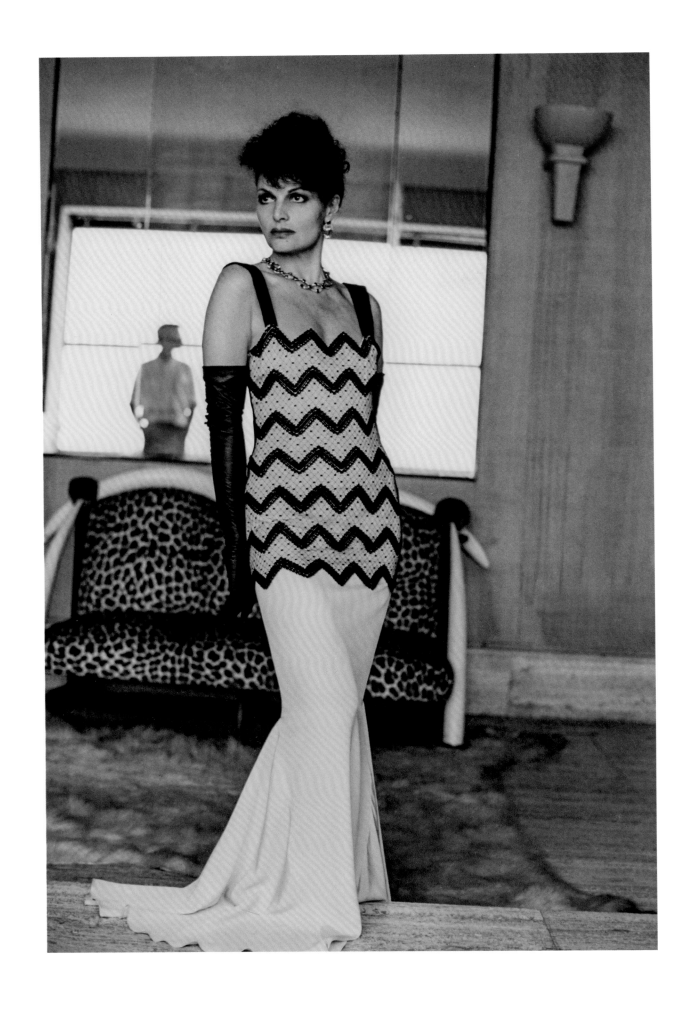

Journey of a Dress

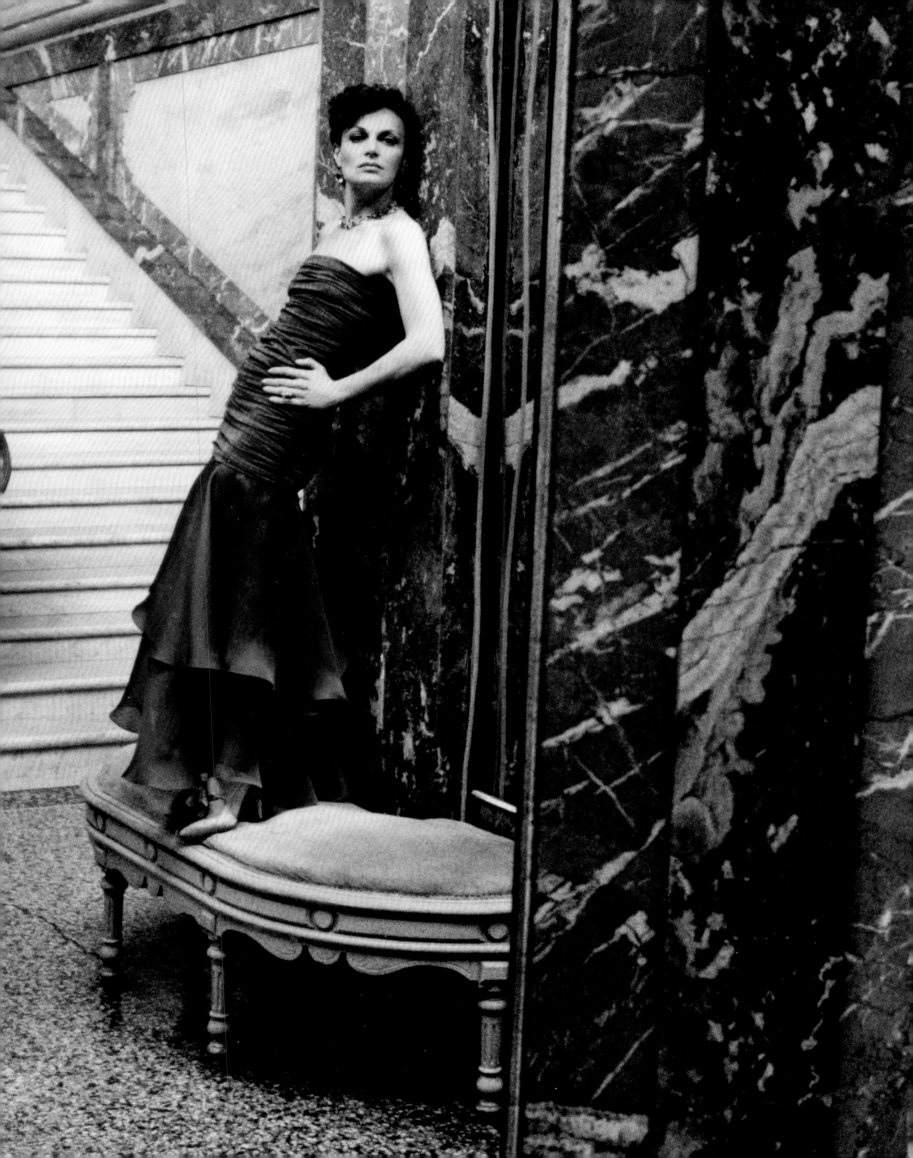

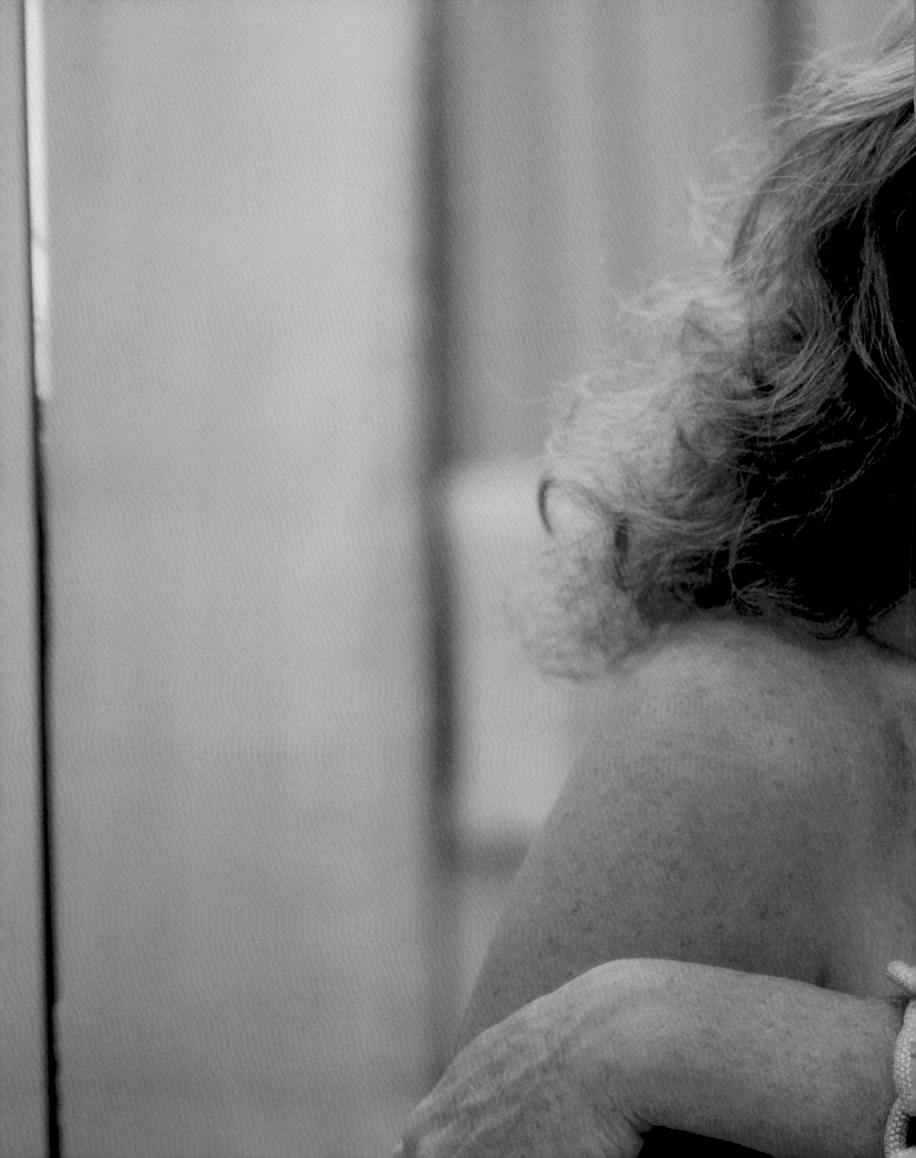

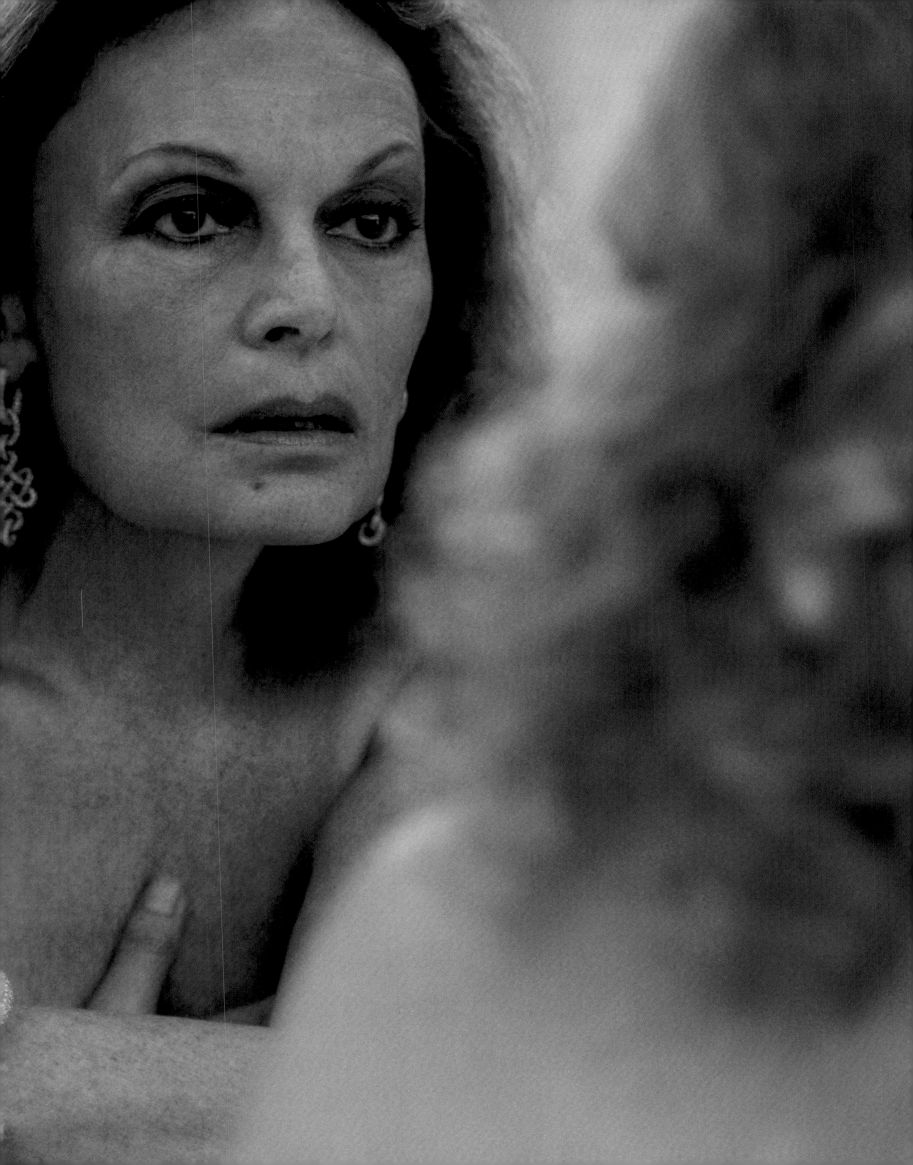

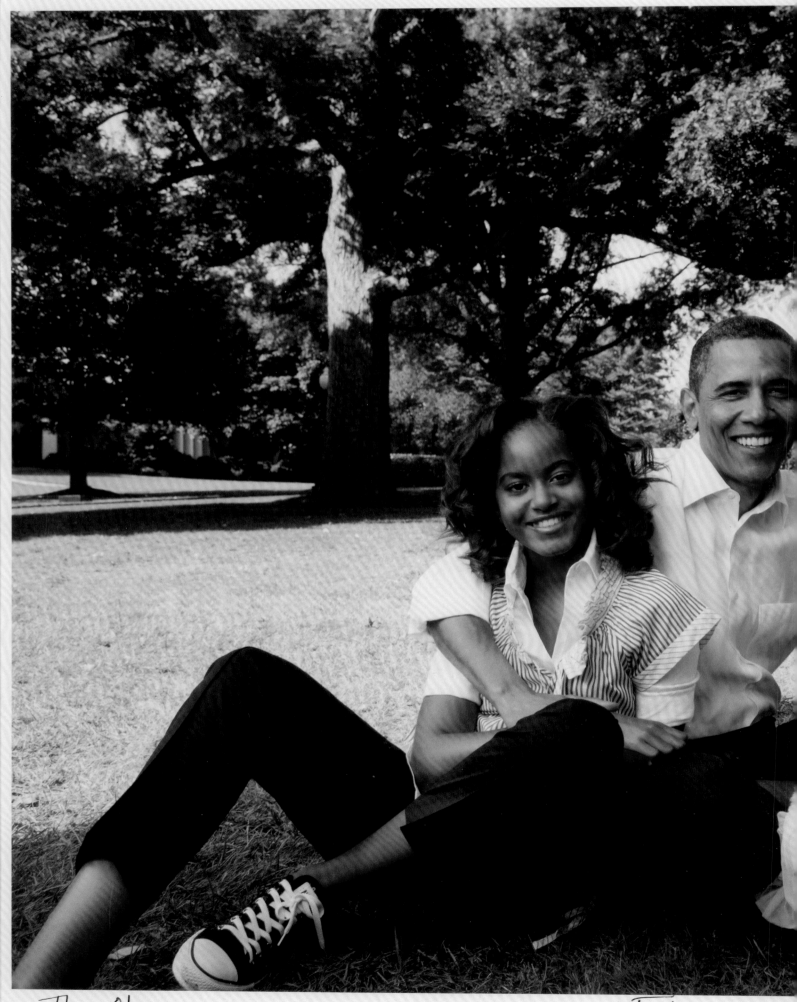

The Obama's *The White House*

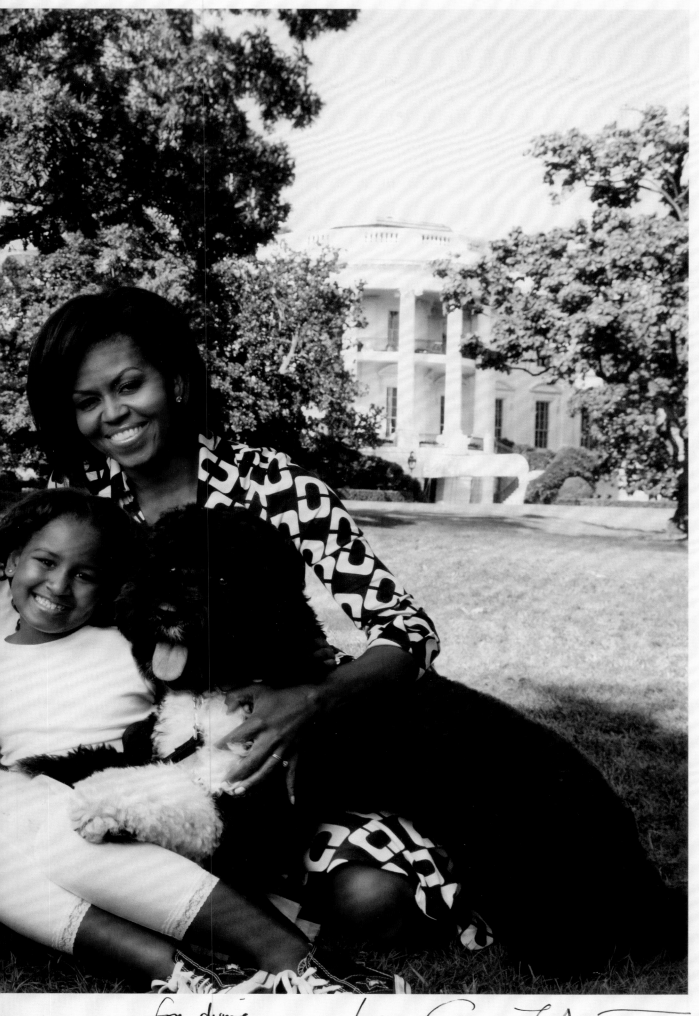

for Diane love, Annie Leibovitz

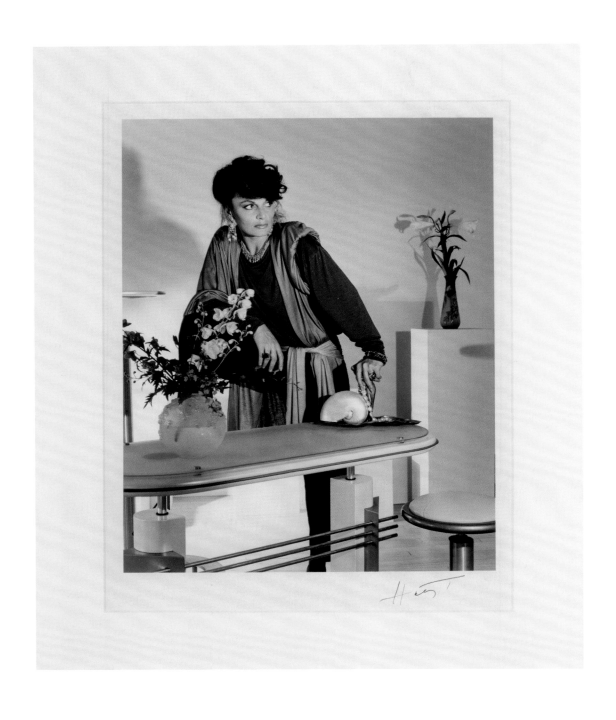

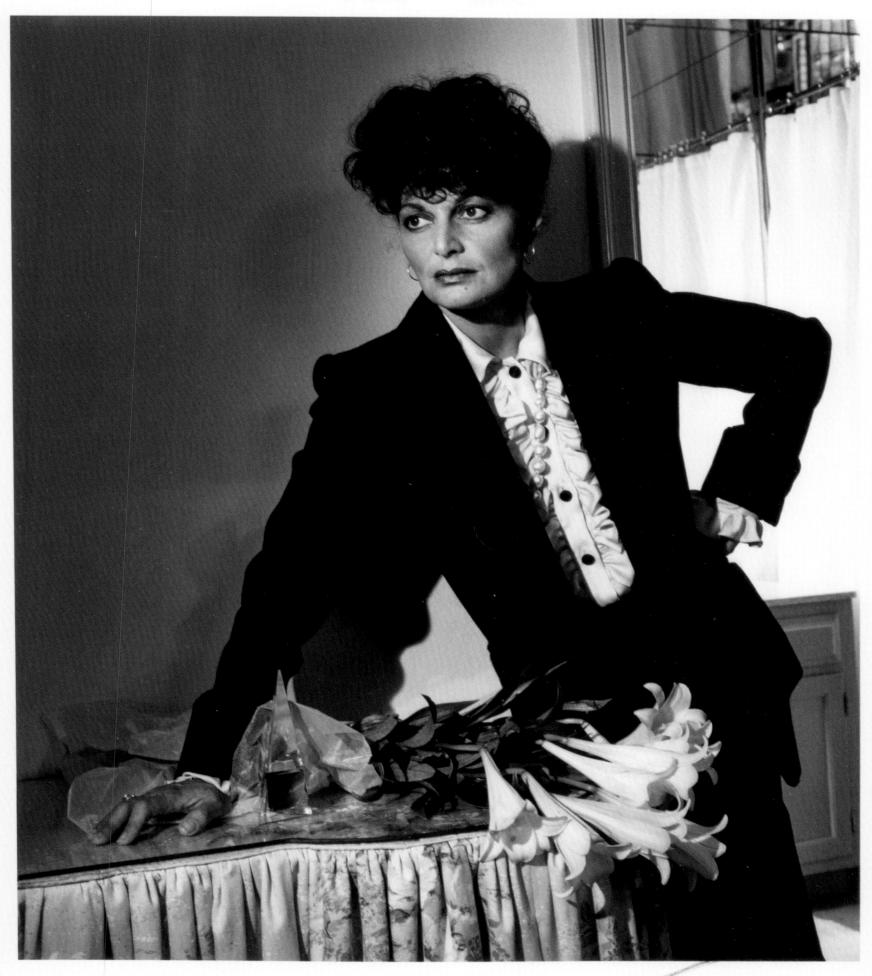

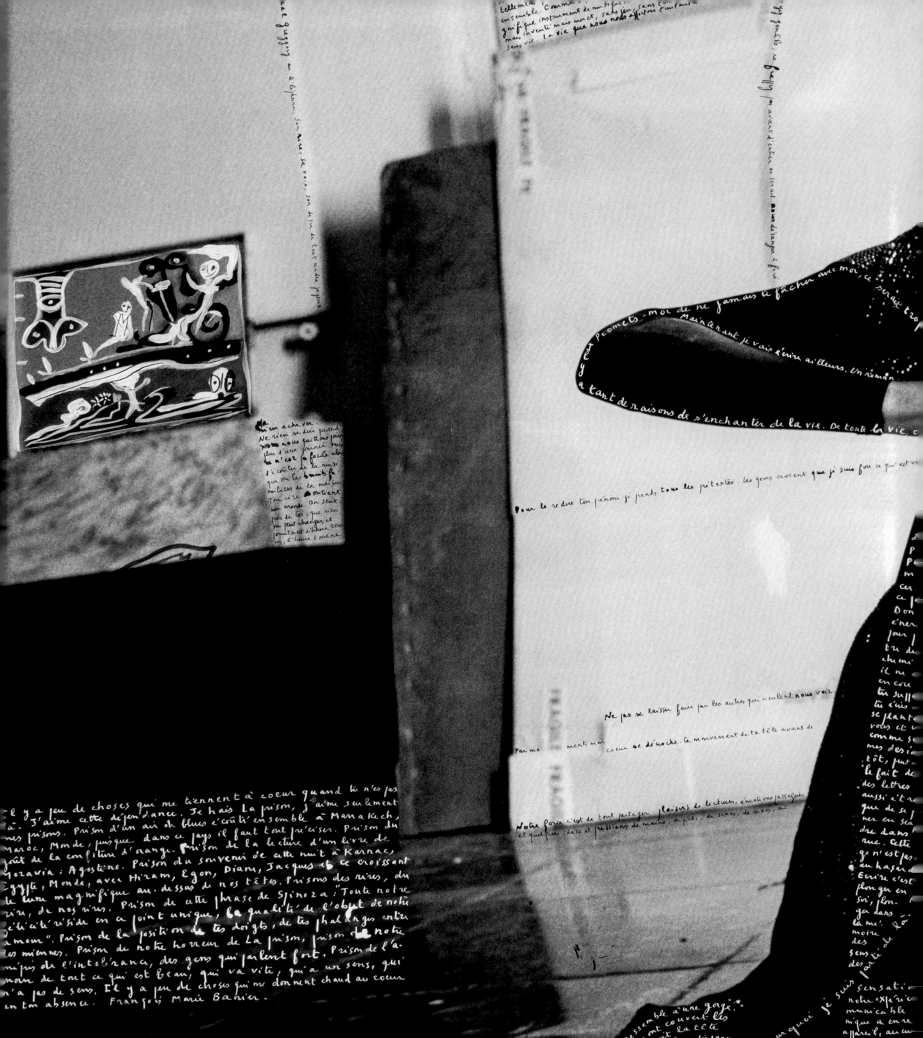

Il y a eu ce moment où, avant de refermer la porte du train, je me suis demandé. Mais pourquoi je descends ? Pourquoi ? Mon Dieu

quelque chose comme une odeur de violettes accompagnait

Nous aimons Carson McCullers

La poésie de Walt Whitman

Banier

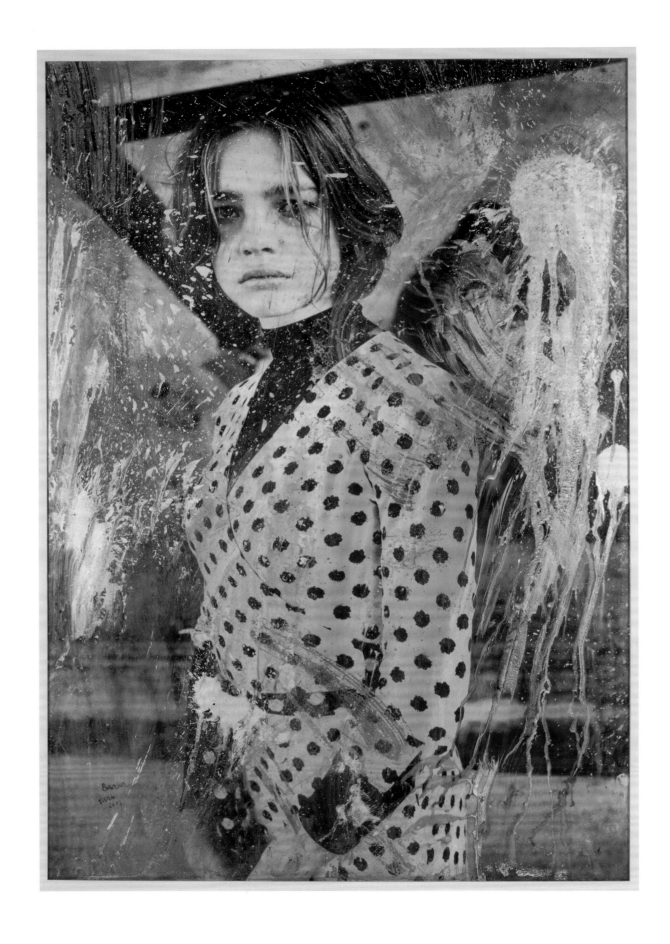

Journey of a Dress

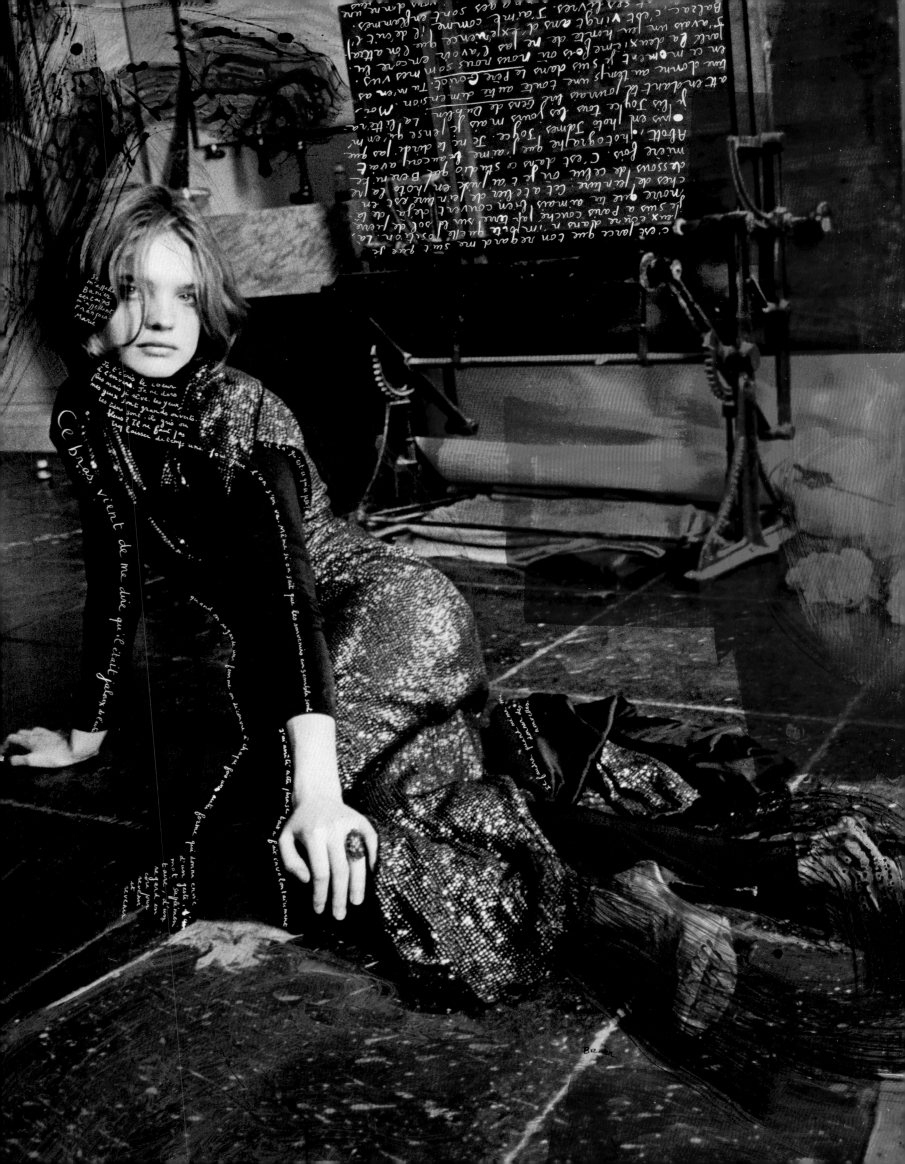

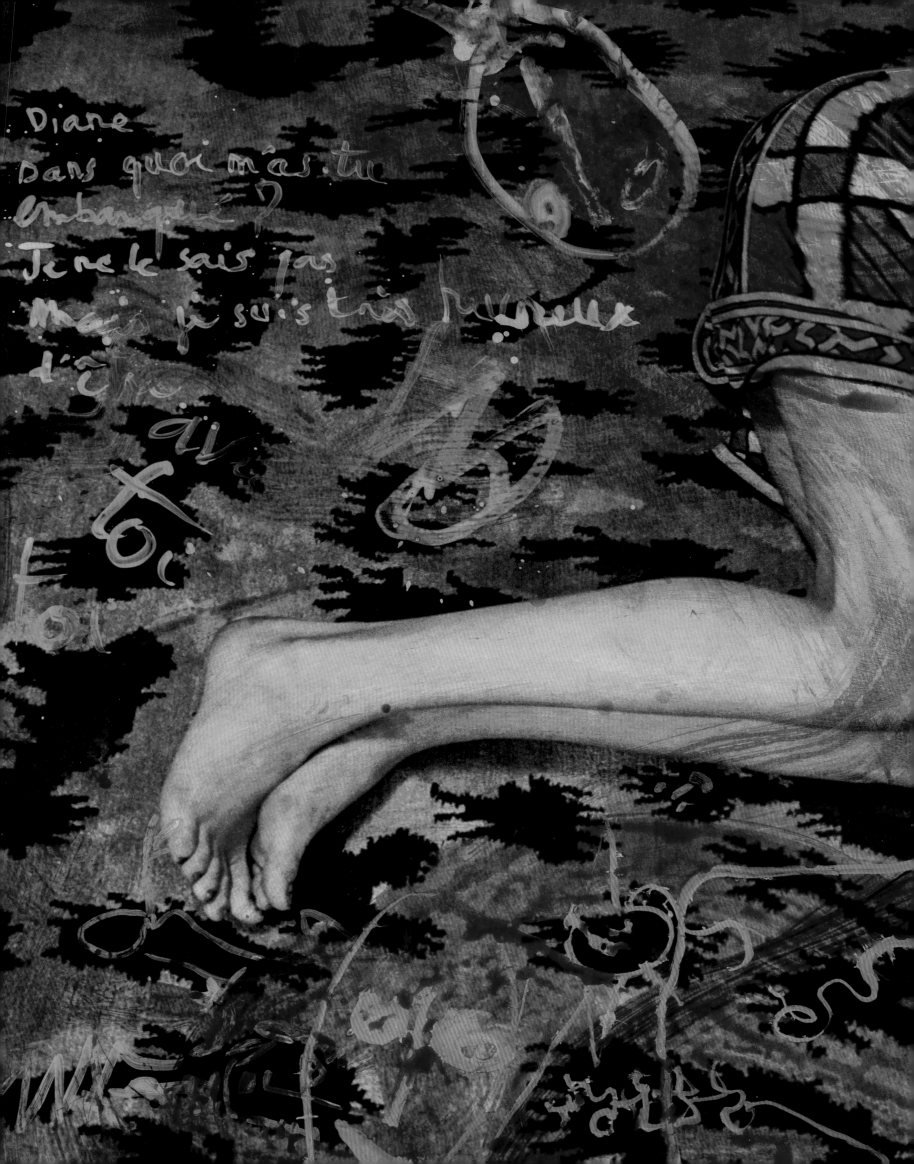

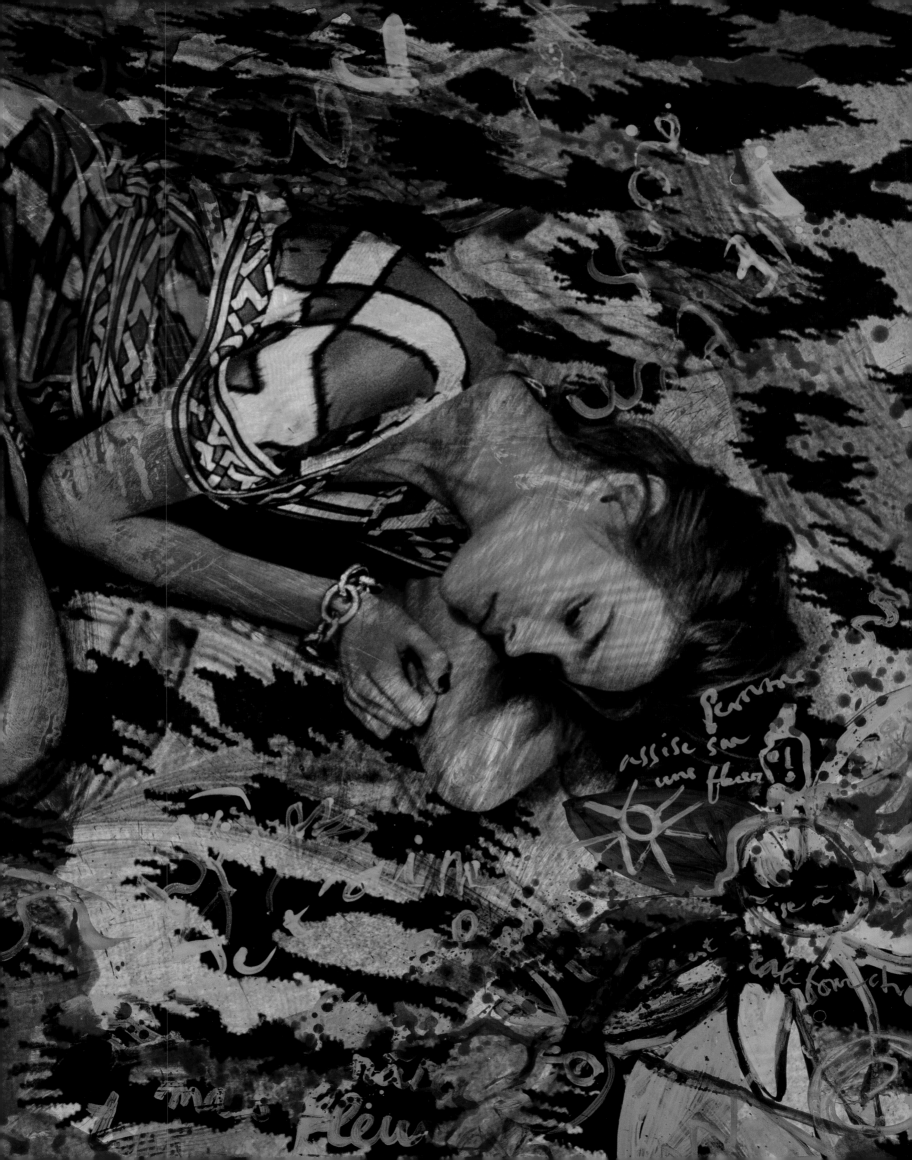

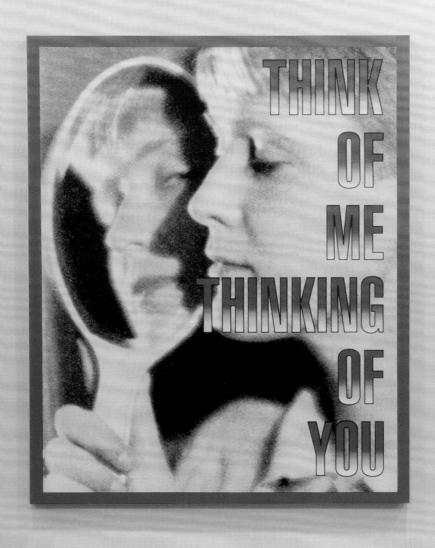

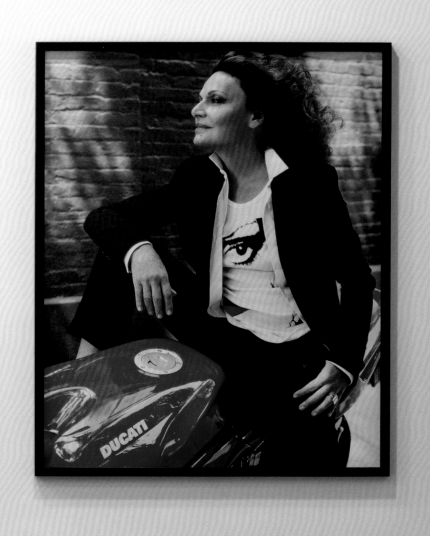

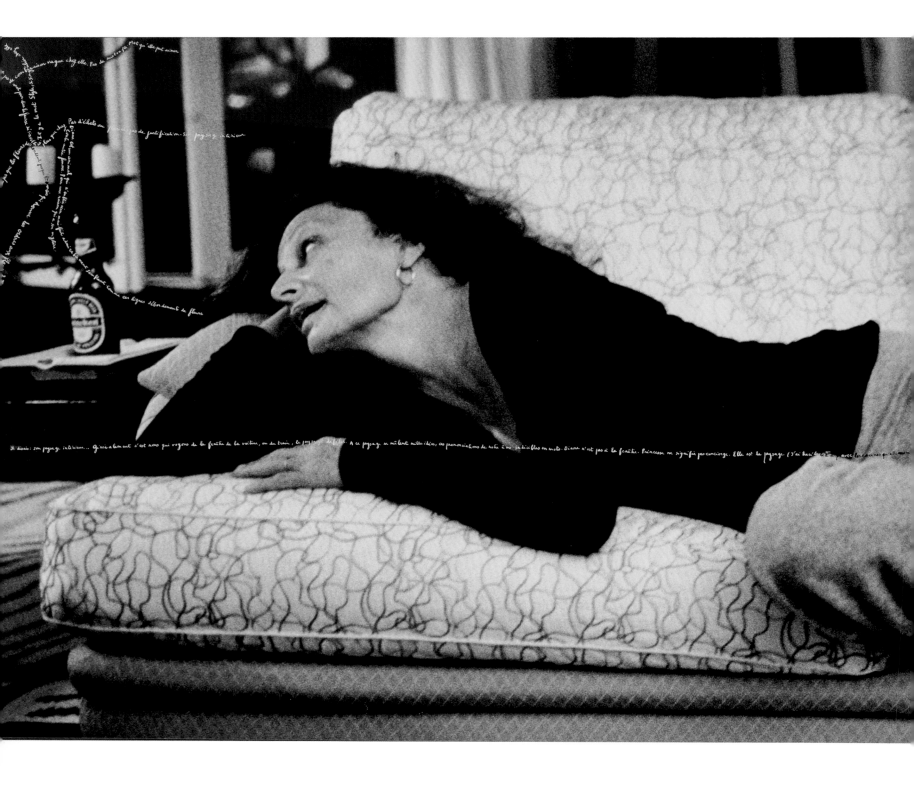

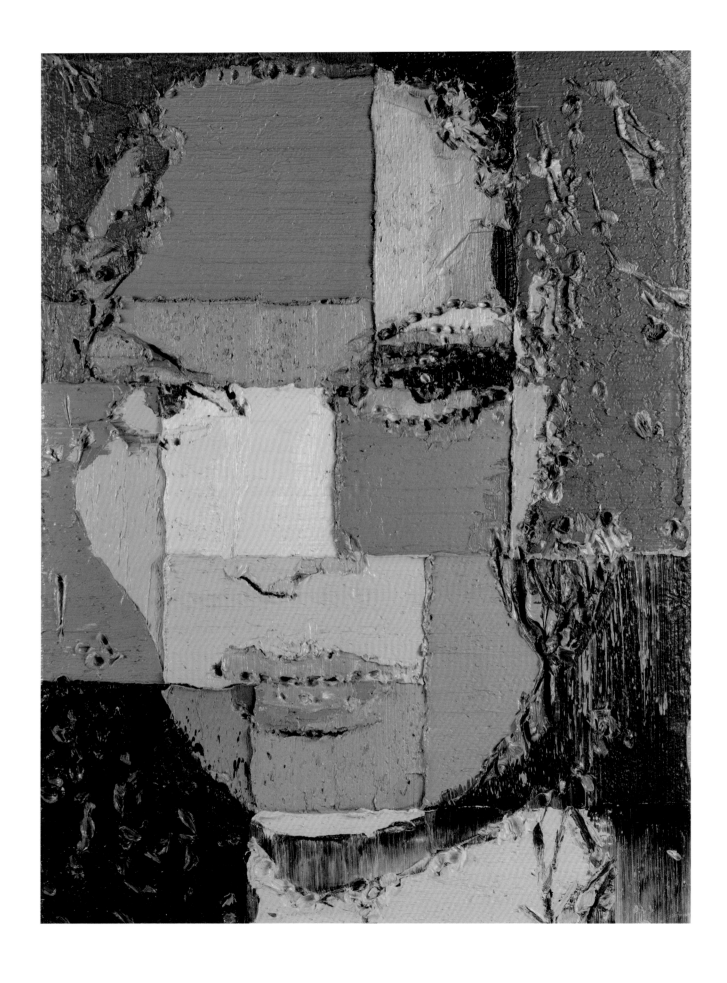

230 Journey of a Dress

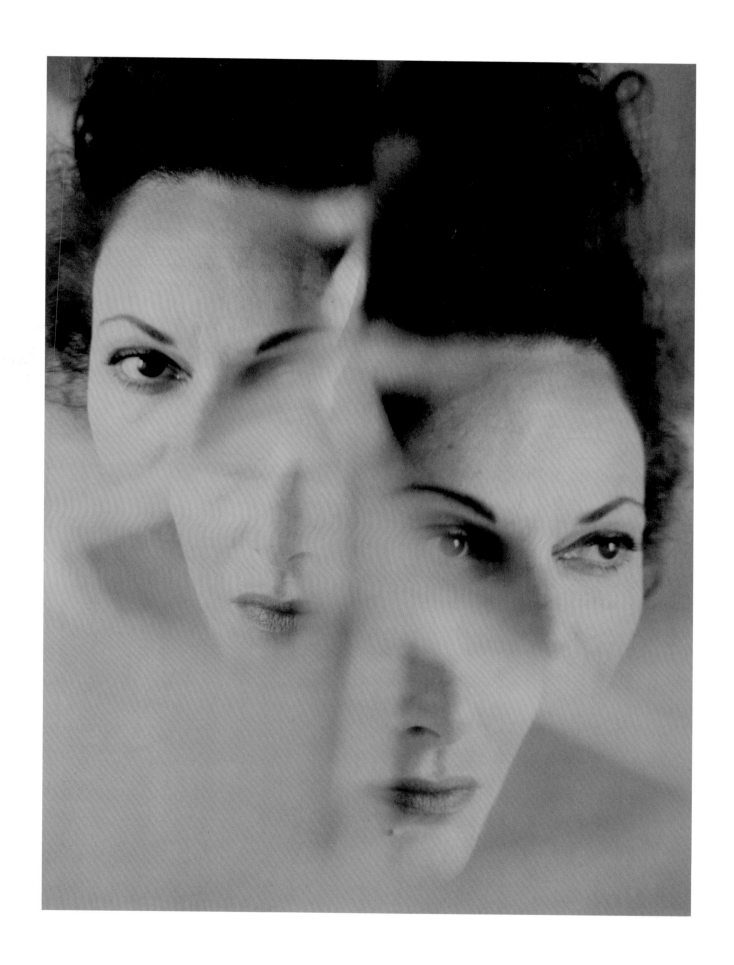

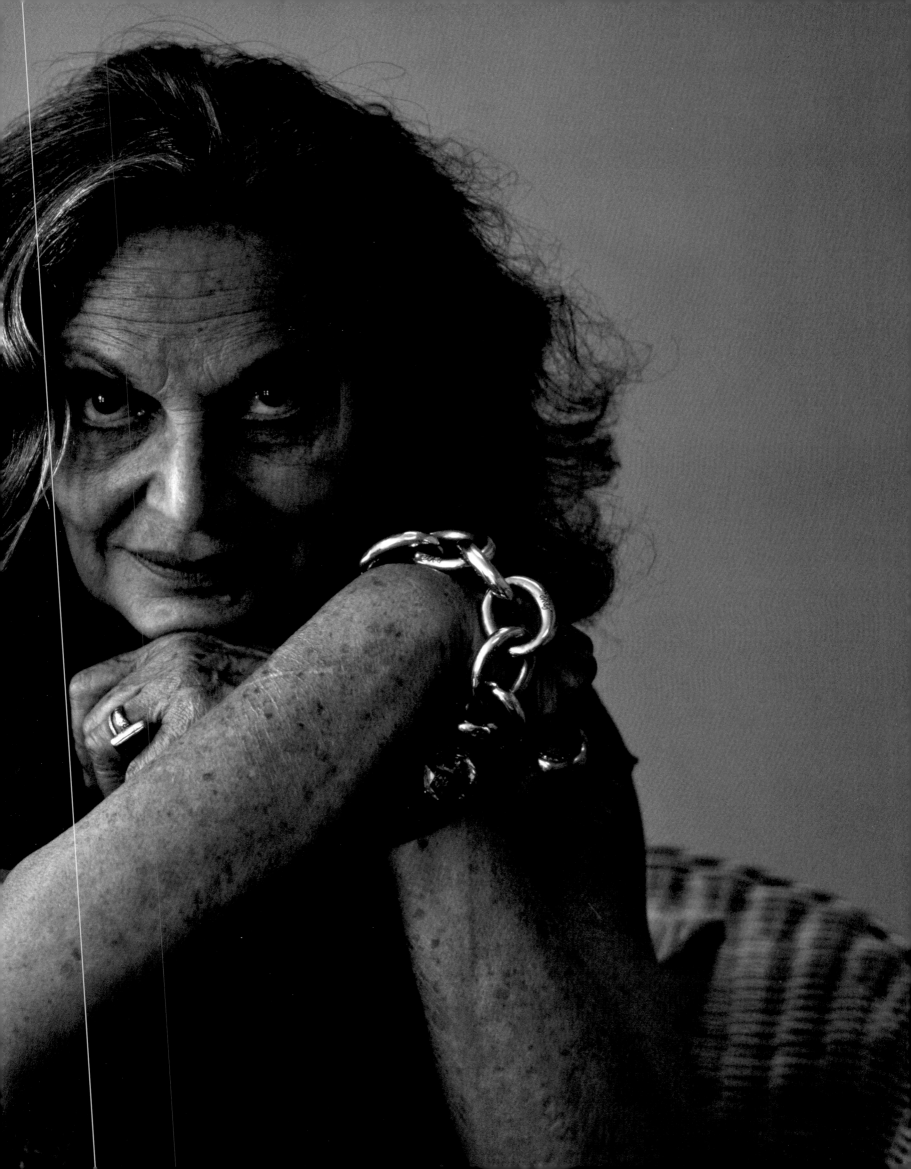

Index

Additional exhibition photography provided by:
Marat Shaya
Samantha West
Joshua White

Acknowledgments

The *Journey of a Dress* exhibition, and this book, would not have been possible without the dedication and hard work of so many people. I am so grateful to Michael Govan at LACMA for suggesting the idea to mount this exhibition at the May Company Building. To Dawn Hudson, Bill Kramer at the Academy of Motion Picture Arts and Sciences, as well as Cheryl Boone Isaacs and its board, for making that happen. I want to thank Bill Katz and Kol Solthon for conceiving of the format for the exhibition, Stefan Beckman for designing the sets, Michael Herz for curating the dresses, Dr. Franca V. Dantes for managing the archives, Luisella Meloni for grand mastering it all with Grace Cha, Eran Cohen, Fariba Jalili, and Anushri Mainthia, and Jeffrey Hatfield for handling the production. A huge thank you to Diego Marini for designing this book, Holly Brubach, Veerle Windels, and Bill Katz for their texts, Liz McDaniel for the captions, and everyone on the DVF Marketing and Creative teams who made *Journey of a Dress* a huge success: Jaclyn Kelly, Tara Romeo, Brenda Greving, Barrett Thomas, Ali Smith, Bethany Freund, Sarah Thompson, Tarida Nimman, Laura Harvey, Kelly Fitzpatrick, Arielle Mason, Lisa Cross, Inga Shoberg, Danny Chung, and Michael Horowitz. Thank you to Charles Miers at Rizzoli for your enthusiasm, Andrew Wylie, my agent, and Christina Burns for hunting for the rights. I would also like to acknowledge Robert Sciasci, Michel Gaubert, Brandon Angle, Jane Burrell, Terry Morello, Ralph Pucci, Andy Cohen, Coco Rocha, Danielle Rago, Sharon Johnson, all of the docents, Hive Social Lab, and Amy Marcus Hollub, who lent me my original wrap! Thank you to Fiat for our wonderful printed 500s—we loved them. To John Hayes and everyone at American Express—thank you for your generous support and for always being there for me! And finally, I want to thank every visitor who came to the exhibition to learn and enjoy the little dress that changed my life, and so many others along the way.

Diane von Furstenberg

Exhibition Team
Exhibition designer: Bill Katz with Kol Solthon
Production designer: Stefan Beckman
Fashion curator: Michael Herz
Archival curator: Dr. Franca V. Dantes
Project manager: Luisella Meloni

Publication Team
Creative direction: Diego Marini
Design assistant: Laura Harvey
Editorial coordination: Christina Burns
Project coordination: Allison Power
Design coordination: Kayleigh Jankowski
Production: Maria Pia Gramaglia
Archival conservator: Dr. Franca V. Dantes
Project manager: Luisella Meloni
Copywriting: Liz McDaniel

Rizzoli International Publications, Inc.
300 Park Avenue South, New York, NY 10010
www.rizzoliusa.com

© 2014 Diane von Furstenberg Studio

ISBN: 978-0-8478-4154-7
Library of Congress Control Number:
2019935208
Printed in Italy

2015 2016 2017 / 10 9 8 7 6 5 4 3 2

Not a wrap

Von Furstenberg is still a force in fashion world

By Lynn Carey
TIMES STAFF WRITER

IT'S 9 A.M., but Diane Von Furstenberg is already tired. She's walking slowly toward the hotel restaurant. She's already taped a TV show — "It was stupid," she says, rolling her eyes — and is ready for sustenance before her next few interviews.

She hates mornings in general, especially when she's doing a publicity tour for her book, which is what brought her to San Francisco last week.

"I don't like putting on the makeup," she says. Her voice is still languorous and has a strong European accent, a bit of a surprise considering she's lived mostly in the United States for more than 20 years.

At 51, Von Furstenberg's striking looks have changed very little since she was crowned one of the Beautiful People in the mid-1970s, thanks to a fairy-tale marriage to a prince that was eclipsed only by her success as a designer. She says she hasn't had any cosmetic work done on her face, though she briefly considered getting the eyes done.

"But I'm so worried about changing my face," she explains. "And I'm also thinking that soon women who haven't had anything done will look more interesting."

Von Furstenberg was in her early 20s when she began dabbling in a fashion career. Newly married to Prince Egon Von Furstenberg of Germany, she hung out with a jet-setting crowd that introduced her to all the

INTERVIEW

WHO: Diane Von Furstenberg
WHAT: Fashion designer and author of an autobiography, "Diane: A Signature Life" (Simon & Schuster, $25, 237 pages)

"When I first started, I was so young. I was just learning how to be a woman. ... I was creating little tools for women to help them be better by themselves."

And now, Von Furstenberg is getting back into the fashion business. The idea of remaking the wraps came when she discovered the original dresses were being snapped up by edgy young girls from thrift shops.

Now the new wrap-dress (it's now silk jersey knit instead of cotton, and a little more snug in the derriere) has made a phoenix-like revival. Costing about $200, it's most often seen on the daughters or granddaughters of the women who originally wore them.

"It's been interesting," she says. "The girls who are most interested in me now are the young girls. Claudia Schiffer came to the office and all she wanted was wrap dresses, because she travels a lot."

The first time around, Von Furstenberg didn't wear the dress, she admits. Her tastes ran more to the shirt dresses she design two-piece wraps.

"But this time, I'm wea wrap dress. I don't know w day she's in a solid navy w a blue-dyed beaver

Wrapp

esigner favored in Kentucky styles are "pro-women"

E'S one dress style that's beuniform for fashionable Kenwomen, it's the printed jersey esigner Diane Von Furstenlike a woman, wear a dress" n on her hangtags, and wome country obey to the tune of a year for her stylings.

the major stores and bououisville are selling her spring r collection of dresses, a real hat's considered a "trouser w has Von Furstenberg been women back into dresses?

started designing, everyone t American women wouldn't s, but I didn't believe that," In a dress, a woman walks sits and acts differently. I felt was a need for a very simple, ress for the woman who can't to the office or to dinner. was right."

the popularity of trousers ith the rise of the women's novement, Von Furstenberg y-clinging dresses as part of on. "Today's emphasis on a body is pro-women. Fashion tal 'F' is over and gone. It n anything anymore. Today's ts to wear what she feels mmicky clothes don't mean ore because women are more themselves. They don't hide clothes.

do dress for men, and men lothes that are too fancy. dress they can see the woman ciate her legs and her figure. y legs myself, and I like to

her, who turned 30 recently, 20s were "a nightmare."

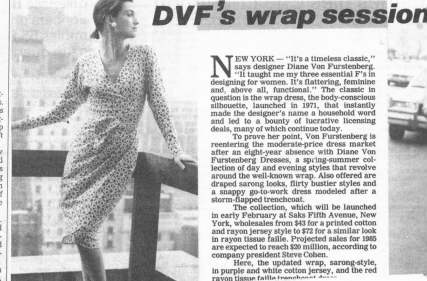

NEW YORK — "It's a timeless classic," says designer Diane Von Furstenberg. "It taught me my three essential F's in designing for women. It's flattering, feminine and, above all, functional." The classic in question is the wrap dress, the body-conscious silhouette, launched in 1971, that instantly made the designer's name a household word and led to a bounty of lucrative licensing deals, many of which continue today.

To prove her point, Von Furstenberg is reentering the moderate-price dress market after an eight-year absence with Diane Von Furstenberg Dresses, a spring-summer collection of day and evening styles that revolve around the well-known wrap. Also offered are draped sarong looks, flirty bustier styles and a snappy go-to-work dress modeled after a storm-flapped trenchcoat.

The collection, which will be launched in early February at Saks Fifth Avenue, New York, wholesales from $43 for a printed cotton and rayon jersey style to $72 for a similar look in rayon tissue faille. Projected sales for 1985 are expected to reach $20 million, according to company president Steve Cohen.

Here, the updated wrap, sarong-style, in purple and white cotton jersey, and the red rayon tissue faille trenchcoat dress.

International Herald Tribune

PUBLISHED WITH THE NEW YORK TIMES AND THE WASHINGTON POST

Edited in Paris Tuesday, December 1, 1998 Printed in New York

It's a Wrap: The Image of an Era

The Charmed Lives and Free Spirit of Diane Von Furstenberg

By Suzy Menkes
International Herald Tribune

LONDON — Like the pussycat she resembles, with her feline face, purring voice and glossy hair, Diane Von Furstenberg seems already to have lived at least nine lives.

There was, famously, the glamorous wife, who married Egon von Furstenberg, a scion of the Agnelli family, in 1969, turning the golden couple into dedicated members of European jet-set society. That was followed by the 24-year-old New York fashion tycoon, whose sinuous dresses, wrapping the body, expressed a new era of sexual and social freedom. Their creator won out over President Gerald Ford for a cover of Newsweek in 1976, as "the most marketable female in fashion since Coco Chanel."

Then there was the cosmetics queen in her purple showroom, business woman by day, wild young divorcee at night, arriving at Studio 54 in cowboy boots to pick out likely studs, while on weekends, she was a single mom mopping up Rice Krispies at Cloudwalk, her 150-year-old Connecticut farm.

In 1983, Von Furstenberg sold for $22 million the beauty business that had been founded on 12 cotton knit dresses and $1,000 13 years before, and reinvented herself: first as a sarong-wearing hippie in Bali (with handsome Brazilian, Paulo), then as an intellectual among the Paris literati (with an Italian novelist).

In the 1990s (are you still following?), she was back in fashion, selling $750,000 worth of silken separates in 15 minutes on a television shopping channel owned by Barry Diller, her former lover, best friend, the man who gave her "29 loose diamonds in a Band-Aid box" for her 29th birthday and whom she calls "the pillar of my life."

After her landmark 50th birthday in 1996, she was back to selling the revived wrap dresses to the daughters and granddaughters of her first customers, helped by her daughter-in-law Alexandra, who was one of the

Diane Von Furstenberg: "There is a side of me that has to have a window

easy to read "Diane, a Signature Life" (Simon and Schuster) as the story of a woman defined by her current man. That, she says, is how her children — Alexandre, 28, and Tatiana, 27 — tease her: a mom who changed "paraphernalia and decor" according to her partners. Part of her yearns to be carried away on a tide of passion like Anna Karenina or Emma Bovary, she says. But that doesn't quite fit with the dynamic dress tycoon, nor as a description of her freewheeling independent spirit.

"So much of me is a contradiction," says Von Furstenberg. "But after having done this book I realize that I commit myself to work or to relationships, but I like to have the illusion that I am free. There is a side of me that has to have a window to escape."

That is expressed by a haute-Bohemian style ("Bohemia Luxuria," she calls it) and a joy in being on the road, whether the current book-promotion tour, a recent trip to Uzbekistan or an affair that ends with "pack and go."

There is no doubt that her dresses caught a fashion moment, as the angular, geometric miniskirts of the 1960s melted into the softer, wispier 1970s. Von Furstenberg now realizes

both men and women recall events associated with the clothes.

"Looking back I am amazed at how much, by accident, it touched people," she says. "They all have a vivid souvenir of who they were at that time."

Although the book (Von Furstenberg calls it a "business memoir") is light on descriptive images, there are vignettes of Talitha Getty dancing under the stars, of Henry Ford 2d trying on one of her orange caftans and of the author stepping out in the 1970s on platform shoes with tiny hot pants under an Yves Saint Laurent blazer. That was after she and her friend Marisa Berenson had ironed their frizzy hair flat.

HER descriptions of famous social events are frustratingly feeble: At the Proust ball held by Marie-Helene de Rothschild, "people had made a big effort to dress up." Other remarks seem bathetic, like the "terminal damage" done to her new shoes on a wet White House lawn while attending the signing of the Camp David peace accord, or recording that she shared with Jacqueline Kennedy Onassis not only a recent battle against cancer, but also "the same hairdresser, Edgar."

Von Furstenberg Leaves The Wrap-Around Behind

By JENNIFER SEDER

DIANE VON FURSTENBERG'S million-dollar baby has been put to bed. The historic $86 wrap dress that made millions for the princess-turned-designer in the early '70s is noticeably not included in her fall collection.

Furthermore, the designer whose price tags still announce, "Feel like a woman, wear a dress," is for the first time planning to include pants, sportswear and business suits in her spring collection.

Why the changes?

Ms. von Furstenberg shrugs. Making a personal appearance at a store in Westwood near Los Angeles, she

other things. Also, a lot has bee happening to women and tudes in the past several ye are feeling more secure, bo capable of looking glamoro ferent ways. They don't comfort of knowing their c filled with dresses they can around once and then co world."

Ms. von Furstenberg, dau Belgian electronics distrib made international headli she married Prince Egon stenberg of Austria, is loo von Furstenberg. Her fac still mirror the glossy, photo attached to her dress as always for her business

HOUSTON, TX.
CHRONICLE
D. 425,560 — S. 528,000
HOUSTON METROPOLITAN AREA
MAR 23 1989

Unwrapping the wrap dress

Von Furstenberg revives ...le that made her famous

By KAREN KANE
Houston Chronicle

Dianne Neidigk drove in from Tomball. Lisa Miller stopped by on her lunch break from Texas Commerce Bank. Naomi Barton didn't have time to try on a dress but had to introduce herself to Diane Von Furstenberg, nevertheless.

"I was one of your first customers," Barton told Von Furstenberg. "I wore it for years. It cost $86. Then my daughter wore it. I still have it. I love it."

The occasion was Von Furstenberg's appearance at Foley's marking her return to fashion design. Now the sole owner of her licensing business, Von Furstenberg has brought back the wrap dress that made her a phenomenon of the '70s and put her on the cover of Newsweek magazine in 1976.

Still as slim as she was 13 years ago, Von Furstenberg is wearing one of her short cotton jersey print dresses, her curly hair frizzed by the Houston humidity.

"It took some humility to come back," she confessed.

Like others, she had signed her name to licensing agreements that were less than satisfactory. But now, she said, "I've regained control of my designs. I'm now responsible for the quality and the look. What I don't want is to look like a Gloria Swanson rerun.

"But it's less fun than I thought it would be. I needed some time away from fashion. I was becoming a

"It's the fabric that makes these dresses great. And t simple," Diane Von Furstenberg tells Lisa Miller.

fragrances.) Miller waits to be "wrapped" by Von Furstenberg.

"Ah," said Von Furstenberg. "Let's see, yes, like this. You have a perfect body. It looks great.

"The dress shows yo

New York designer Diane ...berg says that in dresses, ... sit and act differently.

correctly into your life. You makes a woman attractiv active, a participant."

It was once traumatic fo see another in the same d print, but today the dupli with Von Furstenberg. "It ognition of a product that serves your purpose," she mind if I go to the theater women in my dresses and offs [copies], too."

14 FASHION RTW/SPORTSWEAR

DIANE WRAPS — AGAIN

NEW YORK — She started wrapping more than a decade ago, and eventually Diane Von Furstenberg, in her own words, "dressed everyone in America, and was on the cover of Newsweek."

As her printed cotton knit dresses grew into something of a status uniform for middle America in the Seventies, Von Furstenberg, still in her 20s, became a household name. "I was too young and too proud," she says of her rise to apparel fame. "I never had the backup." And, she says, she lost control in a licensing agreement with Puritan Industries.

Von Furstenberg, now 40, is back in the dress market for spring. She has signed a licensing agreement with Donnkenny Inc., a moderate sportswear manufacturer, to produce a line for department

sign down to people," she says. "Of course, I love to have a Saint Laurent tuxedo that I can wear now and in 20 years. That's different. But today, most clothes are so expensive, and poorly made. I want to give women value — and a certain style. The woman I relate to works. She's busy. She has no

and slim, knotted-front shapes. "They look like nothing. But it's not so easy to make nothing clothes that look terrific on.

— BRIDGET FOLEY

Diane Redux

The little dress returns

J ust about everybody makes New Year's resolutions. Fashion maven Diane Von Furstenberg's resolution "to bring back the little dresses" has come to fruition.

You remember her — in the early '70s, Ms. Von Furstenberg designed a V-neck cotton jersey wrap dress that put her name on the fashion map. By 1976, 3 million had sold

fabrications, she said she still believes that Italian knits are the best.

"I love the way they feel against the skin," she said.

Every customer wanted it. And were there ever rip-offs! As I remember, it sold for under $100.

ment stores this spring. The dresses come in sizes 4 to 16 and will sell for between $110 and $160.

Comeback einer Kämpfe

NEW YORK POST

MONDAY, JUNE 23, 1997

NEWYORKWOMAN

A POST PLUS SECTION

he wrap make a comeback?

mavens are
on Furstenberg
ess is a hit

At once vulnerable (one tie and you're all undone) and provocative (one tie and you're all undone), the wrap dress and its phenomenal success landed Von Furstenberg — in a body-clinging green-and-white striped version — on the cover of Newsweek in 1976.

"The concept is still a valid one," says Von Furstenberg, who's teamed up with her 24-year-old daughter-in-law Alexandra Von Furstenberg to create her new clothing line, Diane. It will be available exclusively at Saks Fifth Avenue later this summer.

In her heyday, she sold five million of these frocks. Today, the idea of the dress, brings a feeling of nostalgia to the women who wore the originals and inspiration to young designers who're creating their own.

Question is, will '90s women embrace Von Furstenberg and get wrapped up in this style again?

Carolina Herrera, who showed two wrap dresses in her Spring 1997 collection — a silk yellow ruffled dress and a red jersey — says the style's appeal is that it's "easy to wear, airy and looks sexy. It's good for summer more than anything else."

Personally though, Herrera eschews wearing wrap dresses.

"I don't feel comfortable," she says. "It feels like I'm wearing a dressing gown."

Nicole Miller reports that the two wrap dresses she designed for her Spring 1997 collection — a reversible crepe with bamboo ring and a nylon long sleeved pale

green — were rather modest sellers.

"I put them in for a mix of silhouettes and shape and to test the market," Miller says. "But they don't hang well on hangers."

Besides, Miller says, most women today shop for work clothing, for evening wear and head to The Gap for weekend clothes. "Where does the wrap fit into today's lifestyle?" she asks.

That's a question Von Furstenberg asked herself before deciding to introduce a late '90s version of the wrap dress in silk knit (original was cotton and rayon). She's bringing back the bold prints, and the collar and cuff on one version, but the skirt will be leaner.

"Yes," Von Furstenberg acknowledges, "the challenge is that women have been wearing jackets for so long."

After much deliberation and encouragement, Furstenberg became convinced to unwrap her famous dress because of the younger generation, who were snapping up the originals in vintage clothing stores.

"I can't stop being surprised," she says.

Downtown designer Pixie Yates, 30, is among the admirers.

"I remember my mother wearing a wrap dress with sandals and a little straw bag," Yates recalls.

Now she designs her own in solids and prints in rayon and polyester micro fiber.

"What do I like about the wrap dress?" asks Yates. Just like a woman of the '90s, she says, "They're ladylike, but at the same time they're not."

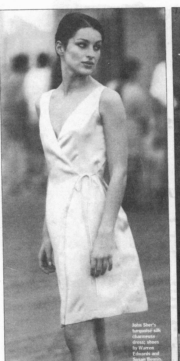

WOMEN'S WEAR DAILY, TUESDAY, AUGUST 23, 1994

Taking the Wrap

DVF '75

John Sher's turquoise silk charmeuse dress; shoes by Warren Edwards and Susan Bennis.

Hayward, CA
Review
(Cir. D. 38,173)
(Cir. Sun. 38,558)

DEC 19 1976

Diane von Furstenberg

$30 million gross—
Princess' business

By RICHARD BONNER
(Chicago Sun-Times)

CHICAGO — Diane Von Furstenberg, merchant princess.

In the past se Brussels has par a dress, cosmet will gross $30 to take into account such products and rainwear, so

Hardly an acc nected as a princ

"A TITLE ce concedes with from frequent er when you're sta that I'm a very se ing mind. I follow sense. And taste,

"I think you co independent and dustry and give i

Clad in one of stenberg sits in arms of the chai gins of her Dinner

After a brief s Cornfield in Swi (without graduati she met Prince F whose title was I Fiat automobile.

IN 1969 the tw caught on quickl stenberg knew sh as possible: "I k boutique or some

"We rushed in berg. Though ha ienced her, it did some inventory m cesarean section

Among designs from Diane Von Furstenberg's current collection are, left, an off-the-shoulder peasant dress in jersey with long sleeves and dropped waistline, and right, a "tulip fantasy" wrap-style of black jersey in yellow, red or blue print, made with deep

A consummat wonder why she castle. Simple. S business — and

wrap dress launched fashion career

In Fashion

for clothes; they
t in the world and
sly beautiful, but
table," she said.
I design costumes,
gn clothes for the
e woman who
to look terrific."
years ago, when
d her husband,
Egon Von Fur-
rg, moved to
can from Belgium.
Von Furstenberg
d to create femin-
esses that would
wear well
her first patterns
ut out on the dining

room tables in her apart-
ment.

She shipped the dresses
to a friend in Italy who
had them manufactured
at a factory outside of
Florence and when the
first designs arrived in
New York, she packed
them up in a suitcase and
started showing them to
the various department
stores in tie area. These
featherweight, classic
shirt-dresses were the
beginning of Diane Von
Furstenberg, Ltd. "The
fabric I use, which con-
sists of a cashmere-
blended jersey, is still
knit, dyed and printed in
Italy," she said.

Although the Von Fur-
stenberg enterprise has
grown from a single-
handed operation to a
group of 20 cutters and
designers, Diane per-
sonaly selects and de-
signs all the prints that
are used in her collec-
tion. "I fight to keep the
process as inexpensive as
possible so the average
woman can afford to buy
an outfit," she added.

Like Coco Chanel, a
woman designer of the
'40s, Von Furstenberg of
the '70s, is more inter-
ested in volume than
designing creations for
individual women. Her
fall collection retails

Diane Von Furstenberg, above, made designer headlines in the fashion world last year with a simple wrap dress, below at left.

want in their fashions.
"Fashion show clothes
are on the way out. I
design the things I like. I
put them on and see what
they look like and how
they feel," she said.

Diane fell in love with
lavender and purple
shades this fall and much
of her collection sports
that color. "The basic
dress I design may be
worn loose and flowing or
tied with a self belt," she
said. "When you start
wearing jersey dresses
like these, it's hard to
wear anything else; if
you add a little weight the
dress stretches with you.
You can wash it and pack

dresses — simplicity,
comfort and versatility.
"Every woman should
do her best to look as good
as possible," she said.
Believing that it should
not take hours to do so,
Von Furstenberg in-
vented a line of cosmetics
that consist of 13 make-
up products, all clearly
labeled and ten treatment
products that are bene-
ficial to all skin types
when used regularly.

"People have asked me
if I'll ever go into
children's or men's
fashions, but I cater only
to women," she said. She
admitted she is interested
in interior design and is
flirting with the idea of
trying a hand at it.

"I love my career, but
it's difficult because I
have to travel a lot," said
Diane, mother of two
children, ages six and
seven. She lives with her
husband in an apartment
in New York and vaca-
tions on an estate in
Connecticut.

Ms. Von Furstenberg
admits that being the
wife of a prince has
helped her career, but
she said it didn't make it
the success it has be-
come. "When you bake a
cake you have to have all
the ingredients or it won't
turn out," she said. "I've
worked hard on my own
and created a good,
lasting product."

it and not have to worry.
My fashions are designed
for today's busy life-
style."

The Von Furstenberg
wrap-dress has remained
a "favorite" and women
everywhere have adopted
it as their own unique
look. Her latest style fea-
tures a piped neckline,
narrow cuffed sleeves
and a waistline defined
by thin wrap ties.

Besides creating
clothes that make sense,
Von Furstenberg has ex-
panded her line into
cosmetics, jewelry and
fashion accessories and
she uses the same princi-
ples she relied on for her

Diane Von Furstenberg

TUCSON, SUNDAY, FEBRUARY 20, 1977

The tried-and-true wrap

's a wrap — Diane Von
Furstenberg is back

seasoned
cially her
ress, is back

fashion, where design-
red garments one sea-
next, Diane Von Fur-
an arbiter of a

se signature "wrap
s experienced a come-
on philosophy: "If you
u feel really com-
ou will act as such and
e attractive."
ak-walled studio, Von
mfitting, silk-jersey
uflage pattern. "I don't
plained. "I like dresses

Wearing one of her signature wrap dresses from her fall collection, designer Diane Von Furstenberg poses in her New York shop.

tently shows shades of purple, blue, orange and
green in bold, geometric patterns. Fabrics in-
clude jersey, chiffon and georgette.
She was born Diane Halfin in Brussels, Bel-
gium, but she moved to New York in 1969 after

daughter and a brand. And my son and my
daughter turned out great and the brand had
just fallen apart.

"But I had time to retire young and come
back to work," she says.

Wrapping up success

Diane Von Furstenberg

Owes success to 'little dress'

By BARBARA HERRERA
Copley News Service

Diane von Furstenberg, 29, the socialite-
turned-designer, in six years has built her
fashion operation from nothing to what she
estimates will amount to $100 million in retail
sales this year.

At 5 feet, 6 ½ inches tall, Miss von Fursten-
berg presents a leggy, loose-jointed ap-
pearance in a size 6 dress. Shining auburn hair
waves over her shoulders. Tawny blusher
colors her aristocratic cheekbones. Shadow
highlights her prominent eyelids.

And a fine line of blue drawn under her huge
brown eyes is the only touch of color in her
otherwise all black-and-white outfit. Her own
black-and-white, three-piece knit dress. Black
stockings. Black patent leather high-heeled
shoes.

Miss Von Furstenberg has no trouble explain-
ing her own success.

"Nobody was doing what we call in French
'le petit robe (the little dress)'," she said. "So
I filled the gap."

Miss Von Furstenberg came along with her
flattering, feminine dresses when Halston,
Calvin Klein and the other superstars were
concentrating on all those classic pants, jump
suits and evening pajamas.

Or as Miss von Furstenberg put it herself:

Se imp
"wra

□ Por
Redacto

Aunque aquí en la Isla, e
idad, parece que han pasado
otros países que nos ha toc
mamente el cuadro es otro.

Nos referimos a los "tra
"wrap around", la invención
ra Diane Von Furstenberg.
ese modelito sensual, tan mo
tiene más de 20 años desde
en el mercado y está próximo
meña de hace dos décadas, cua
vendió como pan caliente.

En tiempos recientes, g
tenberg, quien lanzó al merca
bajo el nombre "Diane" con un
lizadá de los modelos "envolv
ve a lucir uno? □

Y lo mismo ha hecho
del "retro look", diseñadores
lockfeld lo volvieron a colocar en
dial. De hecho, ahora vemo
reinterpretado no sólo en ye
bién en blusas y faldas.

Wrap dress c

By ELIZABETH A. KENNEDY
ASSOCIATED PRESS

YORK — In the fickle
ashion, where designers
tary-inspired garments
n and gothic frocks the
e Von Furstenberg has
an arbiter of a feminine,
style.

rstenberg, whose signa-
dress from the 1970s
enced a comeback, has
ashion philosophy:

wear clothes that make
eally comfortable and
you will act as such and
utomatically be attrac-

wed in her pink-walled
n Furstenberg wore a
ng, silk-jersey wrap
camouflage pattern.